In Defense of Humanism: Value in the Arts and Letters is a response to the critique of traditional humanism, and particularly its cultural dimension, which has been at the heart of intellectual discourse for the past decade. In simple, clear language, Richard A. Etlin articulates the nature of aesthetic experience through analysis of works in a wide variety of media, including painting, sculpture, architecture, drawing, literature, and dance. Establishing categories for determining value in the arts and letters, Etlin also explores the operations of the creative process in a discussion of artistic genius. He reaffirms the transcendent moral and enduring qualities in great works of art. Etlin offers, moreover, a critique of the fundamental premises of the poststructuralist thinkers, including Jacques Derrida, Stanley Fish, Hayden White, Pierre Bourdieu, and Edward W. Said, whose work is placed within the context of modern intellectual history.

In Defense of Humanism

Value in the Arts and Letters

Richard A. Etlin
University of Maryland

CAMBRIDGE
UNIVERSITY PRESS

Published by the Press Syndicate of the University of Cambridge
The Pitt Building, Trumpington Street, Cambridge CB2 1RP
40 West 20th Street, New York, NY 10011-4211, USA
10 Stamford Road, Oakleigh, Melbourne 3166, Australia

First published 1996

Printed in the United States of America

Library of Congress Cataloging-in-Publication Data has been applied for.
A catalog record for this book is available from the British Library

ISBN: 0-521-47077-3 Hardback
0-521-47672-0 Paperback

For my children
David and Marc

Contents

List of Illustrations

Preface

Reade not to Contradict, and Confute; Not to Beleeve and Take for granted; Nor to Finde Talke and Discourse; But to weigh and Consider. Some *Bookes* are to be Tasted, Others to be Swallowed, and Some Few to be Chewed and Digested: That is, some *Bookes* are to be read onely in Parts; Others to be read but not Curiously; and some Few to be read wholly, and with Diligence and Attention.

> Francis Bacon, "Of Studies,"
> *The Essayes or Counsels, Civill and Morall* (1597–1625)

This book addresses the cultural dimension of the radical left's critique of traditional humanism. In the epilogue to the 1991 edition of *Tenured Radicals: How Politics Has Corrupted Our Higher Education*, Roger Kimball, who comfortably places himself within the conservative camp, observes that "the real battle that is now shaping up is not between radicals and conservatives but between radicals and old-style liberals."[1] Although I join that battle as an "old-style liberal," I am less concerned with assaulting the radical position than in offering guidance in the quest for meaning in the arts and letters, understood according to the humanist tradition, as they sustain an attack from the political and cultural tendencies of leftist thought. It has not been my intention to contribute to the ongoing animosity of today's so-called culture wars by engaging in the facile quip or the rapid put down. Rather, I have attempted to adhere to Francis Bacon's counsel to "read not to contradict and confute . . . but to weigh and consider."[2] In the process, when I have disagreed with an author, I have tried to present my criticism with full and measured response.

Years from now, when later generations are no longer interested in the cultural phenomenon of poststructuralism and the controversies that it has sparked in our times, I would hope that the reflections about the nature of art and of aesthetic experience, as well as of their relationship to moral feeling, will still be of value. To this end, I have divided the book into two parts. The first is devoted primarily to establishing categories of value for the arts and letters in general, as well as

according to the distinctive features of the individual disciplines. The second seeks to explain the shortcomings of the major poststructuralist thinkers who have attacked humanist notions.

Each of these two sections has been further subdivided into two chapters. Part one opens with a discussion of categories for aesthetic value and is followed by a chapter that explores the phenomena of creativity and genius. In the course of these discussions, I raise questions about the methods and goals of the self-consciously avant-garde "art" of the last half century and about the philosophy used to explain and justify it. My objective in the second chapter is simultaneously to demystify as well as to celebrate the importance of creativity and genius by explaining their operations to the extent that reason can and by demonstrating the great abyss that separates their inherent mystery from rational discourse. Here I follow the ancient author known as "Longinus," who understood that genius was most fully revealed by studying the limits of ratiocination.[3]

Part two begins by addressing the radical skepticism of poststructuralist thought and proceeds in the last chapter to place the current attack on humanism within the context of the various nineteenth-century intellectual determinisms, ranging from German Idealism to French positivism to Marxism and ending with a consideration of the aftermath of Nietzschean nihilism. If life were literature, one would imagine that confirmed poststructuralists were close cousins from the other side of the family of Charles Dickens's inimitable Mr. Gradgrind in *Hard Times* (1854). For Mr. Gradgrind, all was "fact, fact, fact!" For his poststructuralist relatives there is no fact, no certainty, no truth. Each holds a mirror to the other. With Mr. Gradgrind, Dickens intentionally created a perfect caricature; poststructuralists, though, are perfectly serious, thereby offering unintentionally a caricature of the rich complexity of life with its share of certainties as well as ambiguities, the one not excluding the other.

The questionable premises and conclusions of poststructuralist thought have attracted the attention of able critics in both the scholarly and popular press. The scholarly books generally have been focused on specific aspects of poststructuralist thought or on its relationship to its nineteenth-century heritage.[4] The social and political components associated with poststructuralism have been addressed by Arthur M. Schlesinger, Jr., in *The Disuniting of America* (1992). Schlesinger's book is directed toward a general readership, as are the others discussed below. In the course of explaining the positions of various poststructuralists, critics such as Roger Kimball and David Lehman have demonstrated that it is entertaining to ridicule their foibles, which they do with verve.[5] In a more understated manner, Dinesh D'Souza has perfected the technique of letting the cultural left expose its own weaknesses simply through the apt quotation.[6] I am primarily interested in identifying the underlying positions of a broad range of poststructuralist thinkers – including Jacques Derrida, Paul de Man, Stanley Fish, Barbara Herrnstein Smith, Hayden

White, Pierre Bourdieu and his predecessor Walter Benjamin, Norman Bryson, and Edward W. Said – and then explaining what I see as the problems with their method of arguing. In addition, I also address problematic aspects of the writings of Roland Barthes, Jonathan Culler, Terry Eagleton, Michel Foucault, Julia Kristeva, and Michael Riffaterre. At times this process requires a longer exposition and a more detailed textual analysis than generally found in Kimball's, Lehman's, and D'Souza's studies. My primary interest in these poststructuralists has been with their attack on value and meaning in their own right and as this relates to art and literature.

In pursuing this intellectual strategy, I have attempted studiously to avoid the type of unsubstantiated generalizations that mar Allan Bloom's *The Closing of the American Mind* (1987). These generalizations are both social and cultural. For the former, consider: "This is not to deny the reality of the problems presented by too many children for the poor, the terrible consequences of rapes and battered wives. However, none of those problems really belongs to the middle classes, who are not reproducing themselves, are rarely raped or battered. . . ."[7] These observations about the middle class are offered without any substantiating documentation. For the latter: "Freud and Plato agree about the pervasiveness of eroticism in everything human. But there the similarity ends. Anyone who wished to lay aside his assurance about the superiority of modern psychology might find in Plato a richer explanation of the diversity of erotic expression, which so baffles us and has driven us to our present nonsense."[8] Once again, Bloom offers no evidence to demonstrate his point. He expects his readers to accede to his judgments as a matter of faith. Faith obviously has its place in this world, but not in a work of social and cultural criticism.

My book ends with a postscript directed toward what I call the parameters of culture, framed by Michael Oakeshott's notion of the distinct "voices" that humans create in each of their disciplines and by Rudolf Otto's attention to "primal numinous awe" in his study of the idea of the holy. This dual focus, on the one hand looking to the type of helpful distinctions that reason can afford us, and on the other hand considering the nature of deep emotional, aesthetic, spiritual, and moral experience, presents in microcosm the subject matter of the entire book. Reason and awe, mind and heart – these are my themes.

In the course of writing this book, I have discovered that the very process of reasoning itself has become a major point of contention. Here I found myself identifying different types of errors in reasoning. I bracket the book with warnings, taken initially from Henri Bergson and Walter Pater in the first chapter, and then from Leo Tolstoy and Francis Bacon in the last chapter, about the dangers of creating artificial systems of thought, driven by a restrictive inner logic that denies important components of experience. These components of experience include the knowledge provided by common sense and by deep-seated moral and affective sentiments. They also involve making the most helpful types of distinctions for the purposes of rational discourse.

Thus, in Chapter 1 I distinguish between the sociology and the aesthetics of art to

separate the social and political uses of art from its aesthetic nature. Having made this distinction, I then postulate, with assistance from Hegel and Ruskin, a range of aesthetic experience, as well as attempt to define a unifying moral and aesthetic inner axis. These categories of thought enable me to address the crisis in contemporary art by further distinguishing between the conventions of art and its aesthetics, thereby questioning the procedures of contemporary philosophers, such as Arthur Danto and Richard Wollheim, who alter the definition of art on the basis of the former instead of keeping it grounded in the latter. This process of redefining the terms of a discourse I follow throughout the remainder of the book, arguing against poststructuralist radical skepticism, which confuses value and valuation, and against poststructuralist mistaken populism, which fails to distinguish between pre-Enlightenment and Enlightenment concepts of elitism, as well as between the legitimacy of high ideals and the flawed reality of their implementation. In a brief excursus on moral sentiments, I argue that Richard Rorty, in denying that we have a "core self," has failed to distinguish adequately between the tribal sense and the moral sense.

My division of the domain of art into categories of value in Chapter 1 – the depths of the psyche, the inner patterning of a work of art, the conventions of the genres, the concept of echo, the primary categories of diction (balance, serial development, and simplicity in the service of the sublime) and their relationship to sentience – and of the artistic process in Chapter 2 – patient search, imitative genius, artistic will, simplicity, radical conjunction, act of making, stylization, and humor and wit – have all been determined inductively. As I explain in the text, these categories are intended to present a representative sampling rather than a complete compendium. The same is true of my illustrative examples, drawn from literature (poetry and prose), drawing and painting (abstract and representational), sculpture, music, dance, gardens and cemeteries, and architecture (domestic, civic, and ecclesiastical).

The entire process of making these types of distinctions throughout this book has reconfirmed for me the wisdom of Plato's dialectical method, grounded precisely in this procedure, which has been explained as a "method of definition and division of notions" based on "division and classification."[9] This manner of reasoning works in two directions, for it involves learning to discriminate between dissimilar issues as well as to discern connections among those that are related. As Plato has Socrates say in the *Phaedrus*:

> Believe me, Phaedrus, I am myself a lover of these divisions and collections, that I may gain power to speak and to think; and whenever I deem another man able to discern an objective unity and plurality, I follow "in his footsteps where he leadeth as a god." Furthermore – whether I am right or wrong in doing so, God alone knows – it is those that have this ability whom for the present I call dialecticians.

Commenting on this passage, R. Hackforth explains that according to Plato, this was the method of "the only true philosopher."[10] Considering the arcane language and

abstruse reasoning that passes for so much of philosophy today, especially in the domain of poststructuralism, it is comforting to remember that the philosopher par excellence saw his task in a more direct way. As both Theaetetus and the visitor from Elea in the *Sophist* confirm, this dialectical method of making appropriate distinctions is the path to wisdom.[11] Finally, the purpose of Plato's dialectic, as the Rev. Lewis Campbell cautions us, "is not to exalt a formal method, but to quicken and regulate the free action of the inquiring mind."[12]

Since I entered university life as a freshman nearly thirty years ago, I have been involved with various fields in the arts and letters – first pursuing French literature along with European intellectual and cultural history as an undergraduate, then graduate school in a professional program to train as an architect, and finally concluding with a doctorate in architectural history. Teaching architectural history primarily in schools of architecture to students studying to become professional architects, and working with these students in their design studios, I have for over two decades now been in close contact with the creative process. The reflections that I offer in this book are grounded in a love for all the arts and in a conviction about their ultimately civilizing, by which I mean humanizing, importance.

All authors hope that readers will find their texts worthy of the cogitation that Bacon ascribes to a minority of works. In writing this book I have been repeatedly reminded of the wisdom of Aristotle's analogy between a text and an animal, both requiring what would appear to be an organic relationship between well-proportioned parts, the whole in turn being neither too large nor too small, hence neither too long nor too brief.[13] Yet with a subject as broadly ranging as value in the arts and letters, I have felt obliged to demonstrate my points as conclusively as possible, to discuss the intellectual traditions behind the major arguments, and to forestall criticism by anticipating objections. I have also wanted this book to suggest resources for further reading. In order to achieve these ends without sacrificing the clarity that a well-structured discourse should provide, I have placed a considerable amount of material in the notes located at the end of this volume. Some of these notes become miniature or even full-fledged essays in their own right, often on controversial subjects, such as the meaning of *sensus communis* in Giambattista Vico or the moral role of slavery in Jane Austen's *Mansfield Park*. For the reader's convenience, these and other themes treated in the notes are listed in the index.

It is my hope that readers will proceed through the text to become acquainted with the overall flow of its argument and then return to specific issues discussed in greater detail in the notes. For most of the passages translated from other languages, I have given the original in the endnotes.[14] To facilitate reading, I have subdivided each chapter into titled sections. This method, which I have used in all of my books, helps to focus an author's thoughts while writing, just as it assists the reader's comprehension by providing mental guideposts. To this end, I have also employed a

variation of the technique popular in late nineteenth- and early twentieth-century French writing of grouping these subtitles together at the head of the text so as to provide a preliminary overview of the contents. In this book these chapter outlines can be found in the descriptive table of contents.

Finally, my goal has been to use a clear and simple prose. Considering the purposeful obfuscation of so much poststructuralist writing, strewn with neologisms as well as with clusters of Greek and Latin words, often combined in a confusing concatenation, it seems important to reaffirm one's belief in the intellectual and social benefits of a text readily understandable by all without special training. It identifies the humanist's project, it marks our sense of community, and it deepens our common humanity.

In the West we have arrived at a sad point, hopefully not an impasse, when a word such as "humanist" has become the object of derision. From the extreme right, the separation of church from state and the insistence on scientific criteria for the teaching of biology, and hence the rejection of the pseudoscience of "creationism," are dismissed with disparagement as "secular humanism." From the new radical left, intelligible intellectual discourse, the belief in transcendent moral and aesthetic values, and the very faith in the possibility of finding patterns of intentional meaning in a work of art that correspond to the artist's actual purpose are dismissed as "humanism," sometimes further denigrated with the qualifier "conservative" to make "conservative humanism."

How unfortunate it is that today's cultural climate requires an intelligent observer, sympathetic to this traditional humanism and writing in a humanist publication like the *Times Literary Supplement*, to assure his readers that by applying the label "humanist" to an author under review he means no insult. The writing in question, we are told, "is deeply grounded in familiar humanistic assumptions (by which I intend no disparagement), and his way of writing about a work of literature is instantly accessible to anyone."[15] I would feel honored if somebody would say the same about my book. Yet I would hope that he or she would be able to use the word "humanism" without qualification. It is my hope that this work will contribute to changing the contemporary cultural climate in that way.

College Park, Maryland
December, 1994

Acknowledgments

I began this book in response to the challenging question about value in the arts and letters postulated by Frank Kermode in the Spring, 1992, inaugural issue of *Common Knowledge*. (The query is stated at the opening of Chapter 1.) By the fall of that year I had an eighty-page manuscript that I considered to be a manifesto ready for publication. In November I showed this manuscript to Dr. Beatrice Rehl, Fine Arts Editor of Cambridge University Press, who expressed enthusiasm for my text while suggesting that the book was underwritten. This was further confirmed by one of the two extremely useful readers' reports secured by Cambridge University Press, which encouraged me to engage more explicitly the major ideas of the leading poststructuralist thinkers. Most of my book at that time contained an affirmation of and explanation about humanistic values; only a small part consisted in refutation of the attack on these values by poststructuralists.

Over the course of the next two years I further developed all sections of the book, expanding the three original chapters and adding a fourth one as well as a postscript. Throughout this process I enjoyed the continuing support of Beatrice Rehl, who patiently read and critiqued my successive drafts with a prompt attentiveness that was both helpful and encouraging. My debt to her interest in this project is enormous.

Other people and institutions also assisted me; I am happy to acknowledge their help at this time. During the 1992–3 academic year I enjoyed a sabbatical as the Paul Mellon Senior Fellow at the Center for Advanced Study in the Visual Arts at the National Gallery of Art. Although my primary research project there dealt with the politics of style in the institutional architecture of Fascist Italy, the free time and highly stimulating intellectual atmosphere at the Center permitted me to develop and clarify my thoughts on this other task. Peter Brunette and Anabel Wharton, also Senior Fellows at the Center, and I formed a study group to read and debate significant works by major poststructuralist thinkers. I greatly enjoyed and benefited from the discussions in which a wide range of Fellows participated. Brunette also generously placed at my disposal his extensive library of poststructuralist texts. Anne Coffin Hanson, then the Samuel H. Kress Professor at the Center, kindly read

my initial manuscript and offered helpful suggestions. I thank Henry Millon, Dean of the Center, for supporting the intellectually nurturing atmosphere that made such impromptu activities possible.

My other greatest institutional debt is to the University of Maryland. The University of Maryland Library System has provided me with hundreds of books, many readily available from the Architecture, Art, Hornbake, and McKeldin libraries on my College Park campus, but many also coming by rapid dispatch from the other libraries in the statewide system. I thank all the people involved in funding and maintaining such a useful research tool. At the Library of the School of Architecture, Cindy Larimer in particular has been especially helpful to me over the years.

Chapter 2 was developed from a public lecture that I delivered in March, 1991, as part of my responsibilities as a Distinguished Scholar-Teacher for the 1990–1 academic year. Originally conceived as "Creativity in Architecture," this paper formed the basis of my broader study into creativity in the different arts and letters. I am grateful to have had the stimulus and opportunity to focus my ideas on the subject through this public lecture, which is still being shown on the university's educational cable access Flagship Channel.

Friends and colleagues have helped by suggesting books and articles for further reading. In particular I thank the anonymous readers for Cambridge University Press as well as Peter Bentel, Ray Carney, Anthony Colantuono, Robert M. Coogan, Joseph A. Kestner, Mark Lilla, William Pressly, Lee Vedder, and Michel Vernes. The press office of the Musée d'Orsay, the United States Navy Memorial Foundation, and the Women in Military Service for America Memorial Foundation, Inc. all provided helpful documentation. So too did Weiss/Manfredi Architects and ACT Architecture, with Marion Weiss and Pierre Colboc of their respective firms generously spending time with me to explain their team's work.

Several colleagues kindly helped with difficult aspects of translation. I thank Beatrice C. Fink and Pierre M. Verdaguer for assistance with French, Peter U. Beicken with German, Anthony Colantuono with Italian, Robert M. Coogan and Judith P. Hallett with Latin, and Roann Barris with Russian. I approached these scholars for advice about particular words or passages. In thanking them for their suggestions and clarifications, I assume full responsibility for any imprecise or erroneous renderings of the foreign texts into English.

Finally, I express my gratitude to the numerous individuals and institutions that provided me with visual documentation used to illustrate this book. Each is acknowledged in the photo captions. Special thanks is expressed through the mention "photo courtesy of" when the photographic print or the permission to use it has been generously provided without fees.

Part I

Defining Value

. . .

O Lady! we receive but what we give,
And in our life alone does Nature live:
Ours is her wedding garment, ours her shroud!
 And would we aught behold, of higher worth,
Than that inanimate cold world allowed
To the poor loveless ever-anxious crowd,
 Ah! from the soul itself must issue forth
A light, a glory, a fair luminous cloud
 Enveloping the Earth –
And from the soul itself must there be sent
 A sweet and potent voice, of its own birth,
Of all sweet sounds the life and element!

O pure of heart! thou need'st not ask of me
What this strong music in the soul may be!
What, and wherein it doth exist,
This light, this glory, this fair luminous mist,
This beautiful and beauty-making power.

. . .

Samuel Taylor Coleridge,
"Dejection: An Ode," 1802.

I

Aesthetic Value

Writing about aesthetic experience, Susan Sontag has justly observed that, "To become involved with a work of art entails, to be sure, the experience of detaching oneself from the world. But the work of art itself is also a vibrant, magical, and exemplary object which returns us to the world in some way more open and enriched."[1] How does art enrich us in this manner? In what ways can art become a "vibrant, magical, and exemplary object"? To answer these questions requires a discussion of the nature of aesthetic experience and of the qualities of aesthetic value that make that experience possible. Yet to pursue this course today is fraught with difficulties, because a major current of intellectual discourse denies the importance of this experience and denigrates the possibility of articulating values in art.

Defining the Method

If a present-day Hazlitt or Horne were to appear among us to provide an updated study of the "spirit of the age," a sequel to those earlier "contemporary portraits" that offered reflections on current intellectual fashions and characteristic ways of thought, then no doubt the subject of "critical" theory, with its radical skepticism as to the location of value in art and morality, would figure prominently in that work.[2] Its pendant would be found in the conservative defense of what both ideological parties stereotypically call the "canon." For the former party the problem of defining value has become such a conundrum that in the call for papers in the recent inaugural issue of *Common Knowledge* Frank Kermode requested that readers address the position that "value is attributed to certain works (paintings and music as well as books) only by institutional (and oppressive) fiat."[3] Before the ascendancy of "critical" thought, the question would hardly have arisen. It would have seemed self-evident that the arts and letters have inherent value independent of what another writer associated with this journal terms the "aura of sanctity" imparted from without. That the question arises as a burning issue is very much a sign of our times.

How is one to answer such a query? Certainly the mere iteration that great art has a timeless quality can hardly be satisfactory. One of the most disappointing

aspects of Roger Kimball's otherwise admirable *Tenured Radicals: How Politics Has Corrupted Our Higher Education* is the unexamined way in which the "great works of the Western tradition" are repeatedly invoked as if their value were self-evident. Although the subtitle of this book reflects the author's primary concern, I wish nonetheless that he would have explored at least briefly some of the features which have made certain works "great" and hence of enduring value. When encountering the initial references to these "great works" in this text, I had the impression that they were being invoked as a type of cultural Holy Grail, whose mere mention evoked awe and reverence which required no further explanation. This is partly ameliorated in the final chapter, as well as in the epilogue to the 1991 edition, which asserts that the traditionally valued great works have been instrumental in sustaining a belief in our common humanity.[4] Yet this explanation does not go far enough. We still need to explain what exactly establishes value in the arts.

The answer will not be found in the skepticism associated with contemporary "critical" thought,[5] nor in the nihilist or messianic fervor of "deconstruction," the two main trends in today's "poststructuralism."[6] Rather, I propose to address the question that Kermode has postulated from an intermediary stance whose spirit is more akin to Clym Yeobright's in Thomas Hardy's *The Return of the Native* (1878): "He left alone creeds and systems of philosophy, finding enough and more than enough to occupy his tongue in the opinions and actions common to all good men." Hardy, of course, was not that naive to believe that "all good" people would agree with Yeobright's stance. As he explained, "Some believed him, and some believed not." I am sure that the champions of "critical" thought will find my words, as did certain members of Yeobright's audience, "commonplace."[7]

My approach entails a manner of thought encapsulated by Thomas Paine's profession of intellectual purpose: "In the following pages I offer nothing more than simple facts, plain arguments, and common sense."[8] Because common sense is commonly ridiculed by poststructuralists, I find the need to reaffirm its value.[9] For those who deplore what David Lehman terms the recourse to "mystification" and what Roger Kimball characterizes as the "deliberate obscurity" of so much of "contemporary intellectual and cultural life, especially in the academy," Paine's call for plain argument compels assent.[10]

Common sense, then, is my guide. My allegiance to it is grounded in the conviction that the mental and spiritual operations associated with common sense are allied with those that sustain the notion of "self-evident truths" as enunciated by the American Declaration of Independence. In that sense, this book is very much a child of the Enlightenment. As Max Horkheimer explains:

> In the history of social philosophy even the term "common sense" is inseparably linked to the idea of self-evident truth. It was Thomas Reid who, twelve years before the time of Paine's famous pamphlet and the Declaration of Independence, identified

the principles of common sense with self-evident truths and thus reconciled empiricism with rationalist metaphysics.[11]

Yet these truths are not known simply by the mind; they are impressed within the heart. As Rousseau explains, "If natural law had been written only in human reason, it hardly would be capable of directing most of our actions. But it is also engraved in the heart of man in unerasable characters. . . . It is there that it cries out to him."[12]

In emphasizing the importance of common sense, I appeal not only to the lessons of the Enlightenment but also to the classical tradition of rhetoric in which arguments about universal issues, called "commonplaces," were stored in the mind — and in books — for repeated use on specific occasions where, because of the enduring truths that they embodied, they would apply. This classical tradition of commonplaces is particularly appropriate for an approach to moral values grounded in natural law and self-evident truths and to aesthetic values known in comparable ways, because, as Sister Joan Marie Lechner explains, "The early definitions and the ancient concepts of the commonplace relate it to the science of moral philosophy."[13] Here is an apt example cited in a work on rhetoric dating from 1596 in which the author shows how Cicero used such a commonplace in his celebrated speech prepared for the defense of Titus Annius Milo, the Roman tribune who killed the tyrannical gang-leader Clodius in battle in 52 B.C.:

> The commonplace, in the *Pro Milone*, concerns the natural right to defend oneself against force. "This, O judges, is a law, not written but innate in man: a law which we have neither learned, nor received, nor read; but we have appropriated it from nature herself, we have been nourished with it, we have expressed it not according to what we have been taught, but to what we have accomplished, not according to what we have ordained, but to what we have been imbued with;"[14]

The author then proceeds to explain that Cicero could use this speech to defend somebody else because it applies a general principle, a "natural right," and as Cicero argues, a "law . . . innate in man."[15] Let us restore, then, the original sense to commonplace as a general truth and thereby seek the matter for such commonplaces in our inquiries.[16]

Thus, in the course of this book I will appeal to the knowledge of the "heart" and "soul." If this approach to explanation appears commonplace, what advocates of "critical" thought dismiss as "humanist platitudes," I would remind them of the nighttime scene in *Tom Jones* when the squire finds the newborn child in his bed. Listening to the harangue of the elderly woman servant who warns him against the world's gossip while recommending putting the infant in a basket outside the church warden's door, the squire responds otherwise: "But he had now got one of his Fingers into the Infant's Hand, which, by its gentle Pressure, seeming to implore his Assistance, had certainly out-pleaded the Eloquence of Mrs. Deborah, had it been ten times greater than it was."[17]

The gentle pressure of a newborn's hand appeals to a realm of feeling and understanding that in the domain of art has occasioned even champions of rationalism such as Viollet-le-Duc and Le Corbusier to ponder and affirm the inextricable rights of the heart in aesthetic experience. As Viollet-le-Duc has observed, reason in art is best "directed by the senses," an insight that Le Corbusier confirmed through his expression of artistic faith uttered in front of the Parthenon, that "formidable mass raised up with the inexorability of an oracle": "In face of the inexplicable precision of this ruin, the abyss grows increasingly deeper between the soul that feels and the mind that measures."[18]

If my recourse to Clym Yeobright's methods may fail to satisfy the moderate camp in the current intellectual tendency termed poststructuralism, the school of "critical" thought represented by Kermode and the editorial policy of *Common Knowledge*, it will exasperate the followers of Jacques Derrida, the "deconstructionists" who occupy the intellectual fringes. Derrida's work, a metaphysics of Being grounded in a German philosophical tradition reaching from Hegel to Husserl and Heidegger, has spread its method throughout the humanities. This, argues Derrida, is the prerogative of philosophy: "That is to say, I have learned from philosophy that it is a hegemonic discourse, structurally hegemonic, considering all discursive regions to be dependent upon it."[19] Derrida's camp has certainly taken this thought to heart, for the language and thought patterns of philosophy, especially metaphysics, have pervaded deconstructionist texts throughout the various domains of the arts and letters. So popular has this method become in poststructuralist circles that, as Lehman has observed, "In practice, this has led to a proliferation of 'theoretical' studies – books and essays that refer primarily to theories of literature and only incidentally (if at all) to literary works themselves." "It has also led," continues Lehman, "to many meticulous and minute dissections of given 'texts' with a view toward demonstrating some a priori axioms."[20] To these people, I respond with observations taken from Walter Pater and Henri Bergson. In the "Conclusion" (1868) to *The Renaissance: Studies in Art and Poetry*, Pater warns:

> What we have to do is to be ever curiously testing new opinions and courting new impressions, never acquiescing in a facile orthodoxy, of Comte, or of Hegel, or of our own. Philosophical theories or ideas, as points of view, instruments of criticism, may help us to gather up what might otherwise pass unregarded by us. "Philosophy is the microscope of thought." The theory or idea or system which requires of us the sacrifice of any part of this experience, in consideration of some interest into which we cannot enter, or some abstract theory we have not identified with ourselves, or of what is only conventional, has no real claim upon us.[21]

To sustain that curiosity, to avoid falling into the confining strictures of a system, to grasp and to explain the aesthetic experience that art provides is my aim. As

Bergson likewise cautions, the best route does not pass through the domain of metaphysics. Rather, it is more empirical in nature:

> In dealing with this problem we cannot reckon much on the support of systems of philosophy. The problems men have most deeply at heart, those which distress the human mind with anxious and passionate insistence, are not always the problems which hold the place of importance in the speculations of the metaphysicians. Whence are we? What are we? Whither tend we? These are the vital questions, which immediately present themselves when we give ourselves up to philosophical reflexion without regard to philosophical systems. But, between us and these problems, systematic philosophy interposes other problems. "Before seeking the solution of a problem," it says, "must we not first know how to seek it? Study the mechanism of thinking, then discuss the nature of knowledge and criticize the faculty of criticizing: when you have assured yourself of the value of the instrument, you will know how to use it." That moment, alas! will never come. I see only one means of knowing how far I can go: and that is by going.[22]

To delve into the matter of aesthetic value, we must follow Pater when he counsels us to proceed with "this sense of the splendour of our experience and of its awful brevity,"[23] just as we also must adhere to Bergson's analogous advice to eschew the arid abstractions of philosophical systems in favor of grasping the nature of the experience:

> On the other hand, as nothing is easier than to reason geometrically with abstract ideas, [the philosopher] has no trouble in constructing an iron-bound system, which appears to be strong because it is unbending. But this apparent strength is simply due to the fact that the idea with which he works is diagrammatic and rigid and does not follow the sinuous and mobile contours of reality.[24]

The task, then, is to follow the "sinuous and mobile contours of reality" in aesthetic experience, while accepting the challenge to explain how "high value" can be assigned to what has been called the "great works of the Western tradition" in a way that would distinguish them from "westerns" and "TV soaps." In pursuing this goal, Kermode advises that one "consider the similarity of this problem of artistic valuation to that confronted by students of ethics . . . to distinguish good from less good choices of conduct."[25] This advice is extremely helpful, for in the end the source of value in art and the source of morality in ethics have common roots.

The Aesthetic Scale versus the Sociology of Art

The problem with the argument that "value is attributed to certain works [of art] only by institutional (and oppressive) fiat" resides in the qualifier "only," which pertains only at times and only to a secondary degree. It ignores the heart of the matter, which is the aesthetic response, the experience that makes one "more open

and enriched" through contact with "a vibrant, magical, and exemplary object," to
repeat Sontag's characterization. The degree to which value in art is assigned by
"institutional fiat" pertains not to the aesthetics but rather to the sociology of art.
The distinction is important, for art serves many ends. It has been used to glorify
individuals and regimes; it has been impressed into the service of magic; it has
presented allegories either moral or political; it has served the aspirations of rulers
and the pretensions of the wealthy. All of this concerns the sociology of art.

None of these sociological purposes can negate the aesthetic purpose and aesthet-
ic role of art. Year after year, and eventually century after century, countless people
are transported by a Beethoven symphony, awed by a Gothic cathedral, and touched
deeply by a Rembrandt self-portrait (Fig. 1) or a Shakespeare play, because these
works of art speak directly to a deeply rooted understanding about the nature of
being and of human relationships in a way that is indissolubly tied to aesthetic
experience. This phenomenon is intimately related to questions of ethics, not in the
sense that the beautiful is the good and vice versa, but rather that feelings of
kindness, compassion, and love arise just as spontaneously in the human heart as
does the response to great works of art. The latter, at times, may require more
cultural mediation than the former, but both touch a common wellspring of human
experience. To pursue this issue further requires a consideration of the nature of
aesthetic experience and its relationship to the wide range of factors that constitute
the sociology of art: the dynamics of acculturation, the vicissitudes of taste, and the
role of artistic conventions.

Anybody who has had this type of aesthetic experience with art would probably
agree with Susanne K. Langer that the "artistic symbol, *qua* artistic, negotiates
insight, not reference; it does not rest upon convention, but motivates and dictates
conventions. It is deeper than any semantic of accepted signs and their referents,
more essential than any schema that may be heuristically read."[26] Of course, one's
ability to respond fully to any work of art depends, to varying degrees, on famil-
iarity with the conventions through which the work of art has been developed. A
familiarity with the tonal patterns of Western music no doubt helps the listener
respond to Beethoven; an understanding of the distinctive vocabulary of Elizabethan
English is required to gather so much of the meaning in a play by Shakespeare.

The aesthetic response will also be colored by current tastes. For nearly four
centuries after the Gothic cathedrals were completed, they were largely ignored and
often disparaged in treatises. Their rediscovery in the nineteenth century was only in
part an aesthetic matter; it also enjoined pride about what was deemed as national
heritage and at times was made to sustain an idealized view of community and ethics
attributed to the medieval period that saw their creation. To observe, however, that
the aesthetic experience is mediated in varying degrees by conventions and taste is
not to deny the fundamental nature of that experience when it occurs.

Once we are aware of the difference between the sociology of art and aesthetic

response, we can put the former aside temporarily so as to address the latter. The next issue to be considered, then, is how art affects us. Can we give precision to the characterizations by Sontag and Langer? Sontag rightly explains that art provides "an experience of the qualities or forms of human consciousness."[27] Yet what is the nature of that experience? Freud, who accords to aesthetic experience a prominent role in the "life of the imagination," describes it as inducing a "mild narcosis," as providing a "mildly intoxicating quality of feeling."[28] This explanation is doubly useful, for it alerts us to two misconceptions about the depth and breadth of aesthetic experience. First, art can effect a much deeper and a much more meaningful sentiment than Freud has discerned. It can be the vehicle of a transcendent experience, which touches the mystery and the sacred nature of life. Second, aesthetic experience is not singular in character. Just as the "qualities or forms of human consciousness" are multifarious, so too the aesthetic experience of art can assume an entire range of attributes, ranging from the more superficial to the most sublime, and certainly encompassing Freud's mild narcosis.

In other words, the possibilities for aesthetic experience occur along a continuum. This was fully recognized by two nineteenth-century thinkers who devoted much attention to the question of art, Georg Wilhelm Friedrich Hegel and John Ruskin. Of course, one could not imagine two more widely divergent thinkers than these two men. Yet on this one issue they shared a common understanding. In drawing a concise characterization of the range of aesthetic experience from the work of each, though, I am neither recommending nor adopting their entire respective philosophies of art. I am concerned rather only with their capacity as keen observers of the human spirit to define the range of aesthetic response that people have to art. Both Hegel and Ruskin saw aesthetic response as ranging from forms of pleasure and enjoyment that might be said to remain close to the surface of our psyche to the most deeply moving feelings associated with tragedy, wisdom, love, or spiritual transcendence. First Hegel:

> [I]t is of course the case that art can be used as a fleeting play, affording recreation and entertainment, decorating our surroundings, giving pleasantness to the externals of our life, and making other objects stand out by artistic adornment. Thus regarded, art is indeed not independent, not free, but ancillary. (. . .) [Art] only fulfils its supreme task . . . when it is simply one way of bringing to our minds and expressing the *Divine*, the deepest interests of mankind, and the most comprehensive truths of the spirit.[29]

This observation, taken from Hegel's *Aesthetics* (1823–9), is essentially the same as the following from Ruskin's *Seven Lamps of Architecture* (1848):

> In thus reverting to the memories of those works of architecture by which we have been most pleasurably impressed, it will generally happen that they fall into two broad classes: the one characterized by an exceeding preciousness and delicacy, to

which we recur with a sense of affectionate admiration; and the other by a severe, and, in many cases, mysterious, majesty, which we remember with an undiminished awe, like that felt at the presence and operation of some great Spiritual Power.[30]

Let us leave aside for the moment the issue of whether Hegel was correct in qualifying the decorative aspects of art as "ancillary" to art's purposes and hence not "free," and let us ignore as well the fact that Ruskin in this passage was talking specifically of architecture rather than of art in general. The remarkable aspect of both texts is their shared insight that aesthetic response covers a range which extends from the more superficial – "fleeting play" and "entertainment" – to the most profound – "the deepest interests of mankind and the most comprehensive truths of the spirit."

The goals that artists set for themselves, as well as the degree of success in realizing them, help determine where a work of art will appear on the aesthetic scale. Decorative motifs, for example, whether on wallpaper or along the string-course of a building, through the rhythmic repetition of their patterns, the grace of their forms, and the liveliness or harmony of their colors, will generally offer simple pleasures that we can situate to one far side – shall we say, low side – of the aesthetic scale.[31] The deep humanity conveyed by the Rembrandt self-portrait (Fig. 1), where everything about the depiction of the face and body, the atmospheric effects of the coloring and shading, the uncanny look suggesting wisdom about life and mortality, that pensive reflection which speaks through the eyes, the suggestion about the poignancy of the painter's task through the parallel created by the dead matter of paint – shown as mere paint – on the palette used to portray a timeless image of a man or woman with time-bounded life, all of these thoughts and sentiments combine to move us with the manner of deep spiritual insight that can be located at the opposite end of the aesthetic scale, at the high side.

Saul Bellow has put this matter succinctly by stressing "the powers of soul, which were Shakespeare's subject (to be simple about it) and are heard incessantly in Handel or Mozart." Bellow continues by lamenting about what he sees as the current neglect and disparagement of these powers and by affirming their reality and centrality to the artist. These powers "have no footing at present in modern life and are held to be subjective. Writers here and there still stake their lives on the existence of these forces."[32] In short, any aesthetic response that deeply engages "the powers of soul" belongs at the high end of the aesthetic continuum.

For convenience, throughout the course of this book, when addressing the range of possible aesthetic responses, I will refer to this phenomenon as the "continuum of aesthetic response" or "the aesthetic scale." Any discussion of value in art, then, should consider where on the continuum of aesthetic response art affects its audience. Such a scale of values offers a means by which quality can be ascertained and through which value can be distinguished from convention.[33]

Cultural Conventions and Political Purposes

All art forms – indeed, all forms of human discourse and organization – operate according to conventions. If one considers the Western academic hierarchy in painting dominant in the seventeenth and eighteenth centuries, for example, one finds a culturally established scale of values that placed grandiose history painting at the top, portraiture in the middle, and still life at the bottom. Today in a time of different tastes, it is likely that more people would be moved more deeply by the quiet beauty of a Chardin still life than by any of the merits of what would seem to be the pompous history canvases of that era. Most likely painting from neither genre would affect the viewer as profoundly as one of those mature self-portraits by Rembrandt (Fig. 1) where, as Jakob Rosenberg has put it, "To the keen self-observation of his earlier years has been added a profound thoughtfulness," a "dignity which . . . seems to be rooted in an uncompromising search for truth, . . . express[ing] the most intense integration of the artist's physical and spiritual existence."[34] The value of art, at any time, will derive from an interplay between the cultural conventions of the age, as well as its taste, and with what I would call the timeless qualities that observers such as Hegel and Ruskin placed at the upper end of the spectrum of artistic worth.

Generalizations about the arbitrary (and oppressive) character of cultural conventions can be extremely misleading. Are Shakespeare's plays "high art" because of some arbitrary decision by the ruling classes? Lawrence W. Levine, in *Highbrow / Lowbrow: The Emergence of Cultural Hierarchy in America* (1988), argues that Shakespeare was widely appreciated in popular nineteenth-century culture. His plays were not seen as elitist; they were enjoyed in all their aspects, not merely their bawdiness, by the ordinary populace living even on the Western frontier. It was not until the twentieth century that Shakespeare moved from being "an integral part of mainstream culture" into " 'polite' culture." The change, as explained by Levine, owed not to some arbitrarily restrictive or repressive definition of the "canon," but rather to the loss of the "art of oratory," that "seemingly inexhaustible appetite for the spoken word," which characterized nineteenth-century America.[35] In this instance, the notions of lowbrow and highbrow art are helpful only in the sense that they can be used to designate the widespread popular appeal of an artist, as opposed to appreciation by a highly educated, wealthy, cultural elite. In that sense, Shakespeare in nineteenth-century America was both lowbrow and highbrow.

If, on the other hand, one assigns values to these terms, which are seen as a reflection of aesthetic depth as articulated by Hegel and Ruskin, then a comparison between Shakespeare and some vaudeville act would place the former at the high end and the latter at the low end of the spectrum. Before using terms such as high and low art, it is important to establish their relative meanings. With this in mind, one can inquire into the significance, for example, of the distinction so popular in the late nineteenth and

early twentieth centuries between the fine arts and the decorative arts. To a degree, this is an arbitrarily established cultural hierarchy that assigned greater value to the fine arts of painting and sculpture. It is also a hierarchy being questioned today largely on the grounds that it is elitist, and hence arbitrary and even oppressive – arbitrary because culturally decided by the ruling classes, oppressive because it assigns greater value to Western art, where the fine arts flourished, than to non-Western art, whose art objects often fall within the domain of decorative art. To recognize that the distinction between the two genres has been culturally determined is not tantamount to denying the possibility of establishing the aesthetic value of the individual objects of art. What we have ascertained here is that in such cases value has been assigned according to the sociology of art rather than according to its aesthetics.

In the realm of the sociology of art, one finds, for example, that Western society has bestowed greater artistic value to an easel canvas than to wallpaper or a decorated vase. The former belongs to the culturally determined category of fine art, whereas the latter two examples do not. Sociologically this distinction is certainly arbitrary and in ways is elitist and at times oppressive within the context of the cultural politics of the times.

Yet the distinction between fine art and decorative art can also reflect a fundamental difference in artistic intention that corresponds to a great degree to the aesthetic hierarchy outlined by Hegel and Ruskin. Whereas not all objects that belong to the domain of fine art attain that quality of "great Spiritual Power," it is in the realm of the fine rather than the decorative arts that the artist generally defined the task in this way and succeeded in this manner. Once again, it is important to ask what the nomenclature is designating, what the artist is intending, and how the audience is responding.[36]

To argue for the primacy of what I am calling the continuum of aesthetic response is not to deny that art can be used to bolster ego and status, and thereby to help legitimize political power, social prestige, and so forth. Just as it was necessary to distinguish between inherent aesthetic value and the culturally decided categories of highbrow and lowbrow art, so too must we differentiate between aesthetic value and the political uses of art. Cultural categories for art and political exploitation of art belong to the realm of the sociology of art. They help explain how individuals, groups, and cultures might assign value to art according to social purpose, but they do not necessarily address the inner workings of aesthetic experience.

It is a truism that ever since the first princes and priests commissioned works of art, they were enhancing their position within the community. Even beyond the age of princely and church patronage, we find that art was readily intertwined with politics, whether governmental or cultural. In nineteenth-century France, for example, public statues were the subject of heated political debate. June Hargrove has chronicled how republicans, monarchists, and Bonapartists used commemorative public statues to further their respective causes. Erected to honor the dead person and to stimulate emulation of his or her virtues or deeds among the living, these statues also were imbued with political messages only superficially masked by "an individual's apolitical fame." It was a

question not only of a mode of government, but also of a related vision of culture. Positivism, secular education, and religious toleration were among the issues debated.[37] What is so extraordinary is that the aesthetic value of these works of art was taken for granted.

This is not always the case when politics and art meet. Under the Fascist regime in Italy in the 1930s, for example, competing groups of Futurists, Rationalists, and traditionalist architects all jockeyed for position to make their aesthetic credo the official state art.[38] In the French example, the aesthetics and sociology of art ran parallel to each other; in the Italian example, they became intimately intertwined. In neither case, though, did the presence of politics nullify the issue of aesthetic value, which seeks its own definition in the continuum of aesthetic response.

The Crisis of Contemporary Art

The distinction between the aesthetics and sociology of art, as well as the recognition of the independence of artistic conventions from the continuum of aesthetic response, enable us to throw light upon aspects of the present crisis in Western art. The aesthetic scale articulated with help from Hegel and Ruskin is grounded within the constellation of aesthetic categories that by the end of the eighteenth century ranged from the beautiful to the sublime and to the picturesque. Nineteenth-century Romanticism also employed the grotesque, a sort of obverse to the beautiful that turned it inside out while refracting it through the dual prisms of the sublime and the picturesque. In any case, whatever aesthetic categories were used, the work of art could be placed on the aesthetic scale. It afforded some type of aesthetic pleasure.

In the twentieth century, the definition of art was altered radically, yet the term "art" persisted. Music became unmelodic to a degree that it no longer fit on the aesthetic scale. Painting and sculpture, since the time Marcel Duchamp offered up a urinal as "art," became conceptual. Rapid changes in these two visual arts were made as people derived new definitions of what might constitute art. To this was joined "abstraction" in art, which, soon after the generation of Wassily Kandinsky and Paul Klee, seemed in many cases to offer less contact with the world of the spirit. Robertson Davies explains this latter phenomenon well in the novel *What's Bred in the Bone* (1985) through a telling exchange between the master restorer Saraceni and the aspiring artist Francis Cornish:

> "What's wrong with modern art? The best of it is very fine."
> "But so much of it is so puzzling. And some of it's plain messy. (. . .) But the moderns don't paint God and all His works. Sometimes I can't make out what they are painting."
> "They are painting the inner vision, and working very hard at it when they are honest, which by no means all of them are. But they depend only on themselves, unaided by religion or myth, and of course what most of them find within themselves is revelation only to themselves. And these lonely searches can quickly slide into fakery. Nothing is so

easy to fake as the inner vision, Mr. Cornish. (. . .) They [i.e., the "moderns"] are sick of what they suppose to be God, and they find something in the inner vision that is so personal that to most people it looks like chaos. But it isn't simply chaos. It's raw gobbets of the psyche displayed on canvas. Not very pretty and not very communicative, but they have to find their way through that to something that is communicative – though I wonder if it will be pretty."[39]

In both cases – conceptual art from the onset and abstract art after a few generations – the visual arts have generally moved off the aesthetic scale. Rather than give a new name to these creations, the definition of art has been broadened to include them. In doing so, it has attached the prestige that traditionally has been associated with the fine arts to these new endeavors. To the extent that this prestige has been culturally determined, this is a small matter. Yet to the degree that the ultimate value that can be assigned to art is a function of its position on the aesthetic scale, the persistent use of the term "art" to designate these creations is misleading and even erroneous.

The problem resides in the new and omnipotent role accorded to the conventions of art. A convention, such as the representation of the exterior world, was the means by which an artist might create a work of art. The history of art reveals a constant shifting, altering, and questioning of the nature of these conventions. In the twentieth century, the focus was radically changed. The convention itself became the primary concern.[40] Interest in creating a work of art that satisfied some aspect of the aesthetic scale was diminished, sometimes abandoned, and even scorned.[41]

The intellectual challenge of this development has great appeal to art historians and philosophers who take pleasure in charting the course of the successive challenges to the conventions of art. Anthony Savile's recent review of the philosopher Arthur C. Danto's *Beyond the Brillo Box: The Visual Arts in Post-Historical Perspective* (1992), reflects the fascination that such changes have elicited:

[T]he backbone of "Beyond the Brillo Box" . . . is supplied by the overarching question of how to understand our present situation in the visual arts since Andy Warhol painted "Brillo Box" in 1964, and also what can sensibly be expected of art thereafter. Mr. Danto's title points to the answer. We best see our own period – Modernism, which began around the last century's end – as executing a progressive dismantling, or erasure, of the themes that our predecessors' paintings centrally embodied: the abandonment first of aspiration to beauty; then, of the need to have a subject; then, of the deployment of forms in pictorial space; then, of the requirement to be the product of the artist's touch and so on. This sequence has an internal impetus, and with the advent of Minimalism and Pop it had progressed to a point at which the resources of what Mr. Danto calls "the common style" are exhausted; there are no more internal demands left to fulfill. The thought that Mr. Danto is above all anxious to sustain is that by the mid-1960's, with Warhol's "Brillo Box," art as we understand it had reached the end of its trajectory; there was nothing else within the familiar program for the artist still to do.

Savile correctly observes that this historical sequence is one of successive "erasures." Speaking as a philosopher, he cleverly observes that there is a "logical" step beyond Danto's ultimate erasure, which consists in continuing the sequence further through "novel 'stylistic' steps of 'post-historical' *erasures of erasures*." Speculating as to what such "erasures of erasures" might be, Savile postulates, "merely by way of example (not factual report), we might suppose that after terminal abstractionism has seemingly swept the board, a resurgence of pictorial realism might occur, this time around deeply imbued with the distinctively novel thought that *here* is a patent retrieval of what had previously been deliberately abandoned."[42]

I have summarized this argument at length because I wish to emphasize the degree to which the conventions of art are the principal and even sole basis of such discussions. The aesthetic dimension is ignored as irrelevant. If art is merely a question of convention, then Danto is correct in maintaining that the "question of what made them [i.e., "transfigured objects" such as Duchamp's urinal] artworks could be broached without bringing aesthetic considerations in at all." If art refers to creative endeavors that prompt in the audience an experience that belongs to the continuum of aesthetic response, then Danto is wrong in this assertion just as he is wrong in maintaining that no definition of art "can be based upon an examination of artworks." In that case, one need not agree that "any definition of art must encompass the Brillo boxes," whether the originals or Andy Warhol's facsimiles.[43]

This is not simply a question of abstraction versus representation. The first abstract artists knew that whatever an artist chose as the subject matter, it was a means to an end. As Fernand Léger has said, "All of that, those are the means; what is interesting is the way in which they are used." For Léger, the end was to achieve a "state of organized plastic intensity."[44] Whereas Léger drew upon the distinctive imagery of the modern world – machines, billboards, modern typography, and so forth – for both its plastic and narrative value, other abstract artists such as Wassily Kandinsky eschewed representation altogether for an achievement that far surpassed a mere statement about altering conventions. Kandinsky's explanation as to why he abandoned representational painting is highly instructive:

> Much later, in Munich, I was once enchanted by an unexpected view in my studio. It was the hour of approaching dusk. I came home with my paintbox after making a study, still dreaming and wrapped up in the work I had completed, when suddenly I saw an indescribably beautiful picture drenched with an inner glowing. At first I hesitated, then I rushed toward this mysterious picture, of which I saw nothing but forms and colors, and whose content was incomprehensible. Immediately I found the key to the puzzle: it was a picture I had painted, leaning against the wall, standing on its side. The next day I attempted to get the same effect by daylight. I was only half-successful: even on its side I always recognized the objects, and the fine finish of dusk was missing. Now I knew for certain that the object harmed my paintings.[45]

Note that neither Léger nor Kandinsky was primarily concerned with the thrill of overthrowing customary conventions. Rather, each in his own way saw the fracturing or abandoning of representational art as a means to a spiritual end. For Léger this would be achieved and conveyed through "plastic intensity"; for Kandinsky, a canvas "drenched with an inner glowing." How paltry both Minimalist and conceptual "art" appear when compared with such intentions and realizations. How unsatisfactory later abstract "art" became when it remained in a state of "raw gobbets of the psyche" not yet crystallized into meaningful form.

The expanded definition of art championed by philosophers such as Arthur C. Danto and Richard Wollheim,[46] which includes creations that have no pretensions to lodging themselves on the aesthetic scale or that are unsuccessful in this endeavor, has prompted a crisis among the populace about contemporary "art" and more particularly about government funding for such "art." The current outrage in the United States over public monies supporting creations whose primary intention appears to be to offend is prompted not primarily because these works depart from the current artistic canon, but rather, because they appear as extreme examples of an empty artistic culture that for decades has offered little pleasure or spiritual sustenance.

Many champions of government funding for contemporary art look upon Senator Jesse Helms as a relatively isolated extremist. He is, I would maintain, only the proverbial tip of the iceberg. The real source of contention can be found in the public's response to the mainstream of contemporary art, as typified by the outrage over Richard Serra's *Tilted Arc*, a work that will be discussed later. Generations of viewers have visited museums and galleries to find contemporary art perhaps "interesting," at times confusing or boring, and rarely deeply moving.[47] As John Richardson explains in his discussion about the current Guggenheim Museum and its anticipated European branches,

> But is the average Venetian or Basque or Salzburger, let alone the average tourist, remotely interested in something as recondite as felt floorpieces? Will he or she appreciate the way most conceptual artists eschew aesthetic considerations and make their works look as drab and commonplace as possible lest the concept be distorted or overshadowed? Minimalism should prove more accessible, but I very much doubt whether my own admiration for such artists as Richard Serra, Robert Ryman, Ellsworth Kelly, and Brice Marden is shared by more than one in a thousand sightseers.[48]

Before the age of abstract and conceptual art, the public could accept even mediocre representational art because it offered at the very least a pleasing scene or an instructive tale, as well as exhibiting a satisfying mastery of craft. When truly successful, though, representational works of art also assumed a significant position on the aesthetic scale.

Not everybody will concur as to which works have achieved that high aesthetic value. At times, one even could imagine an entire audience being misled into thinking that a work had superior aesthetic value because its narrative matter, perhaps a stirring patriotic scene, prompted emotions that could easily have been confused with aesthetic

response. Yet if one agrees that artistic value is to be found in the scale of aesthetic response as articulated by Hegel and Ruskin, ranging from pleasure to spiritual sustenance, then the variable nature of people's responses at any time and across the ages does not deny the reality of the experience or the value of the creation.

In the end, the belief in value resides in a conviction that is known deep within the soul in a spiritual locus that nurtures ethics as well as aesthetics. Not all people – either as individuals or as social groups – will abide by the Biblical commandment not to kill. Yet this violation does not nullify its ultimate importance, nor does it reduce this dictum merely to a culturally determined attitude. The impulse to honor and preserve life comes from deep within us. The aesthetic value that art offers issues from the same source.[49]

Aesthetic Experience

At this point, having argued for the importance of distinguishing between the sociology and aesthetics of art, it is time to return to the question of aesthetics. The aesthetic scale may establish the range of aesthetic experience, which is essential for establishing value in a work of art, but it will not enable us to articulate the reasons for this response. Here we must attempt to define the qualities that yield aesthetic worth and to demonstrate their presence within individual works of art. In that way we can explain why a play by Shakespeare has greater artistic value than westerns and TV soap operas.

Let us consider more fully Sontag's assertion that art provides "an experience of the qualities or forms of human consciousness." I believe that there are two overriding categories to the qualities and forms of human consciousness which constitute the major components of aesthetic experience. One concerns the insight into the nature of people and life afforded by art. This involves, as Sontag relates, "an act of comprehension."[50] You can ascertain the nature of this "comprehension" by gazing at the face in Rembrandt's self-portrait (Fig. 1). The other involves a heightened sensation of what might be called the feeling of life.[51] This is what Jean-Jacques Rousseau had termed "le sentiment de l'existence" and what philosophers of aesthetics more recently have designated as "the flow of our energy" (Raymond Bayer) or "the pattern of sentience" (Susanne K. Langer).[52] In her essay "On Style," Sontag quotes approvingly from Bayer's explanation about the nature of aesthetic experience: "What each and every aesthetic object imposes upon us, in appropriate rhythms, is a unique and singular formula for the flow of our energy."[53] Using music as a point of departure for a fuller consideration about aesthetic experience in general, Langer has offered us a similar observation:

> Music has *import*, and this import is the pattern of sentience – the pattern of life itself, as it is felt and directly known. Let us therefore call the significance of music its "vital import" instead of "meaning," using "vital" not as a vague laudatory term, but as a qualifying adjective restricting the relevance of "import" to the dynamism of subjective experience. (. . .) Here, in rough outline, is the special theory of music which may, I believe, be generalized to yield a theory of art as such.[54]

It is through "sentience" that we are intimately linked to the work of art. Numerous writers on aesthetics in general or on specific genres of art have attempted to explain that aesthetic experience involves a union between the inner pattern of the work of art and a profound, even primordial feeling of a life force within the depths of one's being. The difficulty in assessing the degree to which the experience commingles the intangible and the physical, spirit with matter, is conveyed well by I. A. Richards's ruminations, quoted approvingly by Paul Fussell in his study, *Poetic Meter and Poetic Form*:

> According to I. A. Richards, the effect of poetic rhythm is distinctly physiological and perhaps sexual. As he says, "Its effect is not due to our perceiving a pattern in something outside us, but to our becoming patterned ourselves. (. . .) We shall never understand metre so long as we ask, 'Why does temporal pattern so excite us?' and fail to realize that the pattern itself is a vast cyclic agitation spreading all over the body, a tide of excitement pouring through the channels of the mind."[55]

There is a close correspondence between the patterning of a work of art and the pattern of our inner feeling of vital life, of sentience. The poet Ezra Pound expressed this well when he said, "I believe in an absolute rhythm, a rhythm, that is, in poetry which corresponds exactly with the emotion or shade of emotion to be expressed."[56] Philosophers of aesthetics have long argued as to whether there is a direct correspondence between emotion and art. While we need not concern ourselves with the technicalities of this debate, Langer's observations about the "close logical similarity" between artistic form and "forms of human feeling," as well as between these forms of feeling and emotion help to clarify these issues:

> The tonal structures we call "music" bear a close logical similarity to the forms of human feeling — forms of growth and of attenuation, flowing and stowing, conflict and resolution, speed, arrest, terrific excitement, calm, or subtle activation and dreamy lapses — not joy and sorrow perhaps, but the poignancy of either and both — the greatness and brevity and eternal passing of everything vitally felt. Such is the pattern, or logical form, of sentience; and the pattern of music is that same form worked out in pure, measured sound and silence. Music is a tonal analogue of emotive life.[57]

The value of Langer's explanation is to alert us to the similarity between sentience and emotion while pointing out that the two are not precisely identical.[58] In a similar vein, to Richards's speculation that "the effect of poetic rhythm" is "perhaps sexual," we can respond that they share a common psychic source but cannot be conflated as identical.[59]

An "Oceanic" Feeling

Having defined the two principal components of the "qualities or forms of human consciousness," first as insight into the nature of people and life and second as the heightened experience of the inner feeling of life itself, I must now demonstrate how

these two components of aesthetic experience coexist or combine in a work of art. To this end, I will attempt to identify categories of aesthetic value that employ them. Both my list and my examples will be merely illustrative. Neither is meant to be complete. Yet before proceeding in this manner, I wish to emphasize how diametrically opposed this approach is to the skepticism of "critical" thought, as typified by the approach to literature advocated by Stanley Fish in *Self-Consuming Artifacts*. Raising the issue of quality, Fish explains:

> My method allows for no such aesthetic and no such fixings of value. In fact it is oriented *away* from evaluation and toward description. It is difficult to say on the basis of its results that one work is better than another or even that a single work is good or bad.[60]

In contrast, I believe that it is desirable to ascertain whether one work is better than another. To lead a rich life, we need the full range of aesthetic experiences that Hegel and Ruskin outlined, especially those that place us within the presence "of some great Spiritual Power." To this end, we must identify and seek out superior works of art that afford us these opportunities. Furthermore, we must attempt, as I have done in the following sections of this chapter, to heighten our awareness of those categories that invest works of art with value according to the twin parameters of comprehension about life and feeling of life.

Why would one want to avoid this task? Why deny its value, its validity? If the reason issues from outrage about the repressive purposes that art has served, then this confusion of the sociology of art with its aesthetics can only be lamented. If the motivation comes from an incapacity to experience the deeper truths afforded by the aesthetic scale, then the denial can only be pitied. One of the most astounding passages on the subject of these deep truths in the critical literature of our times comes in the opening pages of *Civilization and Its Discontents* (1930), where Freud recounts the response by a reader of his "small book that treats religion as an illusion":

> [H]e answered that he entirely agreed with my judgement upon religion, but that he was sorry I had not properly appreciated the true source of religious sentiments. This, he says, consists in a peculiar feeling, which he himself is never without, which he finds confirmed by many others, and which he may suppose is present in millions of people. It is a feeling that he would like to call a sensation of "eternity," a feeling as of something limitless, unbounded — as it were, "oceanic."[61]

The type of feeling described here belongs to the same domain of sentience discussed by Langer and in many respects is comparable to the upper end of the continuum of aesthetic response that places us within the "presence and operation of some great Spiritual Power." This passage is a useful testimonial to the intertwining of religious and aesthetic experience.

The truly astonishing aspect of the account, though, resides in Freud's response: "I

cannot discover this 'oceanic' feeling in myself."[62] It is difficult to understand how somebody who did not know this feeling could possibly articulate an adequate theory of the human psyche. Certainly, this explains why Freud could find in art no more than a "mild narcosis."

Similarly, one wonders whether the champions of "critical" thought experience something like this "oceanic" feeling through certain works of art? If they do not, then one can understand their skepticism. If they do, then one wonders why they deny the significance of the experience, for in its deepest form, it is essentially spiritual in character.

Aesthetic Axis and Diagonal Sciences

Finally, before proceeding, one has every right to ask how is it that certain works of art embody the categories of value that will be defined here and that thereby situate great art on the higher reaches of the aesthetic scale? How do they accomplish this in a manner that is superior to other works of art which are less successful? One can answer these queries in part by demonstrating the skill by which the artist has invested his or her work with these qualities.

Yet, such a response can only be incomplete. Here one must speculate. My own suspicion at this point in life is that although art is infinite in its capacity for variety, there may well be what one might term a specific aesthetic axis within the human psyche such that when the artist touches it, like a chord it vibrates with greater sweetness, pathos, etc., than when the artist misses this mark. Can we really be certain that the psyche is amorphous in matters of artistic creation and aesthetic response? One could raise this doubt simply on the basis that human beings are filled with inner patterns from a genetic code that regulates their development as humans.[63] And yet, if we consider the musings of Roger Caillois, we find that perhaps our inner patterns are also consonant with even larger forces within the universe.

As Caillois reminds us, we are as much a part of the world of nature as the plants, insects, and rocks whose inner patterns we study through our sciences. Might we not also have inner patterns, he speculates, some linked with those of the nonhuman animate and inanimate worlds? Consider, for example, the spiral, that ubiquitous form in decorative art, reaching from the ancient Egyptians to the Mycenaeans, the ancient Greeks and Romans, early medieval Armenian monasteries, late medieval Muslim art, late nineteenth-century building decoration by Louis Sullivan, and contemporaneous facial tattoos worn by the Maori of New Zealand: "[T]he spiral constitutes the synthesis par excellence of the two fundamental laws of the universe, symmetry and growth; it combines order with expansion. It is almost inevitable that the realms of animals, plants, and stars find themselves equally under its sway." Likewise, the "opposition between the right and the left is found in all the realms, from quartz and tartaric acid to the snail's

shell, always right-handed except for the rarest of exceptions, and even up to preeminence of the right hand in man."[64]

Caillois calls the study of such similarities the "diagonal sciences," because they reach obliquely across customary domains. As Caillois reminds us, great artists such as Leonardo da Vinci and Goethe made repeated attempts to understand either human nature or the human body according to such diagonal glances.[65] Certainly Goethe was not speaking simply metaphorically when he postulated "elective affinities" between humans comparable to those between chemical substances.[66]

In light of such patterns, Caillois cautions us: "Across the entire keyboard of nature multiple analogies of this type appear for which it would be foolhardy to affirm that they signify nothing. . . ." Just as it would be dangerous to engage in an anthropomorphism that "endows beings and things with the emotions, sentiments, reactions, preoccupations, ambitions, etc. proper to men," it would be equally mistaken to assume that human beings do not partake of the inner patterns of the nonhuman world: "Man is an animal like the others, his biology is that of other living beings, he is submitted to the laws of the universe, those of weight, chemistry, symmetry, whatever."[67] By extension, is it not possible that we have an inner spiritual axis, with its moral and aesthetic components, around which the insights into the nature of life and the feelings of life cluster and revolve? This inner axis constitutes the core of our nature and touches the larger world of nature of which we are a part.[68]

With respect to aesthetic matters, Caillois postulates a veritable aesthetic order within the domain of nature to which the domain of human art provides a corresponding type: "paintings [are] the human variety of the wings of butterflies." With such insect wings, beauty arises but without choice and without unique realizations. With painted canvasses, free will and imagination determine all, but at a price, for the human artist "has the advantage of truly being the author of his paintings, which, in turn, through an unfortunate choice or through defective work by this being, the only one capable of fallibility, can make a bad painting, straying from the millenary norms of which those works [of nature], indefinitely repeated, cannot avoid achieving a cold and immutable perfection."[69] Though recognizing the impact of personal taste and of societal acculturation on ideas of beauty, Caillois, nonetheless, argues that humans, as part of nature, can derive their sense of beauty only from inner laws of nature itself:

> That which appears harmonious to man can only be that which manifests the laws that govern at the same time both the world and himself, what he sees and what he is, thus, what – BY NATURE – that's the word – suits him and transports him. He is a captive of the fabric of which he is woven.[70]

This line of reasoning about an inner aesthetic axis finds sustenance in the insights of modern linguistics. In his first Russell Lecture in 1971, "On Interpreting the World," Noam Chomsky concluded:

The major point that I want to show, by this brief and informal discussion, is that there apparently are deep-seated and rather abstract principles of a very general nature that determine the form and interpretation of sentences. It is reasonable to formulate the empirical hypothesis that such principles are language universals.[71]

As Chomsky stresses, he believes "that the principles of formal grammar do express the properties of a basic component of the human mind, not directly observed. . . ."[72] Rather, they form the "deep structure" that underlies the linguistic patterns of infinite variety throughout the numerous languages that humankind has created.[73] In approaching the aesthetic categories that will be defined here, and when considering the nature of aesthetic response, we might also postulate the existence of a deep structure to the psyche, of what Chomsky terms "distinct innate schemata,"[74] that the artist touches more closely and more completely in the greatest works of art. If one is troubled by the thought that such innate schemata in some way diminish art, then one might consider the wisdom of Chomsky's closing remarks:

> If, as [Bertrand] Russell frequently expressed it, man's "true life" consists "in art and thought and love, in the creation and contemplation of beauty and in the scientific understanding of the world," if this is "the true glory of man," then it is the intrinsic principles of mind that should be the object of our awe and, if possible, our inquiry.

Addressing himself to "the most familiar achievements of human intelligence – the ordinary use of language," Chomsky ends as follows: "I think it is fair to say that it is the humanistic conception of man that is advanced and given substance as we discover the rich systems of invariant structures and principles that underlie the most ordinary and humblest of human accomplishments."[75] That should also be our task for understanding aesthetic value in art.

Invariant Structures and Principles

In identifying what might be termed "invariant structures and principles" that will yield insight to be gained into the "qualities or forms of human consciousness," let us start with a category that would qualify as belonging to Clym Yeobright's "opinions and actions" common to all. I refer to the understanding about people and life gained by a perspicacious study of human motivation. Let this be our initial category of value and, to demonstrate how it can be achieved, let us begin with Choderlos de Laclos's *Les Liaisons dangereuses* (1782).

Early in this epistolary novel, it becomes clear that the two scheming protagonists are going to be successful, that the Vicomte de Valmont will seduce the virtuous twenty-two-year-old Présidente de Tourvel and that the Marquise de Merteuil will effectuate the debauching of the innocent fifteen-year-old Cécile Volanges, just out of the sheltered life of a convent school. Whereas the plot will become more complex and obstacles to its resolution will demonstrate the author's ingenuity, the principal category of value

here might be said to reside in Laclos's perspicacious study of human motivation. Placing himself alternately in the character of seven different protagonists, Laclos creates as many different personalities who respond to issues of love, desire, honor, and commitment in very different ways. The inner turmoil of the innocents and the creative deceptiveness and deviousness of the villains provide a fascinating study of the human psyche. One can take such a book, then, as a touchstone by which to judge other literature by asking to what degree it offers its own mining of the human psyche.

A second category for value here can be found in the relationship of *Les Liaisons dangereuses* to the genre of the epistolary novel. It can be compared in its aim to a book such as Samuel Richardson's *Clarissa, or The History of a Young Lady* (1747–8). Just as Valmont explicitly rejects the strategy of rape that is employed in *Clarissa* in favor of undermining his victim's resolve by inspiring a combination of affection and desire, so too Laclos appears determined to surpass Richardson's book in the complexity of his literary achievement. Yet the definition of the genre in this case need not be confined to the epistolary novel but can be extended to any book in which the author assumes the voices and hence personae of different characters all involved in the same situation but from different points of view, such as Wilkie Collins's *The Woman in White* (1860), William Faulkner's *As I Lay Dying* (1930), and Robertson Davies's *The Rebel Angels* (1981).[76] In other words, part of the meaning as well as the quality of a work of art can be achieved through the way it uses a particular artistic convention and in recollection of other examples of this genre.

Writing about this phenomenon of recollection in poetry, John Hollander refers more broadly to the function of "echo" in literature, which subsumes the more detailed categories of "echo, allusion, and quotation." "[F]or readers of English and American poetry from *The Shepheardes Calender* to the present, the various engines of allusion have always been central to the poetic record and the poetic procedure. The way in which poets like Spenser, Jonson, Milton, and Marvell deal with prior texts seems a matter almost as important as the nature of poetic rhetoric (indeed, I shall suggest that it may be part of it)." Hollander distinguishes between varying degrees of success in the use of "echo": "What a great writer does with direct citation of another's language is quite different from what a minor one may be doing. Similarly, his handling of a commonplace will be radically interpretive of it, while the minor writer's contribution will be more one of handing on the baton, so to speak, of cultivating tropes rather than replanting or even building there." A poet himself, Hollander offers insight into the way echoing in art engages a dialogue with the spirits of our predecessors:

> Our marginalia all insist
> – Beating the page as with a fist
> Against a silent headstone – that
> The dead whom we are shouting at,
> Though silent to us now, have spoken

Through us, their stony stillness broken
By our outcry (*We are the dead*
Resounding voices in our stead)
Until they strike in us, once more,
Whispers of their receding shore,
And Reason's self must bend the ear
To echoes and allusions here.[77]

In these few lines Hollander prepares us to read once again T. S. Eliot's reflections on this subject in "Tradition and the Individual Talent" (1919), where, "as a principle of aesthetic, not merely historical, criticism," an earlier poet explained how the use of the past both appropriates and redefines it while focusing the parameters of contemporary identity.[78]

A third category for value derives from the quality of the language used. The diction employed in *Les Liaisons dangereuses* is precise, elegant, and musical. All of these effects are used to achieve the ends summarized above. How does the artist employ language here to create the rhythmic and tonal analogues of emotive life and to yield insight into human nature? First, there is the balancing of phrasing that pervades the text:

> I studied our manners in novels, our opinions in philosophers. I even sought in the most severe moralists what they required of us, and I learned in this way what one could do, what one ought to think, and how one should appear.[79]

When done skillfully, this balancing pattern is extremely satisfying on the level of sentience. Following the spirit of Roger Caillois's "diagonal science" that cuts across the different domains – human, vegetable, geological – we might note that such balancing has a musical quality, that it is also like the up and down motion of waves, and that it echoes the bilateral symmetry that pervades so much of the organic and inorganic world. Thus the balanced patterning of Laclos's elegant diction belongs to a category of value that may very well have affinities to the inner spiritual and aesthetic axis postulated here. Any consideration of artistic value, then, will depend, in part, on the discovery of meaningful patterns of diction.

Second, in addition to the pattern of balancing there is also the phenomenon of serial development, as found in the last part of the passage quoted above, in which each successive element modifies and nuances the previous. In this particular case, Laclos has used a figure from rhetoric called "gradation," a "figure of elocution" in which each term progressively augments or diminishes in intensity. The importance of this type of diction was lucidly stated by Pierre Fontanier in his classic treatise on figures of speech other than tropes, *Traité général des figures du discours autre que les tropes* (1827):

> *Elocution* . . . is a form of *diction* nurtured with art and with taste in order to convey a particular idea or sentiment in a way that will have the greatest effect possible on the mind or heart. Now, how can *diction* achieve this? How can it acquire this type of force

and magical power? By the choice, arrangement, and combination of its elements, that is to say, of words. It is this that also gives rise to different figures. (. . .) Do you want to make the main idea more vivid, more luminous, or should the heart be more strongly seized by the strength of the feeling? Then, it seems as if one can never express it enough, and, in order to draw out all aspects of its expression, one *deduces* it repeatedly from itself, and [thus] one reproduces it either with the same form or with different forms: [hence the subcategory] *figures by deduction* [, of which "gradation" is an instance].[80]

Both strategies of diction – balancing and gradation[81] – constitute part of a more general fluidity in the rhythm of the text, which, through its various modulations, flow, pause, and stresses, yields what Langer has called its "vital import."

Having introduced "rhetoric," it is important here to distinguish between those "figures of discourse" that sustain, modulate, and give precision to the feeling of life related to the heart of aesthetic experience and those that do not necessarily contribute to this end. This is especially important because today's "critical" thought commonly makes extensive use of rhetoric, or rather, an aspect of rhetoric called tropes. A trope is a figure of speech whereby one thing is made to stand for another.

The set of tropes favored by "critical" thought are: metaphor, metonymy, synecdoche, and irony. A metaphor associates or compares two different things to create a resemblance; metonymy uses the name of one thing for another to which it is related; synecdoche names something by substituting the part for the whole or vice versa. Irony, however, does not function as these others, for the first three tropes are mechanical in nature.[82]

I use this word "mechanical" to describe rather than to judge, for a metaphor involves a "transference" of meaning, hence the ancient Roman name for metaphor as *translatio*.[83] Of course, too often these mechanical tropes have been used to create a self-consciously "poetic" language with stifling results. In such cases, they appear as precious verbal operations. At times, they primarily entertain and delight, "to refresh the Mind, whenever those Slumbers which in a long Work are apt to invade the Reader as well as the Writer, shall begin to creep upon him."[84] At their best, "metaphors are the very stuff with which human beings make sense of the universe."[85] In contrast to what I term the mechanical nature of tropes, "figures of elocution" directly involve spiritual operations. They engage the woof and warp of sentience; they weave it around the aesthetic axis while they further our understanding about life.[86]

Any work of art will certainly exhibit different degrees of the fundamental categories that people will define as imparting value. Passing, for example, from Laclos's *Les Liaisons dangereuses* to Victor Hugo's *Notre-Dame de Paris, 1482* (1831), we find a dazzling complexity of plot that far surpasses Laclos's earlier book, while losing the sustained subtle mining of emotional range in the characterization of the protagonists. Yet, as in Laclos, there is the literary equivalent to the rhythmic flow of "sentience" in the text that is like a whirlwind when compared to the earlier work.

In addition, Hugo uses that type of serial development known as "gradation" with an

insistence that becomes truly awe inspiring as he qualifies and embellishes both physical descriptions and psychological motivations. Here is an example of a physical description in which the serial development amplifies and colors, broadens and focuses. Even more, the pattern of life infused into the rhythms of the phrasing has been passed onto the character of the physical world itself. This too is a further accomplishment for literature, which makes the description more than a mere reflection of the visual world and elevates it to the level of what Langer terms "vital import":

> Little by little, the tide of houses, always pushed out from the heart of the city to the exterior, overflows, corrodes, wears down, and obliterates this enclosure. Philip-Augustus gives it a new dike. He imprisons Paris within a circular chain with massive towers, tall and strong. For more than a century, the houses press together, pile up, and raise their level in this basin like water in a reservoir.[87]

It is almost as if Hugo were rendering through his prose that "oceanic" feeling about the connectedness of all things.[88]

At the other pole of aesthetic categories, opposite the pulsating or overflowing rush of words, is simplicity. To achieve simplicity in a work of art is generally deemed a virtue. A classic way is to use a laconic expression, which can convey extraordinary power when the subject is of great importance or magnitude. The most famous discussion of this type of simplicity can be found in "Longinus's" *On Sublimity*, where sublimity is attributed to the Biblical account of creation: "God said, Let there be light, and there was light."[89] As Pierre Fontanier has explained in his treatise on rhetoric:

> Isn't it the extreme simplicity of the words? How, in effect, these words, with no pretensions, help us to conceive the all-powerful word of God and the rapidity with which the light produced by this word spreads at that very instant throughout the immensity of space![90]

Simplicity is often employed to achieve climax or to effectuate a denouement, both potential sources for value as well. Of course, climax and denouement belong to the traditional categories by which literature has long been evaluated. They are taught to students in secondary and even primary schools. Yet, in an age beset by the dizzying abstractions of "intertextuality" and other such poststructuralist wonders, it behooves us to reaffirm the importance of the most commonplace but nonetheless invaluable aspects of storytelling.[91]

I offer three examples here to illustrate these principles, the first two selected from works of literature that also allow me to demonstrate briefly the mistake made by people who disparage those "dead White males," whose works are regularly included in the "canon," for their purported indifference to the oppression of women and minorities. Ignoring for the moment the broad humanity conveyed in so many of these classics, let us consider more particularly those currently popular issues that such "canonical" works purportedly either fail to address or are said to address in a primarily negative manner: imperialism and sexism. My first example comes from the other side

of the story not told by Edward W. Said, who in *Culture and Imperialism* (1993) accuses nineteenth-century Western literature of generally condoning imperialist exploitation, especially slavery in the Americas.[92] The passage that concerns me comes from Victor Hugo's *Les Misérables* (1862) and is the denouement in the development of the character of Thénardier, undoubtedly one of the most despicable personages in Western literature up to that time. We first encounter Thénardier as the innkeeper whose family has taken in the little girl Cosette, whose single mother Fantine is working in another town to support the two of them. Using the funds sent by Fantine for themselves and their two girls rather than to feed and cloth this young child, Thénardier and his wife make Cosette into a modern-day Cinderella, leaving her poorly dressed, poorly fed, harshly worked, beaten, and shivering in the cold. We next encounter Thénardier on the battlefield of Waterloo — after the battle, that is — as he is stripping the dead of their medals, money, and jewelry. This is followed by an attempt to extort a fortune from a wealthy benefactor of humanity (the disguised Jean Valjean) who had come to the lodgings of the destitute Thénardier and his family to offer material assistance. The plot included the kidnapping of the benefactor's adopted teenage daughter (Cosette), the preparations for torture of the young lady's elderly father with hot irons, and possibly the eventual murder of both. At the end of the novel, Thénardier is attempting to extract money to go to the Americas by offering to reveal to the novel's young hero Marius Pontmercy, recently married to Cosette, what Thénardier deemed the real identity of Cosette's present father, a convict (true) and a murderer (false). In so doing, Thénardier unwittingly enlightens Marius as to the identity of the man who had saved his life after he had been seriously wounded while fighting on the Parisian barricades, a rescue that had entailed a long and perilous passage through the fetid and crumbling underground sewers of Paris with the possibly dead Marius on Jean Valjean's shoulders. Overjoyed with this revelation and wanting to rid his family of Thénardier, Marius gives the blackguard money both for the voyage and for a new life. Hugo concludes this episode as follows, using the laconic ending that fuses the power of its style with the force of moral indignation that the words evoke:

> The moral misery of Thénardier, this failed bourgeois, was irremediable; he was in America what he had been in Europe. The contact with a bad person suffices sometimes to ruin a good deed and to make of it a bad thing. With Marius's money, Thénardier became a slave trader.[93]

With this ending Hugo simultaneously marks Thénardier's ultimate degradation while condemning the practice of slavery.

My second example comes from Dostoyevksy's *Crime and Punishment* (1866), which presents one of the most moving condemnations of the social conditions that force women into prostitution through abject poverty. This is a popular theme in nineteenth-century literature. The scene presented here involves the climax and denouement of a vignette, told with laconic simplicity, by Marmeladov, whose drinking has left him

without a job and his family without food. Marmeladov has recently witnessed the
beating of his consumptive wife by a wealthy man who refused him a loan and the
dismissal of his daughter from work by a Counselor of State who also fabricated an
excuse not to pay for shirts that she had made him. With her three young children from
her previous marriage not having eaten for three days, Katerina Ivanovna, the wife,
wrongly chastises Marmeladov's daughter Sonya of selfish idleness. Marmeladov partially
awakens from a drunken stupor to hear Sonya respond, "Oh, no, Katerina Ivanovna, you
don't want me to go and do that, do you?" To which the older woman retorts
"mockingly": "What's there to protect? Some treasure!" Marmeladov continues his tale
as follows:

> But don't blame her, don't blame her, dear sir, don't blame her! It was something she said
> when she wasn't in full possession of her faculties, she was ill and agitated, and her
> children hadn't had anything to eat and were crying; it was said more in order to wound
> than in any precise sense . . . For that's just the way Katerina Ivanovna is by nature: as
> soon as the children cry, for example, even if it's because they're hungry, she immediately
> starts beating them. Well, then I saw Sonechka — this would be about six o'clock in the
> evening — get up, put on her shawl and her "burnous" mantlet and leave the apartment,
> and at nine o'clock she came back again. She came in, went straight up to Katerina
> Ivanovna, and silently put down thirty roubles on the table in front of her. Not one word
> did she say as she did this; she didn't even give her a look; she just picked up our big,
> green *drap-de-dames* shawl (we have a *drap-de-dames* shawl which we all make use of),
> completely covered her head and face with it, and lay down on her bed with her face to
> the wall; only her small shoulders and the rest of her body kept quivering . . . And
> meanwhile I went on lying there in the state I'd been in all among . . . And then, young
> man, I saw Katerina Ivanovna go over to Sonechka's bed, also without saying a word; all
> evening she knelt before her, kissed her feet, wouldn't get up, and then they both fell
> asleep together, in each other's arms . . . both of them . . . both of them . . . yes,
> sir . . . while I . . . lay there drunk.[94]

In searching for a touchstone for the categories of climax and denouement at the end
of a long novel, told with a laconic simplicity, is there any work of literature that can
surpass *Notre-Dame*? The emotive power of the final vignette in the brief last chapter,
"Marriage of Quasimodo," derives only in part from the intense love and devotion of the
hunchback Quasimodo for the incarnation of innocent and radiant life that was La
Esmeralda, and only in part to the resolution of the complex plot that owed its temporal
origins to the kidnapping of the baby Esmeralda by the gypsies who substituted the
deformed infant Quasimodo in the young girl's crib, an intertwining of the story line
that was revealed only in bits and pieces over the course of the long narrative. Rather,
the full force of this marriage stuns the reader because these types of narrative and
psychological considerations have been sustained by an exuberance of imagery and
rhythmic development that involve the physical and moral worlds in that type of
sentience that is so fundamental to art.

The text of the "Marriage of Quasimodo," although short in the book, is too long to quote here in its entirety. It opens with the announcement that Quasimodo disappeared from Paris after the hanging of La Esmeralda and proceeds to describe the tower of Montfaucon, surrounded with gibbets from which hung by chains the skeletons of executed criminals, along with the cellar where corpses and bones of the executed were thrown. Then, using the seemingly banal excuse to visit this cellar to find the corpse of a notable personage executed about two years after the end of the drama that involved Quasimodo and La Esmeralda, Hugo ends the book as follows:

> They found among all of these hideous carcasses two skeletons with one holding the other in a singular embrace. One of these two skeletons, which was that of a woman, still had several shreds of a dress of a material that had been white, and they saw around her neck a necklace of adrezarach seeds with a small silk bag, decorated with green glass beads, which was open and empty. These objects had so little value that the executioner no doubt had not wanted them.

In this description the reader recognizes the dead Esmeralda, just as he or she will find Quasimodo in the lines that follow:

> The other, which held this one in a tight embrace, was a man's skeleton. They noticed that the spine was curved, the head was between the shoulder blades, and one leg was shorter than the other. Besides, there was no rupture to the vertebrae of the neck, and it was evident that it had not been hung. The man to whom it had belonged had thus come here, where he had died. When they tried to separate it from the skeleton that it was embracing, it dissolved into dust.[95]

With this last passage Hugo takes us into the realm of deep feeling, which I invoked in the beginning of this chapter, that pertains to both aesthetics and ethics. He has achieved a level of aesthetic value that occupies a position at the top end of the scale of aesthetic response.

Just as the first two categories of diction discussed earlier – balance and serial development – when used most successfully fuse meaning with the feeling of sentience, so too do the structural components of a story known as denouement and climax, as well as the category of simplicity, involve powerful feelings related to the essential nature of being in this world. "Longinus's" example of the laconic phrase is particularly apt because its subject – God's creation of the universe – inspires feelings of wonder and awe that correspond to the rhetorical effect of the phrasing. Simplicity through laconic expression and the analogous type of focus achieved through my examples of denouement and climax heighten the sense of the mysteries of life, whether the depths of Thénardier's depravity, Sonya's self-sacrifice, or Quasimodo's love. In the case of Quasimodo's marriage we are in the presence of the rhetorical sublime, which achieves an immediate effect of emotional or spiritual transport.[96] Considering the importance of the relationship of balance and serial development to sentience, it is understandable

that they played a central role in Western rhetoric ever since the time of their first codification in Greece in the fifth century B.C.[97] Indeed, according to Cicero, the art of elocution in rhetoric, whether through prose or poetry and like music as well, was grounded in the skillful use of "rhythms and sounds" to match the colorations of sentience that are our emotions.[98] Similarly, it is also understandable that the psychological phenomenon that came to be called the rhetorical sublime required its own term, one which eventually became identified with the awe-inspiring aspects not merely of literature but also of all the arts as a category of aesthetic experience and even of nature itself.[99]

There are other categories that one could enumerate if this were primarily a study of literature rather than a sampling of items to demonstrate a point. Those given here do not have parallel structure. My purpose is not to create an abstract system of categories of value but rather to suggest the many and varied ways in which one can define the nature of value. Like a field of pick-up sticks, each category for value articulated here has an intellectual vector that points in a different direction. We started with a plumbing of the depths of the psyche, moved to a consideration of the conventions of a genre, then inquired into the relationship between diction and sentience, and finally postulated certain features of structure.[100]

Having briefly explored the endpoint of the form that narrative often assumes through climax and denouement, we should also note that the whole patterning of a work of literature also has been widely appreciated as a source of value. One of the most striking instances of the importance of complex pattern arose through the debate in Italy in the 1920s between Benedetto Croce and the allegorists as to whether the artistic worth of Dante's *Divine Comedy* consisted in the poetry of its images or the so-called architecture of its inner allegorical patterning. Rarely has human ingenuity been applied so thoroughly to attempt to demonstrate an inner structure as richly patterned as that of the most complex crystals.[101] This is a perennial issue in literature that arises especially in the works that not surprisingly have become the touchstones of the so-called canon. Thus, we find in a recent review by Jonathan Bate, King Alfred Professor of English at the University of Liverpool, of a new study of Shakespeare a reiteration of this same issue: "Where I would define great literature according to its supreme affective qualities, [R. A.] Foakes wants to define it according to its formal ones: 'the value and pleasure we gain from watching or reading a play as a work of art . . . is finally determined by our sense of the design of the whole.'"[102] Of course, there is no need to choose between these two positions.

Touchstones in Architecture and Dance

This analysis of literature is not intended to convey the full range of categories that give value to art. It is a representative sampling that defines several important features specific to this art form as well as identifying several shared with other arts. It would not

be difficult to identify the basic categories for other types of artistic endeavor. Let us, for example, briefly look at architecture and dance.

Proceeding with this model of artistic exemplars that can serve as touchstones for considering value, we could ask of domestic architecture to what degree it fosters a primordial sense of sheltered well-being that we know is possible thanks to the houses of Frank Lloyd Wright. Wright achieved a satisfying sense of "home" largely through the way the house appears married to the ground, through the sheltering aspect of the roof, through the ritual of arrival that either directly or circuitously makes movement into the building and then to the central hearth seem a journey into an inner sanctum, through decorative detailing that focuses on the immediate spot where the body is present as well as establishing continuity with space beyond the room, and through orchestration of compressed with expansive spaces by means of varied ceiling heights, extended horizontal lines, narrow and wide places, and solid or glazed walls.[103] With Wright's buildings as a point of reference, we can identify various artistic strategies and evaluate their effectiveness.

Looking to sacred building, we could ascertain the degree to which the edifice leaves us with a sense of what Le Corbusier called *l'espace indicible*, ineffable space, as found in works as profoundly different as the High Gothic cathedral in Chartres (1195–1220) and the pilgrimage Chapel of Notre-Dame-du-Haut at Ronchamp (1950–5), the latter by Le Corbusier himself. Certainly the mysterious quality of light contained within such places contributes strongly to this effect as does the otherworldly quality of the masses and surfaces that envelope them. In both buildings grand spatial effects come into play that are judged through the circumscribed conditions of our own body-sense – at Chartres the clustered shafts of the stone piers that seem to ignore gravity as they appear to spring upward to great height along the great length of the vessel; at Ronchamp the curving roof separated from the tilting or curved walls by a thin sliver of intense light, while the gentle slope of the floor promotes an actual kinesthetic sense of union with the total material and sensorial realm of the chapel.[104]

With respect to institutional architecture, we would gauge the appropriateness of expression to the social or cultural function housed there, as typified, for example, by the work of the brilliant Beaux-Arts architect Paul Philippe Cret, in buildings such as the Pan American Union (now Organization of American States [OAS]) (1907–10), the Folger Shakespeare Library (1928–32), and the Federal Reserve Board (1935–7), all in Washington, D.C. At the heart of each of these buildings is a great central hall that encapsulates the essential character of the institution housed there – the gracious Latin American patio of the OAS, the Elizabethan reading room at the Shakespeare library, and the cluster of offices for the twelve regional Federal Reserve districts around the skylit atrium with the symbolic American eagle. Not only does Cret create a sense of place in his civic buildings, he carefully orchestrates the sense of arrival with sequences of rooms and corridors carefully sized to impart a sense of progression, transition, and arrival, while establishing the institutional character through a grand scale and guarding

the human proportion with mezzanine levels, short flights of stairs, and diminutive treatments of the classical orders, as well as delicate ornamental detailing close to the eye or hand.[105]

To approach the subject of dance, we might watch a performance of the contemporary piece *Griot New York* (1991), choreographed by Garth Fagan and performed by Garth Fagan Dance (Fig. 2). It is a veritable school of instruction as well as a great source of pleasure. On the one hand, it reminds us about the degree to which dance relies on the conjunction of rhythm and counterpoint. As in music, dance offers its gestures as complete phrases that satisfy not only in themselves but also with their "follow through" to the succeeding phrase and then by the patterns established over the course of the performance. In *Griot New York* the counterpoint created through variations in movement and timing is richly conceived in all available ways – within the body of a single performer, among individual dancers, and between the different groups that can function as in music where the melody is played against the basso continuo.

Griot New York also heightens our awareness of the conventions of dance that explore the way the human body can move in space with meaningful patterns. It uses classical ballet where the body is balanced at the waist with an invisible central axis that permits rotational movements of the entire figure, as well as horizontal and diagonal extensions of the limbs and even of the torso and head. In *Griot New York* Fagan utilizes this grammar while adding new movements to the classical repertory.

Yet this is not a classical ballet. It is modern dance that works with the logic of classical dance grammar while combining it with two other dance systems – the body stance with a lower center of gravity and with movement that seems to radiate outward from the gut with a rippling effect to convey powerful expressive force as pioneered by Martha Graham; and a fluid, sinuous universe of bodily motion possibly derived from Caribbean dance. The result is a dance that presents an intense and varied feeling of sentience, a dance that conveys the mysteriousness of life itself through the full range of body movements employed. Yet, if this might be said to constitute the "pure" component of dance, it is also joined here with the expression of emotion, assisted by facial expressions, ranging from wit to love and anguish. These are all categories of value within the parameters of dance itself.

Looking beyond this framework, we know that dance also has a setting and usually is accompanied by music. In *Griot New York* we find a mutually sustaining achievement in the coordination between Garth Fagan's choreography, Wynton Marsalis's music, and Martin Puryear's sets that adds still another category of value.[106]

After reviewing individual art forms separately, we can ask how they relate together in achieving value. Here it is possible to find other aspects of sentience besides that imparted through rhythm. Consider, for example, architecture and dance, the former composed of inert matter, the latter based on the moving human body. These two arts, ostensibly worlds apart, depend upon our own body-sense, which engages our most primal sense of being in this world. Any work of art that strongly engages our body-

sense in ways that relate to an awareness of the essential human conditions, such as life, love, and death, is a prime candidate for high artistic value.

Distinguishing between Greater and Lesser Art

Using the categories for ascertaining value already established, let us judge the degree of artistic depth attempted and attained by comparing, for example, two works of environmental sculpture: Richard Serra's *Tilted Arc* (1980–1), designed for Federal Plaza in Manhattan, and Maya Lin's Vietnam Veterans Memorial (1981–2) in Washington, D.C. Serra's own description of his intentions and achievement, as voiced at the public hearing of March 6–8, 1985, called to ascertain whether the piece should be removed from the site because of widespread protest, can be taken as an accurate reflection of the work's value, because it is closely echoed by other testimony and by published accounts of Serra's work in general. Serra and his supporters had to contend with a variety of complaints, whose features most relevant to my argument here can be found in the letter of November 5, 1984, by Edward D. Re, Chief Judge at the United States Court of International Trade, to the Acting Administrator of the General Services Administration: "Even if one were to assume, for the sake of argument, that this 'piece' once had some semblance of artistic 'shock' value, this minimal value has long since dissipated, and we who work here are left with a once beautiful plaza rendered useless by an ugly, rusted, steel wall [120-feet long and 12-feet high]." Here is how Serra responded to such criticism:

> My hope is that the viewer can learn something about a sculptural orientation to space and place. The work, through its location, height, length, horizontality, and lean, grounds one into the physical condition of the place. The viewer becomes aware of himself and of his movement through the plaza. As he moves, the sculpture changes. Contraction and expansion of the sculpture result from the viewer's movement. Step by step the perception not only of the sculpture but of the entire environment changes. The space can be experienced as compressed, foreshortened, or extended.[107]

To use the terminology employed in this chapter, Judge Re did not believe that *Tilted Arc* could be situated on the scale of aesthetic response and furthermore that it was an irritating eyesore.[108] Serra's explanation of his artistic intentions, pallid by itself, seems even more so in face of the criticism voiced by Judge Re and others.[109]

To explain the disappointing nature of Serra's approach to art in a work such as *Tilted Arc*, we should consider the underlying premises of Minimalist sculpture. During the public hearing, Rosiland Krauss provided the following instructive lesson:

> Bodies were still to be represented by sculpture, but bodies now, in their aspect as inhabited, the human body not as it is understood from without, but as it is lived from within. (. . .) For if I extend my arm to reach to pick up something or to catch an object before it falls, I do not think of my hand, my arm, my shoulder; I think of the

space that must be bridged between me and the object I am reaching for. These gestures and movements are thus more representable as vectors and trajectories through space than they are as bone and skin.

Applying these criteria to *Tilted Arc*, Krauss has argued that the work "invests a major portion of its site with a use we must call aesthetic," such that "this sculpture is constantly mapping a kind of projectile of the gaze that starts at one end of Federal Plaza and, like the embodiment of the concept of visual perspective, maps the path across the plaza that spectator will take."[110]

Through these descriptions of the purposes and effects of *Tilted Arc* offered by Serra and by Krauss, we see that Minimalist sculpture has discovered for itself one of the fundamental aspects of architectural experience, which is the sense of the relationship of one's own body to spatial enclosure. Yet, this phenomenon is only the alphabet of architecture. What counts is what the artist does with it. Serra errs in pronouncing so assuredly, "This is a condition that can only be engendered by sculpture and nothing else."[111] Rather, it has furnished one of the underlying components of architecture for millennia. The concern with vectors and trajectories as envisaged by Krauss and with compression and expansion as fashioned by Serra is where architecture begins, not where it ends.

Because of differences in size and complexity between sculpture and architecture, to compare the sense of one's body moving in relationship to *Tilted Arc* with the great monuments of the past, with the ancient Egyptian pylon temples where, "as one approaches the sanctuary[,] the floor rises, the ceilings are lowered, darkness increases, and the sacred symbol appears only when shrouded in a dim light"; with the feeling of immensity in the nave of the Byzantine Hagia Sophia where the giant dome, ringed at its base by a golden necklace of sacred light, seems suspended miraculously high above, thereby appearing "somehow to float in the air," such that Justinian is said to have proclaimed, "O Solomon, I have surpassed thee"; with a walk through the ancient Roman imperial baths where "the well studied gradations of their several halls, courts and chambers, the magical contrasts of the sections, and playful exuberance of the accompaniments, captivate the attention, and lead in willing chains the enchanted imagination of the beholder"; with the feeling of having reached, to borrow a line from T. S. Eliot, "the still point of the turning world" when standing at the center of the Pantheon; with Le Corbusier's pilgrimage chapel at Ronchamp, briefly discussed earlier, but which we can now consider more fully, for here an uncanny sense of silence permeates your body as you pass under the heavy curve of the roof suspended above a sliver of light that shines above the walls that bend toward you and then away, above the wall that leans outward while cones of colored light pass inward as beacons from another world, and as you feel the kinesthesia of walking slightly downward across the sloping floor toward the diminutive statue of Mary, placed high above your head in a glass prism cut clear through the end wall and surrounded by small punctures that send

forth twinkling rays of illumination; to compare *Tilted Arc* with such architectural experiences would be unjust.[112] Rather, let us take a cue from one of Serra's champions, the art critic Roberta Smith who compared *Tilted Arc* to the Vietnam Veterans Memorial. Serra's piece, she explained,

> is an excellent example of Minimalism, which has already been watched by the influential. The Vietnam Veterans' Monument, which has been such a hit in Washington, is a result of someone working with Serra's idea. So now we have the real thing, the original, genuine article right in our midst.[113]

Smith's comparison is instructive on two accounts. First, it permits the suggestion of alternative ways to assign value. Whereas Smith gave primacy to *Tilted Arc* over the Vietnam Veterans Memorial because Serra's work used a long wall as Minimalist art before Maya Lin, I would ask whether both works can be situated on the continuum of the scale of aesthetic response and by what means they might have achieved this. Second, Smith's juxtaposition of these two works facilitates discussion of the thorny issue of the difficult reception accorded to new art. As defenders of *Tilted Arc* repeatedly explained, novelty in artistic vision, as typified, for example, by the Impressionist painters of the 1870s, often is met with hostility because the art reaches beyond, some might even say violates, not only the expectations but also the conceptual framework of its audience.

Like *Tilted Arc*, the Vietnam Veterans Memorial prompted vehement opposition. Yet whereas the former grated on public sensibilities three years after it had been constructed, the latter won over a hostile public as soon as it was inaugurated.[114] The heart of the matter resides in Maya Lin's successful use of two different but equally powerful aspects of one's body-sense to fulfill the symbolic "function" of this memorial and hence to impart value to the work. The first is the descent into the earth; the second is the sense of touch focused in the finger reaching out to the wall.

As the great eighteenth-century academic teacher of architecture Jacques-François Blondel had explained to his students, if you want to impress people with a sense of mortality, then use the powerful effect of kinesthesia by lowering the level of the land in a cemetery a few steps below the surrounding terrain. Maya Lin applied this understanding by making a gradual descent down into the ground an integral feature of the memorial. As visitors walk down into the earth, they reach out with a subtler sense of movement, a single finger that touches the wall by the inscribed name, in an effort to sense the absent life commemorated here on this polished black marble wall, which reflects the blue sky as it points symbolically to the Washington and Lincoln memorials, evoked as reminders of the country's original principles and of national reconciliation. In using the sense of touch, Maya Lin has created the obverse to Michelangelo's *The Creation of Adam* on the ceiling of the Sistine Chapel, for this is not a life-giving touch but rather its opposite, an evocation of a life lost, cut off in its prime, an existence felt through the tip of a finger, but impossible to retrieve across the barrier of the black marble wall.[115] Both works discussed here use body-sense. Only one joins it to a

meaningful narrative purpose and in a way that engages deep feelings through a profound aesthetic response.

Zola's Whirlwind

In this search for artistic value, of course, there will always be disagreement about the nature and relative worth of the various categories that the critic will define. There will be dissension about the degree of success that various artists have achieved in realizing them. There will be differences as to where on the scale of aesthetic response any work of art deserves to be situated. And as Stephen Toulmon has suggested, any observer may very well undergo a change of mind at some later time.[116] Yet, for anybody who has known the experiences with art evoked throughout this chapter, the conviction about the deep reality of value will remain solid. If we falter in our ability to define it as precisely as we might desire, the failure is in our own abilities of ratiocination and not because value is arbitrary, elitist, and repressive.[117]

To the contrary, value in art is liberating.[118] If we doubt that, perhaps we can find a reminder of its worth in the work of Emile Zola, that "realist" or self-styled "naturalist" author who "descended to the lowest depths of society in order to demonstrate . . . the inexorable depredations of an unjust social system."[119] Here then it would seem that we would find a repudiation of the categories of value that I have outlined for Hugo's historical epic tale of a cathedral and its city, overlaid with a love story. Yet, we have only to read once again Zola's own epic of the depths of Paris, *Le Ventre de Paris* (1873), to find this realist author creating a mirror image to Hugo's earlier book. Early in the novel it becomes evident that the new, colossal iron markets, the Halles Centrales, are the nineteenth-century equivalent to the Gothic cathedral of Notre-Dame and that once again the protagonist is as much the city of Paris as any of the characters. The reader soon learns that Zola has achieved his own haunting variant of the marriage of Quasimodo, this time overlaid with a burning indignation at social injustice. What is so striking in the final analysis, what is omnipresent in the novel from the opening passages to the end, is that same whirlwind of language that had characterized the rhythmic prose of the earlier crusading Romantic author. It is, moreover, a prose that in Zola as well impresses the physical world into the realm of sentience, of "vital import." If this category of value held deep meaning for the socially committed Zola, then certainly those people who dismiss aesthetics as superficial, who deny quality as arbitrary, and who disparage art as irrelevant to the more pressing concerns of life, owe it to Zola and to themselves, to reconsider their position.

2

Creativity and Genius

Creativity and genius are among the most mysterious aspects of human existence. Yet whereas neither can ever be understood fully, their operations can be observed closely. Any exploration of artistic creativity will bring us one step closer to comprehending how the artist invests the work of art with transcendent value. Taking that step has a dual purpose. It will show us how far removed the creative leap of imagination is from rational discourse; it will simultaneously enable us to demystify the dilemma that today's poststructuralism sees in the phenomena of creativity and genius. A current syllabus for a university course on the identity of the artist in seventeenth- and eighteenth-century Europe states as a primary aim its intention to "challenge the myth of the Creative Genius, that creativity is the expression of personal emotional experiences, welling up from within despite any obstacles put in its path." The syllabus then rejects this "quasi-religious formulation" in favor of concentrating on "social and institutional structures."

By capitalizing the words "Creative Genius," this poststructuralist syllabus suggests that the concept is in some manner inflated and that the "quasi-religious formulation" is mistaken.[1] It is ironic that a university course on this time period would ridicule a concept so closely associated with that era. As Logan Pearsall Smith has demonstrated, our modern notions of creativity and genius were largely formulated in the second half of the eighteenth century, which saw an outpouring of treatises on the subject. Thus, the same period that conceived of the dignity and rights of the individual that poststructuralists champion in their defense of the oppressed and the victimized also gave us, actually as a complement to the notion of political liberty, an understanding of artistic creativity, which poststructuralists would dismiss as elitist and nonsensical. I say that these concepts were complementary because the divine spark which gives and sanctifies creativity and genius in the domain of art is comparable to natural law that gives and sanctifies the rights of man. Both foresee and celebrate the potential of the individual, whether in the possibilities for creativity or in the opportunities for liberty.

Before the eighteenth century, the word "genius," explains Smith, referred to a person's "natural bent or disposition." During the seventeenth century, though, the

word "came to be tinged . . . with religious associations, for *Genius* was the name of a god or spiritual being," and came to be associated with "inspiration," which Dr. Johnson would define as "infusion into the mind by a superior power." Noting that seventeenth-century critics would mock the idea of inspiration, Smith observes, "But no ridicule could banish this idea of inspiration, based as it was on real experience; for poets, finding that their ideas came to them in special moments of excitement, and from some source as it were outside themselves, would by a natural symbolism come to call the poetic impulse a gift from the gods."[2]

Smith is correct when he explains that an artist is likely to feel that his or her words or images come from some type of outside source, some greater power. No amount of disparaging creative genius can deny that intuition, that self-knowledge. Whereas modern psychology teaches that a subconscious or subliminal state of being contributes to this feeling, as well as to the creative process itself, the profound spiritual experience that yields this understanding precludes any simple explanation of its actions.

My task here, though, is not to oppose the poststructuralist stance with a mere panegyric to genius, but rather to make creativity seem comprehensible to the degree to which we can observe its workings. Yet, before proceeding on that path, I propose that we keep before us a definition of creativity and genius from one of those mid-eighteenth-century treatises as a point of reference to which we can return in our minds as we dissect the creative process as much as reason permits. I choose the definition offered by William Duff in *An Essay on Original Genius; and Its Various Modes of Exertion in Philosophy and the Fine Arts, Particularly in Poetry* (London, 1767). The "principal ingredients" of genius, according to Duff, are "imagination, judgment, and taste." The most important and controlling aspect of this trio is imagination:

> That imagination is the quality of all others most essentially requisite to the existence of Genius, will universally be acknowledged. Imagination is that faculty whereby the mind not only reflects on its own operations, but which assembles the various ideas conveyed to the understanding by the canal of sensation, and treasured up in the repository of the memory, compounding or disjoining them at pleasure; and which, by its plastic power of inventing new associations of ideas, and of combining them with infinite variety, is enabled to present a creation of its own, and to exhibit scenes and objects which never existed in nature. So indispensably necessary is this faculty in the composition of Genius, that all the discoveries in science, and all the inventions and improvements in art, if we except such as have arisen from mere accident, derive their origin from its vigorous exertion.

Stated more briefly, the "distinguishing characteristic of true Genius" is a "creative Imagination." When this is present it is possible for genius to be "original": "It may be proper to observe, that by the word ORIGINAL, when applied to Genius, we mean

that NATIVE and RADICAL power which the mind possesses, of discovering something NEW and UNCOMMON in every subject on which it employs its faculties."[3]

Duff then proceeds to explain that judgment regulates and controls the imagination, just as taste qualifies it:

The proper office of JUDGMENT in composition, is to compare the ideas which imagination collects; to observe their agreement or disagreement, their relations and resemblances; to point out such as are of a homogeneous nature; to mark and reject such as are discordant; and finally, to determine the truth and utility of the inventions or discoveries which are produced by the power of the imagination.

Duff favors Cicero's explanation of taste: "'We may define TASTE to be that internal sense, which, by its own exquisitely nice sensibility, without the assistance of the reasoning faculty, distinguishes and determines the various qualities of the objects submitted to its cognisance; pronouncing, by its own arbitrary verdict, that they are grand or mean, beautiful or ugly, decent or ridiculous.'" "From this definition," observes Duff, "it appears, that Taste is designed as a supplement to the defects of the power of judgment, at least in canvassing the merit of the performances of art."[4]

Any analytical description of the operations of the human mind is more useful as a way to begin to grasp the parameters of an issue than it is as an accurate reflection of the true workings of the mind. In actuality, the three components of creative genius as articulated by Duff commingle in ways that rational thought can never fully understand.[5] Yet definitions such as those offered by Duff and others are helpful when they attempt to explain the multiple facets of a creative mind at work. Respect for the complexity of the operation seems preferable to that type of unthinking awe, which Duff terms "a foolish face of wonder,"[6] that so readily leads to the belittling of genius by poststructuralist critics.

For the remainder of this chapter I wish to discuss the partial operations of creative genius by considering eight components of the creative process, which I name as follows: patient search, imitative genius, artistic will, simplicity, radical conjunction, act of making, stylization, and finally, humor and wit. This list covers a range of phenomena but is not complete. Rather it presents a representative sampling either of aspects of the creative process or of parameters by which it is regulated.[7] Several of my categories are of the type proposed in Chapter 1 as ways to establish value in art and hence can be readily used to that end.

Creation is a Patient Search

"Creation," Le Corbusier was fond of saying, "is a patient search." No matter what the art form, it is a commonplace that the artist will rework his or her material to reshape, mold, and polish it to a point of perfection. Great art almost invariably involves cross outs, erasures, and the addition of new lines, notes, words, forms,

colors, and so forth. Whereas Athena, goddess of arts and crafts, was said to have sprung fully formed from Zeus's forehead, it seems rare for great art to be born in similar fashion.[8] To assist in an understanding of the workings of the creative mind, I would distinguish here between three types of patient searching. The first, which is rare, occurs when the artist formulates the work in the mind and then sets it down on paper or canvas or fashions it in plastic form as essentially the finished product without the aid of preliminary studies or subsequent refinements. The second involves establishing an initial project, which is then reworked and hence developed into something far superior in its finished form. The third occurs when an artist creates a work whose principal features he or she reuses in an even fuller manner in a later work. As examples, I will use the genesis of Fallingwater by Frank Lloyd Wright, of Le Corbusier's Swiss Dormitory at the Cité Universitaire in Paris, and of the opening passage of Marcel Proust's *A la Recherche du temps perdu*.

It is said that Fallingwater (Fig. 3), that breathtaking vacation house at Bear Run, Pennsylvania, designed by Frank Lloyd Wright in 1935 for the Pittsburgh department-store owner Edgar J. Kaufmann, Sr., and his family, was conceived entirely in Wright's head. As related by Donald Hoffmann, Wright visited the site with Kaufmann in December, 1934, where he was deeply impressed with the view of the waterfall along the stream called Bear Run. Hoffmann explains that in a letter of December 26, Wright told his client about "how the visit to the waterfalls remained with him, and how a house had taken vague shape in his mind to the music of the stream."[9] One of Wright's apprentices, Robert Mosher, has recorded that Wright did not begin to draw up the house until he had received a telephone call from Kaufmann on September 22, 1935, informing him that he was leaving Milwaukee to come to Wright's headquarters in Spring Green, Wisconsin. In the course of a few hours, Wright sketched with his colored pencils what would be the final design. "Mr. Wright," explained Mosher,

> was not at all disturbed by the fact that not one line had been drawn. As was normal, he asked me to bring him the topographical map of Bear Run, to his draughting table. . . . I stood by, . . . keeping his colored-pencils sharpened. Every line he drew, vertically and especially horizontally, I watched with complete fascination. . . . Mr. Kaufmann arrived and Mr. Wright greeted him in his wondrously warm manner. In the studio Mr. Wright explained the sketches to his client. Mr. Kaufmann, a very intelligent but practical gentleman, merely said . . . "I thought that you would place the house near the waterfall, not over it." Mr. Wright said quietly, "E.J., I want you to live with the waterfall, not just to look at it, but for it to become an integral part of your lives." And it did just that.[10]

Although the logical culmination of over thirty years of creative work, Fallingwater was nonetheless a drastic leap forward not only for Wright's architectural aesthetic but for Western architecture in general. With its main fireplace rising above

exposed bedrock in the living room, its expansive terraces cantilevering dramatically out over the waterfall and echoing in form and spacing the projecting flagstone ledges of Bear Run just below the house, and its walls and massive chimney stack built with this same flagstone piled in irregular courses with jutting layers to mimic the natural rock stratifications on the site, Fallingwater married architecture to nature in a way that gave new meaning to the notion of "organic architecture." The originality of its aspect, the drama and poetry of its features, have made it a place of pilgrimage, in spite of its remote location, for over 130,000 people annually. That the architect appears to have conceived this design first as a "vague shape" in his mind where he nurtured it to perfection without working it over on paper or with models is amazing testimony to the creative process.

A more usual course of action can be illustrated through the genesis of Le Corbusier's Swiss Dormitory (1930–2) at the Cité Universitaire in Paris. This building is not only one of Le Corbusier's masterpieces (Figs. 4–5), it also represents a turning point in his development away from the predominantly white Cubist prisms of the 1920s, conceived as complements to modern industrial civilization. Le Corbusier's early concept for this building adhered to the machine aesthetic of his previous work: a long rectangular slab of dormitory rooms joined to a subsidiary rectangular block that contained the building's other functions (Fig. 6). In keeping with his modern architectural principles, Le Corbusier envisaged elevating the entire edifice off the ground with thin piers, here conceived as vertically standing rectangular steel I-beams (Fig. 7).

The ingenuity of this configuration – that is, separating the repetitive cells of the dormitory rooms from the other functions – was to appeal to other architects who followed Le Corbusier's lead at this campus and elsewhere. Although their buildings differed in appearance, they presented the same organizational strategy. Yet Le Corbusier was dissatisfied with the forms used in his initial scheme. As he reworked the project, he modified the design so as to introduce a narrative theme that contrasted nature and the machine.

By the time the final design was crystallized, the entire ground level had been given over to the aesthetic expression of organic nature, to which Le Corbusier assigned the functions of sociability and community. An informal gathering space was provided under the elevated dormitory block, now lifted off the ground with thick, organically shaped piers (Fig. 8). Next followed the spacious entrance hall with the S-shaped stairs (Fig. 9). Beyond was the social hall with its curved and nonparallel walls. Rising merely one story, its exterior north wall was made of rubble stone with bulging mortar joints. Curving in an arc, this wall presented a powerful metaphor of nature. Departing from the rational structural grid of his 1920s architecture, Le Corbusier warped his field of columns to make them mediate between the curved rubble wall on the north facade and the crisp glass wall with elegant steel frame of the dormitory block facing the athletic field to the south.[11]

We know that beginning in the early 1930s Le Corbusier was concerned about the dehumanizing aspects of what was regarded as the contemporary machine civilization. Whereas his first avant-garde villas of the 1920s had celebrated the machine without qualification, by the end of the decade Le Corbusier was moving toward polemically reaffirming the role of the natural world, its materials, colors, and textures, as well as the humanizing movement of the walking person, no longer being swiftly conveyed by the automobile or train, in the creation of a modern architecture.[12] The Swiss Dormitory was a milestone in Le Corbusier's development of this message. When we consider the distance traveled between the first project and the final edifice, which was a perfecting of the initial idea, we see that the architect had improved the functional arrangement, that he had achieved an aesthetic vigor initially absent, and that he had invested a mere building with a richly symbolic narrative tale that spoke directly to the human condition in an industrialized world. The story of the genesis of the Swiss Dormitory is a fitting illustration of the creative process whereby creation is a patient search.

The opening passage of Marcel Proust's masterpiece, *A la Recherche du temps perdu* (1913), translated with the title "Remembrance of Things Past," illustrates a third type of patient searching, whereby the artist reuses an earlier creation in a way that develops its internal qualities and extends its importance outward in relationship to the entire work. Proust began his literary career in the early 1890s by publishing short pieces in the journals *Le Banquet* and *La Revue Blanche*. Many of these short sketches, which were appropriately entitled "Etudes" (Studies), were assembled into his first book, *Les Plaisirs et les jours* (1896). One entitled "Rêve" (Dream), which had appeared first in *La Revue Blanche* in 1893, is centered around a dream and waking sequence that Proust would refashion for the opening of the *Recherche*.[13]

"Rêve" explores the power over the waking person of strong emotions generated by a dream. In this sketch, the narrator opens by recalling his indifference to a certain Mme Dorothy B***, a young woman of about twenty-two, whom he hardly knew. Then he has a dream in which he encounters this lady whose meaningful looks and suggestive actions fill the dreamer with feelings of "adoration at the same time both voluptuous and spiritual." Upon awakening, the narrator discovers that his previous lack of interest in Mme Dorothy B*** has been replaced, "in spite of all reasoning," by a strong passion for her. In time, these new feelings begin to dissipate. The sketch ends with the observation that in waking life love works the same way: "Alas, love has passed over me as in this dream, with a power of transfiguration as mysterious."

The dream sequence in "Rêve" begins as follows:

I went to bed early Saturday. But around two o'clock the wind became so strong that I had to get up to close a loose shutter which had awakened me. I reflected upon my brief bout of sleep and was pleased that it had been restorative, without discomfort,

without dreams. Hardly had I returned to bed, before I was asleep again. But after a certain time, I began to wake up again, or rather I gradually was awaking to the world of dreams, confusing at first as is the real world when one usually awakes, but a world that then came into focus. I was resting on the beach at Trouville, which was at the same time a hammock in a garden that I did not know, and a woman was looking at me with a steady sweetness. It was Mme Dorothy B***.[14]

The narrator subsequently is awakened suddenly just at the moment of his greatest "voluptuous and spiritual" pleasure, which almost immediately returns to his memory and fills him with a strong passion for this woman:

She came over to me, bent her head down by my cheek where I was able to study its mysterious grace, its captivating vivacity, and darting her tongue from her fresh, smiling mouth, gathered all of my tears from the edge of my eyes. Then she swallowed with a slight sound of her lips, which I felt like an unfathomable kiss, more intimately troubling than if it had actually touched me. I suddenly awoke, recognized my room and as in a nearby storm a thunderbolt immediately follows lightning, a dizzy memory of happiness followed my awakening although it was preceded by the crushing certainty of its illusion and of its impossibility. But, in spite of all these reasonings, Dorothy B*** had ceased to be for me that woman whom she still had been before awakening. The small wake left in my memory by the few encounters that I had had with her was almost erased, as after a strong tide, which upon receding, had left behind weak traces. I had a strong desire, although with no illusions, to see her again, an instinctive need, coupled with a sober caution, to write to her. Her name mentioned in a conversation made me shudder. . . .[15]

Although the sketch ends by using the example of the dream as a metaphor for the experience of love itself in the waking state, the heart of this sketch has been the current of life that flows through the living person creating "little furrows" and "large waves" that commingle and succeed each other not only in the waking state but also when sleeping, with the feelings from each state passing into the other, especially in the direction from the latter to the former.

In Chapter 1, I stressed the importance of sentience, that feeling of vital life, as one of the main categories of value in art. At the time, I used Susanne K. Langer's observations about how music affects us this way and how this experience can be generalized to other art forms as well. In another sketch, "La Mer" (The Sea), dating from 1892 and republished in *Les Plaisirs et les jours*, Proust himself reminds us of this connection. The piece ends:

[The sea] refreshes our imagination because it does not cause us to think of people's lives, but it gladdens our soul, because it is, like it, infinite and impotent aspiration, *élan* without cease broken in falls, eternal and gentle lament. It enchants us thus like music, which, unlike language, does not carry the trace of things, which tells us nothing about man, but which imitates the movements of our soul. Our heart, by

soaring upward with their waves, by falling downward with them, in this way forgets its own shortcomings, and consoles itself in an intimate harmony between its sadness and that of the sea, which mixes its destiny with that of things.[16]

The subject of these two sketches, like that of the *Recherche*, is first and foremost the "movements of our soul." That is why the English title of Proust's great work is less "Remembrance of Things Past" than "In Search of Lost Time." Not things, but time, lived time, with the entire panoply of feelings and thoughts that mark it, is Proust's subject. The delusions of life, its moral dilemmas, its hopes and disappointments, egotism and selflessness, love, loyalty, and death, all become intertwined in a quest to map out the movements of the soul, which proceed like the sea, like music. Proust engages in this literary quest with a prose style that echoes the "movements of the soul" with a precision, delicacy, and flow without equal in the history of world literature.

In this manner, Proust synthesizes what I have argued in Chapter 1 to be the two principal components to the qualities and forms of human consciousness related to aesthetic experience: insight into the nature of people and life and a heightened sensation of the feeling of life. When Proust achieves this end not in short sketches but rather in his multivolume *Recherche*, he opens with a reworking of the dream and waking sequence from "Rêve": "Longtemps, je me suis couché de bonne heure." The passage is too long to quote here. The reader will undoubtedly recall the analogy with metempsychosis by which the waking narrator identifies with the subject of his dream, which had been stimulated by what he was reading just before sleep; the evocation of the *fauteuil magique* (magical armchair) that liberates the memory from a strict chronology of time and place; and the possibility of total disorientation upon awakening that leaves the narrator psychologically devastated, filled with the "primal simplicity" of the "sensation of existence as it might shudder within the depths of an animal." The sleeping and dream sequence has been reworked and broadened. In the *Recherche*, it starts the novel from the very first words; it is not circumscribed by a consideration of romantic love for one person, but rather it extends outward to encompass the narrator's entire life, which, in conjunction with a charting of the "movements of the soul," will be the subject of the novel.

Proust's accomplishment in the sketches is transfixing. His integration of the material assembled in disparate pieces in *Les Plaisirs et les jours* into the coordinated narrative of the *Recherche* appears truly wondrous. We cannot explain how it was done. Yet we can chart the principal stages of the creative act as the writer engaged in a patient search.[17]

Imitative Genius

The process by which individuals crystallize their own works of art through the successive transformations of a "patient search" with their own first sketches has its

equivalent in the achievements of artists who draw upon the work of their contemporaries or predecessors for inspiration. Since at least the ancient Greeks, the notions of both "imitation" and "emulation" have been staples in the literature on artistic inventiveness.[18] Emulation has provided the spur to equal and even surpass the achievements of others. In Renaissance treatises on rhetoric it was sometimes contrasted with "imitation," understood as merely following rather than outdoing.[19]

Yet the word "imitation" did not mean merely copying. Rather, it served to denote an important aspect of the creative process by which material from existing works of art was assimilated into new creations, with results ranging from purposeful quotation to unrecognizable transmutation. A reference to the past was itself a cherished value to the point where we find the great seventeenth-century painter Nicolas Poussin defining novelty in painting as "not consist[ing] principally in a subject that has never been seen before, but rather in new and excellent disposition and expression, and thus the subject is transformed from being common and old into something unique and new."[20] This particular type of artistic operation was termed in classical and Renaissance rhetoric "filial imitation," in reference to the filial resemblance of the child (i.e., new artistic work) to the parent (the artistic work that served as the basis for the transformation). For the purposes of this chapter, I wish to explore examples of still another type of "imitation," which the rhetoricians understood as "apian" or "mellificative" imitation, whereby, like the honey bee, the artist culls distinctive features from various sources and fuses them together into a new and original work of art. To explain how these artistic riches were not simply collected but instead were transmuted into a new and original creative work, rhetoricians used metaphors of digestion.[21]

The concept of "apian" or "mellificative" imitation lay at the heart of what the early nineteenth-century landscape gardener, horticulturist, and popularizer of aesthetic ideas, John Claudius Loudon explained as of the operations of the artistic mind. "When we speak of imagination," explained Loudon, "we allude to that power of the mind which consists in recalling ideas previously treasured up there by the memory, and presenting them in new combinations."[22] These ideas were not to be limited to one's own thoughts or images. Rather, "[t]he more richly [the artist] stores his mind with the ideas of others, the more likely will he be to bring forth new ideas of his own; for a new idea can be nothing more than a new combination of ideas which had previously existed."[23] Writing at the time when the modern concept of genius was just coming into general usage, Loudon used the older sense of the word, meaning an overall frame of mind and manner of mental operation, to distinguish between "inventive genius" and "imitative genius."[24] These two terms tied the creative process to two modes of action, each historically determined:

> In the infancy of all arts, the artist must have drawn his materials from nature, and created an art by the exercise of his inventive powers; but, in an advanced state of

society, such as that to which we have now arrived, the artist derives his materials from the works of artists who have preceded him, and thus, as it were, works at second hand. In the former case, he must necessarily display inventive genius; and in the latter, imitative genius only.[25]

Let us consider, then, two examples of "imitative genius" working according to the process of "apian imitation" to explore still another aspect of the creative process. When artists were successful in fusing together their sources, culled widely and used imaginatively with personal material, all "digested" according to an inner, guiding creative impulse, then the result was what eighteenth- and early nineteenth-century writers called "original genius." It is this passage through "imitative genius" to "original genius" that we shall follow in the work of two artists, the writer Edgar Lee Masters and the amateur architect Thomas Jefferson.

Masters achieved fame as the author of the *Spoon River Anthology* (1915), a type of literary rendition of those sixteenth-century drawings or paintings of the Dance of Death, in which Death, usually a nimble skeleton, often with a scythe, leads away a procession of people of both sexes, presenting all ages and conditions. Sometimes the Dance of Death was accompanied by a text, which commented on the situation of each type of person – prince, bishop, judge, young bride, miser, knight, and so forth – to mock their pretensions, to castigate their greed and vanity, and to emphasize the transiency of life, as well as its seemingly arbitrary abruptness.[26] Masters has taken the tradition of these texts and recast them as individuals representing all walks of life, two hundred forty-four citizens of Spoon River who speak from their graves where "All, all are sleeping, sleeping, sleeping on the hill."[27] Presented as separate short poems in sequence, after the manner of the texts that accompanied the Dance of Death, these isolated statements in Masters's work offer with great perspicacity a social and moral picture of the town and of its denizens through "nineteen stories developed by interrelated portraits."[28] Although most effective in relationship to each other, each individual story has a power that covers the full range of character and motivation. Cynicism, bitterness, censure, and self-pity in all shades abound. Amanda Barker's story is typical of this vein:

> Henry got me with child,
> Knowing that I could not bring forth life
> Without losing my own.
> In my youth therefore I entered the portals of dust.
> Traveler, it is believed in the village where I lived
> That Henry loved me with a husband's love,
> But I proclaim from the dust
> That he slew me to gratify his hatred.

Within this general ambience, expressions of true love and goodness stand out as exceptions. Masters gives these people a poetic expression that becomes truly

luminous, whether in the straightforward but nonetheless surprising tale of Lois Spears or in the unconventional morality of Sarah Brown:

> Here lies the body of Lois Spears
>
> . . .
>
> Mother of Myrtle and Virgil Spears.
> Children with clear eyes and sound limbs –
> (I was born blind).
> I was the happiest of women
> As wife, mother and housekeeper,
> Caring for my loved ones,
> And making my home
> A place of order and bounteous hospitality:
> For I went about the rooms,
> And about the garden
> With an instinct as sure as sight,
> As though there were eyes in my finger tips –
> Glory to God in the highest.

Within the context of the laments voiced by so many of the other dead, the radiant happiness of Lois Spears is startling. So too is the poignant wisdom of the adulterous Sarah Brown:

> Maurice, weep not, I am not here under this pine tree.
> The balmy air of spring whispers through the sweet grass,
> The stars sparkle, the whipporwill calls,
> But thou grievest, while my soul lies rapturous
> In the blest Nirvana of eternal light!
> Go to the good heart that is my husband,
> Who broods upon what he calls our guilty love: –
> Tell him that my love for you, no less than my love for him
> Wrought out my destiny – that through the flesh
> I won spirit, and through spirit, peace.
> There is no marriage in heaven,
> But there is love.

Spoon River Anthology is a work that scholars have hailed as a masterpiece within an otherwise relatively undistinguished literary output. To use Loudon's terminology, Masters's early work was characterized by a mediocre imitative genius. As the poet May Swenson explains, Masters's "early work reflected a too obvious and energetic worship of Keats, Shelley, Milton, Swinburne and Whitman."[29] Yet, with the *Spoon River Anthology*, Masters was able to make imitative genius into a virtue. He synthesized his influences and sources in a way that enabled him to transcend their lessons so as to create a powerful, inimitable work of singularly piercing vision and high aesthetic effect. Outside of the general model of the Dance of Death, John Hollander

has identified three major literary sources for this poem. One of these is a book written by Masters's law partner Clarence Darrow, who at that time published *Farmington* (1904), "a strangely lyrical novel done as a set of sketches about a small Pennsylvania town." "It probably influenced Masters strongly," explains Hollander, "first in his desire to write that novel about that Illinois town, and eventually in the transmutation of that intention into Spoon River." Another source was Robert Browning's four-volume masterpiece, *The Ring and the Book* (1868–9), which "raised for Masters with lasting effect" the "question of undecidable narrations, . . . that is, it gives local narrative force to the diptychs and the polyptychs and the deferred pairings of epitaphs, one correcting, revising, making ironic the special pleading of another, basically supplying the 'plot' of the whole sequence." The third source mentioned by Hollander was J. W. Mackail's "elegant prose translations of *Select Epigrams from the Greek Anthology*, which his friend and editor William Marion Reedy gave Masters in 1913." These epigrams, "particularly the sepulchral epigrams of Book VII," seem "to have had the precipitating formal effect" on Masters's writing. In conceiving the *Spoon River Anthology* "in this unique format and under unique imaginative pressures [Masters] excelled himself by producing a masterpiece."[30] In this particular case, as in all great art that proceeds according to the workings of "imitative genius," it was a work that exhibits genius in the highest degree.

The genius of Masters's *Spoon River Anthology* is grounded in its poetry, which renders the insights into the human psyche with a particularly apt combination of word and rhythm. The author, explains Hollander, "described the metrical convention of the Spoon River epitaphs as 'a kind of free verse which was free as iambic pentameter is free, where the lack of rhyme and the changing caesuras, and the varying meter give scope for emotion and music.'"[31] Masters's own account of his verse is especially important to the overriding argument of my book, for it confirms, once again, the fundamental importance of establishing value in art by investing the work with an appropriate degree and tone of sentience, of vital life, or as Masters expressed it, of "emotion and music."

We can make the workings of "imitative genius" even more vivid if we consider Thomas Jefferson's two masterpieces, his home Monticello and his campus design for the University of Virginia, both in Charlottesville. The former will be discussed here; the latter in the next section. When Thomas Jefferson traveled to Paris in August, 1784, as American Minister to France, he had already begun to construct his house in Charlottesville according to a design seen in a pattern book of British architecture; the University of Virginia was far off in the future. During Jefferson's five years in Paris he was exposed to numerous buildings, both real and proposed, that took him to the heart of the most important developments in contemporary French Neoclassical architecture. Jefferson was attentive. He learned well, absorbed what he saw, and appreciated the new beauties, the functional planning, and the symbolic thought of this French architecture, as well as recent developments in

England. Upon returning to the United States in 1789, he synthesized this new knowledge and thereby created those inimitable masterpieces first of Monticello and later the University of Virginia according to a creative process designated as mellificative imitation.

As Thomas Jefferson's Monticello illustrates, the process of mellificative imitation can yield works of art of special character different from anything that came before.[32] This house exhibits Jefferson's uncanny ability to assimilate and transform a variety of images into something quite new. The building certainly did not start out that way. Its initial overall aspect (Fig. 10), which dates from c. 1771, follows the manner of colonial East coast Neo-Palladian architecture, with its two-tiered pedimented porch. All of these buildings took their cue from the mid-sixteenth-century villas of Palladio known from engravings. If Monticello had been built as originally conceived, it would have become famous solely as the residence of the great Thomas Jefferson without the added fame of what is today its splendid architecture.

In London Jefferson visited Chiswick House (Fig. 11), the Neo-Palladian residence built toward 1725 by Lord Burlington. Here Jefferson gained first-hand experience with a type of Palladian architecture that differed from the American colonial tradition. It was a lineage that descended from the Villa Rotunda, dating from the 1560s and situated on a hilltop outside Vicenza. Palladio's centralized Villa Rotunda, with its majestic dome and classical porticoes was followed by Scamozzi's Villa Pisani in Lonigo, Italy, dating from the late 1570s, which substituted a faceted dome for Palladio's spherical prototype. Lord Burlington's Chiswick House adhered to the Palladian prototype after the manner of Scamozzi's variant and was basically contemporaneous with Colen Campbell's misnamed Mereworth Castle (1722–5, near Maidstone, Kent), which the architect himself declared to have been modeled on the Villa Rotunda.[33]

While living in Paris, Jefferson, as he himself explained, was "violently smitten with the Hôtel de Salm, and used to go to the [Tuileries Garden] almost daily to look at it."[34] The Parisian mansion called the Hôtel de Salm (Fig. 12), begun in 1782 according to the designs of the architect Pierre Rousseau, was a fine example of the new Neoclassical architecture. Standing in the Tuileries Garden, Jefferson would gaze across the Seine at the river front of the Hôtel de Salm where he found a compact, rectangular volume dominated by a gracefully domed party room that pushed outward toward the river. Pierre Rousseau himself was following a tradition whereby great country houses and city mansions featured a projecting *salon*, or party room, along the garden facade.

The overall horizontal outline of the river facade to Rousseau's Hôtel de Salm echoes the garden facade of earlier Parisian *hôtels* with one major exception, which is the new Neoclassical emphasis on closed mass instead of perforated volume. As Jefferson explained with evident admiration,

In Paris particularly all the new and good houses are of a single story. That is of sixteen or eighteen feet generally, and the whole of it given to rooms of entertainment: but in the parts where there are bedrooms they have two tiers of them from eight to ten feet high each, with a small private staircase. By these means great staircases are avoided, which are expensive and occupy a space which would make a good room in every story.[35]

Thus, Jefferson admired the new Parisian two-story mansion that looked on the exterior as if it were only one story high.

After Jefferson returned to the United States in 1789 he conflated the English Neo-Palladian and French Neoclassical models in a redesign of Monticello (Fig. 13). Whereas the blocklike form of the house crowned with a central, faceted drum and dome recalls Chiswick House, Monticello displays a greater horizontal extension learned from the Hôtel de Salm and its French tradition. The dome itself sits closer to the garden facade rather than occupying the center of the house, thereby recalling once again the French prototype, and the treatment of windows and walls is intended to convey the impression that this two-story house is actually a one-story building, after the manner of the latest French fashion. Built in red American brick with white wooden trim, Monticello is thoroughly American in aspect and original in feeling. It is a perfect example of what Loudon would call "imitative genius," whereby the mind recalls "ideas previously treasured up there by the memory, and present[s] them in new combinations" through the action of the "imagination."[36]

Even the entrance hall with its triple portal belongs to the integrative process of Jefferson's imitative genius. Not only was it a popular feature in contemporary French architecture, it graced in particular the new Château de Chaville built in 1764 by the great Neoclassical architect Etienne-Louis Boullée for Jefferson's dear friends, the Comte and Comtesse de Tessé. Did the entrance to Monticello function as a spur to memory? Jefferson, it should be remembered, placed in Monticello the busts of friends and contemporaries, whom he and his fellow Americans revered as the great men of the age – Lafayette, Franklin, Washington, and John Paul Jones – to serve as silent companions. Was this to be achieved through the use of a borrowed architectural feature as well?

Jefferson and the Comtesse de Tessé shared a common enthusiasm for ancient classical and modern Neoclassical architecture, as well as modern gardens. From southern France where he visited the Roman architectural antiquities, Jefferson wrote to the Comtesse de Tessé: "Loving, as you do Madam, the precious remains of antiquity, loving architecture, gardening, a warm sun, and a clear sky, I wonder you have never thought of moving Chaville to Nismes."[37] Howard C. Rice, Jr., in his wonderful study, *Thomas Jefferson's Paris*, recounts that while Jefferson was living in France, "Madame de Tessé was then engaged, at Jefferson's bidding, in the . . . im-

portant business of compiling a list of the American plants she particularly wanted –
and 'in abundance' – for her garden at Chaville." When Jefferson was about to
depart for the United States in September, 1789, the countess, explains Rice,

> surprised Jefferson with a parting gift, which he discovered one evening awaiting him
> in the hallway of the Hôtel de Langeac. It was an "altar," a garden ornament for the
> groves of Monticello, consisting of a classic column set on a pedestal inscribed in
> Latin "to the Supreme Ruler of the Universe, under whose watchful care the liberties
> of North America were finally achieved, and under whose tutelage the name of
> Thomas Jefferson will descend forever blessed to posterity."[38]

With this gift and inscription the Comtesse de Tessé effectively provided Jefferson
with the rough draft for his own tombstone and epitaph. Jefferson stipulated that he
wanted his grave marked by

> a plain die or cube of three feet without any mouldings, surmounted by an obelisk of
> six feet [in] height, each of a single stone: on the faces of the obelisk the following
> inscription, and not a word more:
> "Here was buried
> Thomas Jefferson
> Author of the Declaration of American Independence
> of the Statute of Virginia for religious freedom
> and Father of the University of Virginia."
> Because by these, as testimonials that I have lived, I wish most to be remembered.[39]

The entrance foyer to Monticello, while important for understanding the opera-
tions of imitative genius, takes us beyond the subject of this chapter into the realm
of architecture as a theater for memory. This has a long and noble history, including
such masterpieces as the Emperor Hadrian's villa at Tivoli (A.D. 118–34), a verita-
ble village of buildings, which was a type of memory theater to recall his life and
travels in Asia Minor, Greece, and Africa; Marie de' Medici's Luxembourg Palace
(begun c. 1614) in Paris, said to recall for the homesick queen the "Florentine ducal
residence (Palazzo Pitti) in which she had grown up";[40] and Alexander Pope's
garden at Twickenham (begun 1719) along the Thames, which commenced in a
grotto with "its variety of rooms, each with an anthology of reminiscence," provid-
ing "rich associations with friend and topographical location," and which ended in an
obelisk dedicated to the memory of the poet's mother.[41]

Memory gardens and memory buildings add a new dimension to the concept of
imitative genius. They remind us that creative activity serves multiple purposes. If a
general theory of aesthetic intentionality can be grounded in an expression of
sentience, modulated to accord with varied ideas and sentiments, one specific
manifestation of creative life can also be found in objects – whether grottoes,
buildings, words, pictorial images, or musical phrases – that have special meaning
for the artist in relation to his or her own life experiences. The presence of memory

objects in a work of art also brings us closer to the widespread phenomenon of "echo," of allusions to other works of art that grace the entire spectrum of great art, as it engages in an active dialogue with its own artistic culture.[42] For example, in his commentary on Masters's *Spoon River Anthology*, Hollander observes, "Masters's speakers from beyond the grave are frequently allusive; phrases from the Bible, from Shakespeare, and from English poetry keep appearing, without fanfare and with a variety of rhetorical uses."[43] This discussion of the personal element in the creative process takes us to the next category, artistic will, where the personal asserts itself more insistently, issuing forth from a primitive place deep within the soul.

Artistic Will

I am adopting the term "artistic will" from the turn-of-the-century Viennese art historian Alois Riegl's *Kunstwollen*.[44] Riegl was particularly concerned with the imagination. Against a mechanistic interpretation of art, he offered the concept of *Kunstwollen*, which he explained was a "teleological hypothesis."[45] I have no intention of following Riegl down the Hegelian path of the teleological purpose of entire epochs and civilizations. Rather I am using the term to designate the driving force within the creative psyche of individual artists that repeatedly manifests itself in a distinctive way. Loudon's three categories of creative activity – inventive genius, original genius, and imitative genius – lacked one important component, designated here as "artistic will." Artistic will is personal and does not appear to be conditioned by the integrative process of imitative genius. It appears to issue from within the artist to impart a powerful aesthetic signature to his or her works. It appears to be a manifestation of pure sentience, not its tributaries but rather the main stream.

Several of the artists already considered already exhibit this quality in their work. Let us consider, for example, Frank Lloyd Wright. Has there ever been an architect whose work is more thoroughly imbued with a primal sense of psychological sheltering? From his Winslow House to Fallingwater (Fig. 3), from the Prairie houses to the textile block houses and then to the Usonian houses, from Taliesin in Spring Green to Taliesin West in Scottsdale, Wright's forms change dramatically, but the theme of shelter dominates. It is not imposed from without; rather, it issues from within. If the French phenomenologist Gaston Bachelard had written an architectural sequel to his books on reveries on the four elements – air, fire, water, and earth – and to the dialectics of shelter achieved through the "poetics of space," he undoubtedly would have focused on Wright. He would have found a kindred spirit in this author of *The Natural House* (1954), which reads like a soul brother to Bachelard's own *La Poétique de l'espace* (1957).[46] He most likely would have used as an opening epigram Wright's often repeated line, "It comforted me to see the fire burning deep in the solid masonry of the house itself."[47]

Thomas Jefferson also exhibited a strongly marked artistic will. His mature

architecture is filled with interlocking spaces that engage one's bodily sense of self in an invigorating way, with the same power that Wright's sheltering rooms and roof lines achieved for the sense of shelter. After his return from Paris, Jefferson did not merely integrate the lessons of contemporary French and English architecture, which he had culled abroad according to the workings of imitative genius, he also imbued his house with a series of interlocking spaces (Fig. 14) that carry the imprint of artistic will. These include the double-height entry hall and rear salon (connected by a large glass door), which create a central core that passes entirely through the house while interlocking with the mezzanine balcony, which moves across the house in the other direction; the paired rooms to either side of the house with their semioctagonal projections interwoven with the interior greenhouse (left side) and the exterior porch (right side) respectively; the dining room with its perforated wall that opens onto the semioctagonal breakfast room (located to the right of the salon in this analytical drawing but without showing the arched perforation above the doorway); and finally, the complex interlock of spaces of different shapes and heights that make up the bedroom (to the left of the salon) and adjacent study (comprised of the paired semioctagonal projecting rooms with their intermediate passageway), with the bed placed within a niche in a wall, not against the side of the room in the French manner, but rather projecting boldly into the room as a partial space divider (between the bedroom and the semioctagonal projection of the study).

The same obsession for interlocking spaces is manifest in Jefferson's campus created for the University of Virginia between 1816 and 1826 (Fig. 15). We can explain the amalgamation of the main features, up to a point, as the creative work of imitative genius that has fused together its sources in a truly original work of art. As is well known, the parallel rows of buildings, with larger "pavilions" to house the teachers and their classes linked by single-story lines of dormitory rooms, the whole preceded by a peristyle, is a transposition of the layout both of Louis XIV's Château de Marly and of modern, functional hospital design, much in discussion during Jefferson's Paris sojourn.[48] The head building, the famous Rotunda, is also a modified half-scale adaptation of the Roman Pantheon with liberal alterations to the interior.[49] Its plan (Fig. 16), as has also been pointed out, is derived from the plan of that most fantastic piece of playful architecture, that garden *folie*, the house in the form of a giant broken column at the so-called Désert de Retz, which features two oval rooms (Figs. 17–18).[50] One could also add that Jefferson's inspiration for the library on the upper floor of the Rotunda (Fig. 19), a circular room crowned with a dome that was to be painted blue and gilt with the stars of the nighttime sky, was the dome of the Pantheon itself mediated by two Pantheist projects by Boullée from the mid-1780s, a library in the form of an amphitheater of books conceived as the repository of humankind's knowledge of the universe — a theme indicated at the entrance by paired atlantes carrying a cosmic globe — and a cenotaph to honor Sir

Isaac Newton (Fig. 20) whose interior was to be a hollow cavity symbolic of the cosmos and lit by "stars" created by puncturing holes in the domed roof. Jefferson fused all of this into an entire complex of buildings that cannot be reduced to a simple summation of sources.[51]

Yet, that is not all. The campus is infused with multiple instances of interlocking spaces. The paired oval rooms inside the Rotunda are not isolated as were those in the broken column at Retz. Rather, these ovals in the Rotunda interlock gracefully with the sculptural shape of the intervening hallway. Similarly, the serpentine walls that link the inner and outer ranges of buildings and that separate the professors' private gardens from these pathways create a dynamic intermediate zone which interlocks with the adjacent areas. There are no leftover spaces here. The pathways contained within the serpentine walls are not back alleys but rather animated places in their own right.

Finally, the entire central lawn presents an elaborate image of interlocking lines of columns, with the colossal classical columns of the pavilions reaching out beyond the smaller columns of the peristyle that weaves the entire range together. The French movement in Neoclassical architecture was characterized by a great enthusiasm for the experiential effects afforded by vast numbers of free-standing columns, arranged in lines or in entire fields, like an extended quincunx.[52] The motif of the interlocking larger and smaller orders had been used in Jacques Gondoin's Ecole de Chirurgie (1770–5), one of the two buildings that initiated the French Neoclassical style. They were then used even more dramatically along the courtyard facade of the Hôtel de Salm (Fig. 21), whose construction, as we have seen, Jefferson watched assiduously.[53]

Jefferson outdid his French counterparts with his interlocking rows of columns at the University of Virginia where he applied them on a greater scale and with a repetition that far exceeds the more modest renditions in Paris. Furthermore, unlike the French buildings where the interlocking orders were a singular theme, the University of Virginia used them as simply one of numerous instances of spatial interpenetrations. It would seem as if while in Paris Jefferson saw an architectural motif – the interlocking orders – that touched a deep chord in his creative persona. When he returned home, he invested first his house and then his university campus with all possible variations of the more general principle of interlocking spaces, using the specific motif of the columns as one of many different features of this type.[54]

Marcel Proust too appears to exhibit his own particular "artistic will." The flowing sentence that pervades his prose is too universal a phenomenon in his writings, too insistent in its texture to be attributed merely to the influence of Henri Bergson's theories about *élan vital* and its relationship to *la durée*[55] or simply to Proust's place within the development of Symbolist art. This is not to divorce Proust from his times. As Debora L. Silverman has suggestively written,

French Symbolism originated as a literary movement but emerged in the 1880s as a broad theory of life and an attitude toward the material world that introverted outer and inner reality. (. . .) We can thus trace affiliations in the artistic avant-garde that explain the new link between psychological self-exploration and interior space as a domain of suprahistorical self-projection. This diachronic line extends from the Goncourts, via Huysmans and de Montesquiou, to Marcel Proust. Proust amplified the Symbolists' ideal of the expressive and visual capacities of language to evoke the fluid, suggestive power of the interior realm. He chronicled a flowing give-and-take between the insulated narrator and his furnished decor, correlating the materials of the inner space with the nervous vibrations they stimulated, even as the concrete rooms dissolved in the transfiguring fevers of inner vision. The Goncourts' projection of visual animation onto the walls of the bedroom in the *Maison d'un artiste* led finally to the whirling room envisioned by the narrator in the opening section of Proust's *Swann's Way* [the first book of the *Recherche*].[56]

Grounding his fictional writings in experiences such as the terror of awakening in a position that momentarily leaves one totally at a loss as to where and, by extension, who one is; such as the hypersensitive awareness of the alien quality of all new rooms in that brief moment before one inserts one's vital space into the room with an assurance that is solidified only through the force of habit; and such as the experience of the real and pulsating feelings of passion that a suddenly interrupted erotic dream can impart, Proust developed his flowing prose style upon a bedrock of sensitivity to human sentience, to *élan vital*, whose ramifications are repeated line after line throughout the *Recherche*. This sensation greets us from the opening lines and leaves us at the end of the second book with a sense of a primordial moment of stillness and a quiet amazement simply about the feeling of life:

Because the light outside was so strong, I kept closed as long as possible the large violet curtains that had shown me so much hostility the first night. But as, in spite of the pins with which, so that the light would not enter, Françoise closed them each night and which she alone knew how to remove, in spite of the blankets, the tablecloth of red cretonne, the cloth found here and there that she adjusted to this end, she did not succeed in closing them entirely, the darkness was not complete and they allowed [the daylight] to spread across the carpet like a scarlet cascade of anemones which I could not refrain from momentarily visiting in order to touch with my naked feet. And on the wall opposite the window, and which was partially illuminated, a golden cylinder with no visible support was placed vertically and was slowly moving like the luminous column that preceded the Hebrews in the desert. I went back to bed. . . . At ten o'clock, in effect, [the concert] burst out under my windows. Between the intervals in the music, if the tide was high, would begin again, slurred and continuous, the gliding movement of a wave that seemed to enfold the sounds of the violin within its crystal scrolls and to make its foam spray out over the intermittent echoes of a submarine music. (. . .) And over the coming months, in this Balbec that I had so greatly desired because I had imagined it only as battered by

storm and obscured in fog, the sun had been so bright and so constant that, when [Françoise] came to open the window, I always was able, without error, to expect to find the same patch of sunlight bent across the corner of the outside wall, and of an immutable color that was less moving as a sign of summer than dreary as the color of a lifeless and awkward enamel. And while Françoise was removing the pins from the imposts, taking down the cloths, drawing back the curtains, the summer light that she uncovered seemed as still, as immemorial as a sumptuous and millenary mummy that our old servant would have only unwound of its linen wrappings as a precaution before having it appear, embalmed in its robe of gold.[57]

We have all the main Proustian themes of sentience interrelated here – the sea, music, the room, and waking and sleeping – all enveloped by an even greater unifying force, the bright sun, first entering the obscurity by "moving slowly like the luminous column that preceded the Hebrews in the desert" and then flooding the room with light, experienced as the miracle of life.

Simplicity

I briefly introduced the subject of simplicity in Chapter 1 where I stressed the value of the laconic expression. Certainly Thomas Jefferson's own epitaph works in this manner. At the opposite end of the spectrum is the simplicity that results when all parts, even of a complex composition, are so interrelated that they seem to form an organic whole. Here simplicity derives from a thorough unity whose classical expression in aesthetic theory was given by Alberti's definition of beauty, whose foundations he attributed to Socrates. "Beauty," explained Alberti, "is that reasoned harmony of all the parts within a body, so that nothing may be added, taken away, or altered, but for the worse."[58]

My interest in simplicity in this study of the creative process will touch upon both these poles, as well as intermediary points within the full range of simplicity in art. I am primarily concerned with the question of how the artist achieves the sort of simplicity that makes everything about the work of art seem so right.[59] My first example provides a variation on the theme of creation as a patient search, in which through trial and error, worked out through consecutive studies, the artist comes upon an appropriate solution. This operation can be illustrated by the genesis of Seurat's *Un Dimanche à la Grande Jatte* (1884–6). My subsequent case studies are intended to demonstrate how difficult it is to reach this state of simplicity. By considering the genesis of the United States Navy Memorial in Washington, D.C., I will show how chance, rather than purposeful intentions, can intervene to direct the creative process in a fruitful direction. Two final case studies, the transformation of the former Parisian train station of the Gare d'Orsay into a museum of nineteenth-century art and the design competition for the Women in Military Service Memorial in Washington, D.C., are reviewed to demonstrate how easy it is to miss the

opportunity for the simple solution that seems so natural and how rare it is to achieve it. For me, all four stories augment the awe that great works of art deserve, not only for their superior value, but also for the process that saw their birth. Once again, reason is humbled by the creative imagination.

From the first season in which it was shown in 1886, Seurat's *Un Dimanche à la Grande Jatte* (Fig. 22) became a celebrity, achieving a status that made it "both the star turn of Neo-Impressionism and the most famous painting of the decade."[60] Explaining to an art critic his intentions as a painter, Seurat expressed his admiration for the aesthetic achievement of the Greek classical frieze and his desire to create an analogous effect using modern people in a modern art: "[T]he Panathenaeans of Phidias [on the frieze around the Parthenon] formed a procession. I want to make modern people, in their essential traits, move about as they do on those friezes, and place them on canvasses organized by harmonies of color, by directions of the tones in harmony with the lines, and by the directions of the lines."[61] Seurat certainly achieved this not only by applying the lessons of the Greek frieze but also, as contemporaries observed, through the conventions of ancient Egyptian art.[62] The result is a unified feeling imparting calm throughout the canvas.

Yet this simplicity was a result of experiment and choice. One of the most remarkable aspects of Seurat's studies for this painting are those in which he experimented with the directionality of the lines by including figures or forms that break away from general guiding lines of the composition, which present people, animals, trees, and boats primarily parallel to the picture plane and secondarily aligned with the gentle diagonal of the shore. In the study shown here as Figure 23, most notable is the man to the left whom Robert L. Herbert characterizes as "so amusingly assertive."[63] The attitude of his body presents a diagonal thrust that breaks with the line of the shore and the line of the shadows and furthermore seems twisted as well. Similarly disruptive is the attitude of the central woman whose right arm crosses over her body as it holds her umbrella at an angle that likewise crosses disruptively over her face. In the final painting this man is not present and the umbrella is held closer to the perpendicular and without having to reach over the torso. Similarly, in several studies the tree to the left in the completed canvas bends either with a forceful curve or with a more pronounced diagonal. In the end, this tree is made to harmonize with the placid tone of the entire composition not only through its shape and thickness but also in combination with neighboring human figures. Thus, for the finished painting, Seurat rejected discordant notes issuing from these more dramatic diagonal and twisted shapes, in favor of a consistent, unified treatment obtained through full profiles and frontal views, seconded by the gentle effect of the diagonal line of the river's edge and its related lines, the most dominant being shadows. In this manner, and in conjunction with the finer application of pointillist brush stokes, the final painting achieves a simplicity absent from these earlier studies.

The particular quality of such simplicity gives the appearance of capturing a moment of time in a way that raises it outside of time. Through this simplicity it becomes a painting that reaches what T. S. Eliot would call the "still point of the turning world":

> At the still point of the turning world. Neither flesh nor fleshless:
> Neither from nor towards; at the still point, there the dance is,
> But neither arrest nor movement. And do not call it fixity,
> Where past and future are gathered. Neither movement from nor towards,
> Neither ascent nor decline. Except for the point, the still point,
> There would be no dance, and there is only the dance.
> I can only say, *there* we have been: but I cannot say where.
> And I cannot say, how long, for that is to place it in time.
> The inner freedom from the practical desire,
> The release from action and suffering, release from the inner
> And the outer compulsion, yet surrounded
> By a grace of sense, a white light still and moving,
> *Erhebung* without motion . . . [64]

There is an epiphany here in both painting and poem related to sentience. The dance here, with "neither arrest nor movement," is an epiphany of that feeling of life which Langer had related to music and which finds its analog here as elsewhere in dance. We must keep in mind that the sense of grace issues from the "grace of sense," whose white light joins Proust's brilliant light from the last lines in the second volume of the *Recherche*.

The United States Navy Memorial along Pennsylvania Avenue in Washington, D.C., is another example of a work of art marked by simplicity. It seems so right for its purpose and its location. The Navy Memorial consists of a circular plaza with perimeter amphitheater to the north and bas-reliefs to the south. The circular pavement is fashioned as a polar projection, showing "about 90 percent of the world's land mass and the vastness of the ocean areas, the Navy's domain." Off center and to one side on this circle stands a somber but determined figure of the *Lone Sailor*.[65] Four pools with moving water surround the 100-foot diameter plaza.

Around the northern half of the plaza is a semicircular sweep of buildings faced with classical columns. This facade is more than a backdrop for the Navy Memorial, it also serves to anchor the entire design into the axial sequence of Neoclassical civic buildings that includes the National Archives, to the one side of Pennsylvania Avenue, and the former Patent Building, now the National Portrait Gallery and Museum of American Art, to the other side at the end of the cross-axis a few blocks away.

The relationship between these three monuments is not limited to this axial

alignment of classical architecture. The shapes of the main forms and spaces themselves relate in significant ways. On the one hand, the semicircular walls of the plaza of the Navy Memorial envelop an outdoor forum that echoes the semicircular, domed Rotunda room in the National Archives which displays the Declaration of Independence, the Constitution, and the Bill of Rights. On the other hand, the same semicircular sweep of columns to the northern side of the Navy Memorial effectively frames the view of the neighboring classical portico that fronts the National Portrait Gallery. It would be difficult to imagine a more appropriate design solution both to achieve suitable character for the Navy Memorial itself and to relate it to the other buildings on the site in a way that strengthens the character of the place according to Pierre L'Enfant's original intentions for the plan of Washington, D.C. Yet the circular plaza for the Navy Memorial was the third and almost accidental solution to the design problem.

The first proposal for the Navy Memorial was a triumphal arch, an "Arc de Triomphe lifted almost in entirety from Paris." The project initially won widespread acceptance. "With great enthusiasm, the Navy Memorial Foundation board approved the arch concept and pressed hard for its approval, [which was] endorsed by the Commission of Fine Arts, the PADC [Pennsylvania Avenue Development Corporation] and the National Park Service." Nevertheless, the project was defeated with a nine to three vote by the National Capital Planning Commission "for reasons that the arch was overpowering to surrounding buildings, threatening to the National Archives across the street and impairing to the sacred vista."[66]

Having to abandon the project for a triumphal arch, the Navy Memorial Foundation in conjunction with its New York architects explored the possibility of a plaza with a bordering amphitheater. Although the architect "continually presented squared-off or rectangular amphitheater designs," the people in the Navy Memorial Foundation "preferred a circle." The issue was decided when retired Rear Admiral William Thompson, President of the Navy Memorial, "saw a polar projection of the world on the bottom of an ashtray," which he then hurriedly brought to his office "to announce the discovery of the amphitheater's deck."[67] Thus, the polar projection on the bottom of an ashtray decided the debate. It gave a purpose to using the circle and as a secondary consequence, it established the site conditions that enabled the Navy Memorial to relate most effectively to the National Archives and the National Portrait Gallery. No doubt, it would have been possible to make a proper memorial with a square or rectangular amphitheater. Yet, the entire site benefited immeasurably once the circle was given preference and especially with the map of the world in mind.

The difficulty in discerning the simplest and most apt solution to an artistic problem can be further illustrated by reference to the 1978 competition to transform into a museum of nineteenth-century art (actually covering the period 1848–1914) the abandoned Gare d'Orsay train station (1898–1900) at the heart of Paris,

along the Seine and cross the river from the Tuileries Garden. This grandiose Beaux-Arts building was roofed over with a huge and extensively glazed barrel vault whose iron-ribbed central spans and lower side walls were covered with porcelain coffers. The large skylights admitted abundant light to the train tracks that emerged from their underground tunnels in a broad open pit which ran through the center of the space. Along the side facing the Seine, the building welcomed departing travelers with a linear vestibule seven bays long, each covered with a skylit dome. Arriving passengers left the building under an expansive glass canopy along the short side to the west across the street from the side facade of the Hôtel de Salm. Of the six designs submitted to the invited competition, all but one engaged in dramatic volumetric gyrations in varying attempts to fill the giant interior volume with a dynamic sculptural form.[68]

In contrast, the winning scheme presented the image of simplicity itself (Fig. 24). The architectural team ACT Architecture (Renaud Bardon, Pierre Colboc, and Jean-Paul Philippon) understood that in a long linear building, parallel to the equally linear geometries of the Tuileries Garden and to the river Seine between them, and moreover in a building whose history was the arrival and departure of trains along straight lines running parallel to the central axis of the edifice, the most logical solution, both from the point of view of current program, historical memory, and urban context, was a restrained, linear design. To this end, the architects closed the river facade and reversed the entrance sequence by making the glass canopy that once bid travelers farewell as they left the station into a welcoming entrance to the new museum goers. Once inside, the museum visitors would make a graceful descent into the pit where the train tracks had once run. There they would then begin a gradual ascent along the long central axis of the building. In this manner the architects preserved the grand space of the Beaux-Arts interior while affording an extended vista along an interior "street" fully consonant with the monumental classical urban axis of Paris that stretches from the Louvre, through the Tuileries, across Place de la Concorde, down the Champs-Elysées to the Arc de Triomphe on the hill at Place de l'Etoile, and more recently out to the Grande Arche at La Défense.

The central interior street in the Musée d'Orsay was conceived as a showplace for academic sculpture. It was a fitting location, not only because the statues would be seen under the natural light flooding in from the grand barrel vault, but also because the unencumbered Beaux-Arts space was a perfect match for this academic sculpture. Even more, the nineteenth century saw the development of extensive public statuary placed in urban streets and squares.[69] Hence, the interior sculpture allée provided an appropriate historical metaphor. Painting galleries were arranged to the sides of this central, open passageway.

In 1980, as a result of a second competition, this time for an interior architect,

the Milanese designer Gae Aulenti was hired to develop further the winning scheme with an eye to the particular requirements for exhibiting the art work. Aulenti strengthened the initial project by lining the central interior street with battered walls that created a strong sense of a self-contained volume within the grander space (Fig. 25). The pedestals for the statues were moved away from the side walls so that now the sculpture would be fully visible in three dimensions. The delicate bridges across the central void that the architects had envisaged were eliminated, thereby strengthening the thrust of this central zone. And twin towers with internal exhibits and a panoramic view back across the entire long building replaced the semicircular hemicycle that the architects had hoped to use to terminate the axis. The towers also mediated between the lower scale of the central street and the high barrel-vaulted roof.[70]

Of course, it was the simplicity of the ACT prize-winning scheme that made each of these changes possible. More fundamentally, even ignoring these modifications, we find that the initial project displays a logic and a naturalness that seem so appropriate for the building and the site. In the end, it even seems obvious. Yet, as we discover time and again through design competitions, it is so difficult to come up with the scheme that in the aftermath seems self-evident. It is a credit to the creative ingenuity of the architects when they discover such solutions.

This is also true of the 1989 competition for the Women in Military Service for America Memorial at the site of the ceremonial entrance to Arlington National Cemetery (Fig. 26). The monumental entrance, a Beaux-Arts hemicycle dating from 1932 by the successor firm of McKim, Mead, and White, terminates the long vista across Memorial bridge and serves as a retaining wall to the slope on which Arlington National Cemetery is located. Among the one hundred thirty-one projects submitted to the competition, it appears that only two selected the simplest and, I would argue, most appropriate strategy. Instead of adding new buildings to the site, they proposed to hollow out rooms behind the retaining wall, thereby using it as the main facade and realizing the unfulfilled potential of the hemicycle. (In the grand Baroque garden at the Villa Aldobrandini in Frascati, the hemicycle retaining wall, which served as the model for the McKim, Mead, and White design, actually contained rooms behind it, including a chapel.)

The virtues of this approach were multiple. Not only would the site remain undisrupted, but a sequence of spaces, beginning in buried rooms and passing upward to a terrace with views over monumental Washington, D.C., in one direction, and over Arlington National Cemetery to the other side, provided rich possibilities for a memorial theme. The winning project by Weiss/Manfredi Architects made the simplest and most poetic use of the excavation strategy. Once again, as in the competition for the Musée d'Orsay, the winning design seems so natural, so appropriate, so obvious. Yet the evidence of all the other unsuccessful entries

demonstrates how difficult it was to arrive at such a solution. The selection of these winning schemes by the respective competition juries confirms that when true simplicity has been attained as a true fit to the problem, it is readily acknowledged. The incapacitating doubts of the poststructuralist mind – how do we know? how can we be sure? – in face of the force of such evidence seem so misplaced and so insignificant.

Radical Conjunction

Whereas simplicity involves a solution that seems natural to the point of being self-evident, radical conjunction startles the mind by juxtaposing two conditions which traditionally have been deemed worlds apart, with no evident relationship. In a sense, simplicity and radical conjunction represent opposite poles of creative endeavor. When radical conjunction is present in a work of art the audience is given a heightened awareness of the creative act itself. The willful nature of the juxtaposition reveals not only its intentionality but also the great imaginative leap made by the artist to join such dissimilar things together. As with simplicity, the mere appearance of radical conjunction does not an art work make. Rather it becomes the underlying basis for investing the work of art with value. It remains an idea that still has to be realized artistically. The work of art still must register on the aesthetic scale of experience discussed in Chapter 1.

Most of the examples of radical conjunction that I know come from avant-garde twentieth-century art where they partake of the broader questioning of customary subject matter for art, of the raw material for aesthetic creation, and of the nature of artistic conventions. This has occurred in virtually all artistic disciplines. In sculpture, for example, we find Picasso using a bicycle seat and handlebar to suggest a bull's head in which both the bicycle parts and the representation of the bull are simultaneously in evidence (Fig. 27). The same is true of his sculptural bouquet of flowers that uses baking tins for the effect of open petals (Fig. 28).

In painting we find that the Surrealists especially were fond of using radical conjunction. They presented what purports to be a representational picture in which the logic of the natural world is violated. We find this in Salvador Dali's melting watches and in René Magritte's nighttime street scene in which the sky is shown in broad daylight (Fig. 29).

In literature, this occurs in a novel such as Alain Robbe-Grillet's *Dans le Labyrinthe* (1959), in which the people in the story and in an engraving on the wall of a room become interchangeable. As the narrator describes the engraving, the reader discovers the protagonist among the people depicted there. Suddenly the picture comes to life – that is, with the same reduced life of the mechanical people in the narrative. Since all fiction is a creation, the author is implicitly saying, then why can't the

fictional people in the narrative trade places with the figures in the fictional painting that is placed in the fictional narrative? In dance, which traditionally relies upon the movement of the human body with its capacity to extend or contract feet, arms, and legs, as well as moving the head and torso, the use of bag creatures by Alwin Nikolais (Fig. 30), in which the dancer dons an encompassing sack that uses contracting and extended protrusions and that then becomes displaced in space without revealing the individual features of the body contained within, exhibits radical conjunction.

In architecture perhaps the most striking example of radical conjunction is Boullée's unrealized Cenotaph to Sir Isaac Newton (Fig. 20). Boullée, who envied the ability of painters to create convincing illusions of reality on canvas, ardently desired to outdo painters with architecture by working with the materials of nature itself, notably space, light, and darkness. Until Boullée's time architects had used numerous devices to portray symbolically either the vast cosmos or heaven in a way that would impart an experience adequate to the concept. We can think of the cosmic dome of the Pantheon, the heavenly dome of Hagia Sophia, and the new Jerusalem of the Gothic cathedral. Yet Boullée's Cenotaph to Newton actually attempts to create the illusion of the vast cosmos, using natural light and darkness itself, within an enormous edifice. To place the cosmos in a building, not symbolically but rather experientially, is a clear example of radical conjunction.

All of the examples of radical conjunction cited up to this point are single works of art, real or ideal. Radical conjunction can also occur by pairing in the mind disparate objects. Consider, for example, the relationship between Le Corbusier's avant-garde villas of the 1920s and his polemical manifesto, *Vers une Architecture* (1923). It is well known that the predominantly white, prismatic buildings of the so-called International Style of the 1920s were conceived as an architecture to give appropriate cultural expression to what was being celebrated as a machine civilization. It is also widely accepted by historians and architects that streamlined styling of ships, trains, and automobiles influenced the overall appearance of architecture in various modern movements from the 1920s through the 1940s. And it has also been repeatedly pointed out that Le Corbusier went even further than most of his contemporaries in actually using formal configurations in his 1920s villas that were readily apparent as features taken from the icons of the modern world, such as ocean liners, automobiles, and airplanes. On the most general level his horizontal strip windows are like the windows on the cars that he strategically places in photographs to reveal the analogy (Fig. 31). Le Corbusier also followed his own advice to architects to use the rear deck of the *Aquitania* as inspiration for a villa (Fig. 32) when he made it the basis for the Villa Savoye (1928–31, Fig. 33).

The real radical conjunction occurred, though, when for the design of the Maison Cook (Boulogne-sur-Seine, 1926, Figs. 34–35) he took the nose of the Goliath

Farman airplane (Figs. 36–37), which he had published in the chapter of *Vers une Architecture* entitled "Eyes That Do Not See," and used it for the entrance hall to the house.[71] Yet, this is not all. Le Corbusier did not merely create a collage by combining the image of an airplane part with his cubical house to characterize the building as a product of the machine age, he also alluded to the airplane as an object lesson about the principles for a modern architecture. Le Corbusier was asking his audience to look again at the airplane, blink a few times, and open the eyes to see that the features of the airplane were precisely analogous to his radical Five Points for a New Architecture.[72] Using the new material of reinforced concrete, Le Corbusier postulated a revolution not only in building design and construction, but also new possibilities for the setting for modern life through a radically new image of the house and a new aesthetic. Briefly enumerated, the Five Points were (1) to lift the house off the ground on concrete columns, (2) to provide a flat roof with a roof garden, (3) to reduce the structural supports to free-standing columns, such that the rooms of each floor could be planned independently of the others, (4) to provide a "free facade" with no structural purpose, which would enclose the building as it wrapped around the perimeter of the cantilevered concrete floors, and (5) to use long, horizontal strip windows to provide even and abundant illumination. In designing the Maison Cook according to these Five Points, Le Corbusier developed a powerful new aesthetic that kept the walls, some straight and others curved, separate from the free-standing columns.

With the Five Points in mind, we can now see the body of the airplane elevated off the ground as suggesting the same position for the house, the flat top of the upper wing as becoming the roof garden, the free-standing vertical struts as suggesting the free-standing concrete columns between the floors, and the rounded nose of the fuselage projecting out between the struts as suggesting the aesthetic of separating the volumetric shapes within the house from the free-standing columns. Hence, through this radical conjunction, Le Corbusier teaches that the ultimate lesson of the machine, this machine, which is the airplane, has been to suggest a completely new architecture based on a straightforward analogy between homologous parts.

Such radical conjunction was not unique to Le Corbusier. Rather it was widespread in the various avant-garde art forms associated with Cubism, as was Le Corbusier's architecture of this period. The Cubist image was often grounded in the sharp juxtaposition of seemingly disparate objects whose rapprochement created uncanny analogies. We find this, for example, in the analogy between the human body and the guitar or violin in Cubist paintings where the musical instrument is literally juxtaposed with the body or where it substitutes in a still life for the body shown in a portrait. In either case, the resonating chamber, its sound-holes, and the strings become a metaphor for the heart and soul.[73] The avant-garde poet Pierre Reverdy explained the new character of the poetic image in this new art, an art that

did not imitate reality but rather created its own artistic reality, in terms of what I am calling radical conjunction:

> The image is a pure creation of the mind.
>
> It cannot be born through a comparison but rather from the juxtaposition of two realities more or less separate.
>
> The more the relationships between the two juxtaposed realities are distant and apposite, the more the image will be strong – the more it will have emotive power and poetic reality.
>
> . . .
>
> An image is not strong because it is *brutal* or *fantastic* – but because the association of ideas is distant and apposite.
>
> . . .
>
> Analogy is a means of creation – It is a *resemblance of relationships*; . . .
>
> . . .
>
> One does not create an image by comparing (always weakly) two disproportionate realities.
>
> One creates, to the contrary, a strong image, new for the mind, by juxtaposing without comparison two distant realities for which *only the mind* has seized the relationships.[74]

Radical conjunction understood in this manner was effectively an attempt to push beyond the boundaries of metaphor.

The Act of Making

Radical conjunction is only one form of creative endeavor that heightens the awareness of the creative act itself. Another important aspect of creativity might be termed "the act of making." Here the work of art shows itself either in the process of becoming or gives the impression of being created as it proceeds along. The notion of "the act of making" can also apply to the appearance of the art object as an artifact rather than as a natural phenomenon.

Perhaps the most obvious example of works that show themselves becoming art out of the raw materials of the discipline are the unfinished statues by Michelangelo (Fig. 38). Thanks to the unintended state of incompletion, the contrast between the raw stone and the art that has been created out of it provides a vivid reminder of the imaginative distance, as well as of the sheer hard labor and manual skill required, to be traversed by the artist. A contemporary account of Michelangelo's working method makes the juxtaposition between rude stone and smoothly rendered musculature and between amorphous block and dramatically twisted body stance appear even more amazing:

> The best method ever was used by the great Michelangelo; after having drawn the principal view on the block, one begins to remove the marble from this side as if one

were working a relief and in this way, step by step, one brings to light the whole figure.[75]

"Vasari," relates Howard Hibbard, "explaining this method, compares the gradual emergence of the figure from the marble block to a model sunk under water that is slowly pulled up, revealing the topmost parts first and then, part by part, the rest."[76] It would be difficult to imagine a more awe-inspiring demonstration of the creative process or the quality of high genius.

Another way of becoming aware of what appears as the act of making can be found in music where an introductory motif is then repeated and developed. Whereas this musical repetition and elaboration does not necessarily correspond to the actual dynamics of composing the piece, it presents an image of the act of making that heightens one's sense of the creative process. This can be illustrated most simply by considering Beethoven's *Fifth Symphony*. Here the opening musical phrase is repeatedly played higher and lower and with embellishments in a way that directly suggests the act of artistic creation.

Architecture, too, is a domain of art in which the act of making is broadly apparent. This occurs in two ways. As Arthur Schopenhauer suggested in *The World as Will and Representation* (1819), architectural aesthetics are generally grounded in the expression of load and support. Wherever we see the piling of stones or bricks, the mutual abutments of domes and vaults, the vertical or diagonal lines of concrete or steel supports or of their horizontal spans, or the umbrella-like spread of coffered concrete ceilings or thin concrete shells, we are presented with an image of a building as a completed act of construction and as a living organism, so to speak, that is carrying its burden of weight down to the ground. So powerful has been the need to express dead weight or diagonal thrust, that architects have often given an illusion of the support handling the burden through the creation of a metaphorical structural scaffolding. The entire history of classical architecture from the Renaissance through the Baroque period, taking cues from ancient Roman and Italian Romanesque building styles, is a combination of these two attitudes, showing the real or metaphorical structure. Even the interiors of Gothic cathedrals operate in this way, their clustered piers seeming to deny gravity by appearing to spring upward away from the ground. For this reason, Schopenhauer dubbed the Gothic the "negative pole" of architecture, because it presented an illusion rather than an actual depiction of load and support, as had Greek architecture.[77]

A second way in which architecture has suggested the act of making occurred particularly in the Renaissance and Baroque eras when rough stone finished as "rustication" was juxtaposed with smooth stone. This would be found either in buildings with the smooth walls rising above a rusticated base, or in gardens where architectural features furthest from the house were made of rough stone and those closer of smooth stone. In both cases, the rough surfaces designated the world of

nature; the smooth surfaces portrayed nature worked into art. Of course, both types of stone required artistic handling. It has even been argued that rusticated stone was more costly to produce! Aficionados aware of this difference in price would appreciate the extra effort, as well as the patron's superior financial means, required for executing a rusticated finish.

In painting the act of making appears in various manners. Here it is possible to identify two opposing poles in the treatment of the canvas. At one extreme we find the thick application of paint, such as the impasto used by Rembrandt to heighten the effect of gold jewelry in his portraits. In these oil paintings the impasto plays a double role, serving at the same time the needs of representation by portraying the gold ornament and reminding the viewer as it stands out from the overall smoothness of the painted surface that not only this but the entire picture is the product of a creative act. The other extreme occurs when part of the white canvas itself is left blank, as in the late still lifes and landscapes by Cézanne. This naked surface also plays a dual role, forming part of the overall composition and announcing the act of making that went into the painting.[78]

The self-conscious portrayal of the creative act in painting, though, is not limited to these examples but rather extends broadly to many other types of devices. We see this whenever a figure is outlined in black rather than primarily modeled by color. We become especially aware of this whenever the colors used depart purposefully from a seeming illusion of accurate representation, as in Fauve painting. Likewise, we readily see that the act of making the brush stroke calls attention to its technique, as in Impressionist and Neo-Impressionist painting with its juxtaposed dashes and spots of pure color. Although Robert L. Herbert is undoubtedly correct in expressing his relief that Seurat's term *chromo-luminarisme* "never took hold," it would still have had the virtue, over "Neo-Impressionism," of suggesting both the act of making the painting and the effect that the juxtaposition of points of color was intended to achieve.[79]

With Impressionist and Neo-Impressionist painting the entire surface of the canvas announces itself as a created object through the juxtaposition of the dabs of color applied in visible brush strokes. This phenomenon occurs even more generally throughout the history of art in the medium of drawing and through its close relationship with etching. When we consider Rembrandt's etching, *Woman at the Bath* (1658, Fig. 39), we see that the human figure – even the entire scene – is created through clusters of lines, most of which are done as cross hatches. Similarly, this drawing of *Cottages among the Trees* (Fig. 40) shows itself as completely composed of gracefully moving lines, which subtly change in weight to model the forms and also to suggest shadow. At times, it seems that not only the figures in the drawing but the very breath of life that pervades them comes from the act of moving the drawing instrument over the paper. This is true of Seurat's numerous drawings with conté crayon in which the people seem to owe their existence to a fragile clustering

of dark spots coming out of the void to give them form and to invest them with life (Fig. 41).[80]

This discussion of the act of making in painting and drawing brings us close to the next topic, which is stylization in the arts. All of the effects discussed in this section are aspects of the conventions employed by artists to establish tone and unity in their work.

Stylization

All good art has a consistent tone and overall unity that is achieved through stylization. Whereas this appears most readily in music and architecture, it requires a greater degree of conscious focusing to see in representational painting and sculpture. All representational art operates by establishing a tension between the real world and its depiction. The viewer never sees the actual object but rather is presented with an illusion of reality suggested through particular artistic conventions.[81] These conventions give a stylization of reality. Look at the eyes and eyebrows in the sixth-century Byzantine mosaics in the Church of San Vitale in Ravenna (Fig. 42) or in the figures painted by Giotto (Fig. 43) in the early fourteenth century. Their stylized quality, so readily apparent, helps us next to see the stylization of the entire face and then of the entire body. Consider the famous *Spear Bearer* (c. 450–440 B.C.) by Polyclitus (Fig. 44), whose "studied poise," "anatomical detail," and "harmonious proportions" made it the "standard embodiment of the Classical ideal of human beauty."[82] Yet this statue is an idealized presentation of the human body, whose anatomical detail is, as the Jansons point out, "overexplicit."[83]

The mind, however, lends itself so readily to the illusion of reality in representational art. Walk through a collection of Greek statuary in a museum and admire the beauty of the faces. When you arrive at the Roman busts of individual citizens from the first century B.C. you undergo a shock at seeing so realistic a portraiture (Fig. 45). The eyes are slightly uneven, the face is wrinkled, the mouth has irregular curves. At this point you realize how seductive the illusion of reality had been while looking at the idealized figures of Greek art. Yet, even with these Roman busts, there is an overall tone and unity that reflects a distinctive artistic stylization.[84]

This stylization is everywhere in representational art. Consider landscape paintings by three different Impressionists such as Camille Pissarro, Alfred Sisley, and Claude Monet. If you look at them separately, each will readily suggest a real view. Yet when placed side by side, as often occurs in museum exhibits, each scene will have a tonal aura different from the others. At such moments it becomes easier to see that all representational art relies on stylization and as such demonstrates the nature of the creative act. An important aspect of the hold that the work of art has over us, beyond the overall nature of the composition, resides in this unified tonal aura that transports us into a different world.

This tension between the real world and its stylization also applies to what is

generally termed abstract art. Whether we consider a synthetic Cubist canvas from the early twentieth century in which objects are shown in fractured or distorted form, or even a nonrepresentational work such as the "Farbkonstrukte" or color constructions from the late 1980s by Burghard Müller-Dannhausen (Fig. 46), the response to these paintings is still largely in terms of this tension. With their overlapping angular shapes, Müller-Dannhausen's "color constructions" readily suggest scenes such as autumn leaves falling to a forest floor or crows flying above a field.

A word of caution is needed here. By discussing the tension between our vision of the real world and the way it is presented through varying degrees of stylization, ranging from the tendency toward more complete representation to that of more complete abstraction, I am not denying the importance of the dynamic and rhythmic components of composition perceived through the movement of lines, the repetition of forms, the contrasts between colors, and so forth. All of these formal components come into play in our aesthetic response to the painting.

When we move to nonrepresentational painting that offers no explicit association with the real world, then the mind seems automatically to seek a more direct association with the formal components of the picture through the identification of body-sense or through feelings of pure sentience. This is where art most easily runs into trouble, for it is extremely difficult in this type of nonrepresentational art to move beyond what Robertson Davies's protagonist termed "raw gobbets of the psyche" on display.[85] When successful, such art presents, as Kandinsky explained, the "spiritual" in a convincing and moving way. "Form," wrote Kandinsky, "is the outer expression of the inner content."[86]

Successful nonrepresentational art such as Kandinsky's, which presents a type of fireworks of the soul through shape, color, and composition, teaches us that this outer expression of inner content is also present in representational art. There we find it, to a large extent, in the tone and unity of the stylization. I say to a large extent, because its other source comes from the way in which the real world, such as the human body or face, is presented. In the first chapter I invoked the example of the deeply moving humanity reflected in a late self-portrait by Rembrandt (Fig. 1). Whereas stylization shows creativity as it puts a veil of consistent tone across a canvas or upon a statue, it is the portrayal of human character in representational art that constitutes its pendant. This leads us to my final category, humor and wit.

Humor and Wit

Art affords the occasion for profound insights into the nature of the human condition and it does so primarily through the action of two poles, one grounded in humor and wit and the other effected through catharsis or a baring of the soul. To a limited degree these two poles correspond to the classically established dramatic

genres of comedy and tragedy. Yet, the range of situations to afford insight extends far beyond these genres.

The crucial term here is insight. It comes in a moment of recognition, of enlightenment. That moment is deeply charged with the awareness of the creative act, for it is the artist's purposeful creation that has yielded this understanding. Earlier in this chapter I reproduced several of the short sketches in Masters's *Spoon River Anthology*. At the end of each one the reader is given a different partial insight into human character and motivation. As this insight crystallizes, the reader is made aware that the writer has organized the presentation to usher the reader to that point.

Both humor and wit, which the dictionary tells us are contrasting and complementary – the former of a gentler nature, the latter keener – have traditionally been associated with the modern concept of genius. As Duff explained in the opening passage to an entire chapter on the subject, "GENIUS, WIT, and HUMOUR, have been considered by many as words of equivalent signification," a confusion that he then proceeded to rectify by distinguishing between their different attributes.[87]

For my purposes there is no need to follow Duff in these arguments. Rather, from a field much too broad even to begin to summarize I would like to select one example to illustrate my point, a watercolor by Paul Klee entitled *Old Steamer* (1922, Fig. 47). It presents an image filled with incongruities, for surely this is no literal representation of an actual river boat. Instead it is a humorous depiction whose initial effect depends on the impossibility of the mechanism shown here. As we "make" this image into a boat we become vividly conscious of the willful nature of Klee's creative act. Our second level of response, focusing on the delicacy of the image and the frailty of the apparatus, conjoined with the qualifying aspect of the title as an *old* steamer, may further prompt us to reflect on the transience of things and life. If we pass into this second phase, once again we will be aware that the artist's creative gesture has put us into that mental disposition.

These, then, are just a few of the ways in which the artist makes the operations of creativity highly visible to the audience; these are several of the processes by which the artist fashions and perfects a work; and these are but a few indications that great art issues from great minds in ways that we cannot possibly fathom. We can understand genius only up to a point. Beyond that, it commands our awe. We need not feel embarrassed by the murmurings and ridicule of poststructuralist polemics at making such a simple and clear profession of admiration; for the poststructuralist argument is riddled with muddled thought and nihilistic impulses. Part two of this book is devoted to explaining what is mistaken about these notions and to situating the poststructuralist phenomenon within a broader historical context.

Part II

Defending Value

"It may not, therefore, in this Place, be improper to apply ourselves to the Examination of that modern Doctrine, by which certain Philosophers, among many other wonderful Discoveries, pretend to have found out, that there is no such Passion [as Love] in the human Breast. Whether these Philosophers be the same with that surprising Sect, who are honourably mentioned by the late Dr. *Swift*; as having . . . discovered that profound and invaluable Secret, That there is no God: or whether they are not rather the same with those who, some Years since, very much alarmed the World, by shewing that there were no such Things as Virtue and Goodness really existing in Human Nature, and who deduced our best Actions from Pride, I will not here presume to determine. In reality, I am inclined to suspect, that all these several Finders of Truth are very identical men. . . . Whereas the Truth-finder having raked out that *Jakes*, his own Mind, and being there capable of tracing no Ray of Divinity, nor any thing virtuous, or good, or lovely, or loving, very fairly, honestly, and logically concludes, that no such things exist in the whole Creation."

Henry Fielding,
Tom Jones (1750 ed.), Book VI, chapter 1.

3

Pascal's Reason

Poststructuralism is characterized by a radical skepticism about the nature of meaning and value. According to this current intellectual orientation, all value in art is relative as are all notions of morality. It is argued that there are simply no absolutes. Given the breadth of issues covered by this phenomenon, I will first address the general themes that constantly reappear in poststructuralist texts. Then I will explain what I see as the major errors in reasoning of three of the most important poststructuralist thinkers: Barbara Herrnstein Smith, Stanley Fish, and Jacques Derrida. Smith's notion of the "contingencies of value" is highly respected in the poststructuralist camp of "critical" thinking, an orientation that is essentially humanist in outlook. Derrida is the creator and leading figure of the "deconstructionist" camp, which I see as profoundly antihumanist. Stanley Fish occupies a middle ground with his characterization of literature as a "self-consuming artifact."[1] Whereas Fish's rhetoric of self-consumption is reminiscent of deconstruction, his approach is essentially humanist in its search for meaning. The chapter ends with a consideration of "intertextuality" and base metaphors.

Art and Culture

To a great extent the attack on value in the arts is tied to a critique of political injustice. Poststructuralists have attempted to reformulate Enlightenment ideals about liberty, equality, and fraternity in terms of a theory of the radical relativity of all thought as related to a model of oppression and victimization. Because the values of the Enlightenment have not been fully realized, then Western society, frozen into a caricature of the "establishment," is deemed as inherently corrupt and the values associated with the West are seen as an equally pernicious "canon."

The poststructuralist attitude toward these two villains has not limited itself to opening doors for previously ignored and excluded ideas and people but rather has become an assault on the "establishment" and the "canon" (now deemed an instrument of oppression) and has been accompanied by a belittling of moral and intellectual values that for millennia have constituted the core of the Western tradition. The

popular phrase, "dead White male," used to reject a work of art ("art" is used here to include literature as well as the visual, plastic, and dramatic arts) on the basis of the gender and race of the artist, as well as the time in which he worked – that is, before the "canon" was assaulted by poststructuralism, – reflects this attitude.

It is ironic that this orientation arises at a time in which opportunity is being extended to entire categories of people who have to a greater or lesser degree been excluded from power within Western democracies. In politics more women and minorities are acquiring positions of leadership. In law the definition of sexual offenses has been given greater precision and children's rights are acquiring extended recognition. In business and the professions the exclusionary practices that have either limited the access or the advance of women and minorities have come under attack. In culture the art of non-Western traditions is receiving not simply more acclaim but also is being given its own prestigious institutions within the pantheon of high art, as exemplified, for example, by the cluster of museums within the Smithsonian Institution. In the domain of patriotism the sacrifices and accomplishments of women in military service are being officially recognized with a national memorial in Washington, D.C. In education private secondary schools and universities both public and private are seeking to attract and retain minority students. In public schools children with learning disabilities are winning the right to equal education. In housing discriminatory barriers based on race, ethnicity, and even family status are under attack. In the work force the health of the employee is receiving greater attention. In the marketplace consumers have more information to guide their choices and more opportunities for redress if they have been misled, wronged, or cheated. Were Voltaire to return among us and see these aspects of progress, all conceived in the spirit of the eighteenth-century Enlightenment that saw the birth of modern Western democracies, he undoubtedly would be extremely gratified.[2]

Yet, having reached this level of achievement – and certainly much remains to be done in the never-ending fight against poverty, injustice, and war – it is as if intellectuals have taken for granted the assumptions upon which this social progress has been grounded and have felt a need to proceed one step further. The problem basically resides in knowing when a proper balance has been achieved if not in the arena of actual realization then at least in the domain of ideals and expectations.[3] The dual concept of oppression and victimization, though, which owes much to Marxism, is not the primary subject of this chapter. It will enter only to the degree to which it inextricably coincides with my main theme, which is the radical skepticism of poststructuralist thought as it pertains primarily to the arts.

Radical Skepticism and Self-Importance

Never in modern times since when Hegel in the early nineteenth century placed his own intellectual discipline of philosophy on a par with religion and divinity have intellectuals exhibited such hubris in attributing to themselves the power to arbi-

trate all meaning by insisting on the relativity of all thought and value. And yet this
is not all. At the same time that poststructuralists adhere to this type of radical
skepticism, they also appropriate for themselves the power to assign meaning to the
creations of artists in ways that are often patently at variance with the works of art
themselves. This is done through the so-called deconstruction of the art work in
which the poststructuralist determines hidden meaning purportedly unknown even
to the artist and at variance to the artist's purpose.[4] Deconstruction represents the
extreme condition of poststructuralist thought. In arguing that "all readings are
misreadings" deconstructionists simply abjure all humanistic values. As David Leh-
man succinctly summarizes the deconstructionists' orientation:

> It is considered the height of naiveté to suppose that a character in fiction – and
> everything, including history, is a fiction – is anything but a "sign": a cipher signifying
> nothing or, perhaps, a mark of economic class or sexual "difference." It is retrograde
> in the highest degree to imagine that Shakespeare's heroes and Jane Austen's heroines
> resemble actual human beings and may therefore have something to teach us about
> the conduct of our lives. Mimesis as a project – literature as the representation of
> experience – is held to be a futile anachronism. For the hard-line deconstructionist,
> not only is literature self-referential; its meanings are undecidable, as "indetermi-
> nate" as the velocity and location of a moving electron.[5]

There are two principal motivations behind poststructuralist radical skepticism.
First is belief that absolute values and transcendent meanings are inextricably tied
with a rigid, unyielding, exclusionary, and oppressive cultural "canon." Second is the
natural tendency among intellectuals to cherish complexity and ambiguity.[6] Yet in
today's poststructuralist academic world, the delight in complexity and ambiguity
has been imbued with a boundless egotism that deconstruction readily sustains. As
we watch the deconstructionist allegedly discover concealed and encrypted mean-
ings in a text, meanings which are often said to "subvert" the ostensible purpose of
the document, we are reminded that the frame of mind which attracted people of
high intelligence centuries ago to the mysteries of alchemy and astrology can coexist
as easily in a civilization with computers and cellular car phones as one with horse-
drawn plows, hand-sewn clothing, and the plague.[7]

The free association and word play that characterizes so much of deconstruction-
ist work reveals an appreciation of complexity that perhaps achieved its most
sophisticated form during the Middle Ages when churchmen were certain that "the
created universe [w]as a book written by God for man to read" according to the
doctrine of the four senses.[8] In interpreting the Bible, the medieval reader would
see the text as a layered construct harboring four simultaneous meanings: literal,
allegorical, moral, and anagogical. As a contemporary couplet explained:

> The literal teaches the deeds, the allegory what to believe,
> The moral what to do, the anagoge whereto you should strive.[9]

The degree of creative ingenuity employed in the service of spiritual understanding at that time is astounding. We have only to consider how in the twelfth century Richard of St.-Victor ventured where neither Saint Jerome nor Gregory the Great could see the way in providing a literal reading to the famously obscure vision of Ezekiel, or how in the early fourteenth century Dante in the *Divine Comedy* masterfully applied the doctrine of the four senses to what has been termed the "first and perhaps sole of use" of this method "as the central technique of signification in a fictional invention."[10] I am reminded of this mental outlook when watching deconstructionists engage in free association and word play. Deconstructionists, though, serve a different divinity, this one inflected by Marx, Freud, and Nietzsche, rather than the God of the Old and New Testaments. And their method of exegesis lacks the discipline of the doctrine of the four senses. Instead, in the words of Gertrude Himmelfarb, it "play[s] havoc with reason, common sense, and emotion."[11]

It is easy for people outside the university community to underestimate the extraordinary sense of power that intellectuals feel when they have convinced themselves that they are the ultimate arbiters of value and meaning. One marvels at the need for self-esteem that is so often reflected in the academic's embrace of poststructuralist thought. This sense of "empowerment," to use a term much in vogue, is not limited to the broader issues of radical skepticism as found in the camps of "critical" thought and of "deconstruction," but even extends to the vocabulary employed within poststructuralist circles. Whereas poststructuralists are fond of discussing the "aura" that is attached to high art and to which they are wont to attribute much if not all of its meaning, they are remarkably indifferent to the aura that their own vocabulary creates as a form of self-satisfaction and personal aggrandizement. Many poststructuralist texts tend toward a dense prose style that smacks more of intellectual obfuscation than clear explication. Fortunately this tendency is constantly being attacked by writers in the more mainstream intellectual journals, such as the *New York Review of Books*, *New Republic*, *Times Literary Supplement*, *London Review of Books*, and *Literary Review*.

Even among poststructuralist intellectuals whose writing is relatively lucid, there is the tendency to use terms that give both the writer and his or her readership a feeling of self-importance and that give the work a certain prestigious intellectual cachet. I remember the aura attached to the announcement that one was engaging in a "structuralist" analysis when I was a graduate student. Today the same status applies to "poststructuralism." Even more prestigious is the idea of "critical" studies. People who use the term can feel proud not only of participating in what is widely deemed the cutting edge of thought; they also can feel an inner self-congratulatory glow that their work has ipso facto a special importance. After all, the term "critical study," which derives from the agenda of the Frankfurt School, suggests that it is both a crucial study and a criticism of the status quo.[12] Other prestigious terms

include "hermeneutics," "metanarrative," and "praxis," all worn as badges of intellectual refinement and even superiority. Sometimes "hermeneutics" is used properly and to good effect to designate a theory of interpretation, but often it is misused to mean "exegesis" or, more simply, "explication."[13] "Praxis" has become the word of choice in my own discipline of architecture as a lofty term for "practice." As for deconstruction, it has its own vocabulary, which will be discussed. As Lehman observes of certain university programs, "To mouth the jargon of deconstruction does more to establish a student's academic standing than to 'dismantle' any system of thought or action."[14]

In a variety of fields, countless public lectures begin today with an obligatory mention of our current interest in "race, gender, ethnicity, and sexual orientation," cited like a mantra that imparts respectability to whatever will follow. By mentioning all components of this conglomeration of current concerns, the speaker is signaling to the audience that he or she is helping to (wo)man the barricades, so to speak, of progressive social endeavor.[15]

Poststructuralist thought also favors another category of terms that skirts the boundaries between a theory of knowing and a theory of being. These include: the "Other," the "gaze," the "disembodied presence," the "invisible body," and more simply, "absence." To use these words and phrases is to conjure a heady combination of Eros, Thanatos, and numen, highly suggestive in its allusiveness, but generally difficult to focus with precise meaning, and often arbitrarily applied to situations in which it simply is not warranted.

The true "Other" is poststructuralist "theory" itself. It comes from the outside, imposing its vision on works of art arbitrarily, finding what it wants in spite of the absence of confirming evidence and even in the presence of contradictory evidence. "Theory" does not need evidence to sustain its claims because it weaves its own self-justifying explanations. While proceeding in this manner, it obscures its own procedures through a prose style that alternates between the appearance of hyperintellectuality and of existential profundity in order to dazzle the reader (as well as the writer himself or herself).[16]

As with all revolutionary movements, poststructuralism has its heroes and its martyrs.[17] References to and quotations from Theodor Adorno, Paul de Man, Jacques Derrida, Michel Foucault, Jacques Lacan, and so forth invoke the former; citations from Walter Benjamin, who committed suicide at the age of forty-eight to avoid falling into the hands of the Nazis, and Antonio Gramsci, who died at the age of forty-six of medical complications developed while suffering for ten years in an Italian Fascist prison, provide the latter.[18] Sometimes the quotations are apt and represent a debt to a concept uttered first or most clearly. At other times, though, the references serve primarily to establish the writer's credentials. And, as in all crusades, its champions cannot always resist the tendency to invest their cause with an absolute rightness, as well as to forecast its imminent victory. Thus, in my field I

recently read the premature claim that "the production of history is now taking a back seat to the production of theory."[19]

History or Theory?

Such a Manichean opposition between history and theory is accompanied by lemming-like battles in which one poststructuralist intellectual after another tilts verbal lances at phantom windmills and runs verbal rapiers through strawmen all wearing the blazon of "narrative history."[20] In one collection of papers, submitted by scholars interested in "historiography and architecture" to the 1990 annual meeting of the Society of Architectural Historians and then published in the *Journal of Architectural Education*, the house organ of the Association of Collegiate Schools of Architecture, one finds the repeated condemnation of what is deemed the delusions of narrative history. One scholar concludes her article by warning us of the "conundrum" arising because "architectural history should but cannot faithfully represent the past." Still another begins his by explaining, "My case is largely drawn from developments over the past twenty years in philosophical historiography and literary theory that challenge the long-standing supposition that historians can recover and represent in a text a coded segment of actual events occurring in linear time." And another scholar wonders, "But what prompts the historian to write a narrative in the first place?" The question is raised because the author adheres to the poststructuralist position that

> recent studies in historiography insist on the determinant role played by the discourse of the historian upon the representation of history. In these works, critical insights developed in the fields of linguistics, rhetoric, and literary theory are brought to bear upon the analysis of historical discourse.

Most important to this author is Hayden White's contention

> that it is difficult in a historical discourse to distinguish between the facts and their interpretation, asserting that "the fact is presented where and how it is in the discourse in order to sanction the interpretation to which it is meant to contribute." (. . .) What is at stake, then, in the larger historiographical debate is the belief in the scientificity of historical methods, and the very authority of the "objectivist" accounts they purport to produce.

These references to "scientificity" and to "'objectivist' accounts" rely as well, as the author explains, on

> what Dominick LaCapra calls a "documentary model of knowledge," where "the basis of research is 'hard' fact derived from the critical sifting of sources." In such a model, the historian's task is conceived as the gathering, selection, and verification of facts,

the interpretation of which is then presented in "literary" form for the sake of communicability. As such, a separation of form from content is assumed.[21]

All of these points of contention are directed toward imaginary enemies. Historians today, as well as decades ago, and in certain cases, even more than a century ago, certainly do not and did not believe that they were writing what is so inelegantly called "objectivist" accounts grounded in "scientificity." Every humanist historian knows that any narrative that he or she writes is limited by one's own frame of mind, largely determined by personality and culture, by the documentary material that has been found and that is considered relevant to the subject, and by each person's groping toward a synthesis that clarifies to the writer as well as to the reader a fundamental understanding of the subject. As every historian knows, a thought is not really there until what seem like the appropriate words have been found.[22] The act of writing is simultaneously the process of understanding for the historian himself or herself. And some of us are more successful at this than others. History, moreover, is a constant reworking of narratives that seek to reinterpret the past by modifying previous explanations in light of new or different documentary evidence considered according to new perspectives about the nature of the issues to be discussed, as well as the conclusions to be drawn. Narrative historians working in the humanist tradition know that their work offers only partial insights to historical questions that may not even seem relevant to subsequent generations.[23]

Blind to the modesty of the humanist enterprise, the poststructuralist is thrilled to point to the alleged blindness of so-called objectivist history. This critique has three mistaken aspects. First, as discussed here, is the contention that humanist history is grounded in a belief in its own inevitable objectivity. Yet ever since Herbert Butterfield's *The Whig Interpretation of History* (1931), humanist historians have been perfectly aware of their limitations. Second, the poststructuralist places undue and hence faulty weight on the subjective factor. Third, the poststructuralist grounds his or her critique in a radical skepticism.

The Assault on Meaning

Call it radical skepticism, epistemological relativism, or even intellectual nihilism, the poststructuralist argument is based on a false syllogism. Faced with the impossibility of full certainty, the poststructuralist pronounces the certainty of total uncertainty, which in turn is deemed to be totally incapacitating for a search for historical truth, however relative, and for aesthetic or moral value, no matter how compelling it feels.[24] "How does the author *know*," asks a certain poststructuralist about the contents of Chapter 1, "that other people are deeply moved by certain works of art?" Well, the consensus is never difficult to determine. Sometimes it even is easier to ascertain than others. When the Berlin Wall came down the Germans gave a concert with Beethoven's "Ode to Joy." Is there any doubt as to the

reason for this choice or as to the general tenor of the audience's aesthetic response? Of course, the nature of the feeling, its intensity, and its particular coloring varies from individual to individual and from one time to another. Such differences, though, should not cripple us from postulating categories of value and from attempting to demonstrate their presence in individual works of art.

Time and again we encounter this radical skepticism. In that same session on historiography and architecture, the architectural historian Dell Upton used the same poststructuralist argument. Upton also is concerned with what he sees as the impossibility of determining "normative experience." Thus, he argues, no builder or designer

> can be certain that his or her work will have a specific meaning, be used in certain ways, or be assigned a given value by its public. (. . .) Once introduced into the landscape, the identity of a building and the intentions of its makers are dissolved within confusing patterns of human perception, imagination, and use.[25]

To sustain his argument Upton cites the example of early nineteenth-century prisons where social reformers anticipated that instead of cutting off a criminal's hand as punishment, placing a person in solitary confinement would make the individual look into his or her soul and reform into a virtuous citizen. Rather than cite this cruel experiment in the modification of human behavior, which did not work as generally intended, Upton might have stuck with traditional building types, such as houses or churches, and inquired whether, for example, the new Gothic style that the nineteenth century introduced after four centuries of classical architecture, was generally viewed as creating an effective setting for collective worship and home life respectively. It was. Thus, in this case his doubts about "normative experience" would have dissolved. Similarly, he could ask the many successful developers to what degree they are hindered by the "confusing patterns of human perception, imagination, and use" in deciding what consumers want in suburban homes and shopping centers, for example, and in providing them with it. Here the "normative experience" is readily reflected in the developers' large bank accounts. This financial success gives new meaning to the popular expression "money talks." Never has money spoken so eloquently to confirm "normative experience."

Upton also might have inquired as to why approximately 130,000 people visit Frank Lloyd Wright's "Fallingwater" (Fig. 3) every year. Obviously, each person's reaction to this and other breathtaking buildings is going to be slightly different, but is this a reason to argue against the articulation of categories of value in art? "How does the author know," asks my poststructuralist skeptic of Chapter 1, "that the works of art *themselves* have this motive power, and not, for example, the aura of sanctity that surrounds them?" The answer in this case is simple. Speak to the guides who lead the 130,000 visitors through this splendid house. Ask them, as well as the

visitors, about their reaction to the architecture. It will be easy to determine the degree to which the "aura" of art dominates as opposed to the beauty of the building in its site.

For skeptics who seek this type of confirmation in documents, we can consider the case of the Cemetery of Père Lachaise, opened in Paris in 1804 as the first Western landscape garden cemetery. We know from published travel accounts throughout the nineteenth century that tourists flocked to this cemetery, sometimes visiting it before seeing the city itself and sometimes even preferring it to Paris. As the first cemetery of its type and as the resting place for innumerable famous French men and women, the Cemetery of Père Lachaise enjoyed widespread renown. I am not sure whether it would be proper to say that its attraction for those who had not yet visited it derived from some "aura of sanctity." Perhaps. In any event, it did have a cultural aura from its reputation as a special place. However, as the century progressed and as the cemetery became increasingly filled with more and larger stone memorials to the detriment of its character as a garden, American and British visitors, who now had what in the United States were called "rural cemeteries," expressed disappointment upon seeing the legendary French prototype. By that time, their own native cemeteries were more rural, more wooded, and hence more appreciated.[26] Here then is a fine example of an instance in which reputation, understood as cultural aura, was readily dispelled upon an encounter with the evidence, which yielded a lesser aesthetic and sentimental experience than the "rural cemeteries" back home. This story can serve as a "parable of value," to borrow a phrase from Barbara Herrnstein Smith, which hopefully will allay the worries of poststructuralist thinkers.

Value and Valuation

Barbara Herrnstein Smith is the author of a book, *Contingencies of Value: Alternative Perspectives for Critical Theory* (1988), highly respected in poststructuralist circles. Here radical skepticism is played out in the subtlest ways. For the purpose of my argument, I wish to address primarily Smith's opening essay, which uses Shakespeare's sonnets to establish a "parable of value" applicable to the larger question of value in art. To make her case Smith uses numerous arguments, including the changing critical fortunes of the sonnets across the ages and her own different personal responses to the sonnets over time:

> We might recall . . . that the sonnets have been characterized, by men of education and discrimination, as inept, obscure, affected, filled with "labored perplexities and studied deformities," written in a verse form "incompatible with the English language," a form given to "drivelling incoherencies and puling, petrifying ravings." We might recall especially Henry Hallam's remarking of the sonnets that "it is impossible

not to wish that Shakespeare had not written them" and that his assessment or distress was shared, at some point in their lives, with some variations, by Coleridge, Wordsworth, and Hazlitt.

Wish Shakespeare had not written them? Lord, man, (we may wish to shout back into that abysm of time), did you really *read* them? Well, presumably Hallam did read them, as did Dr. Johnson, Coleridge, Wordsworth, Hazlitt, and Byron (from each of whom I have been quoting here): but whether any of them read the same poems we are reading is another question. Value alters when it alteration finds. (. . .) *I cannot evaluate Shakespeare's sonnets* – which is not to say that I believe the sonnets cannot or should not be evaluated. On the contrary, I believe that they should be, must be, and in fact, are and will be evaluated, continuously, repeatedly, privately, and publicly, by us and by them and by all who follow. My own incapacity in this regard happens to be a somewhat special case, but I think it is an instructive one for the question at issue.

I cannot evaluate Shakespeare's sonnets partly because I know them too well. (. . .)

But that is not the only or even the basic reason why I cannot evaluate Shakespeare's sonnets. The basic reason is that I am too conscious of how radically variable and contingent their value has been, and remains, for me. (. . .)

In any case, it would be only slight hyperbole to say that there is not one of Shakespeare's sonnets that has not, at some time, been the occasion of the finest and most intense kind of literary experience of which I am capable; and there is also not one among them that has not, at some time, struck me as being awkward, strained, silly, inert, or dead. Some of the sonnets that are now (i.e., this week or the day before yesterday) my favorites, I once (i.e., last week or ten years ago) thought of as obscure, grotesque, or raw; and some that I once saw as transparent, superficial, or perfunctory have subsequently become, for me, thick with meaning, subtle, and profound.[27]

I believe that there are three fundamental problems with Smith's argument. The first resides in a confusion between value and valuation. Throughout her book Smith uses the terms "value" and "evaluation" interchangeably. I would argue that the vagaries of the reception of Shakespeare's sonnets over time, as well as the changing meaning and importance of the sonnets for Smith over the course of thirty-five years, are questions of valuation. In contrast, the value of Shakespeare's sonnets is to be found in the type of aesthetic categories that I attempted to outline in the two previous chapters. Obviously, people in different ages will give different coloring to these categories and will even include several and exclude others not found in a different age. Obviously, different people at the same moment and the same person at different times will respond differently to any work of art. Our relationship with art is an interplay between the inherent value that we find in the work and our capacity to respond to those qualities at a given time.

Inherent Value and Pascal's Reason

The second problem with Smith's reasoning is that she mistakes the nature of inherent value. Smith is adamant in dismissing the notion of "objective value," which she calls "vacuous." She also hopes to avoid the label of "subjective value" from being attributed to her position about contingency. Just as Smith argues that "literary value is 'relative' in the sense of *contingent* (that is, a changing function of multiple variables) rather than *subjective* (that is, personally whimsical, locked into the consciousness of individual subjects and / or without interest or value for other people),"[28] I would argue that value is not "objective" (that is, absolute and singular) but rather is "inherent" (that is, immanent and potential, i.e., capable of being recognized and experienced in a manner that, through the best art, can attain a feeling of transcendence). Contingency resides not in the value of a work of art but rather in the response to its potential to provide value.

The third problem with Smith's approach is her recourse to poetry as the subject for a "parable of value." Of all the forms of written expression – and perhaps of all art forms – poetry is the most allusive and the most elusive. By its very nature it suggests more than it states and it omits as much if not more than it includes. It also requires the most personalized involvement and it is the most subject to wildly vacillating responses.[29]

The deeply personal aspect of poetry is the subject of reflections by Mary Jo Salter, poetry editor of the *New Republic*. Salter compares her lot with that of her fellow editors who consider for publication articles in other fields. Any editor who rejects a writer's "hard work," she imagines, would hopefully feel a "twinge of regret" for depriving the effort of the reward of publication. Yet, as Salter explains, the poetry editor carries a special existential burden: "But normally they [i.e., the other editors] don't have to worry about the writer's hard work being compounded by a pre-existing heartbreak. That's what poems are usually about: heartbreak and death and the happy things that can't last because of heartbreak and death."[30] Smith's autobiographical account of her relationship to Shakespeare's sonnets demonstrates these points. The personal readings of these poems that she shares with her readers involve a full range of emotions encompassing the most delicate and vehement associated with the most intimate of human feelings, love. We also have seen that she noted the variations in her evaluation of these poems to swing from the silly to the sublime.

Whereas Smith's selection of poetry, and love sonnets no less, perfectly suits her purpose, it does not yield the most advantageous approach to mining the notion of value in art. I personally believe that Susanne K. Langer was more successful in this matter largely because she saw that of all the art forms, music lent itself most readily to articulating the general principles that could be applied to all the other

arts. As I argued in the first chapter, it was the experience of sentience, of vital life, that Langer correctly identified in music and then in art in general as a fundamental of aesthetic value and aesthetic experience.

Although I have concentrated on Smith's opening chapter, I would use the same approach for answering the arguments put forward throughout the remainder of her book. In general, hers is a study not of value but of valuation. The author is clever, subtle, and insightful in pinpointing the difficulties of various thinkers and schools of thought that have attempted to articulate the nature of judgment in art. The sources that she explores are primarily historians and critics of literature as well as philosophers of knowledge and aesthetics. Yet if one is to approach the issue of artistic worth, then one should look to the art works themselves. Let us leave aside the inconsistencies of all the observers who try to determine what is good or bad art and plunge directly into the matter itself to define the nature of artistic value. How close are we really to understanding the nature of art when we reach a conclusion that drowns in its multiple qualifications?

> Since the relativist knows that the conjoined systems (biological, cultural, ideological, institutional, and so forth) of which her general conceptual taste and specific conceptualization of the world are a contingent function are probably not altogether unique, she expects some other people to conceptualize the world in more or less the same ways she does and, like her, to find objectivist conceptualizations more or less cognitively distasteful, unsatisfactory, and irritating along more or less similar lines.[31]

Leaving aside for the moment an equal distaste that one might feel for those who deny inherent value and who avoid the issue by deflecting discussion to contingent issues of valuation, I, for one, come closer to understanding art through Pascal's simple aphorism that "the heart has its reasons that reason does not know."[32]

Defending Oneself against Truth

Stanley Fish, like Barbara Herrnstein Smith, worries about claims to "Truth" and to objective knowledge. For Fish, "the objectivity of the text is an illusion."[33] Any literary text, according to Fish, acquires meaning only through the experience of reading. This experience Fish demonstrates with a method that he describes as follows: "The concept is simply the rigorous and disinterested asking of the question, what does this word, phrase, sentence, paragraph, chapter, novel, play, poem, do?; and the execution involves *an analysis of the developing responses of the reader in relation to the words as they succeed one another in time*."[34] That is fine, but this does not mean that the text lacks inherent meaning, for without such meaning, even with attendant ambiguities, the response or responses that Fish or any other reader has would not be possible.

Fish's method of attending to the process by which a text yields up its meaning to

the reader is certainly necessary, but it does not authorize Fish to claim that he has negated the notion of "what does this sentence mean" by asking "what does this sentence do."[35] Rather, Fish is postulating one method that shows to a certain degree how the meaning of a sentence is brought about. Denying meaning – and value – in this manner, Fish argues that works of literature are, as he has entitled his book, "self-consuming artifacts." For Fish, the only "meaning" in literature comes from the act of reading with none accorded at all to what has been read:

> And what the sentence does is give the reader something and then take it away, drawing him on with the unredeemed promise of its return. An observation about the sentence as an utterance – its refusal to yield a declarative statement – has been transformed into an account of its experience (not being able to get a fact out of it). It is no longer an object, a thing-in-itself, but an *event*, something that *happens* to, and with the participation of, the reader. And it is this event, this happening – all of it and not anything that could be said about it or any information one might take away from it – that is, I would argue, the *meaning* of the sentence.[36]

To say that the meaning of literature depends on the reader to ascertain or experience it is such a truism as to say nothing at all. Yet from this observation it does not follow that one can circumscribe the meaning to the experience itself of reading and to deny the sentence of its status as an object.

In placing all meaning in "what is happening in the reader," Fish feels justified to oppose his approach to what he sees as the traditional viewpoint, "the claims usually made for verbal art – that they [i.e., "its productions"] reflect, or contain or express Truth."[37] I am not sure why the idea of a text rooted in what Fish terms "what is happening on the page" earns it the status of Truth with a capital "T." If Fish is bestowing an exaggerated claim upon his opponents to ridicule them more easily, then his method of ridicule is transparent. If Fish means by "Truth" a reality and value independent of the vicissitudes of any particular reader's response, then the characterization is apt. This was the issue that I addressed in the previous section by distinguishing between value and valuation and by substituting the concept of inherent value for objective value. These distinctions are borne out fully by following Fish in his method.

To explain his method, Fish utilizes, among other examples, part of a sentence from Walter Pater's "Conclusion" to *The Renaissance*: "That clear perpetual outline of face and limb is but an image of ours." After preliminaries about how critics might not find anything exceptional in this passage, Fish then proceeds to show how it is read. For the sake of brevity I slightly abridge Fish's demonstration:

> "That" is a demonstrative, a word that points *out*, and as one takes it *in*, a sense of its referent (yet unidentified) is established. (. . .) In terms of the reader's response, "that" generates an expectation that impels him forward, the expectation of finding out *what* "that" is. (. . .) The adjective "clear" works in two ways; it promises the

reader that when "that" appears, he will be able to see it easily, and, conversely, that it can be easily seen. "Perpetual" stabilizes the visibility of "that" even *before* it is seen and "outline" gives it potential form, while at the same time raising a question. That question — outline of what? — is obligingly answered by the phrase "of face and limb," which, in effect, fills the outline in. By the time the reader reaches the declarative verb "is" — which sets the seal on the objective reality of what has preceded it — he is fully and securely oriented in a world of perfectly discerned objects and perfectly discerning observers, of whom he is one. But then the sentence turns on the reader, and takes away the world it has itself created. With "but" the easy progress through the sentence is impeded (it is a split second before one realizes that "but" has the force of "only"); the declarative force of "is" is weakened and the status of the firmly drawn outline the reader has been pressured to accept is suddenly uncertain; "image" resolves that uncertainty, but in the direction of insubstantiality; and the now blurred form disappears altogether when the phrase "of ours" collapses the distinction between the reader and that which is (or was) "without" (Pater's own word).[38]

It should be obvious that Fish has engaged in a highly personalized reading of this line. The " 'image' " does not dissolve into "uncertainty" nor does it "disappear." The initial clause is not "take[n] away" but rather qualified by contrast. This dichotomy is made especially poignant through Pater's stylistic technique whereby the sense of clarity and permanence conveyed by the first part of the sentence is subsequently undercut by the second. Whereas Fish ascertains the two-part movement, he does not precisely enunciate this meaning. Rather, he constrains himself to an impressionistic and misleading reading that talks about "uncertainty" and "disappearing" while ending with a caricature: "Now you see it (that), now you don't. Pater giveth and Pater taketh away."

Looking to the second part of this truncated sentence we see that in fact the image has not disappeared, but rather, as I have suggested, that it merely has been qualified: "That clear, perpetual outline of face and limb is but an image of ours, under which we group them — a design in a web, the actual threads of which pass out beyond it." The word "them" refers to "the elements of which we are composed," mentioned earlier in the paragraph.[39] Pater has been discussing the universality of the elements that compose us and everything around us as well as the movement of all parts of life, including all the fluids and gases that pass into and out of our body, and of the aging that everything animate and inanimate undergoes. The sentence that Fish uses comes toward the end of this paragraph and hence presents no surprises in its first clause. We know immediately from the context that the "clear, perpetual outline" is the exception to what has been presented as the inner reality of life and time. Thus, from the first clause of the sentence by itself, as well as from its second and completing clause, and also from the entire paragraph that precedes this sentence, we know that the clear outline that we chose to see reflects how we might wish to understand the world.

Pater will not deny us the right to make that "design" out of the "web" of elements. Yet, as the text proceeds to consider "the inward world of thought and feeling," Pater warns us against the dangers of thickening our impressions into a dull stupor: "In a sense it might even be said that our failure is to form habits: for, after all, habit is relative to a stereotyped world, and meantime it is only the roughness of the eye that makes any two persons, things, situations, seem alike." Pater wishes us to watch the clear, perpetual outline for its subtle and continuous changes to ascertain peak moments revelatory of intense life or beauty: "Every moment some form grows perfect in hand or face; some tone on the hills or the sea is choicer than the rest; some mood of passion or insight or intellectual excitement is irresistibly real and attractive to us, – for that moment only." Thus, Pater does not want the clear outline to disappear. It can keep its overall form as perpetual. He wishes for us to attend to its moods and appearances so as to be "present always at the focus where the greatest number of vital forces unite in their purest energy." The simultaneous presence of the clear outline and of the recognition of its changing life, not of its blurring or disappearing, makes possible the life that Pater wishes for us all: "Not to discriminate every moment some passionate attitude in those about us, and in the very brilliancy of their gifts some tragic dividing of forces on their ways, is, on this short day of frost and sun, to sleep before evening."[40]

Fish's method, then, does not permit readers to get to the heart of the matter, because it denies them the possibility for continued reflection upon the meaning of the passage. As Fish insists, "Again this description of the reader's experience is an analysis of the sentence's meaning and if you were to ask, 'but, what does it mean?' I would simply repeat the description."[41] Not only does Fish's impressionistic reading miss the crucial point of this passage, his theory does not account for the fact that some readers will not grasp the significance of the line nor will they be aware of how the passage has been constructed to achieve its ends. Does this mean that the passage has no value if it is misread or dismissed as trite? And how can Fish and I resolve our differences over the meaning if the meaning resides only in our individual and opposing readings? For Fish, there is no meaning beyond the highly individualized response to the text:

> In the analysis of a reading experience, when does one come to the point? The answer is, "never," or, no sooner than the pressure to do so becomes unbearable (psychologically). Coming to the point is the goal of a criticism that believes in content, in extractable meaning, in the utterance as a repository.[42]

In the end, whether one joins Barbara Herrnstein Smith in insisting on the primacy of one's differing readings of a text over time or with Stanley Fish in insisting that the text has no meaning or value independent of a particular process of reading, one is faced with a denial of categories of value that is extremely narcissistic. It is part and parcel of a narcissistic contemporary culture that revels in feelings

of "victimization" in the social and political spheres and that enjoys the purposefully confusing complexities, which feel so supremely intelligent to the perpetrator, that masquerade as "deconstruction" in the humanities.[43]

Derrida's Mythical Twilight Zone

We turn now to Jacques Derrida and deconstruction, for no consideration of the contemporary attack on value could be complete without analyzing his fundamental challenge to humanism. As sympathetic as we might be to Roger Kimball's assessment that "Professor Derrida is obviously expert at the interpretive shenanigans that make things seem the opposite of the way they really are,"[44] we are going to have to proceed beyond this point to understand the inner core of Derrida's intellectual enterprise. Similarly, the attempts by academics schooled in linguistics and philosophy, such as Samuel B. Southwell and John M. Ellis, to point out the inconsistencies in those domains that mark Derrida's texts, while illuminating in their own right and heartening to learn, will not take us to the heart of the matter either. Rather, I take my cue from incidental observations made by these two critics of deconstruction to frame my argument. On his way to pursuing his philosophical critique of Derrida, Southwell presciently observes, "While Derrida is obviously too bright to have any doubt about what he is up to, most of his readers have failed to recognize the fundamentally mythic, fictional character of all the intellectual tools that are peculiarly Derrida's own and that constitute the thus mythic foundation of his theoretical position."[45] This mythic character was also noted in passing by Ellis, when he observed the analogy with religious mysticism characteristic of deconstruction's attempt to establish an alternative "logic" to Western patterns of thought through an abolition, in Barbara Johnson's words, of "a simple either/or structure" in favor of "a discourse that says *neither* 'either/or', *nor* 'both/and' nor even 'neither/nor', while at the same time not totally abandoning these logics either." Ellis observes:

> [T]he rhetorical device used here is simply the standard formula of many branches of religious mysticism. As a leading authority on mysticism writes in a standard introductory essay, "Mystical experience permits complementary and apparently contradictory modes of expression. . . . This is because the reality affirmed contains its own opposite." Derrida and Johnson have, then, seized on an ancient rhetorical device for their new, "other" logic. . . .[46]

Having made these insightful observations, both Southwell and Ellis return to their main tasks. For Southwell this is to explain Derrida's crucial logical error:

> In *Of Grammatology* Jacques Derrida most fully develops his theoretical position. The theory is derived from a hypothesis that cannot be taken seriously. At the point of

decisive articulation of the theory, material entirely alien to and contradictory to the theory becomes essential to it.[47]

For Ellis also, the "most influential and central aspect of Derrida's thought in [regard to the theory of criticism] has been his treatment of language and meaning."[48] To this end Ellis analyzes *Of Grammatology* as a treatise on language. Yet, if we keep in mind these observations about the mythic nature of Derrida's thought and of its analogies to mysticism, we will find that a careful reading of the opening arguments in *Of Grammatology* confirms this and points the way to the essential meaning of Derrida's version of language and of its widespread appeal.

Of Grammatology begins with a prologue, which Derrida entitles "Exergue," and a first chapter called "The End of the Book and the Beginning of Writing." Whereas Derrida seems to be engaging in a discussion about the nature of language and its relationship to knowledge, he has a broader purpose in mind, which is the total rejection of humanistic ideas of truth and value, as well as of science and metaphysics. Derrida's stated enemy is what he calls "ethnocentrism" and more particularly, "logocentrism," identified as

> fundamentally . . . nothing but the most original and powerful ethnocentrism, in the process of imposing itself upon the world, controlling in one and the same *order*:
> 1. *the concept of writing* in a world where the phoneticization of writing must dissimulate its own history as it is produced;
> 2. *the history of* (the only) *metaphysics*, which has, in spite of all differences, not only from Plato to Hegel (even including Leibniz) but also, beyond these apparent limits, from the pre-Socratics to Heidegger, always assigned the origin of truth in general to the logos: the history of truth, of the truth of truth, has always been – except for a metaphysical diversion that we shall have to explain – the debasement of writing, and its repression outside "full" speech.
> 3. *the concept of science* or the scientificity of science – what has always been determined as *logic*. . . .[49]

This is a rather heady list of cultural categories to be attributed to "logocentrism": the concept of writing, the history of metaphysics, and the concept of science. It is, moreover, characteristic of the breadth of Derrida's claims, for he will repeat this throughout the opening pages of Chapter 1.

In order to appreciate the full import of Derrida's argument, we should first note the element of conspiracy in this text. The "phoneticization of writing," we are told, "must dissimulate its own history." Why does Derrida attribute a nefarious purpose to the creation of phonetic language – that is, speech? The answer, I believe, is that he is not offering a new theory of language. Rather, he is using a discussion of language to mount a direct and comprehensive attack on Western values of meaning, truth, and morality through a mythical world view that associates itself through oblique reference to the culture of oppression and victimization. In the process,

Derrida's mythic world view provides formulaic intellectual strategies that assist its adherents to think that they are rendering justice to all people and peoples who have been wronged by supposedly rooting out the oppression that exists everywhere, even in words themselves.

Derrida's language of oppression, combined with his insistence upon the historical necessity of this phenomenon, as well as upon the coming triumph of deconstruction, provide the foundations for this mythical world view. Let us consider these issues one at a time before proceeding to Derrida's texts that combine both together. As Ellis notes, "there is a very strange aspect" to Derrida's thoughts about writing and speech: "Throughout, he uses oddly moralistic terms to describe the opposing view."[50] Within the short space of the first six pages of the book, we are told that "the science of writing – *grammatology* – shows signs of liberation all over the world, as a result of decisive efforts," that the "future can only be anticipated in the form of an absolute danger," that "never as much as at present has it [i.e., "*the problem of language*"] invaded, *as such*, the global horizon of the most diverse researches and the most heterogeneous discourses, diverse and heterogeneous in their intention, method, and ideology," that "language itself is menaced in its very life," that language has "disguises" which "are not historical contingencies," and that language has been "*wilfully misleading us*."[51] Ellis himself has chosen his representative sampling of conspiratorial phrases:

> He speaks of the "debasement of writing, and its *repression* . . . ," of the "signs of liberation all over the world," of writing being "enslaved," of its being "feared and subversive." These seem strangely inappropriate moral terms for a discussion of writing.[52]

They would be inappropriate moral terms if this were a discussion of writing, but it is not. "Writing" is Derrida's word for the new intellectual and moral world order that will be ushered in by deconstruction. Derrida uses the word "writing" as if it were an ontological principle and a life principle.[53] Repeatedly in the opening six pages of the initial chapter in *Of Grammatology*, we encounter "writing" as the foundation for a new metaphysics. Let us first follow Derrida as he extends the meaning of the word "writing":

> By a hardly perceptible necessity, it seems as though the concept of writing – no longer indicating a particular, derivative, auxiliary form of language in general (whether understood as communication, relation, expression, signification, constitution of meaning or thought, etc.), no longer designating the exterior surface, the insubstantial double of a major signifier, *the signifier of the signifier* – is beginning to go beyond the extension of language.[54]

Soon afterwards, in discussing "the death of speech," Derrida explains, "'Death of speech' is of course a metaphor here: before we speak of disappearance, we must think of a new situation for speech, of its subordination within a structure of which

it will no longer be the archon."[55] In this sentence, we see that what Derrida is calling a metaphor is the "death" of speech. Yet the entire tenor of the text reveals that it is the entire phrase "death of speech" and also the words "speech" and "writing" that are metaphors. Derrida attributes our entire way of understanding the world to the words "language" or "speech," just as he explains that "writing" means much more than what we commonly term writing. The word "writing," as Derrida would use it, does not refer merely to "the narrow and historically determined concept of writing."[56] Thus, it is a metaphor for a new, overarching world view. Since Derrida uses the word "logocentric" to refer to the world view that he is attacking, we should remember, as Terence Hawkes points out in another context, that the Greek word *logos* signifies not merely the faculty of speech but also the faculty of reason.[57]

That Derrida is discussing metaphysics becomes clear when he complains that "language" has come to mean much more than most of us would ever imagine: "For some time now, as a matter of fact, here and there, by a gesture and for motives that are profoundly necessary, whose degradation is easier to denounce than it is to disclose their origin, one says 'language' for action, movement, thought, reflection, consciousness, unconsciousness, experience, affectivity, etc."[58] Clearly, Derrida is not talking about "language"; he is discussing life – physical, intellectual, and moral life. And yet, as amazing as these attributions to "language" seem, they are not only logical to Derrida but they are deemed objectionable, because according to Derrida it is "writing" and not "language" that should be accorded this metaphysical status. Derrida then proceeds to correct this erroneous understanding of "language": "Now we tend to say 'writing' for all that and more. . . ."[59]

Within the boundless confines of Derrida's mythical metaphysics, "writing" is opposed to "logocentrism," the latter based in the spoken word. Here is one of the characterizations about the all-encompassing nature of "logocentrism" that the reader encounters within the first few pages of Chapter 1:

> The system of "hearing (understanding)-oneself-speak" through the phonic substance – which *presents itself* as the nonexterior, nonmundane, therefore nonempirical or noncontingent signifier – has necessarily dominated the history of the world during an entire epoch, and has even produced the idea of the world, the idea of world-origin, that arises from the difference between the worldly and the non-worldly, the outside and the inside, ideality and nonideality, universal and nonuniversal, transcendental and empirical, etc.[60]

Derrida is saying that the spoken word is responsible for our understanding of life and the universe. He continues a few pages later in the same vein:

> We already have a foreboding that phonocentrism merges with the historical determination of the meaning of being in general as *presence*, with all the subdeterminations which depend on this general form and which organize within it their system

and their historical sequence (presence of the thing to the sight as *eidos*, presence as substance / essence / existence [*ousia*], temporal presence as point [*sitgmè*] of the now or of the moment [*nun*], the self-presence of the cogito, consciousness, subjectivity, the co-presence of the other and of the self, intersubjectivity as the intentional phenomenon of the ego, and so forth). Logocentrism would thus support the determination of the being of the entity as presence.[61]

Once again, Derrida wishes to cover all subjects with his global characterization. If the reader were not convinced that all categories have been enumerated, the ending "and so forth" would call forth any others that Derrida might have neglected to mention. To apply the image of an intellectual steamroller to such sweeping characterizations would be insufficient. For Derrida, then, the word "presence" subsumes all considerations of thinking, consciousness, substance, essence, and existence. I suppose that we could call that life, and life, we are told, is determined by logocentrism. But Derrida, or rather, History would not tolerate this. Instead, Derrida announces the imminent victory of "writing":

> The "rationality" – but perhaps that word should be abandoned for reasons that will appear at the end of this sentence – which governs a writing thus enlarged and radicalized, no longer issues from a logos. Further, it inaugurates the destruction, not the demolition but the de-sedimentation, the de-construction, of all the significations for truth that have their source in that of the logos. Particularly the signification of *truth*. All the metaphysical determinations of truth, and even the one beyond metaphysical ontology that Heidegger reminds us of, are more or less immediately inseparable from the instance of the logos, or a reason thought within the lineage of the logos, in whatever sense it is understood: in the pre-Socratic or the philosophical sense, in the sense of God's infinite understanding or in the anthropological sense, in the pre-Hegelian or the post-Hegelian sense. Within this logos, the original and essential link to the *phonè* has never been broken. It is easy to demonstrate this and I shall attempt such a demonstration later.[62]

Once again, what Derrida calls "writing" is going to overturn our understanding of the world, of ourselves, of the ways in which for "nearly three millennia"[63] people have thought, in all the different ways and through all the different intellectual systems.[64]

Given the breadth of this claim, one might expect Derrida to follow up on his promise to provide the "easy" demonstration. After claiming that "writing" will change our notions of understanding, of truth, and of metaphysics and after insisting that these notions are grounded in the "logos," Derrida confines his subsequent explanation primarily to a discussion of linguistics and of semiological systems. At this point in his argument, Derrida launches into a discussion of the relationship between thought, spoken words, and writing, as if this type of analysis really addresses the prodigious scope of his claims.

If, on the one hand, Derrida takes a detour into linguistics, which has the effect of

avoiding the larger metaphysical issues that he raises, this strategy has its merits for it attempts to relate the qualities of arbitrariness and instability that adhere to the relationship between word and meaning in language with a supposed arbitrariness and instability of meaning and value in art, culture, and morality. Thus, Derrida's subsequent discussion of language serves a precise purpose by associating language with value found in other domains. Here Derrida was drawing on a tradition whose recent major exponents included Hegel, Kierkegaard, and Nietzsche.

In *The Science of Logic*, explains Robert Heiss, Hegel engaged in an attack on history, mathematics, and science by attacking logical thinking that "found its most basic expression in formal logic." Applying his dialectical method, Hegel attempted to demonstrate the relativity of categories such as truth and falseness, being and nothingness, idea and thing.[65] Derrida has certainly capitalized on the dialectical operation that operates reversals between seeming opposites. Yet Hegel's ultimate aim was to demonstrate the essence of God and of divine will.[66]

Kierkegaard applied Hegel's dialectical method to the ethical realm. As Heiss explains it, "In the first volume of *Either / Or* an attitude is developed which basically is neither / nor."[67] Derrida would outdo Kierkegaard, for his method of deconstruction, as we have seen, provides "*neither* 'either / or', *nor* 'both / and' nor even 'neither / nor', while at the same time not totally abandoning these logics either."[68] Yet, against the either / or as neither / nor opposition of the first volume of *Either / Or*, Kierkegaard affirmed the necessity of ethical choice in volume two.[69]

Nietzsche too added to the undermining of values and meaning. As Paul Cantor explains it, "Nietzsche's fundamental aim in the *Genealogy* is to show how man's spiritual concerns develop out of material beginnings, how the high and the low in human nature are related, how altruism, for example, is rooted in egotism: to put it more bluntly, how morality grows out of immorality."[70] As part of Nietzsche's strategy he argued that language itself is unstable with respect to meaning: "Nietzsche's purpose of undermining our naïve faith in opposite values, the belief that good is good, and evil is evil, and never the twain shall meet, is well served by his principle of the continuity of literal and figurative meanings. The ever-shifting boundary line between literal and figurative, the way our moral terms hover between material and spiritual meanings, ensures for Nietzsche that we can never rest content with sharply formulated moral oppositions."[71] Derrida capitalizes on this association by terming his mythical metaphysics "writing."[72]

All of these intellectual enterprises undertaken by Hegel, Kierkegaard, and Nietzsche play with seeming paradoxes in a way that mistakenly applies the consistency of logic inappropriately to the realm of human behavior and insight. This mistake was noted by Vico when he warned, "it is an error to apply to the prudent conduct of life the abstract criterion of reasoning that obtains in the domain of science." "Doctrinaire" thinkers mistakenly become "satisfied with abstract truth alone" and are not "gifted with common sense."[73] The instability of meaning that

Nietzsche argues in his discussion of metaphor cannot invalidate deeply felt under-
standings about the meaning of life and about the nature of morality as well as of
profound aesthetic experience. On a more prosaic level, the commonsensical per-
ception that metaphor involves a "transference" of meaning from one word or
concept to another, which is the source of metaphor's pleasure and insight, cannot
be eradicated by philosophical reasoning. Yet, deconstructionists proceed in this
mistaken manner. Thus, we find Alan Bass commenting on a passage from Derrida's
"Force and Signification":

> In a sense, any application of a name to a thing is always metaphorical, and for many
> philosophies (e.g., those of Rousseau and Condillac) metaphor is the origin of
> language. The question, then, is whether there is an *origin* of metaphor, an absolutely
> nonmetaphorical concept, as, for example, the verb *to be*, or the notion of breathing,
> for which Nietzsche says the notion of Being is a metaphor (in *Greek Philosophy during
> the Tragic Age*). If it could be shown that there is no absolute origin of metaphor, the
> separation or space implied in metaphor as transfer would become problematical, as
> it would then be nonreducible.[74]

Such reasoning also fails to distinguish between the sense of basic, underlying truth
and the complexity of motivation, judgment, and action in the course of life. Rather
than recognize this duality, the deconstructionist applies the erroneous syllogism
that philosophically argued relativism in one domain, such as language, or even the
need to apply moral precepts within different contexts with different decisions and
results, necessarily means the absence of fixed moral or aesthetic value upon which
such judgments are to be predicated. Once again, Vico clearly articulates the
relationship between truth and its application, while affirming the coexistence of
absolute values and of situations that require varied applications: "But the sage who,
through all the obliquities and uncertainties of human actions and events, keeps his
eye steadily focused on eternal truth, manages to follow a roundabout way when-
ever he cannot travel in a straight line, and makes decisions, in the field of action,
which, in the course of time, prove to be as profitable as the nature of the things
permits."[75] Commenting on people of various types of intelligence and learning,
Vico offers insights that apply to the distinction that I am making here between the
deconstructionist and the humanist manners of proceeding. In the following passage,
the phrase "highest truths" pertains to "abstract knowledge" derived from the
sciences; the "lowest truths" refer to common sense and are "lowest" only in the
sense that they come automatically to us as a gift from divine providence rather than
through advanced reasoning:[76]

> In the conduct of life, fools, for instance, pay no attention either to the highest or the
> lowest truths; . . . learned men lacking prudence derive the lowest truths from the
> highest, whereas the sage truly derives the highest truths from the lowest.[77]

Thus, the humanist proceeds after the manner of Vico's sage by recognizing the importance of regulating human action according to common sense, associated with the deep understanding of moral and aesthetic truths. In contrast, the deconstructionist acts like Vico's men who are learned but lack prudence and hence who reject the insights of common sense in favor of deriving all understanding from abstract philosophical reasoning.

With Derrida, this abstract philosophical reasoning, associated with a mythic account of human history, is presented as an understanding independent of Derrida's own particular interpretation. Rather, Derrida purports to be merely making clear to us what had to be and what has yet to become. Note the deterministic nature of Derrida's account of the march of history. Within the first five pages of Chapter 1 we are repeatedly reminded that what Derrida claims to be explaining has been an unavoidable historical phenomenon: "A historico-metaphysical epoch *must* finally determine," "By a slow movement whose necessity is hardly perceptible," "By a hardly perceptible necessity," "These disguises are not historical contingencies," "Their movement was absolutely necessary," "The system . . . has necessarily dominated," "by a gesture and for motives that are profoundly necessary," and "But this nonfortuitous conjunction."[78] But this is not all, for as Southwell has emphasized, Derrida also knows the future, with a deeply penetrating look across the next several hundred years. In Derrida's own words, the "death of the book undoubtedly announces . . . nothing but a death of speech. . . . Announces it at a distance of a few centuries."[79] Since Derrida is a philosopher who writes in the tradition of the early nineteenth-century German Idealists and of their followers, including Marx the economic determinist, we might wish to hear in Derrida's historical determinism echoes of their own certainty about the past and future course of History. Yet, for American adherents to deconstruction, not schooled in this Idealist tradition and many of whom are not Marxists, this appeal to historical determinism, especially with its apocalyptic overtones, probably evokes other associations. This brings to mind today's messianic conspiracy cults, like those that have been led by Jim Jones and David Koresh. Perhaps deconstruction is the intellectual's armchair equivalent. Why should the intelligentsia be exempt from such tendencies?

For those followers of Derrida immune to the sense of conspiracy and messianic fervor, there is still the promise of deep understanding just around the intellectual corner, repeatedly hinted at, but never revealed. Such enticements abound in Derrida's work, with phrases such as those just quoted – "By a slow movement whose necessity is hardly perceptible" – and by others where the enticement is more explicit, such as the reference to "a metaphor whose genealogy itself would deserve all of our efforts."[80] On encountering such formulations I am reminded of Henry Fielding's warning placed in the mouth of the narrator of *Tom Jones* about a

speaker who

> generally left his Hearers to understand more than he expressed; nay, he commonly
> gave them a Hint, that he knew much more than he thought proper to disclose. This
> last Circumstance alone, may, indeed, very well account for his Character of Wis-
> dom; since Men are strangely inclined to worship what they do not understand.[81]

"Grammatology," explains Derrida, is "the science of writing."[82] It is curious that
writing could be considered a science, especially "writing" understood as a meta-
physical outlook. Once again, historical echoes resonate in such a characterization.
That exceedingly self-important nineteenth-century "science," Marxism, comes to
mind. As with Marxism, deconstruction is like an intellectual meat grinder, one of
those hand-operated instruments with a hopper on top and a grill to the side, into
which you can dump any contents and be assured in advance of the shape of the
substance, in this case of the meaning, that issues from the other end.[83]

And yet, with its entire panoply of terms and procedures, deconstruction resem-
bles more closely that other nineteenth-century "science," the one dismissed first by
Marx and Engels and later by Derrida as utopian, in other words, the intellectual
system of Charles Fourier.[84] In his own mind, Fourier was certain that he was
offering humankind a science as comprehensive in its approach to everything in life
as deconstruction would later offer. As Jonathan Beecher and Richard Bienvenu
explain, Fourier "rested his claim to historical fame greater than that of Newton on
the sole basis that he had completed Newton's work by discovering the laws
governing men's passions."[85]

Fourier, in a manner of speaking and in his own manner, was the first deconstruc-
tionist. Long before Derrida, Fourier applied what he termed "ABSOLUTE DOUBT"
and "ABSOLUTE DEVIATION" to an evaluation of human society. Misappropriating a
line from Montesquieu's *Lettres persanes* (Persian Letters), Fourier explained:

> Finally I thought that if human societies are suffering, as Montesquieu put it, "from a
> lingering disease, an inner vice, a secret and hidden venom," one might find the
> remedy by avoiding the paths followed for so many centuries and with such bad luck
> from our uncertain sciences. Thus I adopted as my rules of research the principles of
> ABSOLUTE DOUBT and ABSOLUTE DEVIATION. These two methods must be defined,
> since before me no one has ever made use of them.[86]

Fourier's "absolute doubt," like Derrida's "grammatology," rejects the entire structure
and fabric of contemporary civilization, situates its ills within an historical perspective
of millennia, and announces the coming future state of life for humankind:

> However, what is more imperfect than this civilization which drags all calamities in
> its wake? What is more questionable than its necessity and its future permanence?
> Isn't it probable that it is only a stage in the life of society? If it has been preceded by

three other societies, Savagery, Patriarchate and Barbarism, does it follow that it will be the last because it is the fourth? Could not others still be born . . . ? Thus the method of Doubt must be applied to civilization; we must doubt its necessity, its excellence and its permanence. These are problems which the philosophers won't dare to face, because in suspecting civilization, they would call attention to the nullity of their own theories, which are linked to civilization, and which will all collapse with it as soon as a better social order is found to replace it.[87]

Just as Derrida would reject all science, logic, meanings of truth, and metaphysics that came before deconstruction, so Fourier postulated a radical beginning. Yet, whereas Derrida would "de-construct" the world, Fourier wanted to reconstruct it according to his science of "passionate attraction." Fourier's system was as positive as Derrida's is negative. For each of Fourier's major points intended to regulate human intercourse harmoniously, Derrida has postulated a negative concept that furthers the cause of perpetual, absolute doubt about truth and value.

Fourier's earlier equivalent to Derrida's grammatology, his system of passionate attraction, purported to explain everything about people and society and therefore regulate all human intercourse. "Passionate attraction," explained Fourier, "is the drive given us by nature prior to any reflection, and it persists despite the opposition of reason, duty, prejudice, etc."[88] Gather 810 males and 810 females together into a community; allow them to pursue any activities that they desire, changing tasks at least as frequently as every two hours; guarantee a minimum wage and provide further compensation according to the value of work, capital, and talent contributed to the group; abolish marriage and the family; and permit the satisfaction of all passions: harmony would reign.

The underlying principle behind Fourier's system was the conviction that "passionate attraction" regulated human motivation the way gravity regulated the movements of the planets. For Fourier, "the passions were benign and harmonious if afforded maximal expression. The source of evil was the unnatural set of institutions and moral codes known as civilization."[89] According to Fourier there were twelve basic passions, grouped into three clusters: the "luxurious" passions based on the five senses, the four "affective" passions (friendship, love, ambition, and parenthood or "*familisme*"), and the three distributive or "mechanizing" passions, which Beecher and Bienvenu describe as "the Cabalist or intriguing passion; the Butterfly or the penchant for variety and contrast; and the Composite or the desire for the sort of happiness which could only be found in the mixture of physical and spiritual pleasures."[90]

In place of "passionate attraction" offered by the self-described "shop sergeant," Derrida the philosopher has offered us "writing" as the overarching principle to explain the world. Where Fourier explained people and society in terms of "passions" organized into "passionate series" and subdivided according to their own

"exponential scale" of degrees of intensity,[91] Derrida reduces everything in the world to writing:

> And thus we say "writing" for all that gives rise to an inscription in general, whether it is literal or not and even if what it distributes in space is alien to the order of the voice: cinematography, choreography, of course, but also pictorial, musical, sculptural "writing." One might also speak of athletic writing, and with even greater certainty of military or political writing in view of the techniques that govern those domains today. All this to describe not only the system of notation secondarily connected with these activities but the essence and the content of these activities themselves.[92]

To reduce domains of action such as warfare, politics, and athletics to a species of "writing," even if understood as a metaphysical principle instead of in the customary sense of notation, makes no sense.

Just as Fourier provided "a passional grammar with its own declensions, conjugations, and syntax,"[93] Derrida does the same for his "grammatology." At the head of the list we should place *aporia*, the goal of deconstructionist textual analysis that, as Lehman explains, achieves a "moment of terminal uncertainty."[94] In many respects *aporia* is to the "science" of "grammatology" what the "Butterfly passion" was to the "science" of "passionate attraction." Whereas the latter propelled people to move from one activity or person to another, the former prevents meaning or value to be assigned by moving from one possible meaning to the next while doubting its propositions along the way, so as to create a web of uncertainties.[95]

What *aporia* offers as a general strategy is seconded by specific lines of attack. Derrida's notion of "hierarchical oppositions" works in this manner. As Southwell explains:

> What Derrida deconstructs are "hierarchical oppositions" the first terms of which are "repressive" of the second – oppositions such as "nature/culture," "meaning/form," "outside/inside." In the analysis of *Of Grammatology* we are most interested in the oppositions "speech/writing," "signified/signifier," "identity/difference," "presence/absence." "In a classical philosophical opposition," says Derrida, "we are not dealing with the peaceful coexistence of a vis-à-vis, but rather with a violent hierarchy. One of the two terms governs the other (axiologically, logically, etc.), or has the upper hand. To destruct the opposition, first of all, is to overturn the hierarchy at a given moment." [96]

Derrida's "hierarchical oppositions" are grammatology's answer to Fourier's "Cabalist" passion, the "passion for intrigue." Deconstructionists are thus licensed to sniff out "violent" hierarchies among ordinary words and concepts and to undermine meaning and value by reversing these so-called hierarchies.

When deconstructionists overturn a "hierarchical opposition," they do not estab-

lish a new truth; rather, they create a state of suspended meaning. Southwell explains:

> Now the purpose of the overturned, or reversed, hierarchy, the reversed opposition, is not to establish a reality, a truth, but to achieve "a general *displacement* of the system," that is, the system of the original opposition and eventually the entire system which is logocentrism. Derrida does not pretend that the reversed opposition has any more authority than the original opposition. The reversed opposition by virtue of being an opposition remains *within* logocentrism, as Derrida readily admits.[97]

In other words, reversing oppositions creates an intellectual and moral twilight zone. Such is Derrida's purpose, such is the nature of deconstruction. This Derrida clearly explains toward the end of "The End of the Book and the Beginning of Writing":

> Heidegger brings it up also when in *Zur Seinsfrage*, for the same reason, he lets the word "being" be read only if it is crossed out (*kreuzweise Durchstreichung*). That mark of deletion is not, however, a "merely negative symbol" (p. 31). That deletion is the final writing of an epoch. Under its strokes the presence of a transcendental signified is effaced while still remaining legible. Is effaced while still remaining legible, is destroyed while making visible the very idea of the sign. In as much as it de-limits onto-theology, the metaphysics of presence and logocentrism, this last writing is also the first writing.[98]

The deconstructionist concept of placing words "under erasure," that is, by printing them crossed out with an X, is Derrida's answer to Fourier's ultimate passion, the Composite. Whereas the "Composite passion" involves "the seduction of the senses and the soul" that "arises from the mixture of two pleasures, one for the senses and one for the soul,"[99] grammatology's "erasure" eviscerates a concept while leaving the skeleton shown as having been destroyed without constructing an alternative.[100] "Under erasure" thereby conjoins the emptied notion and the means of its destruction:

> The hesitation of these thoughts (here Nietzsche's and Heidegger's) is not an "incoherence": it is a trembling proper to all post-Hegelian attempts and to this passage between two epochs. The movements of deconstruction do not destroy structures from the outside. They are not possible and effective, nor can they take accurate aim, except by inhabiting those structures. Inhabiting them *in a certain way*, because one always inhabits, and all the more when one does not suspect it. Operating necessarily from the inside, borrowing all the strategic and economic resources of subversion from the old structure, borrowing them structurally, that is to say without being able to isolate their elements and atoms, the enterprise of deconstruction always in a certain way falls prey to its own work.[101]

This deconstructionist strategy of undermining meaning through *aporia*, "hierarchical oppositions," and placing words "under erasure" appears as an extreme application of the method of reasoning associated with the sophists in Greece of the fifth century B.C. In his history of the sophistic movement, Kerferd explains that the sophists were associated with what was termed the "twofold argument," a process that used *antilogikē* or "antilogic." Antilogic is "an art which sets up contradictory predicates for the same subjects — so the same things are alike *and* are unlike."[102] Plutarch related in his *Life of Pericles* that it was Zeno of Elea "who perfected a kind of skill in examining opponents in argument that brought them to a state of *aporia* through opposed arguments [*di' antilogias*]."[103] In Kerferd's words, through antilogic "Zeno reduced his opponents to silence by showing that their chosen positions were contradictory in that they implied also the negation of themselves."[104] Thus, what was once a method of disputation has become in the hands of Derrida an entire epistemological and metaphysical system.[105]

When deconstruction spreads from literature to fields such as anthropology and law,[106] it has extended its domain of activity according to Derrida's program. This call for "borrowing all the strategic and economic resources of subversion from the old structure," brings us back to Derrida's opening charge that "logocentrism" is "the most original and powerful ethnocentrism." Ethnocentrism means the tendency to judge other cultures by the standards of one's own society, considering them to be superior to all others. As a term of comparison it is neutral in that it can be applied to any society. Yet when Derrida uses the word, it is understood that he means Western ethnocentrism. And Western ethnocentrism encapsulates an entire panoply of sins that are not only to be belittled but which also have been grouped together in a schematic way so as to condemn the West in a global manner. These sins include imperialism, racism, sexism, and capitalism (understood as pure social Darwinism). Because of these assembled crimes, all understood by the word ethnocentrism, Western culture is condemned and its ways of reasoning, based on rational discourse, as well as its most humane ideals, grounded in the Bible and the Enlightenment, all of this represented by the word "logocentrism," are contaminated by association with its faulty political and social practices.

When Derrida uses "logocentrism" to stand for this entire line of reasoning, he operates according to the rhetorical tropes of synecdoche and metonymy. When Derrida writes "logocentrism," he is using synecdoche by having the part stand for the whole. To establish the whole, he employs a doubly tendentious metonymy, as if "ethnocentrism" can logically stand for racism, sexism, or capitalism, and as if "logocentrism" could stand for everything that Derrida has clustered under "ethnocentrism." The comprehensive nature of the deconstructionist undertaking is clear when one reads the texts of its adherents. Participation in any aspect of a "logocentric" culture involves one in the seamless web of oppression that extends through

all of its domains, connecting the most seemingly innocent to those universally recognized as criminal. Thus, in a current article on deconstruction and architecture, one reads:

> The recognition on the part of postmodern, or poststructuralist, critics and historians of the unavoidable relationships of culture and the wider spectrum of ideology and social power has prompted many of these producers of culture to produce objects and discourses that include in an explicit manner their complicity with wider social conditions and cultural politics. This takes various forms, of course. Some artists (Louise Lawler, Sherry Levine, Cindy Sherman, Barbara Kruger, Daniel Buren, Hans Haacke, Michael Asher, and Andrea Fraser, and many others) enfold a deconstruction or *aporia* within their works, preventing narrow aesthetic readings. Others make explicit the relationship between representation, sexual or ethnic identity, and national or international media and politics. In other words, many artists, novelists, critics, and theorists have produced texts with built-in contradictions of the sort that force a critique of institutions and apparatuses. In this sense, we can, with justification and however loosely, term this work deconstruction or at least poststructuralist.[107]

Derrida's ability to capitalize on this cluster of associations about injustices of one sort or another relates to the recent cultural development identified by Alain Finkielkraut in *La Défaite de la pensée*, the defeat or undoing of reason, by which the anthropologist Claude Lévi-Strauss and others, after World War II, attacked the Enlightenment's emphasis on universal values by associating them with the injustices and destruction occasioned by Western colonialism.[108] In this way, Lévi-Strauss could make "ethnocentrism" mean "Western ethnocentrism" in common parlance and could cluster a host of social, cultural, economic, and political ills under this term. Derrida not only capitalizes on these global associations, he reminds his readers of them while attempting to rescue his favorite word "writing" from Lévi-Strauss's own criticisms. The central role of Lévi-Strauss's thought in establishing the meaning of ethnocentrism and of "logocentrism" in *Of Grammatology* is indicated by the special place accorded Lévi-Strauss in this book. After its initial metaphysical stand, *Of Grammatology* devotes most of its text to discussions about linguistics and semiological systems, with the significant exception being the chapter on Lévi-Strauss, which notes his "anticolonialist and antiethnocentric" stance.[109] Yet Lévi-Strauss presents Derrida with a problem, for the former had written: "If my hypothesis is correct, the primary function of writing, as a means of communication, is to facilitate the enslavement of other human beings."[110] While countering Lévi-Strauss's charge, Derrida often emerges from the twilight zone of deconstruction to employ "logocentric" reasoning when it serves his purpose.

In a series of essays on the trends of contemporary thought that undermine value

and claims to truth which appeared in the same year as Derrida's *Of Grammatology* (1967), Susan Sontag noted, "More and more, the shrewdest thinkers and artists are precocious archaeologists of these ruins-in-the-making, indignant or stoical diagnosticians of defeat, enigmatic choreographers of the complex spiritual movements useful for survival in an era of permanent apocalypse."[111] I am not as sanguine as Sontag about living in "an era of permanent apocalypse." Nor do I agree that the "best of the intellectual and creative speculation carried on in the West over the past hundred and fifty years seems incontestably the most energetic, dense, subtle, sheerly interesting, and *true* in the entire lifetime of man."[112] Yet, even Sontag, in spite of her enthusiasm for the contemporary "perspective on its own achievements that fatally undermines their value and their claim to truth,"[113] ends one of these essays with a note of caution: "It seems unlikely that the possibilities of continually undermining one's assumptions can go on unfolding indefinitely into the future, without being eventually checked by despair or by a laugh that leaves one without any breath at all."[114] No doubt, in the long term Sontag will prove correct in this prognosis. In glancing back, however, over the nearly three decades since the publication of *Of Grammatology*, it appears that Derrida has emerged as the shrewdest "archaeologist of these ruins-in-the-making," for he has elaborated a mythical system which provides a semblance of self-justification along with clever strategies for ruination to sustain his followers in ways that will defer that moment of intellectual and spiritual reckoning for as long as possible.

False Populism

The poststructuralist's irritation with the humanist tradition heightens when social injustice is deemed to be present. To return to Dell Upton's article, we find the author arguing for what he considers to be a "more inclusive" mode of architectural history than is currently practiced, which he sees as dominated by the "canon," the "mandarin canon," and the "canonical monument." He also sees this as a corollary to opening up the profession to new groups and new ways of operating. Yet in making these assessments, he feels compelled to ridicule notions such as "high art," "supreme, universal value," and "artistic greatness." This is typical of many poststructuralists for whom these concepts smack of elitism. According to this argument, inclusiveness denotes a democratic, nonoppressive, and egalitarian society. The alleged exclusiveness of elitism and the "canon" is deemed undemocratic, oppressive, and not egalitarian.

The logical inconsistencies here are numerous. First, to open access to the profession, to diversify further its mode of operation, and to expand the way its history is written do not require a disparagement of high art, artistic genius, and transcendent values. The two can coexist quite comfortably. Second, the poststructuralist notion of elitism is grounded in a mistaken populism. Just as Barbara

Herrnstein Smith fails to distinguish adequately between value and valuation, so too does Dell Upton neglect to consider the difference between pre-Enlightenment and post-Enlightenment elitism. Whereas the former is based on wealth and social status (and hence is antidemocratic), the latter, which originates with the Enlightenment and the French and American Revolutions, is grounded in merit. Our democratic ideal – still valid if not always actualized – is to facilitate those circumstances under which people can excel on the basis of talent, intelligence, and hard work. Here it behooves us to consider again the clarity of Wilhelm von Humboldt's articulation of this principle, found, for example, as the epigraph to John Stuart Mill's essay *On Liberty*: "The grand, leading principle, towards which every argument unfolded in these pages directly converges, is the absolute and essential importance of human development in its richest diversity."[115] As Humboldt also affirms, "Man's highest end is the highest and most harmonious development of his powers in their perfect individuality."[116] It is ironic that the same people who are promoting the expansion of opportunity to those previously excluded wish to deny the possibility for excelling and to denigrate superior accomplishment.

When elitism means unfair advantage it is wrong; when elitism means the recognition of superior achievement, it is ennobling. To stifle human potential is a moral crime. To belittle and dismiss the study of the individual creative genius in art on the grounds that this is elitist is a sorely misguided notion. The humanist studies genius to appreciate better the workings of the human mind, to understand better how value is achieved in art, and to marvel at the splendor of artistic creation that far exceeds anything that we can explain.

"Intertextuality" and Base Metaphors

If any one word or concept can take us to the heart of poststructuralism, it is intertextuality. If any one term can epitomize the constellation of meanings that cluster together the skepticism and relativism of Smith's contingencies of value, Upton's doubts about normative experience, Fish's self-consuming artifacts, and the nihilism of Derrida's entire panoply of deconstructionist strategies, from placing words under erasure to creating an *aporia*, as well as the various permutations on the primacy of context over subject that will be discussed in the next chapter with respect to the work of Pierre Bourdieu, Michel Foucault, Paul de Man, and Hayden White, it is intertextuality. As Marc Angenot has observed, "intertextuality" is one of those "key words" that sum up the tenor of a cultural phenomenon, in this case, poststructuralism.[117]

In the most general sense, "intertextual" has come to mean "infinitely complex interwoven interrelationships, 'an endless conversation between the texts with no prospect of ever arriving at or being halted at an agreed point.'" This is the glossary definition given by Pauline Marie Rosenau in her study of the diffusion of post-

modern concepts throughout the social sciences.[118] As Angenot emphasizes, the idea of intertextuality denies the possibility "of any closure to a text." It is used to undermine the primacy of the author and of his or her work in favor of considering a work as an interweaving of anterior texts and modes of discourse.[119] To describe the nature of this interweaving, champions of intertextuality talk of the "discursive space" in which any work of art situates itself. Thus, in the words of Jonathan Culler, a preeminent advocate of deconstruction, intertextuality "is less a name for a work's relation to particular prior texts than an assertion of a work's participation in a discursive space and its relation to the codes which are the potential formalizations of that space."[120]

The notion of "intertextuality" is postulated on the premise that the work does not have its own coherence or even existence independent both of the anterior works that it reflects and more generally of the general codes of discourse that make such a work possible. "Outside of intertextuality, the literary work would be simply imperceptible."[121] These codes of discourse refer to the various genres that a work might intermingle or even more generally to the systems of meaning and being in which it operates.

> If, in effect, for J[ulia] Kristeva, [the originator of the concept of intertextuality], "any text constructs itself as a mosaic of citations and any text is an absorption and transformation of another text," the notion of text is significantly broadened by her. It becomes synonymous with "system of signs," whether literary works, spoken languages, unconscious or social symbolic systems.[122]

Champions of intertextuality insist that it is not to be confused with the traditional practice whereby an author or artist draws upon earlier works, as discussed in this book under the categories of "echo" and of "imitation." "The study of intertextuality," writes Culler, "is not the investigation of sources and influences, as traditionally conceived. . . ."[123] Intertextuality, stresses Jenny, is "far from being . . . an effect of echo."[124] The reason is that intertextuality creates its own indeterminate "space" which is the nexus of the crossing of the "texts" that constitute the new work. In the words of Kristeva, each work is "a permutation of texts, an inter-textuality: in the space of a text, several enunciations taken from other texts cross each other and neutralize each other."[125] As Jenny explains, the anterior text, once having a "transitive" function becomes "intransitive" by virtue of its new context.[126] Thus, through a double reversal the old text ceases to be an actor but rather is acted upon and the new text loses its status as original and complete because it dissolves into the interstitial network of self-canceling intersections of textual fragments. In that sense, intertextuality has the same effect as placing words "under erasure" in deconstructionism. The body has been lost; all that remains is a palimpsest.

When passing from the theory of intertextuality to its application as a means of explaining a work of art, usually a work of literature, again and again we find the

enthusiasts of this concept slipping back into the time honored practices of echo and imitation.[127] Even Culler cannot refrain from registering his disappointment with Kristeva's intertextual analysis of Isidore Ducasse, Comte de Lautréamont's *Poésies II*:

> [A]nd anyone under the impression that the whole point of intertextuality was to take us beyond the study of identifiable sources is brought up short by Kristeva's observation that "Pour comparer le texte présupposé avec le texte des *Poésies II*, il serait nécessaire d'établir quelles éditions de Pascal, de Vauvenargues, de la Rochefoucauld, Ducasse a pu utiliser, car les versions varient beaucoup d'une édition à une autre" ["In order to compare the presupposed text with the text of *Poésies II*, it would be necessary to establish which editions of Pascal, Vauvenargues, La Rochefoucauld, Ducasse could have used, because the versions vary much from one edition to another"]. The point is not that such questions are uninteresting or insignificant but only that a situation in which one can track down sources with such precision cannot serve as the paradigm for a description of intertextuality, if intertextuality is the general discursive space which makes a text possible.[128]

As Culler presciently observes, "Particularly striking is Kristeva's decision to use as her 'example frappant de cet espace intertextual qui est le lieu de naissance de la poésie' ['striking example of this intertextual space which is the birthplace of poetry'] Lautréamont's *Poésies*, which contains a very large number of explicit negations or deformations of identifiable maxims and sententiae."[129] In effect, intertextuality functions more as a way of describing a particular type of literature than as a global concept to explain literature or art in general.[130]

The notion of intertextual literature can be applied to those works that consist primarily of a collage or *bricolage* of fragments of other works.[131] It is interesting that several of the major advocates of intertextuality as a concept to explain art in general are also writers of intertextual texts. Thus, Michel Butor, who is associated with the *nouveau roman*, explains:

> There is no individual work. The work of an individual is a sort of knot that produces itself within the interior of a cultural fabric into the heart of which the individual has not dived but rather in the heart of which he finds himself as having *appeared*.[132]

Because of this conviction, we find Butor in his *Histoire extraordinaire* (1961) creating a collage with a text from Baudelaire. Butor's work is

> a book of 270 pages, at least half of which belongs to Baudelaire. Here Butor rewrites Baudelaire through a process of collage and rearrangement of texts: the material is Baudelaire, the new order and the connections are Butor.[133]

One critic objected to Butor about this process by observing, "By the use that you make of collages, where the quoted texts are distinguished less and less from your own, you dissolve your authors."[134]

Similarly, Roland Barthes has both championed intertextuality as a concept and has applied it in his own work. Thus, he explains,

> The intertext is no law other than the infinity of its reprises. The author himself – the somewhat antiquated deity of the old criticism – can or will be able one day to constitute a text like the others: all that is needed is to renounce the goal of making of his person the subject, the support, the origin, the authority, the Father, from whom his work would derive. . . .[135]

In this spirit, Barthes in *S/Z: essai* (1970) created a collage by operating on a story by Balzac, which he

> decomposed into fragments . . . packaged into blocks . . . , these blocks in turn being enveloped by the Barthean text (which punctuates them, gives them an articulation and a modulation). The full text of the story by Balzac, published at the end of the book, functions itself like a piece of collage: no longer a finished and tutelary object, but a sort of miniature appended to the large picture of *S/Z*, a *quotation*, a spherical mirror in a Flemish interior.[136]

This method of appropriating existing works, especially canonical masterpieces, has not been limited only to literature. We find the same phenomenon at this time in the visual arts as well. Called "appropriation art" or "quotational art," these works present approximate copies made with purposeful distortions of older, usually iconic works of art. The significance of such gestures is multiple. They are intended to diminish the stature of the original artist as well as of the concepts of originality and genius. As one champion of "quotational art" explains it, postmodern art "based on quoting postulates the artist as a channel as much as a source, and negates or diminishes the idea of Romantic creativity and the deeper idea on which it is founded, that of the Soul."[137] This critic's candor in raising the metaphysical underpinnings of this postmodern phenomenon points us in the direction that we should follow as we pursue this inquiry into the ultimate significance of the notion of "intertextuality." As Leyla Perrone-Moisés has observed, the intertextual approach to a work of art is an attack on the idea of "closed and sacred objects."[138]

This reference to "closed and sacred objects" helps to explain why the concept of intertextuality, which has proven so inadequate as an intellectual tool for critical analysis and which is limited to so small a portion of the world of art as a means of creation, has attracted such attention and generated such enthusiasm among advocates of poststructuralism. As Angenot has stressed, intertextuality serves more as an ideological and conceptual notion than as a practical tool for literary or cultural analysis.[139] To understand the full import of this position, we must consider the implications of the poststructuralist attack on the idea of "closed and sacred objects" through the concept of the so-called discursive space of intertextuality, which, we are told, is a space that "obviously has neither an axis nor a center."[140]

Such talk about axis and center is not merely a metaphorical description of analytical thought. Rather it engages the very way in which we know ourselves, in which we understand our fundamental nature. Thus, the concepts of "axis" and "center" belong to what the psychiatrist and phenomenologist Eugène Minkowski has termed a "métaphore de base" or base metaphor. (The word "base" does not mean "lowly" but rather "fundamental" and "foundational.") Whereas a metaphor in the ordinary sense serves as a figure of speech to speak of one thing in terms of another, a "base metaphor" designates "a particular way of affecting the human soul." Considering further the properties of a "base metaphor," Minkowski explains:

> Certain words are "metaphorical" in their essence, and it is there that resides the "veracity" of language. Language does not seek to make a word into an algebraic sign but rather, to the contrary, to designate with the assistance of a word affinities, identities even, between phenomena, that our [faculty of] thought which dissects and juxtaposes misunderstands and destroys all too readily.

Minkowski has just been discussing bitterness of taste and bitterness of feeling to argue that the latter is not a metaphor drawn from the former but rather that both are parallel aspects of the same "base metaphor."[141]

Like the tri-directional topological indications of depth, breadth, and height, to which we readily assimilate feeling and thought (as in deep feeling, elevated thought, and broad learning), the concept of "axis" tells us directly as much about our inner nature and, as one might say in the spirit of Minkowski's work, as much about our inner "space," as about the organization of perceptually known exterior space.[142] Poets, ever sensitive to the inner life, have understood the importance of such base metaphors and thus have used them to great advantage. Without the sense that we have an identity and character grounded in an inner spiritual center, T. S. Eliot's image of the "hollow men" would hardly be so effective.[143] Similarly, Nietzsche's lament that contemporary man is not "hard" but rather that his inner being has been eroded into a hollow space – "Thou art not stone; but already hast thou become hollow by the numerous drops" – also relies on such a "base metaphor."[144] So too does Blake's assimilation of "infinity" to the "vortex":

> The nature of infinity is this: That every thing has its
> Own Vortex; and when once a traveller thro Eternity,
> Has passed that Vortex, he perceives it roll backward behind
> His path, into a globe itself infolding; . . . [145]

In these lines Blake conflates the sense of an inner axis and of an inner core, evoking first the former and then the latter, as both are transformed into a swirling inner void of ever-concentrating energy.[146]

Base metaphors remind us that they are not merely ideas but rather translations

of an instinctive understanding about self into verbal or visual concepts. As Nietz-sche has observed,

> the greater part of conscious thinking must be counted amongst the instinctive functions, and it is so even in the case of philosophical thinking;. . . . [T]he greater part of the conscious thinking of a philosopher is secretly influenced by his instincts, and forced into definite channels.[147]

Yet whereas Nietzsche stressed the primacy of instinct to satisfy "physiological demands, for the maintenance of a definite mode of life,"[148] I would emphasize intuition and, in this case, intuition about the reality of spirit. In that sense, philosophy becomes the intersection of the combined powers of experience and intuition with rational discourse, whereby the individual gropes with the latter to explain what one knows through the former, pausing when one senses that the words explain an understanding known deep within one's being. Base metaphors like "axis" and "center" serve that purpose.

In Chapter 1, I postulated the existence of an aesthetic axis within the human psyche such that when the artist touches it, like a chord it vibrates with greater sweetness, pathos, and so forth, than when the artist misses this mark. I also spoke of an inner spiritual axis, with its moral and aesthetic components, around which insights into the nature of life and the vital feelings of life cluster and revolve. Let us consider further this "base metaphor," for this humanistic understanding of the self has come under attack by the champions of intertextuality. To this end, readers might wish to consider the following observations by Percy Bysshe Shelley and Francis Ponge: "There is a Power by which we are surrounded, like the atmosphere in which some motionless lyre is suspended, which visits with its breath our silent chords at will. . . . This Power is God" (Shelley); "a certain vibration of nature called man" (Ponge).[149] Might we not transform Shelley's image of the soul as a suspended lyre into an inner spiritual axis, and might we not superimpose upon Ponge's image of man as a vibration of nature the image of man's inner axis that vibrates when it is struck in consonance with its nature and with nature itself? We find such a conjunction of related images in the quest for a "cosmology" undertaken by Minkowski who opens his study by making reference to issues "which made my entire being vibrate" and who closes it by evoking "the axis of [our] personal élan," élan understood as a vital, spiritual life force.[150]

Similarly, it should not surprise us to find Herman Melville talking about Shake-speare's accomplishment and about the nature of the human psyche in terms of "intuitive Truth" and "the very axis of reality":

> But it is those deep far-away things in him; those occasional flashings-forth of the intuitive Truth in him; those short, quick probings at the very axis of reality; — these

are the things that make Shakespeare, Shakespeare. Through the mouths of the dark characters of Hamlet, Timon, Lear, and Iago, he craftily says, or sometimes insinuates the things, which we feel to be so terrifically true, that it were all but madness for any good man, in his own proper character, to utter, or even hint of them.[151]

So too the architect Louis Sullivan has characterized our moral capacities with reference to an inner axis:

> The moral group: the great stabilizing power! Much misunderstood and little used by men – turned into trivialities by them; unknowing that its central power of *free-will choice* is the axis of man's being, the determinant of his character. . . .[152]

Behind such base metaphors we find the conviction that people have not only an inner spiritual and moral core but also that they have a personality which is primarily their own and for which they are responsible. Outside influences might impinge upon them, sometimes even in an overwhelming and fatal manner, just as interior changes from disease and aging will cripple and destroy. Yet the conviction about one's identity remains. This is why we ascribe moral responsibility to the individual, all the while allowing for extenuating circumstances either internal or external that might circumscribe one's ability to satisfy such obligations.[153]

Similarly, it is because of such base metaphors that we consider works of art as having their own identity and integrity. Certainly they exist within a cultural context in which they echo and imitate other works in various ways. Yet once again, these relationships to outside works and forces are seen as impinging upon the inner core of an autonomous entity, which, whatever its connections with the outside, exists primarily in its own right. Because of this sense of an inner core we recognize and celebrate the magnitude and wonder of the creative act, of the work of genius. Paradoxically, creativity makes us so keenly aware of the irreducible mystery of life while reinforcing the sense of an inner core, a spiritual axis. That is why Shelley's image of the suspended lyre is so powerful.[154]

When Baudry observed that the space of intertextuality "obviously has neither an axis nor a center" he was pointing out the psychological efficacy of an alternative base metaphor. It is this psychological quality that Blake understood so well when he wrote the line - "In Satan's bosom a vast unfathomable Abyss."[155] We find numerous variations on the theme of the absent center or axis and of the inner abyss in explanations of intertextuality. In this way intertextuality challenges the base metaphors of inner core and inner axis as they relate to works of art and to our very being. Culler uses a passage from Barthes's *S / Z* to this effect:

> *I* is not an innocent subject, anterior to the text . . . This "me" who approaches the text is already himself a plurality of other texts, of infinite codes, or more precisely: lost (whose origin is lost).[156]

In an analogous spirit, Kristeva quotes crucial lines from the Russian critic Mikhail Bakhtin, whose work largely inspired the concept of intertextuality:

> The language of the novel cannot be situated on a surface or on a line. It is a system of surfaces that intersect with each other. The author as creator of the literary whole cannot be found on any of the linguistic surfaces: he is located in this regulating center that the intersection of surfaces represents. And all [these] surfaces are found at a distance different from this center of the author.[157]

Commenting on Bakhtin's success in having "seized the structure" of discourse "at its most profound level," Kristeva creates an analogy with modern physics, talking about the text as "made of relationships in which words function as quanta." "Thus," she continues, "the problematic of a model of poetic language is no longer the problematic of the line or the surface but of *space* and of *infinity*, to be formulated through set theory and the new mathematics."[158] Similarly, Lucien Dällenbach speaks of intertextuality as placing a text within a " 'double' prospective abyss" that leaves the work suspended between the "vector of retrospection" and the "vector of anticipation."[159] Dällenbach proceeded to write an entire book on the concept of the "abyss" in poststructuralist theory to trace the origins of a term used to suggest "a feeling of vertigo," or as one critic expressed it, " 'the Leibnizian impression of a series of worlds each enclosed within another, in a dizzying series of reflections.' "[160] As Craig Owens observes, this notion of the *mise en abyme* "suggests the familiar case of mirrors mounted in series to produce an infinite suite of specular effects. . . ."[161] The suggestion here is of an abyss conceived as a labyrinthian vortex, which is what Derrida argues is the essence of what he terms "textuality." As the master of such theorizing, Derrida creates the impression of such a vortex through the very phrasing of his message:

> And we shall see that this abyss ["to employ the current phrase"] is not a happy or unhappy accident. An entire theory of the structural necessity of the abyss will be gradually constituted in our reading; the indefinite process of supplementarity has already *infiltrated* presence, always already inscribed there the space of repetition and the splitting of the self. Representation *in the abyss* of presence is not an accident of presence; the desire of presence is, on the contrary, born from the abyss (the indefinite multiplication) of representation, from the representation of representation, etc.[162]

With such texts we come to understand the full implications of the notion of the "discursive space" of works of art, with its association of floating without anchor in an infinite void. Whereas once Hans Sedlmayr lamented the supposed "loss of center" caused by the Enlightenment and its aftermath, now poststructuralists celebrate a vision of people and of art that would eviscerate our sense of an inner center, our conviction about the reality of an aesthetic, spiritual, and moral axis.[163]

4

Nietzsche's Error

Nietzsche got it all wrong. God is never dead. For intellectuals over the last two centuries God has simply changed form. People always postulate an Absolute. Even today's poststructuralist dictum that there are no absolutes is an absolute. So too, yesterday's most confirmed existentialist, waiting for Godot, had found an absolute in the total absence of meaning and of God.

If we wish to understand how we have come to the point whereby theory is preferred to history, value is declared contingent, and genius is belittled, then we must look to the changing face of God in nineteenth-century thought. It is in the displacement of absolutes from the values of the Enlightenment to those of German Romanticism and of the French counter-Revolution that we begin to find answers to this query.[1] We also must consider the various modes of deterministic thought, from German Idealism to French positivism, to round out the picture. Then we can see more clearly into the strategies and practices of the leading poststructuralists and their immediate precursors, such as Walter Benjamin, Jacques Derrida, Paul de Man, Michel Foucault, Edward W. Said, Hayden White, Terry Eagleton, and Norman Bryson.

"'Diversity' and Its Dangers"

God never stands alone. For divinity is always associated with beliefs and values that partake of the Absolute. The Enlightenment allied to divinity the idea of universal rights, of the social contract, and of the entire Cartesian rationalist enterprise grounded in the aphorism – "I think, therefore I am" – which offered an alternative through individual thought to religious dogma grounded in revelation or institutional strictures, to political order justified through the theory of the divine right of monarchy, and to societal practices and constraints consecrated by tradition.

Yet, in pursuing this agenda, Enlightenment thinkers largely ignored the particulars of different cultures in the quest for the universals about humankind. It was Herder who has been widely credited with having changed the Enlightenment's perspective by insisting on the relativity of cultural values. For Herder humankind

was like a beautiful garden in which each culture — understood as rooted in a *Volk* or folk, with its own language and soil — constituted a unique and precious flower. The Enlightenment quest for the optimum standards of a single state of civilization was thereby replaced by a Romantic respect for the different values of distinct cultures. Throughout the nineteenth century each succeeding generation felt compelled to reaffirm what appeared to be the truth of Herder's teachings about the relativity of cultural values. One of the most famous formulations was to be found in Hippolyte Taine's highly influential *Histoire de la littérature anglaise* (1863):

> [In] the last century people of all races and of all times were presented as more or less the same, the Greek, the barbarian, the Hindu, the man of the Renaissance, and the man of the eighteenth century, as if all poured from the same mold, and that fashioned after a certain abstract concept, which served the entire human species. They knew man, but they did not know men.[2]

There would have been no problem if Romantic thinkers had permitted the study of "man" and "men" to coexist side by side. Yet the German Romantics and the French counter-Revolutionaries sought to replace the former with the latter. Herder, explains Alain Finkielkraut, undermined the belief in the possibility and desirability of universal values. Herder "returned the Good, the True, and the Beautiful to their local origins; he dislodged eternal categories from their complacent status in the sky to return them to the small parcel of ground where they had been born. There is no absolute, proclaimed Herder, there are only local values and principles that come to pass."[3] Similarly, Joseph de Maistre, while assigning a supremacy to national culture, dismissed the Enlightenment's belief in absolutes that it associated with man's basic nature and situation in this world. Whereas the Enlightenment knew "man" instead of "men," de Maistre could not find "man" anywhere at all: "Now, in this world there is no such thing as *man*. In my lifetime I have seen Frenchmen, Italians, Russians. Thanks to Montesquieu, I even know *that one can be a Persian*; but as for *man*, I declare that in all my life I have never met him; if he exists, he is unknown to me."[4]

The legacy of this outlook remains with us today in the current emphasis on cultural differences. The leaders in institutions throughout the United States feel morally obliged to "celebrate diversity." From different ethnic groups and races students in universities and employees in corporations repeatedly voice a need to "see themselves" pictured in the photographs in campus newspapers, in the advertisements on television and on billboards, and in the annual corporate reports.

And yet, the Romantic legacy has bequeathed to us the imbalance that resulted from the thinking of Herder, de Maistre, and others. In celebrating differences, we too often forget our common humanity. As Andrew Hacker has written in " 'Diversity' and Its Dangers," "ties of ethnicity when acted on in everyday life often become

reduced to
Schlesinge

But, pres...
ethnic gospel re...
new race. Its underlyi...
but a nation of groups, that ...
that ethnic ties are permanent an...
nities establishes the basic structure of ...
American history.[6]

When ethnicity becomes enthroned in this manner, as Hacker ...
argue, it becomes socially destructive. But that is not all, for it also becom...
noxious. Schlesinger's repeated references to the individual bear consideration,
today's cult of ethnicity denies the primacy of the most fundamental bonds between
people, which come from the possibility to relate together, through friendship or
love, as individuals. We must remember that de Maistre had prefaced his skepticism
about the existence of "man" in favor of a person's group identity with a denuncia-
tion of the humanistic Enlightenment credo: "The [French] Constitution of 1795,
just like its predecessors, is made for *man*. Now, in this world there is no such thing
as *man*."[7] The "man" that de Maistre could not find anywhere was the individual.
Like de Maistre, today's champions of ethnicity, seen as the core of a person's
identity, deny that person his or her basic humanity that cuts across race, ethnicity,
and religion.[8]

"Lost in the Battle"

Similarly, the theorists who emphasize the importance of the contingent situations
of cultural origins and values deny the possibility of universal or transcendent values
in art or morality. Furthermore, in this way of thinking works of art that have been
highly respected over time and thus that have been associated with what is seen as a
cultural canon have become, as David Denby has expressed it, "in some way tainted
by their association with power." In other words, "lost in the battle over the great
books are the books themselves."[9] As Terry Eagleton in "Proust, Punk or Both. How
Ought We to Value Popular Culture?" has perceptively observed, objections from
today's cultural left to the "canon" are not simply philosophical positions about the
nature of aesthetics. "[T]hese apparently aesthetic contentions," explains Eagleton,

> are in fact code for a political struggle. It is not really a question of whether Milton
> or Thomas Mann are as good as they are cracked up to be; what is at stake is the
> truth that these and other canonical reputations come to us silently inscribed with
> forms of institutional power. Those who have been for so long excluded from or

demeaned by that power – women, ethnic minorities and others – have excellent reasons for finding it objectionable; and it is not yet possible to disentangle those political judgments from aesthetic response.[10]

Yet disentangle they must, for their confusion together does disservice not only to the cause of art but also to clear thinking. Having once recognized the links between social disfranchisement and cultural legitimacy, one should then become free to separate the sociology of art from the aesthetics. This is not a package deal. Everybody, no matter what his or her political orientation or degree of social acceptance or marginalization, should be free to enjoy Milton and Mann on their own terms and regardless of their role in a cultural canon associated with a certain power elite.[11]

The same rule applies not simply to literature but also to the more general domain of thought and to the vocabulary of humanism. Walking a self-imposed tightrope between the political correctness of poststructuralism, which rejects concepts through contamination, and the traditional values of humanism, which abhors injustice but insists on the validity of terms independent of their tendentious use or rather misuse, Michael Wood addresses the "delicate matter" of the possible acceptability of words such as "universal" and "objective." In a review of Edward W. Said's *Culture and Imperialism* (1993), Wood speculates upon the possibly acceptable conditions of their "rehabilitat[ion]": "At this point, words such as 'universal' might make a comeback, because they would represent not the projection into time and space of whatever our civilization happens to be, but the discovery of authentically shared human grounds, old and new." After discussing the reasons why "[i]t will be more difficult to rehabilitate 'objective,'" Wood concludes, "All knowledge is potentially political, we might say; it does not have to be, shouldn't be politicized."[12]

Edward W. Said: Imperialism Revisited

For Said, though, the cultural and the political are inseparable. Furthermore, the "political context" is "a context that is primarily imperial." This is the underlying position taken in *Culture and Imperialism* where Said, writing about what he calls the "spheres" of politics and culture, asserts: "To the professional student of culture – the humanist, the critic, the scholar – only one sphere is relevant, and, more to the point, it is accepted that the two spheres are separated, whereas the two are not only connected but ultimately the same."[13] To the contrary, the humanist recognizes the use of culture by the world of politics but refuses to conflate the former with the latter in all times and in all respects. Said's caricature of the humanist's position is matched in its unwarranted audacity by the sweeping claims that he makes to sustain his own position. At the heart of his book lies the proposition that " . . . the great European realistic novel accomplished one of its principal purposes – almost unnoticeably sustaining the society's consent in overseas expansion. . . ."[14] Not only

does Said see the support for imperialism at the heart of the nineteenth-century novel's "purpose," he also argues that the very technique of narrative in these works is both analogous to and homologous with imperialism: "Without empire, I would go so far as saying, there is no European novel as we know it, and indeed if we study the impulses giving rise to it, we shall see the far from accidental convergence between the patterns of narrative authority constitutive of the novel on the one hand, and, on the other, a complex ideological configuration underlying the tendency to imperialism."[15] How, though, does imperialism either appear or play a significant role in novels such as Austen's *Pride and Prejudice*, Eliot's *Silas Marner*, Dickens's *Hard Times*, Flaubert's *Madame Bovary*, Zola's *L'Assommoir*, Goethe's *Elective Affinities*, Dostoyevksy's *Crime and Punishment*, and so forth? And how does storytelling – in other words, narrative – equate with imperialism?[16]

According to Said, in nineteenth-century Europe, especially Britain and France, "empire was a major topic of unembarrassed cultural attention."[17] The sweeping nature of this indictment is startling, for it ignores the antiimperialist or antislavery sentiments of important novelists, such as Austen, Hugo, Balzac, Dostoyevsky, Tolstoy, and others. Said does not discuss Hugo's antislavery convictions, expressed, for example, in *Les Misérables* (1862), not only in the incident with Thénardier, discussed in Chapter 1, but also when he declared that "John Brown is greater than [George] Washington."[18] Nor does Said relate Tolstoy's feelings about oppression in general and about imperialism in particular as found, for example, in his "A Letter to a Hindu," which opens:

> I have received your letter and two numbers of your periodical, both of which interest me extremely. The oppression of a majority by a minority, and the demoralization inevitably resulting from it, is a phenomenon that has always occupied me and has done so most particularly of late. (. . .) The reason for the astonishing fact that a majority of working people submit to a handful of idlers who control their labour and their very lives is always and everywhere the same – whether the oppressors and oppressed are of one race or whether, as in India and elsewhere, the oppressors are of a different nation. This phenomenon seems particularly strange in India, for there more than two hundred million people, highly gifted both physically and mentally, find themselves in the power of a small group of people quite alien to them in thought, and immeasurably inferior to them in religious morality.[19]

I do not understand how Said could include Balzac's name among the list of authors for whom "empire was a major topic of unembarrassed cultural attention."[20] One of the central themes, for example, of Balzac's *Eugénie Grandet* (1833), is the betrayal of Charles's love for his cousin Eugénie through the moral depravement that Charles undergoes in the colonial world. Eugénie has secretly given the money bestowed upon her by her miserly father to the penniless Charles, whose father had just committed suicide in shame because of involuntary bankruptcy, so that Charles

could go to the "Indies" to make his fortune. Unlike the later Thénardier, whose descent into the trafficking of slaves represented the final phase of an already advanced moral dissolution, the undoing of Charles Grandet presents the total corruption of a previously innocent young man. Balzac recounts the moral fall in the clearest terms in a chapter given the damning title "Ainsi va le monde" ("So goes the World" or "The Ways of the World"):

> While these things were taking place in Saumur [France], Charles was making his fortune in the Indies. (. . .) Crossing the Equator made him lose many of his preconceived ideas; he noticed that the best way to make a fortune in the tropical regions, as in Europe, was to buy and sell people. Thus he came to the shores of Africa and engaged in the trade of Negroes. . . .[21]

Having lost his moral values, Charles descended into a moral abyss: "Always focused on financial gain, his heart grew cold, contracted, dried up. The [miserly] blood of the Grandets did not fail to reach its destiny. Charles became hard, greedy for gain. He sold Chinese, Negroes, [etc.]."[22] These examples only begin to scratch the surface of a long and honorable tradition throughout the nineteenth and into the twentieth century on the part of novelists, both in their fiction and through letters and essays, who were vocal in their opposition to oppression in all forms.

Said's errors of omission are compounded by tendentious readings. The most important involve substantive interpretations that are made to exemplify the attitudes of an entire era.[23] Here Said's reading of Jane Austen's novels and in particular of *Mansfield Park* (1814, 2nd rev. ed. 1816) figures prominently in this book as it had in an earlier study.[24] In developing his argument, Said refers repeatedly to Austen in order to illustrate his thesis that her novels present an early and significant case of sustaining "society's consent in overseas expansion." Jane Austen is especially important to Said for she wrote "well before the scramble for Africa, or before the age of empire officially began."[25] Thus, for Said, Austen's fiction serves as an exemplary case study from which he would generalize about an entire period: "Perhaps then Austen, and indeed, pre-imperialist novels generally, will appear to be more implicated in the rationale for imperialist expansion than at first sight they have been."[26]

Yet Said's case against Jane Austen does not hold. Said ignores *Emma* (1816) where, through her characters, Austen condemns the "slave-trade," this trade of "human flesh," while referring to "the guilt of those who carry it on" and to the "misery of the victims," and while speaking approvingly of the movement to abolish the slave trade.[27] This explicit condemnation follows upon Austen's subtler treatment of the issue in *Mansfield Park*, a novel that Said uses as a prime example of Austen's alleged acceptance of colonialism and its attendant moral evils. Said is certainly correct in observing that the brief but repeated references to empire in this novel play a central role; but it is not the tacit acceptance of empire but rather its condemnation that emerges from a careful reading of the text. To understand this

point, it is necessary (1) to consider the degree to which the references to empire and slavery were an integral part of Austen's critique of the moral world of the family ensconced at Mansfield Park, (2) to place the action of the novel within the context of the movement to abolish the slave trade, as well as the actual passage of either the Abolition Act or the subsequent Slave Trade Felony Act during the course of the time period covered by the story, and (3) to attend to the pregnant meaning of the very name of "Mansfield Park," which evokes England's Chief Justice, Lord Mansfield, who in 1772 had rendered the famous judgment that had set free a Negro slave brought to England by his master, a judgment widely misunderstood as having emancipated by law if not in fact all slaves in England. Yet Said does none of the above. He does not discuss the meaning of the novel's name, just as he fails to mention the Abolition Act in the context of the discussion of the slave trade in *Mansfield Park*, and just as he ignores Austen's explicit condemnation of the slave trade in *Emma*.[28]

In widely casting his net of moral condemnation, Said includes the names of Wordsworth and Coleridge. Not content with indicting Austen, Said invokes the example of these two other authors so that he can generalize about the entire British establishment in the period that he characterizes as the preimperialistic era. "We must not admit any notion, for instance, that proposes to show that Wordsworth, Austen, or Coleridge, because they wrote *before* 1857, actually caused the establishment of formal British governmental rule over India *after* 1857." Their error, or guilt, according to Said, resides in their "using striking but careful strategies" that "validate" their own world while "tend[ing] to devalue other worlds and, perhaps more significantly from a retrospective point of view, they do not prevent or inhibit or give resistance to horrendously unattractive imperialistic practices." Said then proceeds to indict the British branch of the West's cultural establishment for its silence or acquiescence in this matter: "but it is genuinely troubling to see how little Britain's great humanistic ideas, institutions, and monuments, which we still celebrate as having the power ahistorically to command our approval, how little they stand in the way of the accelerating imperial process."[29]

What could Said possibly mean by associating the names of Wordsworth and Coleridge with imperialism and slavery?[30] He offers no supporting evidence. As numerous authors have noted, Wordsworth, Coleridge, and other Romantics were vocal in opposing slavery.[31] When the Abolition Act was passed in March, 1807, Wordsworth wrote a poem to honor the abolitionist Thomas Clarkson.[32] In addition to this often mentioned poem, Wordsworth, in "Humanity" (1829), condemned the ongoing acceptance of slavery: "Shame that our laws at distance still protect / Enormities, which they at home reject!"[33] As for Coleridge, in June, 1792, at the end of his first year at Cambridge University, he won the Brown Gold Medal for a poem condemning the slave trade, which he then read in a university forum. Wylie Sypher reports that the assigned subject had been "Sors Misera Servorum in Insulas

Indiae Occidentalis" – Wretched Lot of Slaves in the West India Islands.[34] This subject reflects an interest and anticipates a commitment that made Coleridge into an active abolitionist. Subsequently Coleridge would deliver two public lectures – one, "a daring attack" made in Bristol, a major center of the slave trade in England – and publish two articles on this subject, as well as addressing the issue in various other poems.[35]

To understand the context for these British writings, we should turn to a book that Said himself called a "classic," which reported that legislative attempts to abolish the slave trade had been introduced in Parliament beginning in November, 1787: "More than a hundred petitions praying for its abolition, including ones from the corporation of London, groups of clergymen, and the universities of Oxford and Cambridge, were presented."[36] In 1792 alone, some 400,000 people in Great Britain signed petitions calling for the abolition of the slave trade.[37] These hundreds of thousands of ordinary citizens who expressed their outrage over the practice of slavery by signing petitions found articulate champions in the leading figures of the literary world. In the world of letters, there was an extensive literature, especially in the form of tracts and poetry, written against the practice of slavery dating from the second half of the eighteenth century.[38] Readers will learn little of this in Said's *Culture and Imperialism*.[39] Said mentions neither the petitions from Oxford and Cambridge universities nor the protests by Coleridge and Wordsworth. Similarly Said appears to indict the entire British nation at the very least for unthinking complicity in slavery through asserting that "by the early nineteenth century every Britisher used sugar" produced by slave labor in the West Indies.[40] Yet Said does not mention the sugar boycott nor other forms of popular outrage and resistance to the products of slavery.[41] Like Eva Beatrice Dykes, Wylie Sypher had reported earlier that during the early 1790s

> [l]adies at evening parties refused to serve West-Indian sugar and recited anti-slavery tales. [Josiah] Wedgwood's [anti-slavery] seals appeared on snuff-boxes, brace-lets, and hairpins. In the smallest hamlets Clarkson found those who refrained from sugar and rum on principle – [Thomas] DeQuincey's father, for example. Grocers often left off trading in sugar.[42]

Considering the gravity of Said's charge that the leading cultural figures of this era were negligent in giving "resistance to horrendously unattractive imperialistic prac-tices," we might in response turn to an eloquent statement on the subject, found in Coleridge's review of Clarkson's *History of the Abolition of the Slave Trade* in the prestigious *Edinburgh Review* (July, 1808).[43] Published, as was customary of review articles, with no author named, the anonymity makes it an eloquent testimonial to the conscience of the age. From the very first words one senses the reviewer's profound sense of moral purpose: "There are works of so much moral worth, that it would imply a deadness of feeling in the critic, if, in reviewing them, he did not

abate some part of his wonted attention to the minutiae of style or arrangement."
This book, explains the reviewer,

> contains the history of the rise and progress of an evil the most pernicious, if only
> because the most criminal, that ever degraded human nature. The history of a war of
> more than two centuries, waged by men against human nature; a war too, carried
> on, not by ignorance and barbarism against knowledge and civilization; not by half-
> famished multitudes against a race blessed with all the arts of life, and softened and
> effeminated by luxury; but, as some strange nondescript in iniquity, waged by
> unprovoked strength against uninjuring helplessness, and with all the powers which
> long periods of security and equal law had enabled the assailants to develop, – in
> order to make barbarism more barbarous, and to add to the want of political
> freedom the most dreadful and debasing personal suffering.

After condemning the evil of slavery the anonymous writer addresses the moral
corruption that the practice effects not only in those who engage in slavery but also
in the entire society that condones and profits from it:

> The sufferings of the Africans were calculated, no doubt, to make a more rapid and
> violent impression on the imaginations and bodily sympathies of men; but the
> dreadful depravity that of necessity was produced by it on the immediate agents of
> the injustice; the almost universal corruption of manners which at the present day
> startles reflecting travellers on passing from the Northern States of America into
> those in which slavery obtains; and the further influence of such corruption on the
> morals of countries that are in habits of constant commercial intercourse, and who
> speak the same language; these, though not susceptible of colours equally glaring, do
> yet form a more extensive evil, – an evil more certain, and of a more measurable
> kind. These are, evil in the form of guilt; evil in its most absolute and most
> appropriate sense, – that sense, to which the sublimest teachers of moral wisdom,
> Plato, Zeno, Leibnitz, have confined the appellation; and which, therefore, on a well
> disciplined spirit, will make an impression deeper than could have been left by mere
> agony of body, or even anguish of mind; in proportion as vice is more hateful than
> pain, eternity more awful than time.[44]

These lines are among the most deeply moving expressions of moral sentiment in
the entire history of world literature. It is unfortunate that Said, who is a person of
immense learning, has chosen to ignore such an important aspect of the story of the
antiimperial and antislavery stance of the Western intellectuals cited here while
chastising them for their alleged silence.

Said's unwillingness to recognize opposition to slavery and imperialism becomes
even more baffling through his presentation of E. M. Forster's *A Passage to India*
(1924). Repeatedly in *Culture and Imperialism*, Said complains that European novelists
seemed uninterested in comprehending the world from the natives' point of view.[45]
Yet, Said does not inform his readers that after a brief two-and-a-half-page introduc-

tory chapter, the next chapter in *A Passage to India* opens by presenting British imperial rule through the eyes of the Indians who are among the protagonists in this novel. From the early pages of the book it becomes clear to the reader that one of Forster's main themes is that the British are regularly supercilious and disrespectful to Indians of all ranks and professions both through exclusionary rules and despicable behavior. Once again, Said will not recognize the global aspect of this characterization. According to Said, Forster in *A Passage to India* "cannot put his objections to the iniquities of British rule in political or philosophical terms, and only makes local objections to local abuses." Said proceeds to chastise the

> novel's helplessness [that] neither goes all the way and condemns (or defends) British colonialism, nor condemns or defends Indian nationalism. (. . .) Forster is evasive and patronizing. (. . .) His presumption is that *he* can get past the puerile nationalist put-ons to the essential India; when it comes to ruling India – which is what Hamidullah and the others are agitating about – the English had better go on doing it, despite their mistakes: "they" are not yet ready for self-rule.[46]

Forster, though, has presented so much evidence to the contrary. Not only do the British demean the Indians, both parties are keenly aware that the British suffer a moral degeneration of this nature through living in India as rulers.[47] As to the essential political situation, the British army in India is unequivocally called the "Army of Occupation."[48] Forster has Ronny Heaslop, the City Magistrate, ask with contemptuous irony that reflects a nervous self-awareness, "Did [the Muslim Dr. Aziz] seem to tolerate us – the brutal conqueror, the sundried bureaucrat, that sort of thing?"[49] Fielding too, the sympathetic Englishman who stands with the Indians when Dr. Aziz is wrongly accused of making violent sexual advances to Heaslop's British fiancée, reminds the reader about the British position in India when he repeatedly recommends to his Indian friends to "kick us out."[50] Forster obviously admires the character that he has created in Fielding, a man who "had no racial feeling," who lacked "the herd-instinct" which fed on personal insecurities to drive people into groups that hate outsiders. For Fielding, the world was "a globe of men who are trying to reach one another and can best do so by the help of good will plus culture and intelligence."[51]

If at times, through Fielding and others, Forster has reminded his readers of the difficulties that Indians would face in creating a nation with a social fabric of so many castes and religions, with their social barriers and antagonisms, this does not mean that he despaired of the possibility or desirability. As the narrator states unequivocally, the British Major Callendar "never realized that the educated Indians visited one another constantly, and were weaving, however painfully, a new social fabric."[52] To its merit, this novel has been more a reflection of social realities than a propagandistic tract.

Finally, when Fielding mocks Dr. Aziz about India becoming a nation, he is

primarily questioning the very institution of nationhood itself, which he denigrates as that "drab nineteenth-century sisterhood!" Centuries before the existence of nation states, Fielding reminds Dr. Aziz, India once had a greatness "whose only peer was the Holy Roman Empire."[53] Given all the troubles that attend the nineteenth-century nation state and its successor bodies, Fielding is raising questions about the contemporary fascination with this modern form of political association. He is not saying that the Indians are ill prepared for self-rule and that the British must remain as the imperial power.[54] Whatever the difficulties and imperfections of the nation state, this is clearly where Forster sees India headed by both necessity and right.[55] So, when at the end of the novel Fielding asks Dr. Aziz, "Why can't we be friends now?" in spite of their antagonistic political status – the British citizen of the occupying imperial nation and the subjugated Indian – Forster has the entire world respond in protest:

> But the horses didn't want it – they swerved apart; the earth didn't want it, sending up rocks through which riders must pass single file; the temples, the tank, the jail, the palace, the birds, the carrion, the Guest House, that came into view as they issued from the gap and saw Mau beneath: they didn't want it, they said in their hundred voices, "No, not yet," and the sky said, "No, not there."[56]

This concluding paragraph brings to a climax the various strands of the novel, all of which had been moving in this direction.[57]

How are we to account for Said's approach to the response to slavery and imperialism by the world of Western culture? Perhaps the answer can be found in Said's explanation of his method. Said disparages the Western academic tradition of attempting to write as objective a history as possible, given all that the limitations of one's own personality and intelligence, conditioned as they are by one's background and circumstances and constrained as well through the availability of sources, impose upon the scholar. He characterizes the modern Western "norm for scholarship" with terms that suggest that its goals hide either an unstated or unrecognized agenda. Thus, Said speaks of "its supposed detachment, its protestations of objectivity and impartiality, its code of politesse and ritual calmness." Rather than offering a universally valid and normative model for human behavior, such an approach to scholarship, according to Said, would furnish a fit subject "for the sociology of taste and knowledge" to inquire into its historical origins. Said contrasts such Western norms with the "frankly political impulse behind [the] work" of S. H. Alatas, George Antonius, Ranajit Guha, and C. L. R. James. Said's assessment of the writings of these four people can also be applied to his own: "The unresolved political situation is very near the surface, and it infects the rhetoric, or skews the accents of that scholarship. . . ."[58] Yet, the entire point of the Western norms for objectivity that Said dismisses is precisely to attempt the critical detachment from the passions of politics that can distort the historian's vision. Said's *Culture and*

Imperialism offers a warning about the dangers inherent in abandoning the quest for as objective a type of scholarship as possible, which involves considering all of the relevant evidence, even if unfavorable to the author's political and cultural predilections.[59]

Relativism and Determinism

Let us consider now the intellectual chain that links Hegel and Marx to the major poststructuralist writers. Whereas Herder's writings promoted cultural relativism, the German Idealists who followed reestablished universals but of a new kind. Not culture per se but rather the sequence of cultures or civilizations became the new absolute. Divinity was to be found not in the history of any particular culture but rather in the march of History as it proceeded triumphally forward through a progressive revelation of Spirit. Kant knew in his bones that history had a theological purpose. So too did Schelling who accepted this tenet as an "article of faith." For Schelling, "History as a whole is a progressive, gradually self-disclosing revelation of the absolute."[60] Although humanity was far from reaching that goal, Schelling had no difficulty in outlining the three stages through which human history had to pass. Fichte, on the other hand, argued that there were to be "five main epochs of life on earth" as envisaged by the *Weltplan* or "World Plan" whose main characteristics he was privileged to know and which he gladly shared with his readers. Of course, behind the "World Plan" was the "Idea":

> So, I said, the eternal and self-encompassing Idea, in itself living and from itself living, winds itself through the One stream of time. And, I add, in every moment in this stream of time, the Idea encompasses itself totally, penetrates itself totally, as it is in the entire limitless stream, eternal and always omnipresent for itself. What is present in the Idea in every moment *is* only in respect of what *was*, what has passed, and because there *should be* what will be in all eternity. Nothing is lost in this system. Worlds give birth to worlds; times give birth to new times, which latter ones stand in contemplation above the former enlightening the hidden connection between cause and effect in them.[61]

Hegel, coming last in this sequence, gets the credit today for this teleologically conceived vision of History with its predetermined sequence of eras in which the *Volkgeist* or "National Spirit," itself "identical with the absolute Universal Spirit," is a discrete factor within the larger *Weltgeist* or "World Spirit" that directs the march of Time. We should keep in mind Hegel's famous formulation, for we will hear its echoes later in poststructuralist thought: "The World Spirit is the spirit of the world as it reveals itself through the human consciousness."[62]

The German Idealists, then, not only elevated History to the status of divinity, they also added a determinism to the course of human events. Nor were they alone

in this endeavor. Marx, as is well known, turned Hegel upside down by substituting materialistic determinism for the Idealist "World Spirit" as the invisible guiding hand. This was an important move for it brought the Absolute back down to earth, not burying it within the mystical seeds of Herder's *Volk* but rather situating it in the capitalist's pocketbook.

Marx's focus on economic self-interest has had far-ranging effects on poststructuralist thought. In the more general sense its materialist determinism has served in part as godfather to those who deny the possibility of absolute values in morality or art. Yet this current argument also owes much to the deterministic legacy of French positivism as found, for example, in the work of Taine. Just as Taine had argued that history was a "problem of mechanics: the total effect is a composite determined entirely by the magnitude and the direction of the forces that produce it" – which he defined as "race, setting, and time"[63] – so too do today's positivists insist that birth, class, and schooling determine all. A person's ability to respond to art through an unmediated union between the individual's soul and the work of art is denied in favor of the sociocultural and economic background that is said to determine all and everything. We have seen the pendulum swing back and forth in the interminable debates about the respective importance of nature versus nurture. Yet rather than seek a nuanced balance between these two forces, today's positivists seem intent on denying any significant role to nature at all.

Art and Marxist Logic

To Marx's economic determinism Pierre Bourdieu has conjoined a sociological determinism whereby culture is reduced to a form of capital – literally "cultural capital" – with art serving only to enhance social status and power. As Stephen Greenblatt has observed, Bourdieu does not seem to believe that people can appreciate art out of an aesthetic interest or, if you will, a spiritual impulse. Commenting on Bourdieu's survey of motivations in visitors to art museums, a survey that excluded "any answer that would suggest the disinterested love of art," Greenblatt notes that "it is clear that [Bourdieu] regards any answer that appeals to pleasure or wonder or delight in the objects viewed as a screen, a misrecognition or misrepresentation that hides the motive that, 'in reality,' brings people to the museum."[64]

Such a repression of "true" motivation reminds us of Freud's obsession with repressed motivations, in his case generally of sexuality. Yet its origins derive from "the doctrine that states that valorizing man as such masks differences of class – a doctrine that one can find even in Marx himself, and one that he uses with great skill in *The Jewish Question* for a radical critique of the Declaration of the Rights of Man of 1789."[65] Thus, in a totalizing vision of the world circumscribed by class conflict, material self-interest, power, and status, humanist concepts of creativity, genius, and aesthetic values, along with the rights of man, are dismissed either as a ploy to mask

true and nefarious intentions for domination or as a weapon in the struggle to oppress the masses.

This conflation of what are actually separate issues – concepts about moral values rooted in Judaeo-Christian tradition and sustained by the Enlightenment's vision of natural rights, and concepts about the mind and spirit such as creativity, genius, and aesthetic experience, on the one hand, and, on the other hand, the unfair distribution of power and wealth in contemporary Western, or for that matter, any society – owes much to the legacy of the totalizing view of German Idealism. In the late nineteenth- and twentieth-century aftermath of this intellectual tradition, post-Hegelian and post-Marxist philosophers have connected the Enlightenment notion of human rights, the assumptions and attitudes of modern science, and the dynamics of contemporary capitalism and technology as philosophically interrelated in an indissoluble manner. All of these phenomena from disparate realms of societal activity are seen as belonging to one Idea. In this view of the world, the Enlightenment has an inner "dialectical" contradiction whereby its humanism has led to oppression – colonial, political, cultural, social, and sexual – thereby rendering its premises sterile and invalid and its basic propositions inherently self-contradictory.[66]

My concern here is with how Marxists view the world of culture, termed the "superstructure," in contradistinction to the material world, termed the "substructure." Whereas Marx had concentrated on the latter, Bourdieu has addressed himself to the former. Here he follows a tradition of Marxist intellectuals who had been active in the 1920s and 1930s, and for whom, as Hannah Arendt has observed, "the doctrine of the superstructure, which was only briefly sketched by Marx . . . assumed a disproportionate role in the movement as it was joined by a disproportionately large number of intellectuals. . . ."[67] One of the most influential of these earlier Marxist intellectuals was Walter Benjamin, whose essay, "The Work of Art in the Age of Mechanical Reproduction," has become a cult piece among today's Marxists as well as among non-Marxist poststructuralists.[68]

The popularity of Benjamin's text may explain to a large extent why the concepts of genius and creativity have been so widely denigrated in poststructuralist thought. Now that inexpensive mechanical reproductions of works of art are possible, affirmed Benjamin, the new means of reproduction "brush aside a number of outmoded concepts, such as creativity and genius, eternal value and mystery."[69] Just how the ability to disseminate an image of a work of art through mechanical reproduction "brushes aside" these concepts remains a mystery. Nonetheless, Benjamin adduces arguments to explain in part his conviction.

First, Benjamin believes that the "plurality of copies" diminishes the "aura" of the original. Yet, one might argue just the opposite. Anyone who has seen either black and white or even color reproductions of a painting has probably had the experience of heightened wonder and awe upon seeing the original, so much more resplendent in its physical reality. Only the sight of the original can convey the subtleties of

color, texture, light, shading, and expression. This is true not only with regard to painting and its photographic copies, but also of artistic photographic prints and mechanical reproductions of these "originals." Similarly, no amount of technical wizardry in compact disk recording can recreate those privileged moments at a concert when the audience feels that it is watching the players give coloration to the very breath of life through their music, a sensation conveyed especially through the mouthpiece of reed and wind instruments and, analogously, through the sense of touch on string instruments.

Benjamin is similarly mistaken when he argues that the "authenticity" and the "aura" of a work of art are dependent upon its "uniqueness" and that this aura is lost when the work is reproduced. The valuing of "uniqueness" belongs to the domain of the sociology of art.[70] The true, intrinsic "aura," as well as "authenticity," adhere to the aesthetics of art.

Photography, to Benjamin, has greatly contributed to the devaluation of painting and what he saw as its attendant "outmoded" aesthetic concepts. Here Benjamin mistakenly believed that the historical purpose of painting had been to reproduce literally what is seen in this world and that photography achieves this goal in a neutral, objective manner, thereby rendering the "aura" of painting obsolete. Not only are these two forms of art independent, but photography is as much an art of composition and expression as is painting. This is achieved in photography through the combination of a myriad of factors: the focal length of the lens, the angle of vision and its attendant distortions, the degree of focus through depth of field attained by lens settings as well as through the manipulation of the lens itself, the translation of light values often beyond the range of the film into the limited chemical parameters of the film, the alteration of this limit by manipulating time exposure and then chemicals used in developing, the rendering of lights and shadows through the type of paper employed in printing as well as the length of exposure, and the cropping of the image from the negative into a possibly different composition in the print. It is revealing of Benjamin's doctrinaire blindness not only about painting but also about photography that he labels as "ultrareactionary" the suggestion that film, which Benjamin sees as the most revolutionary of art forms, can serve an ostensibly nonobjective and nonrepresentational purpose. Benjamin dismisses Franz Werfel's observation that film "has not yet realized its true meaning, its real possibilities . . . these consist in its unique faculty to express by natural means and with incomparable persuasiveness all that is fairylike, marvelous, supernatural."[71]

Why was Benjamin so blind to such possibilities? The answer can be found in his Marxism. Marx, explains Benjamin in the opening part of "The Work of Art in the Age of Mechanical Reproduction," undertook his critique of the capitalist mode of production in a way that had "prognostic value," showing "what could be expected of capitalism in the future," whereby capitalism would create the conditions for its own overthrow by the proletariat. Benjamin saw his task as elucidating the changes in the

superstructure that correspond to this substructure. The superstructure of culture moves more slowly. "Only today can it be indicated what form this has taken." Benjamin's essay presents his Marxist thesis about the "developmental tendencies of art under present conditions of production. Their dialectic is no less noticeable in the superstructure than in the economy." According to this line of reasoning, then, the current means of production in the arts – mechanical reproduction – must therefore be undermining the culture of capitalist society. For Benjamin the mechanistic process is Marxist materialism operating in the arts. Photography and film, by their nature as well as through their appearance in History, are "revolutionary" forms of art.

Hence Benjamin's conclusions, even if they fly in the face of experience and common sense. These conclusions, moreover, are sustained by Communist values. For Benjamin the notions of genius and creativity seem exclusive and exclusionary; the art associated with these values belonged to the domain of the ruling classes. Only through the new art of film could Communist values be realized. Only in film, whether in newsreels about today's everyman or in Soviet films of Benjamin's time in which the ordinary citizen becomes the actor whereby people "portray *themselves* – and primarily in their own work process," can art belong to the masses. The fact that the film industry in the West was serving the interests of capitalism was to Benjamin a reactionary perversion of its true "revolutionary" purpose. Thus there was an inner historical determinism to the modes of production in art just as there were to the modes of economic production.

Hayden White's Epistemological Determinism

In place of Hegel's Idealistic determinism and Marx's materialistic determinism, Hayden White offers the model of an epistemological determinism. White not only writes approvingly of Hegel and Marx, he also talks the language of German Idealism, whose effect is to give the impression that the process described is inevitable. Thus, we are told that "discourse" is "a product of consciousness's efforts to come to terms with problematical domains of experience" as well as "the verbal operation by which the questing consciousness situates its own efforts to bring a problematical domain of experience under cognitive control." According to White, "consciousness" operates according to what he sees as the four major tropes of classical rhetoric – metaphor, metonymy, synecdoche, and irony. Like Hegel and Marx, White sees the march of history at play here, not the history of entire societies but rather that of individual consciousness. Thrilled to find that Jean Piaget's studies of the four phases of the cognitive development of the child – sensimotor, representational, operational, and logical – can, in his reckoning, be assimilated to these four major tropes, White finds a confirmation in the determin-

ing importance of these tropes for mature human thought, what he calls "the fully matured consciousness." In this post-Freudian era, spiced with Jungian archetypes, White draws Hegel and the Idealists out of the sky to locate the course of the Idea revealing itself and coming to know itself within the innermost recesses of the psyche:

> As thus envisaged, a discourse is itself a kind of model of the processes of conscious-ness by which a given area of experience, originally apprehended as simply a field of phenomena demanding understanding, is assimilated by analogy to those areas of experience felt to be *already* understood as to *their* essential natures. Understanding is a process of rendering the unfamiliar, or the "uncanny" in Freud's sense of the term, familiar; of removing it from the domain of things felt to be "exotic" and unclassified into one or another domain of experience encoded adequately enough to be felt to be humanely useful, nonthreatening, or simply known by association. This process of understanding can only be tropological in nature, for what is involved in the render-ing of the unfamiliar into the familiar is a troping that is generally figurative. It follows, I think, that the process of understanding proceeds by the exploitation of the principal modalities of figuration, identified in post-Renaissance rhetorical theory as the "master tropes" (Kenneth Burke's phrase) of metaphor, metonymy, synecdoche, and irony. Moreover, there appears to be operative in this process an archetypal pattern for tropologically construing fields of experience requiring understanding which follows the sequence of modes indicated by the list of master tropes as given.[72]

It is not certain that Piaget's four stages of the child's cognitive development adequately describe early human development, nor is it certain that these four stages can be assimilated to so-called "tropological" patterns of thought. The phenomenon of understanding, moreover, cannot be reduced to the function of rendering the unfamiliar familiar. It can, for example, involve obtaining insight about the familiar by comprehending it in a new way. It can even, if one adheres to Keats's notion of "negative capability," mean the acceptance of uncertainty over certainty, "that is, when a man is capable of being in uncertainties, mysteries, doubts, without any irritable reaching after fact and reason."[73] Ultimately, an understanding of the overarching mysteries of love, life, and death may render the familiar quite unfamil-iar, totally infused with mystery. Yet White, the ultimate Idealist, is thrilled by the seemingly dual confirmation of "consciousness" revealing itself through time in the four stages of the psyche's history as it develops in the child's mind and then proceeding to reveal itself in the adult's mind through the mature archetypes of this consciousness.

Let us consider, for a moment, what these rhetorical devices are. Synecdoche, for example, is "a figure of speech by which a part is put for the whole or the whole for a part, the special for the general or the general for the special, as in 'a fleet of

ten *sail*' (for *ships*) or 'a *Croesus*' (for a *rich man*)."[74] Can "synecdoche" actually be one of the main operations of human thought, limited in White's theory to four types?[75]

And what are we taught when poststructuralists apply such thinking to history or to historical texts? In my own field of architectural history I recently read that an eminently sensible essay, which had won the prize awarded by the Society of Architectural Historians for the best article published in this organization's scholarly journal in 1981, was not really history guided inductively by the evidence ascertained in the documents but rather an intellectual exercise deductively "guided by the trope of synecdoche." According to this poststructuralist account, the "use of this trope induces the fabrication of a synthetic and unified vision of [the architect] as the author of an integrated *oeuvre*. It also points to [the prize-winning essayist's] vision of the larger aim of the historian's endeavor."[76] Thus, in this late example of post-Hegelian determinism, both art and history imitate the Idea, here conceived as one of the four "tropological" channels of the human mind. It is as if White's alleged archetypes had been encoded into one of those 1950s television channel knobs, the ones with only a set number of places, in the days before digital dialing. Yet, perhaps the seemingly endless possibilities of digital dialing, sustained by the countless channels that ordinary TV coupled with cable TV offers, provide a more accurate "metaphor" for the operations of the human mind.

History's Inner Rhythms

It was this reductive determinism in all of its nineteenth-century variants that further set the stage for today's oversimplification of cultural history and individual thought, as well as creativity. Whereas not all deterministic thinkers have seen History as proceeding forward according to a divinely predetermined path, they have often postulated a different sort of inner rhythm to the course of human events. Saint-Simon's followers, for example, divided history into "organic" and "critical" epochs, thereby distinguishing between what they saw as "the organized systems and the periods of transition" in history.[77] In German-speaking lands, from Goethe onward these distinctions were rendered as "objective" and "subjective" eras, the latter being transitional periods without distinctive and unified character.[78] Students of the nineteenth-century are well aware that the century was plagued by laments about the current times being an inadequate age, lacking in a comprehensive and unifying spiritual impulse that could give direction, purpose, character, and maturity to its art in particular, and to its culture in general.[79] Yet has there ever been a time in history when society enjoyed such a paradisiacal condition? We certainly would not accord this status to the medieval or Greek worlds that were evoked as ideal epochs by wistful nineteenth-century minds. Nevertheless, the myth of "organic" or

"objective" eras remains strong to this day, as we read, for example, that "post-modernism" is

> a transitional cusp of social, cultural, economic and ideological history, when mod-ernism's earnest principles and preoccupations have ceased to function but have not yet been replaced by a totally new set of values. It represents a moment of suspen-sion before the batteries are recharged for the new millennium, an acknowledgment that preceding the future is a strange and hybrid interregnum that might be called *the last gasp of the past*.[80]

To talk about trends in current culture as "symptoms of our present human condition"[81] is also to indulge in the positivistic and ideological thinking of the last century that ignores the complexity of any individual's mental universe, let alone the assemblage of all such universes together in what is termed society. The tendency to cast entire eras in stark terms of unitary intellectual focus remains with us today in both advocates and critics of poststructuralist thought. Thus, we find the conservative professor of aesthetics Roger Scruton observing, "A few noble spirits – from Montaigne through Burke and de Maistre down to Ortega and T. S. Eliot – have resisted modernity," as if the concatenating chain of ideas and ways of thinking that reaches, to use Scruton's own list – from Bacon, to Descartes, to the *philo-sophes*, to Kant, and onward – can be pigeonholed into any singular and unified notion, call it "modernity" or anything else.[82] The same inadequacy arises when poststructuralists attempt to explain the "postmodern" as if our lives have not simply been touched in part by new social phenomena rather than our entire existence having been circumscribed by a so-called postmodern condition.

Yet this entire trend toward generalization is characterized by a faith in theorizing whose ultimate realizations are called "theory" itself, which is set against what is deemed to be "history." The Idealist basis of so much of poststructuralist thought has provided the foundations of its faith in ideology. When Fichte affirmed that the philosopher "does not use history in order to prove anything because his principles were already proven earlier and independently of history,"[83] he was canonizing the ideological outlook that finds its counterpart in today's lionization of "theory."

Justifying "Theory"

Whether the determinism is Idealist, Marxist, or positivist and whether the intellec-tual domain is economics, philosophy, sociology, epistemology, or art history, post-structuralist discourse attempts to replace humanistically based history with its own tendentious "theory." Now we must ask how do the poststructuralists establish and justify their claims for the priority of what they call "theory"? As we look more closely at poststructuralist thought, we must consider not only what is said but also how it is argued.

Poststructuralists often strike the stance of the scholar as Romantic rebel, opposing the received wisdom or standard practices of the profession. Here reference to the so-called tired clichés of the profession are standard fare: the alleged obtuseness of those who preceded serves as a foil to glorify the new approach. In place of their predecessors' "history," poststructuralists will do "theory." Thus, we find Paul de Man, for example, opening his "Autobiography As De-Facement" by arguing in this manner:

> The theory of autobiography is plagued by a recurrent series of questions and approaches that are not simply false, in the sense that they are farfetched or aberrant, but that are confining, in that they take for granted assumptions about autobiographical discourse that are in fact highly problematic. They keep therefore being stymied, with predictable monotony, by sets of problems that are inherent in their own use.

Yet de Man buttresses his claims primarily through a caricature of those purportedly mistaken approaches.[84]

Similarly, Norman Bryson, in *Vision and Painting: The Logic of the Gaze* (1983), a book that countless students in art history read as part of their course work on methodology, tells us that because art history has been relatively exempt from poststructuralist thought, it has slumbered in a "stagnant peace," thereby relegating its accomplishments to "an increasingly remote margin of the humanities, and almost in the leisure sector of intellectual life." Having chosen not to get on the bandwagon of the new thought, it has been left behind by History:

> It is a sad fact: art history lags behind the study of the other arts. Whether this unfortunate state of affairs is to be attributed to the lethargy of the custodians of art, too caught up in administration and the preparation of exhibitions and catalogues to channel their remaining energies into analytic writing, and too preoccupied with the archive to think long and hard about what painting actually is, or to the peculiar history of the institutions devoted in this century to the study of art, a history which from the beginning had tended to isolate that study from the other humanities, or to some less elaborate reason, such as the plain stasis, conservatism and inertia fostered by the sociology of the profession of art history, I cannot say.[85]

Thus Bryson would have us believe that his colleagues have been like so many academic bean counters and nut gatherers, who for some reason have not produced intellectually incisive work. Bryson then proceeds to make the astonishing claim that the only art historical work that "[fills] the gap between philosophy and art history" is Ernst Gombrich's *Art and Illusion*. This is a curious assertion to have been made in 1983, because Gombrich's book publishes the contents of his A. W. Mellon Lectures in the Fine Arts delivered at the National Gallery of Art in 1956. In this manner Bryson dismisses not only the twenty-seven years of art historical scholarly thought that have followed Gombrich's lectures but also the rich intellectual tradition that preceded it.

With Bryson one bold claim follows another. Yet before delving into the nature of Bryson's argument, it should be noted that unsubstantiated generalizations, belied

by the most cursory survey of the historical record, are a common feature of today's "critical theory." Take Terry Eagleton, for example, with his lead article in the *Times Literary Supplement's* ecumenical issue devoted to "critical theory now" (July 15, 1994).[86] Adhering to the rhetorical manner of Theodor Adorno's *Aesthetic Theory*, Eagleton generalizes here about the humanist conception of art as grounded in "a universal humanity" and in a divorce of culture from politics and about the "aloof elitism" of modern art.[87] On the first two themes, Eagleton explains:

> The liberal humanist conception of literature sees the act of reading as one which engages a universal human subject, one which must divest itself of its cultural idiosyncrasies if it is to enter at all deeply into this compact. (. . .) Ever since the Enlightenment, culture has been, in effect, the "other" of political society – the realm of being as opposed to doing, the kingdom of ends rather than of means, the home of transcendental spirit rather than the dreary prose of everyday life.

How are we to square these claims with the patently dual nature of character in the nineteenth-century "humanist" novel? These novelists generally wrote about their particular social and political world. Thus, in the novel there is at once an appeal to a shared humanity and to the specifics of a discrete cultural condition. We find this dual condition, for example, in the depiction of the dilemma of the former convict in early nineteenth-century France through Hugo's Jean Valjean (*Les Misérables*), of the industrial worker in early nineteenth-century England through Dickens's Stephen Blackpool (*Hard Times*), or of the impoverished working woman in mid-nineteenth-century Russia through Dostoyevsky's Sonia Marmeladov (*Crime and Punishment*), among other examples. Furthermore, many of these novelistic characters are not merely types but also distinct personalities, as individual and idiosyncratic as any real person whom one might know from the same distance. Contrary to Eagleton's assertions, the novelists who created these personalities made the "transcendental spirit" shine through their depictions of contemporary people, often with great pain, by dwelling on "the dreary prose of everyday life."

Similarly, the reality of modern art belies Eagleton's generalization that "the critical force of the modernist work of art was deflected by its distance from social life," thereby exhibiting an "aloof elitism."[88] Using a widely accepted notion of the period of modern art, I wonder what Eagleton thinks about the paintings by Goya of the mutilation and murder of innocents in war, by Daumier of the hunched over and weary working women and their children in the French city, by Manet of the lot of the Parisian barmaid, by Millet of the French peasant farm hands, by Chagall of the insular life in the Russian Jewish *shtetl*? If Eagleton wishes for more recent evidence as well as a more abstract modernist style, what would he say about the Russian Constructivist artists in the 1920s who celebrated the Communist Revolution or the American artists in the 1930s and 1940s who used their avant-garde art to condemn various forms of European fascism?

Certainly Eagleton is aware that postmodern architects have mocked the social

convictions of what is now disparagingly termed the Modern Movement in architecture, whose leading practitioners in the first half of this century turned a generally elitist profession that had served wealth and privilege toward a social commitment to sanitary housing and working conditions for the masses; and who, moreover, insisted that the design of buildings could not be divorced from the design of cities because the organization of the entire human habitat impinged directly on the quality of life for the ordinary person. This social engagement was highlighted by polemical rallying cries throughout Europe such as functionalism, rationalism, and *Sachlichkeit*; by neologisms such as *urbaniste* and town planner; and by compound words such as *architecte-urbaniste*. Architects, critics, and practitioners of the applied and decorative arts united to oppose the aestheticizing formula of "art for art's sake" with the commitment to "art in everything and for everybody." Against the elitist concept of what was called an "aristocratic art," congresses were held to promote the creation of a "public art."[89] Yet, in spite of all this evidence, Eagleton and other champions of theory, like their German Idealist predecessors, make grand claims untroubled by the empirical record.[90]

Bryson and Fundamental Errors

Within the domain of contemporary "theory," Norman Bryson's stature in the world of art history is comparable to Eagleton's in the area where politics and culture coincide. According to Bryson, from Roman antiquity to the present, Western writings on art have mistakenly seen painting as the mere reflection of the real world. It is unfortunate that Bryson does not cite the example of critics who centuries ago celebrated aspects of representational painting that depart from the illusion of literal reduplication. One recent study of seventeenth- and eighteenth-century art emphasizes that the "painterly (*pittoresco*) brushwork of Titian, Tintoretto, Veronese and their heirs in the seventeenth century challenged the fondest preconceptions held by many Renaissance and Baroque artists and their critics. Concepts of naturalism, imagination, style and ornament had to be reconsidered as artists began to replace the polished surfaces of tempera or the hazy clouds of *sfumato* with new techniques of visible brushwork, notably dry brush, impasto and other forms of the loaded brush."[91] In other words, the painterly tradition did not begin with the more famous nineteenth- to twentieth-century sequence that proceeds from Turner to the Impressionists to the Fauves. Not only does Bryson ignore the tensions between naturalistic and purposeful brushwork that calls attention to itself, he misrepresents Gombrich's classical study in *Art and Illusion* concerning the nature of illusion created in naturalistic representations of the real world. According to Bryson:

> To the question, what is a painting? Gombrich gives the answer, that it is a record of a perception. I am certain that this answer is *fundamentally* wrong, and in the first three

chapters of this book I try to show why. Because the error is fundamental, I have gone back to the beginning, to the origin of Gombrich's ideas in the aesthetics of antiquity. . . . It is a natural enough attitude to think of painting as a copy of the world, and given the importance of realism in Western painting it is perhaps inevitable that eventually this attitude would be elevated to a doctrine, as it has been by Gombrich. . . .[92]

At this point Bryson has made two amazing claims: first, that the sum total of art historical thinking can be reduced to the equation of painting with a "record of a perception"; second, that this is the theme of Gombrich's book. In response to the first issue, one wonders how Bryson can ignore, for example, the main thrust in art history over the previous half century dominated by iconography, the study of the symbolism, allegories, and related meanings of objects and figures in art, and by iconology, the attempt to relate these symbolic meanings to the broader cultural context, to what Erwin Panofsky, in his seminal essay of 1939, termed "the political, poetical, religious, philosophical, and social tendencies of the personality, period or country under investigation"?[93] Of course, Bryson is fully aware of the iconological tradition, whose importance he explicitly acknowledges in the opening paragraph of Chapter 3.[94] Yet, for the purposes of establishing his overall schema in the preface, this tradition is not considered there.

As for the second issue, it is simply mistaken to characterize Gombrich's *Art and Illusion* as an exposition of the idea that painting is merely a record of perception. To the contrary, Gombrich actually forewarns his readers that he is not equating art with perception and its presentation. Beginning with his first paragraph Gombrich explains that painting is largely "subjective" in its depiction of the world and that different civilizations perceive "nature in a different way." Given this variability, Gombrich has chosen to study, as explained by the book's subtitle, which is not mentioned by Bryson in his own text, "the psychology of pictorial representation."[95] Thus, Gombrich's intention is to elucidate the many different ways that illusionistic art can suggest the real world: "The way the language of art refers to the visible world is both so obvious and so mysterious. . . ." In the end, Gombrich has chosen to explore the question of the art of illusion in order "to teach us the art of wonder again."[96] The particular wonder that is his subject is not the achievement of the total and hence deceptive illusion. It is the willing suspension of disbelief in face of some artistic contrivance that does not really depict but only suggests. It is not the mirror to reality that he seeks but rather the mysterious transformation in the mind that finds aesthetic satisfaction in a purposefully abstracted and stylized approximation of reality.

Thus, after erroneously attributing to Gombrich the notion that art is the record of perception, Bryson then attempts to correct him by explaining that painting is "an art of signs, rather than percepts."[97] It certainly is curious to find Bryson in 1983 telling the author of *Symbolic Images: Studies in the Art of the Renaissance*, published in

1972, that painting is an art of signs. If anybody is "*fundamentally* wrong," it would be Bryson rather than Gombrich.

Not only does Bryson attribute to Gombrich an idea that is diametrically opposed to what Gombrich actually says, he then proceeds to do the same with the eminent Pierre Francastel. Having pronounced that Gombrich mistakenly saw art as a record of perception, Bryson now maintains that there has been a "doctrine of progress that dominates the traditional account of painting from Pliny to Francastel" whereby painting is seen to progress as it comes closer to the creation of a truer illusion of reality and whereby the history of painting has been the record of the various stages of that progress.[98] Turning to Francastel's *La Figure et le lieu: L'ordre visuel du Quattrocento* (1967), Bryson now adduces a quotation apparently by Francastel that demonstrates his point. The problem is that Francastel has not said the words that Bryson attributes to him. Bryson's quotation is a tendentious translation of Francastel's actual words which radically alters his meaning by substituting a poststructuralist discourse for Francastel's humanist argument. As a result, Francastel's wording and hence meaning are changed in the course of translation. In addition, Bryson has omitted a significant portion of Francastel's text without marking the elision for the reader. This further distorts Francastel's text without alerting readers to the fact that they are being presented with an altered quotation tailored to serve Bryson's desired ends. As if this were not enough, Bryson neglects either to mention or quote Francastel's emphatic remark made only two pages later whereby Francastel explains that it is a popular misconception to think of painting as a reproduction of exterior reality.[99]

By the time that Bryson has finished with Francastel, he has the French art historian supposedly championing "Universal Visual Experience," which is a tendentious translation of Francastel's actual words. Rendered by Bryson with capital letters, "Universal Visual Experience" becomes an easy target for ridicule, much like the Idealist *Zeitgeist* in Tom Wolfe's memorable section title, "The Spirit of the Age (and what it longs for)."[100] Bryson concludes by placing Francastel at the tail end of an alleged tradition in which "Each 'advance' consists of the removal of a further obstacle between painting and the Essential Copy: which final state is known in advance, through the prefiguration of Universal Visual Experience."[101] Yet, as I have indicated, the history of Western art criticism has not been synonymous with a theory of advances in representation so as to create a so-called Essential Copy.

Hayden White and the Laws of Discourse

In poststructuralism, it is important to watch how modest claims, initially proffered as such by their authors, are subsequently accorded the status of earth-shaking pronouncements on the level of the earlier German Idealists' "Idea," "World Plan,"

and "World Spirit." This is precisely how Hayden White establishes his claims for the importance of his theory of "tropology." In the opening chapter to *Tropics of Discourse: Essays in Cultural Criticism* (1978), in which White introduces the reader to his theory about "tropology, discourse, and the modes of human consciousness," White correctly asserts the modesty of his theory of the "fourfold pattern of tropes":

> The ubiquity of this pattern of tropological prefiguration, especially as used as the key to an understanding of the Western discourse about consciousness, inevitably raises the question of its status as a psychological phenomenon. If it appeared universally as an analytical or representational model for discourse, we might seek to credit it as a genuine "law" of discourse. But, of course, I do not claim for it the status of a law of discourse, even of the discourse about consciousness (since there are plenty of discourses in which the pattern does not fully appear in the form suggested), but only as the status of a model which recurs persistently in modern discourses about human consciousness. I claim for it only the force of a convention in the discourse about consciousness and, secondarily, the discourse about discourse itself, in the modern Western cultural tradition.

In other words, in this passage White is saying that the purported "fourfold pattern of tropes" appears to be a pattern by which certain but not all thinkers in modern times and in the Western world have organized their ideas. Yet two pages later he makes a far headier claim, one that dominates his work and those of his followers. Now White is claiming that his theory of tropes reflects the "signs of stages in the evolution of consciousness." His theory of tropes has now been elevated to a psychological law, which, he feels corresponds to Freud's discovery about the mechanism of dreams: "Or, to put it in terms of theory of discourse, once we recognize Freud's notion of the mechanisms of the dreamwork as psychological equivalents of what tropes are in language and transformation patterns are in conceptual thought, we have a way of relating mimetic and diegetic elements in every representation of reality, whether of the sleeping or the waking consciousness."

White finds still further confirmation of the universal status of his theory through the work of Marx and of the Marxist historian E. P. Thompson. White affirms, "I have shown how Marx anticipated the discovery of these transformational patterns in his analysis of the forms of Value in *Capital* and how such tropical structures served him as a way of marking the stages in a diachronic process, such as the events in France between 1848 and 1851, in *The Eighteenth Brumaire of Louis Bonaparte*." This last claim for tropology may be the most amazing of all, for not only is it being presented as an explanation of the operations of the sleeping and the waking consciousness, it has now been enlisted to serve the Idealist march of History as viewed by Marx's materialist determinism. Turning to Thompson's *The Making of the English Working Class*, White is not content modestly to discern the use of the

"tropological organization" as a further example of its popularity in modern, Western historical writing. Rather he finds additional confirmation of his understanding of the underlying psychological and Idealistically viewed historical processes that are guided by the four "master tropes" since Thompson "apparently *discovered* the phases in question" from within rather than imposing them from without.[102]

Derrida: "Parasitology" and Nihilism

Finally, we turn to Jacques Derrida. Derrida is certainly the most quoted personage within poststructuralism, universally recognized as the leading "deconstructionist." What exactly is the nature of his argument?[103] How does he attempt to earn our conviction, our adherence to his views? Writing about Derrida's defense about Paul de Man's wartime journalism, an issue discussed shortly, Terry Eagleton has referred to the "tortuous" quality of Derrida's text.[104] Can we assign this epithet to Derrida's work as a whole? Here is a sample, taken from a discussion of the creative imagination:

> To grasp the operation of creative imagination at the greatest possible proximity to it, one must turn oneself toward the invisible interior of poetic freedom. One must be separated from oneself in order to be reunited with the blind origin of the work in its darkness. This experience of conversion, which founds the literary act (writing or reading), is such that the very words "separation" and "exile," which always designate the interiority of a breaking-off with the world and a making of one's way within it, cannot directly manifest the experience; they can only indicate it through a metaphor whose genealogy itself would deserve all of our efforts. For in question here is a departure from the world toward a place which is neither a *non-place* nor an *other* world, neither a utopia nor an alibi, the creation of "a universe to be added to the universe," according to an expression of Focillon's cited by Rousset (*Forme et Signification*, p. 11 [sic]). This universe articulates only that which is in excess of everything, the essential nothing on whose basis everything can appear and be produced within language; and the voice of Maurice Blanchot reminds us, with the *insistence* of profundity, that this excess is the very possibility of writing and of literary *inspiration* in general. Only *pure absence* — not the absence of this or that, but the absence of everything in which all presence is announced — can *inspire*, in other words, can *work*, and then make one work. The pure book naturally turns toward the eastern edge of this absence which, beyond or within the prodigiousness of all wealth, is its first and proper content.[105]

Where have we heard this before, not the actual words but rather the rhythms of speech? One might think back to Heidegger and Husserl. But let's proceed even further back in time to the German Idealists. Derrida has the most musical ear. He has been highly successful in capturing the rhythms of Idealist discourse. Compare this text, for example, with the passage from Fichte quoted earlier.[106] The Idealists

invented a literary style that makes you feel as if you are swimming, or rather, floundering in an intellectual sea of primordial matter. This German cultural invention was sustained in modern times by Husserl and Heidegger but has been perfected in the French language by Jacques Derrida.

What, though, are Derrida's intentions in writing this way? For guidance perhaps we should turn to a scholar who believes that Derrida's writings merit a high level of "sustained analytic attention," especially by philosophers who must "rescue Derrida from the false characterization of his work put about by literary critics." Gladly accepting the judgment of such a person, I was not surprised to read that "[t]hough Derrida has been dismissed as a mere rhetorician, there is no doubt that he presents a serious challenge to those Western philosophers who take philosophy as a rational dialogue in the quest of communicable truth."[107] The passage on creative imagination from this poststructuralist master quoted here makes this assessment eminently clear. If you sense that there is a purposefully disruptive element in such a text, disruptive even in a destructive way, then you can find confirmation of such an intention in Derrida's recent words summarizing the unity of his work:

> I often tell myself, and I must have written it somewhere – I am sure I wrote it somewhere – that all I have done, to summarize it very reductively, is dominated by the thought of a virus, what could be called a parasitology, a virology, the virus being many things. I have written about this in a recent text on drugs.[108] The virus is in part a parasite that destroys, that introduces disorder into communication. Even from the biological standpoint, this is what happens with a virus; it derails a mechanism of the communicational type, its coding and decoding. On the other hand, it is something that is neither living nor nonliving; the virus is not a microbe. And if you follow these two threads, that of a parasite which disrupts destination from the communicative point of view – disrupting writing, inscription, and the coding and decoding of inscription – and which on the other hand is neither alive nor dead, you have the matrix of all that I have done since I began writing.[109]

In a universe literally dominated by the principle of entropy, whereby all physical things tend toward disorder and decay, it has been the humanist goal to foster and sustain all that affirms life and nurtures creativity. Derrida's "parasitology" and "virology" operate, as he explains, in the opposite way. This is nihilism pure and simple. Here we have arrived at the heart of the poststructuralist enterprise, which is profoundly antihumanist.

When we delve more deeply into the heart of poststructuralism we find an obsession with discussing literature, art, and philosophy in terms of violence and dismemberment, thereby mixing an even more somber nihilist spice, at times with erotic overtones, into the poststructuralist soup. The most disturbing of all the poststructuralists who intertwine death and disfiguration with discussions of art and literature is Paul de Man. In an insightful letter to the *Times Literary Supplement* in

1988 during the de Man wartime journalism controversy, Stanley Corngold, Professor of Germanic Languages and Literatures at Princeton University, demonstrated that de Man's poststructuralist writings were "marked by a recurrent and major tone of arbitrary violence" as in texts such as: "'Writing always includes the moment of dispossession in favour of the arbitrary power play of the signifier; and from the point of view of the subject, this can only be experienced as a dismemberment, a beheading or a castration.'"[110] Seeing a unity between de Man's wartime writings of 1939–41 glorifying the Nazi cause and his poststructuralist work, Corngold points out the amoral, or rather immoral, stance that de Man took with respect to Nazi warfare, terror, and murder, and to his understanding of literature:

> What is plain is that in neither case does [de Man's] rhetoric encourage a grain of resistance to the coercions laid on individuals by the "hegemonic" violence of other peoples or texts. Such are the consequences of his steadfast belief in the need for a superself called "poetic consciousness" or "literary language" or "text" to evolve or "occur" according to its own great laws independent of its effect on the moral relations between persons and the lives of persons.
>
> From this de Man emerges as a strong philosopher of the inhuman condition – a condition in which the important relations are necessarily inhuman. It is no individual poet but "poetic language" that engages "in its highest intent . . . tending toward the fullest possible self-understanding." (. . .) Not Shelley but *The Triumph of Life* warns us that nothing, whether deed, word, thought, or text, ever happens in relation, positive or negative, to anything that precedes, follows, or exists elsewhere, but only as a random event whose power, like the power of death, is due to the randomness of its occurrence" (*Rhetoric*, p. 122).[111]

There is a chilling, inexorable quality to de Man's characterization of poetry and life. It has the feel of a steely machine of destruction. Indeed, Corngold points out that for de Man literature "operates like a type of reckless person or implacable machine."

A large part of the terror engendered by this vision comes from the frame of mind nurtured by German Idealism whose language replaces the acting and hence morally accountable person with a passive subject acted upon and directed by larger outside forces. As Corngold observes, for de Man, "[n]ot the writer but 'the text imposes its own understanding and shapes the reader's evasions' (Introduction to *The Dissimulating Harmony* by Carol Jacobs, p. 6)." Similarly, "literature is supposed to arise from the non-empirical transcendental poetic consciousness (*Blindness and Insight*, 1971) and the non-empirical mechanisms of literary language (*Allegories of Reading*, 1979)." Corngold presciently links de Man's approach to mind, reality, and moral responsibility in such poststructuralist texts with de Man's wartime writings, such as "'the development [of literary style] does not depend on arbitrary, personal decisions but is connected to forces which perform their relentless operations across

the doings of individuals' (*Het Vlaamsche Land*, June 7–8, 1942)." This is pure German Idealism, where the greater than individual force is directing History from above. This is also the way, mixed with the German Romantic belief in the mystic quality of the *Volk*, that de Man understood and welcomed the Nazi conquest of Europe, as expressed in another passage quoted by Corngold:

> Germany is a *Volk* [*peuple*] . . . heavy with a host of aspirations, values, and claims coming to it from an ancestral culture and civilization. The War will only bring about a tighter union of these two things – the Hitlerian soul and the German soul which, from the start, were so close together – until they have been made one single and unique power. This is an important phenomenon, because it means that one cannot judge the fact of Hitler without judging at the same time the fact of Germany and that the future of Europe can be envisioned only in the frame of the needs and possibilities of the German spirit. It is not a matter only of a series of reforms but of the definitive emancipation of a people which finds itself called upon to exercise, in its turn, a hegemony in Europe. [*Le Soir*, October 21, 1941].

Here then we have the sad and perverted legacy of German Idealism, for from Kant to Hegel, the march of History was to realize a universal condition of goodness, justice, and salvation. The perversion owes much to Nietzsche. As Corngold rightly observes:

> All these rigorous and relentless textual agents and, later, inhuman mechanisms suggest the "unconscious artist," Nietzsche's artist-type who has "the ability to organize." When de Man in his late work gives texts the properties of persons who entrap, coerce, kill, disfigure and mutilate readers, he conjures a personality beyond Good and Evil of the type of Nietzsche's New Man as he was received in de Man's youth by George, by D'Annunzio, by Benn. This is the "new philosopher," whose goal is "to prepare great ventures and over-all attempts of discipline and cultivation by way of putting an end to that gruesome domination of nonsense and accident that has so far been called 'history.'"

In the end, the poststructuralist denies history by investing Theory with the power, now demonic rather than celestial, that the earlier Idealists had invested in History itself.

Deconstruction's Nihilistic Antihumanism

The ominous quality of Paul de Man's nihilism may stand out in the deconstruction-ist camp because of its unity with his wartime journalism. Yet it is not unique. Nihilistic discourse pervades deconstructionist thought as an active antihumanism that reaches into all fields, all domains. In a recent review of books on Gothic fiction, John Mullan comments on the method of Robert Miles, who has written a study of Gothic writing for the period 1720–1820: "Subversion, transgression,

fragmentation: it is a vocabulary that cares nothing for the artfulness of novelist, playwright – or critic." Miles, the deconstructionist, and Mullan, the humanist, are speaking different languages; they inhabit different worlds. As the latter observes, "It is also a vocabulary that defeats all opposition."[112]

The deconstructionist discourse, to use its own terminology, undermines and subverts the very possibility of humanist considerations. Consider how easily Derrida finds an oppressive authoritarianism everywhere in works of art. Referring to painting, sculpture, and architecture, Derrida remarks, "That is to say, these silent works are in fact already talkative, full of virtual discourses, and from that point of view the silent work becomes an even more authoritarian discourse – it becomes the very place of a word that is all the more powerful because it is silent, and that carries within it, as does an aphorism, a discursive virtuality that is infinitely authoritarian, in a sense theologically authoritarian." Against this alleged authoritarianism of the visual and plastic arts, Derrida opposes what can only be called a pseudohumanism, a desire to expose, resist, oppose, and undermine this negative authority: "Thus it can be said that the greatest logocentric power resides in a work's silence, and liberation from this authority resides on the side of discourse, a discourse that is going to relativize things, emancipate itself, refuse to kneel in front of the authority represented by sculpture, or architecture."[113] Where Derrida would subvert this supposed authoritarianism, Miles the literary historian celebrates the literature that through his deconstructionist lens subverts oppressive authority. In Mullan's words, for Miles "Walpole's failed play is exemplary for its 'systematic destabilization of all "transcendental" ground' (Miles's book is full of such language)."[114]

Wherever we turn in deconstructionist literature we find more of the same. Let's look to Mark Wigley, one of the preeminent deconstructionist writers on architecture:

> The question of deconstruction is therefore first and foremost a question of the uncanniness of violence. To speak here of "deconstruction and architecture" is not to speak simply of an uncanny or violated architecture, but of the uncanniness of architecture as such, the violence of even, if not especially, the most banal of spaces, spaces that are violent in their very banality.[115]

This gratuitous discovery – nay, simply mere assertion – of evil everywhere, within the heart of the arts and letters, is profoundly antihumanist. Jacques Derrida is to be congratulated on the success of his self-proclaimed "virology," his "parasitology." He has successfully promoted beyond the domain of philosophy the nihilism of deconstructionist thought. Although he claims that when looking at the arts he seeks "whatever in the work represents its force of resistance to philosophical authority, and to philosophical discourse on it,"[116] he actually smothers it with his deconstruc-

tionist vision. In no sense can the type of claims about the arts quoted here be considered an attempt to understand any of these arts in their own terms.

Let us not be misled by Derrida's claim to be speaking about "philosophical authority" and "philosophical discourse" in general. This is a particular approach to philosophy that, as Wigley explains it, issues from Martin Heidegger. And yet, Heidegger represents one of the last links in a chain of thought issuing from Hegel onward and passing through Kierkegaard and Nietzsche that Derrida has used to his advantage.[117] Turning to Heidegger now, it would seem that Heidegger directed philosophy toward the perpetual deconstructing of thought: "Construction in philosophy is necessarily destruction, that is to say, a deconstructing of traditional concepts carried out in a historical recursion to the tradition."[118] Wigley explains this to mean that

> [a]uthentic construction involves taking apart unauthentic constructions from within. It is not that the "un-building" of the old tradition is followed by a new construction. Rather, "deconstruction belongs to construction." (. . .) Just as Heidegger displaces philosophy's sense of itself as a construction standing on a stable ground in favor of philosophy as a constructing-through-unbuilding, he also displaces the sense of the structure of that which philosophy describes. While following the tradition's understanding of Being as a certain kind of "standing," it is no longer a standing on a stable ground (*Grund*), but is a standing based on a loss of ground, a construction built upon an "abyss" (*Abgrund*). The abyss, the rupturing of the fundamental ground of things, becomes their very condition of possibility.[119]

This deconstructionist "rupturing of the fundamental ground of things," which refuses transcendent values, which sees violence and oppression in the very artifacts of the arts, makes of this world a terrible prison, a perpetual *1984*, whose arrival has been heralded not only by the deconstructionists but also by the neo-Marxist Michel Foucault and the host of his fellow travelers and followers. If you think as you read the opening passages of Foucault's *Discipline and Punish: The Birth of the Prison*, that you are about to learn simply of the origins about that walled enclosure known as the prison, then you are quickly disabused of this mistaken anticipation. The book opens with a graphic description of the most horrendous physical torture using hot pincers, molten liquids, knives, and horses for quartering to punish in March, 1757, a failed regicide. Chronicling the relatively rapid "disappearance of torture as a public spectacle" over the next fifty to seventy-five years, Foucault wonders whether "it has been attributed too readily and too emphatically to a process of 'humanization,' thus dispensing with the need for further analysis."[120] Such analysis is Foucault's goal and by the end of this first chapter the reader has learned that once people were put in prison rather than publicly tortured and gruesomely executed, then there was a "masked" effort to control their "souls."

Furthermore, for Foucault this masked effort to control the psyche within the prison was not an isolated event nor had it ended by our own times. Rather it corresponds to the emergence of nineteenth-century industrial capitalism whereby "the body becomes a useful force only if it is both a productive body and a subjected body." Hence, according to Foucault, with the institution of the prison, society also became a prison. Foucault comments on the "strict correlation" between labor in prison and labor in the service of capital as he refers to "the political technology of the body" and to how a country's "apparatuses and institutions" operate through "a micro-physics of power" that goes "right down into the depths of society."[121] So here we find the inherent violence and authoritarianism of things, of Being, and of the world, thanks to the wisdom of the deconstructionists, conjoined with Foucault's neo-Marxist assurance about the oppressive strictures of contemporary Western society, ingrained, masked, and subtly interwoven into the microstructures of the social body and the body politic.

Nietzsche's "Will to Power"

The invocation of violence, whether celebrating its alleged presence in a text or unmasking its purported omnipresence in society, constitutes the widespread legacy to poststructuralism of Nietzsche. For Nietzsche, there is a dark underbelly to human nature, which shows itself in the pleasure that people take in the discomforts, misfortunes, and even sufferings of others. Nietzsche relished this aspect of humankind, deeming it psychologically healthy rather than morally sick, and psychologically invigorating rather than morally debilitating. One finds the fullest, clearest, and most straightforward expression of this attitude in Nietzsche's *The Genealogy of Morals. A Polemic* (1887), a book filled with the celebration of the cruel infliction of pain through physical torment, torture, mutilation, and murder.[122] This is the moral, or rather, immoral world whose echoes we find in the vocabulary of violence that characterizes so much of poststructuralism, especially deconstruction.

Before delving into *The Genealogy of Morals*, it is important to note that the portrait of Nietzsche which emerges from this text differs significantly from the Nietzsche with which so many impassioned artists identified themselves in the late nineteenth and early twentieth centuries. These people found in Nietzsche an encouragement to defy bourgeois morality and conventions so as to dare themselves and to challenge society by delving into the deep recesses of the psyche and to celebrate its boundless energy, even if this was found to be tied to irrationality, to chaos, to a sense of existential loneliness and alienation, and ultimately to death. As Luigi Rognoni has written in his analysis of Gustav Mahler's music, it recalls "Nietzsche in its resolve to shatter the forms by which life is limited and defined, through the most immediate sensibility of the subjective interiority which rebels against the preordained schemata of institutionalized reason."[123] We find this re-

flected especially in letters written by musicians associated either directly or tangentially with Expressionism. At his death, Alexander Nicholas Skryabin, as Rognoni has observed, left memoirs with passages that could have been "lifted bodily out of Nietzsche's *Zarathustra*." As Skryabin wrote, "I myself constructed the sphere of my feelings, so I can destroy it." "I can hurl myself against the whole world, I can subdue and dominate it. Then, in the moment of divine ecstasy, I shall feel, in all its fullness, that the world and I are an inseparable unit."[124] Béla Bartók echoed this aspect of Nietzsche in an analogous attitude of self-consciously heroic defiance. In a letter to a woman friend, he retorted:

> What!! You are rebuking me for being a pessimist?!! *Me*, a follower of Nietzsche?!!
> *Each must strive to rise above all: nothing must touch him; he must be completely independent,*
> *completely indifferent. Only thus can he reconcile himself to death and to the meaninglessness*
> *of life.*[125]

This Pegasus in a superhuman form, always ready to leap into the sky, which is also a plunge into the abyss, this *Übermensch* (Superman or Overman), indifferent to fate, indifferent to God's apparent indifference to humans in their sufferings and mortality, is Nietzsche's noblest legacy. It addresses those aspects of life not covered by the reassuring deisms or pantheisms of the Enlightenment.[126]

Yet this side of Zarathustra constitutes only one part of Nietzsche's persona and of his writings. The other side, sketched out in *Thus Spake Zarathustra* (1883–5) and in *Beyond Good and Evil* (1886), and developed more explicitly in *The Genealogy of Morals* (1887), purposefully undermines the basis of Jewish and Christian ethics and of Enlightenment political and moral philosophy.[127] Here Nietzsche assures us that "the *infliction* of suffering produces the highest degree of happiness."[128] Such is the basis of his famous notion of man's "instinct of freedom" understood as a "will to power."[129] In Nietzsche's mind the "will to power" is tantamount to man deploying his "strength," understood as a desire to dominate and to derive pleasure through dominating others: "To require of strength that it should *not* express itself as strength, that it should not be a wish to become master, a thirst for enemies and antagonisms and triumphs, is just as absurd as to require of weakness that it should express itself as strength."[130] Conscience, to Nietzsche, is merely the inwardly debilitating result of the frustration of the free deployment of man's "strength" and "will to power," (which allegedly had served him so well in his earliest prehistoric days,) that came with the formation of society:

> All instincts which do not find a vent without, *turn inwards* – this is what I mean by
> the growing "internalisation" of man: consequently we have the first growth in man,
> of what subsequently was called the soul. The whole inner world, originally as thin as
> if it had been stretched between two layers of skin, burst apart and expanded
> proportionately, and obtained depth, breadth, and height when man's external outlet
> became *obstructed*. These terrible bulwarks, with which the social organisation pro-

tected itself against the old instinct of freedom (punishments belong pre-eminently to these bulwarks), brought it about that all those instincts of wild, free, prowling man became turned backwards *against man himself*. Enmity, cruelty, the delight in persecution, in surprises, change, destruction – the turning all these instincts against their own possessors: this is the origin of the "bad conscience."[131]

Nietzsche's moral philosophy, as expounded in *The Genealogy of Morals*, had two basic components. One can be found in his portrayal of human nature and its tempering through social circumstances, as illustrated by the lines just quoted. The other consists in his belief in the superiority and destiny of German society, which Nietzsche understood as constituting the "Aryan race," which in turn was paired with its alleged antithesis and nemesis, "the Jews," whom he saw as spitefully undermining the superior values of the Aryan race through Jewish morals and through a "blood-poisoning."[132] For Nietzsche, the "will to power," that inner impulsion to show "strength," is the mark most characteristically of "the conquering and *master* race – the Aryan race," which is also the "godlike race."[133] The echoes of this prerogative for the so-called Aryan race have been seen in that wartime article by Paul de Man. In another such piece, de Man addressed the supposedly corruptive influence of Jewish writers on Western culture and civilization:

> All the same, Jews cannot claim to be the creators [of current literature], nor even to have exercised a preponderant influence on its evolution. Upon a close examination, this influence appears even as of extraordinarily little importance. . . . [This] con-clusion is, moreover, comforting for Western intellectuals. That they have been able to protect themselves from the Jewish influence in a domain as representative of culture as literature proves their vitality. There would be little hope for the future of our civilization if it had allowed itself without resisting to be invaded by a foreign force.[134]

As is well known, ever since the horrors inflicted on humanity by the Nazis have been exposed, all talk of the Aryan race and of its rightful "will to power" has been eliminated from mainstream intellectual discourse. References to the corrosive Jewish threat to civilization and culture have undergone a similar fate.

Yet Nietzsche's moral cynicism and armchair sadism continue to pervade post-structuralist discourse.[135] Perhaps more than any other nineteenth-century thinker discussed here, Nietzsche is its godfather. I say this not only because all the talk about violence and mutilation is ultimately rooted in Nietzsche's feverish text but also because the entire tenor of the *Genealogy* was to mock the fundamental premises of the moral thought of the person whom Nietzsche dismissed as "old Kant."[136]

Kant's tombstone is inscribed with his profession of faith about the moral nature of human beings, a nature that constitutes the foundations of humanist thought: "Two things fill the mind with ever new and increasing admiration and awe, the more often and steadily we reflect upon them: *the starry heavens above me and the moral*

law within me."[137] Nietzsche's *Genealogy* is like a sustained outburst of spiteful disdain directed against the second of these premises. Nietzsche reveled in his belief that even Kant's "categorical imperative reeks in cruelty."[138] He was determined to undermine Kant's conviction, expressed in a rhetorical question, "Does not the heart of man contain immediate moral precepts?"[139] So much of poststructuralist thought continues to promote that agenda.[140]

The House of Cards

In countering the deleterious effects of this nineteenth-century legacy briefly sketched here, we should keep in mind the changing nature of discourse that has appealed to intellectuals in various times. No era is ever characterized by unity of thought. At the same time that the German Idealists and French positivists were plying their intellectual wares of an ideological sort, the great novelists and play-wrights were providing insights into the individual human psyche, as well as into the dynamics regulating social intercourse, with a specificity and subtlety lacking in the purveyors of grandiloquent historical schemes. In opposing reductionist thought, we can draw sustenance from competing historical traditions.

If the humane reflections on human nature and society in Montaigne's *Essays* found their continuance in the novels of Austen and Hardy, Balzac and Flaubert, Tolstoy and Dostoyevsky, Wharton, Faulkner, Davies, and others, then why have so many intellectuals today chosen the arid abstractions of theory? To attempt to solve this conundrum would require a study of the very workings of the human mind, which sometimes finds satisfaction in apparent intellectual certainties whose appeal is to defy common sense. The occult cannot be limited to black magic; it finds expression in totalizing intellectual constructs that often carry the most respectable names. It is only years, decades, or even centuries later that public opinion dismisses such intellectual constructs for having violated the most fundamental precepts of thinking and feeling. If today one is reluctant to reject poststructuralist thought, because it has attracted such a seemingly distinguished set of intelligent advocates from such prestigious universities, then it would be helpful to remember that more famous and longer-lasting intellectual movements from the distant and recent past have undergone the same fate of well-deserved ridicule. Will poststructuralism endure as many years or be as influential as the scholastic philosophy of the thirteenth and fourteenth centuries? This earlier intellectual stance, explains Nicholson Baker, was dismissed by Francis Bacon as "a vast and intricate cobweb spun from Aristotle, 'admirable for the fineness of thread and work, but of no substance and profit,' and thus ideally decorative and mannerist rather than function-al, pushed by logical and disputational energy rather than pulled by truth."[141] It is instructive to find Leo Tolstoy dismissing the philosophical systems of Hegel, Scho-penhauer, and others in similar terms. At the end of *Anna Karenina*, as the protago-

nist undergoes an experience of spiritual and intellectual enlightenment, he comes
to understand the source of error in such philosophical systems:

> [B]ut as soon as he began reading or himself devising a solution of the problems, the
> same thing repeated itself every time. (. . .) [D]eliberately entering the verbal trap
> set for him by the philosophers or by himself, he seemed to begin to understand
> something. But he had only to forget the artificial train of reasoning . . . and
> suddenly the whole of this artificial edifice collapsed like a house of cards, and it
> became clear that it had been constructed out of a pattern of words, having no more
> connection than logic with the serious side of life. [142]

When systems of thought are "pushed by [seemingly] logical and disputational
energy" they end by collapsing when viewed from the standpoint of real life. There
is no reason to believe, then, that a movement such as poststructuralism, one of the
many questionable houses of cards that intellectuals have erected over the centuries,
will escape the same fate from a disillusioned public.

Postscript

The Parameters of Culture

After having explored first the nature of aesthetic experience and the ways in which value can be found in art and then the errors in thinking that have been opposed to humanist concepts of value and truth, I now close this inquiry with a brief consideration of the parameters of culture. No matter how helpful are the distinctions between the sociology and the aesthetics of art and no matter how enlightening is an awareness of the logical faults or intellectual sleights of hand by poststructuralists, we still lack a global orientation to help guide our thoughts in a direction other than those offered by poststructuralism. Thus, the need for an outline of the parameters of culture. To this end I wish to present two analogies, one based on the story of the Tower of Babel and the other on the nature of that deceptively ordinary object, the music box.

The Tower of Babel

Poststructuralism sees the world according to two opposing versions of the story of the Tower of Babel. On the one hand, it argues for the universal application of its method to all forms of discourse, not only the various genres within the arts – painting, sculpture, literature, and so forth, – and of the subgenres within each art form – lyrical poetry, narrative poetry, the short story, the novel, for example, for literature – but also to all disciplines – literature, law, anthropology, and so forth. Thus, poststructuralism belongs to that intellectual orientation about which Michael Oakeshott speaks when he explains:

> There are philosophers who assure us that all human utterance is in one mode. They recognize a certain variety of expression, they are able to distinguish different tones of utterance, but they hear only one authentic voice. (. . .) [T]he view dies hard that Babel was the occasion of a curse being laid upon mankind from which it is the business of the philosophers to deliver us, and a disposition remains to impose a single character upon human speech.[1]

We have seen this approach stated explicitly by Jacques Derrida who, in addition, has further confirmed the absolute propriety of applying deconstruction to all fields

of endeavor: "[T]he program as I perceived or conceived it made that necessary. If someone had asked me twenty years ago whether I thought deconstruction should interest people in domains that were foreign to me, such as architecture and law, as a matter of principle my response would have been yes, it is absolutely indispensable. . . ."[2] What Derrida would have us look for in each of these different disciplines is its "resistance to logocentrism."[3]

The other view of Babel considers the Biblical story to point to an irreparable fall from the grace of unity, truth, and objectivity. Here poststructuralism postulates the lack of central meaning, the variability of all values, and the infinity of significations. This approach is reflected in the poststructuralist slogans such as "all interpretation is misinterpretation," in aphorisms such as "what is a center if the marginal can become central," and in vocabulary that sustains such slogans with words such as "textuality" and "intertextuality."[4]

In the preceding four chapters I attempted to counter the proponents of these two tendencies primarily by pointing out distinctions that they ignored and by exposing errors in their reasoning. It is time now to take another tact, by simply redefining the issue in a different manner. Just as Roger Caillois has spoken of creating "diagonal sciences" that cut across the scientific disciplines as presently constituted, so too might we offer an organization of the humanities that approaches these cultural dilemmas from another angle. To this end, I suggest that we apply a third approach to the story of the Tower of Babel, one articulated repeatedly throughout the course of a long career in philosophy by Michael Oakeshott.

Oakeshott offers an image of humankind after Babel as having developed a series of different "voices," which make "human utterance" not singular but rather plural. Each voice has its own mode of thinking and of speaking that derives from the nature of its activity as it has been worked out by people and transmitted over time within and between different societies. Oakeshott identifies these "voices" as those of practical activity, science, history, and poetry. In *The Voice of Poetry in the Conversation of Mankind* (1959), he writes:

> But it is now long since mankind has invented for itself other modes of speaking [since the "one authentic voice" of the mythical time before the Tower of Babel]. The voice of practical activity may be the commonest to be heard, but it is partnered by others whose utterance is in a different idiom. The most notable of these are the voices of "poetry" and of "science"; but it would seem that, more recently, "history" also has acquired, or has begun to acquire, an authentic voice and idiom of its own.[5]

We need not adopt the specific categories of these "voices" to recognize that Oakeshott is reminding us that culture consists of a cluster of different ways of thinking and knowing, each with its own logic, methods, conventions, and traditions. Each presents a partial way of knowing, of feeling, and of being.

Our fullest humanity is inextricably linked with the recognition of the plurality of

these "voices," what Oakeshott also calls our "distinct languages of understanding": "What I am suggesting, then, is that from the standpoint of liberal learning, a culture is not a miscellany of beliefs, perceptions, ideas, sentiments and engagements, but may be recognized as a variety of distinct languages of understanding, and its inducements are invitations to become acquainted with these languages, to learn to discriminate between them, and to recognize them not merely as diverse modes of understanding the world but as the most substantial expressions we have of human self-understanding."[6] I wish to emphasize that last thought: that these diverse modes of understanding are "the most substantial expressions we have of human self-understanding."

As Oakeshott further explains, each "voice" or "language of understanding" by itself and all when taken together are partial groupings, never constituting the entirety of all human possibilities:

> Now each of these languages constitutes the terms of a distinct, conditional understanding of the world and a similarly distinct idiom of human self-understanding. Their virtue is to be different from one another and this difference is intrinsic. Each is secure in its autonomy so long as it knows and remains faithful to itself. Any of them may fail, but such failure is always self-defeat arising from imperfect understanding of itself or from the non-observance of its own conditions.[7]

Note that Oakeshott stresses the conditional nature of the understanding of the world that such "voices" provide. There is no discussion here of acquiring rigidly fixed "objective" knowledge or of limiting understanding to singular immutable "truths," the very issues that poststructuralists ridicule as the heart of humanist discourse. In other words, humanism conceived in this way is concerned with creating meaning within the parameters of the different genres, disciplines, or "languages of understanding." This is not an enterprise that seeks exclusively to narrow the focus to identify "objective" or "universal" conditions.[8]

Universals do exist though. Their nature must be recognized as part of the complex structure of understanding found in each "voice" or discourse. Thus, although knowledge is conditional and partial, this does not mean that there are not absolute values in art and morality. Moreover, truths capable of being experienced by people across different cultures and ages are also always variable to the extent that not everybody will recognize them and that even among those who do, not all of these people will experience them the same way or accord them the same value. And yet, this does not deny the validity of a notion eminently truthful to the people who comprehend its central importance to life. Rudolf Otto addresses this issue in *The Idea of the Holy* (1926) when he faults Friedrich Schleiermacher for

> naïvely and unreflectingly assum[ing] this faculty or capacity of "divination" [i.e., "the faculty . . . of *genuinely* cognizing and recognizing the holy in its appearances"] to be a universal one. In point of fact it is not universal if this means that it could be

presupposed necessarily in every man of religious conviction as an actual fact, though
of course Schleiermacher is quite right in counting it among the general capacities of
mind and spirit, and regarding it indeed as the deepest and most peculiar element in
mind, and in that sense – man being defined by his intelligent mind – calling it a
"universal human" element.

Such universal human elements, explains Otto, are universal *potentialities* for all
people.[9] This is the sense, then, in which we can speak of universals. The entire
poststructuralist enterprise fails to recognize the complexity of this issue as con-
ceived within humanist discourse. It also fails to recognize the value of the separate
"voices" or "languages of understanding" by which humanism gives order and mean-
ing to the world.

 This failure on the part of poststructuralism can be found at the heart of Derrida's
essay "The Law of Genre." From the very first sentences Derrida identifies genre
with the ritualistic world of taboos and transgressions:

 Genres are not to be mixed.
 I will not mix genres.
 I repeat: genres are not to be mixed. I will not mix them.

Commenting on this opening, Derrida points out that it "resound[s]" with "the
authoritarian summons to a law of 'do' or 'do not' which, as everyone knows,
occupies the concept or constitutes the value of *genre*."[10] Everybody, though, would
not acquiesce in this explanation. Certainly the poststructuralists think this way, for
as Derrida's editor explains, "The question of *genre* – literary genre but also gen-
der, genus, and taxonomy more generally – brings with it the question of law, since
it implies an institutionalized classification, an enforceable principle of non-
contamination and non-contradiction."[11]

 Yet the idea of genre is not limited to the psychological and social dynamics of
taboo that oppose purity and contamination, obedience and transgression. Rather, in
the humanities the value of genre is that of a "voice," of a "language of understand-
ing." A genre such as architecture, literature, etc., a subgenre such as the novel, the
short story, etc., has value to the extent that it provides a distinctive voice to create
and sustain meaning. I am reminded here of Peter Conrad's observation that opera
"is the song of our irrationality, of the instinctual savagery which our jobs and
routines and our nonsinging voices belie. . . ." Conrad then contrasts the nature of
the genre of opera with drama: "The characters of opera obey neither moral nor
social law. (. . .) There is no question of such people learning from experience or
reforming themselves, as characters in drama (and moral agents in life) are supposed
to do."[12] What are the distinctive voices of the other art forms? Over the course of
this study I have quoted the reflections by Joyce Cary and Ray Carney about the
distinctive qualities of literature in contrast with philosophy, history, and sociology,
as well as the insights provided by Mary Jo Salter about the particular strengths of
lyrical poetry. I offered my own observations about the psychological, cultural, and

spiritual achievements attained through domestic, institutional, and sacred architecture respectively. I am not referring to what Hegel and his followers termed "the essential content" or "the absolute theme" of each art form, a type of inner nature that has to be discovered.[13] Rather, I am concerned with defining the discrete attributes that people have imparted to the various domains of art through their creative work.

This task should be undertaken both within the individual disciplines and across them. Since meaning in the arts comes not simply from the contents but rather from the interplay between form and content, we must remember that each component is capable not only of transformations but also of admixture with characteristics of other genres. For example, Fielding's *Tom Jones* is a novel, but its characters are largely derived, as well as named, from medieval stock figures of personality types in morality plays. Furthermore, its story line often appears as an entertaining scaffolding upon which to hang "commonplaces" about human nature derived from or inspired by those found in classical rhetoricians. Likewise, Robbe-Grillet's *Dans le Labyrinthe* is a *nouveau roman*, one of those post-World War II "new novels" that tendentiously avoid the self-understanding given to characters and the omniscience accorded to the narrator, as well as the complexities of action in the plot, that had come to characterize the nineteenth-century novel. Yet, it is written like a prose poem utilizing all the major "figures of elocution" from classical discourse, while providing an equivalent with words to the geometrical world in which stylized mechanical human figures appear and move in the paintings of the preceding decades by Willi Baumeister, Oskar Schlemmer, and Fernand Léger. Much of the meaning from these and other works of art come from the rich interplay between genres.

When poststructuralists apply their methods to argue the cause of perpetual uncertainty and incoherency to works of art, they deny the possibility of understanding that this humanist concept of "voices" offers. When poststructuralists affirm that "all interpretation is misinterpretation" they deny the possibility for the "conditional" understandings that humanists seek. Understanding is like an electrode, which gathers electrons about it, or, if you prefer a more nitty-gritty image, like a hanging strip of fly paper that attracts and captures flies. Speaking metaphorically, then, those electrodes or strips of fly paper which gather around them the most electrons or the most flies in patterns that seem most complete and most meaningful through reference to what is found in the work of art and through reference to how these understandings relate to what is known about art and life compel assent. They seem most convincing as constituting the meaning, or the meanings, of a work. When poststructuralists talk about the "canonical" or "objective" meaning they are caricaturing the complexity of understanding and appreciating works of art. They are, moreover, denying the notion of the genre as providing a distinctive "voice" in what Oakeshott calls the "conversation" of human discourses.

Similarly, the poststructuralist notion that to accord value to what had been previously a marginal idea destroys the very notion of centrality likewise fails to

recognize the way humanist thought operates. To bestow value to the previously marginal merely places it closer to the electrode or fly paper. The concept of center remains throughout all of the readjustments to our understanding of the meaning of a work of art. The very existence of words like "central," "fundamental," and "basic" reflects an important human need, as well as a source of profound satisfaction, to impart coherency to works of art (even those with all the complexity of Kandinsky's abstract paintings or Joyce's *Ulysses*) and to find single (or multiple) centers around which to cluster meaning.

This notion of the center points to the vapidity of the poststructuralist argument that meanings are infinite. I would love to see convincing demonstrations of scores of significantly different interpretations of different works of art. I suspect that attempts at multiple perspectives will cluster themselves around a limited number of conceptual centers. The notion of center will not disappear any more easily than those of up and down or inside and outside. They are among the primitive givens of human experience; they serve the needs of intellectual as well as of spatial orientation.[14]

I am reminded here of an occurrence in the world of architectural education when a student presents a scheme claiming that it provides great flexibility. My response is that the design might be flexible, but since the student has not demonstrated a variety of different arrangements, then this flexibility remains purely hypothetical. It might be that no significant alternative arrangements can be organized in the given space, leaving the client with an undesigned area that would poorly serve any purpose. Perhaps a carefully proportioned and well-lit room with easy access and necessary privacy provided through a fixed design would serve differing needs better than the amorphous space with its incomplete accommodations. Claims about variety, endless or even limited, can never be merely asserted; they must be demonstrated with coherent solutions.

Not only do poststructuralists fail to recognize the nature and importance of the distinctive voices found throughout the humanities, when they apply their analytical strategies, they commit the grossest errors. Within my own field of architecture, I repeatedly see poststructuralist critics trained in literary criticism or philosophy who attempt to analyze buildings without a deep understanding of the culture of architecture. By the culture of architecture, I mean the ensemble of ways architects typically think in particular societies at particular times; the ways they create; the ways they envisage the social, aesthetic, and cultural issues that affect them; and so forth. I am sure that this occurs in other disciplines as well. Ellis, in *Against Deconstruction*, remarks that deconstructionists repeatedly use what he calls a naive position that they then ridicule. He further explains that they tend to favor simplistic, outmoded notions no longer given much credence in that particular field upon which to operate their "de-construction." Part of the reason for this phenomenon is that deconstructionists need the stereotype, usually a simpleminded and extreme position to work their deconstructive process.[15] Yet, to a great degree, this decon-

structionist practice results from simple ignorance about the discipline. This is also a willful ignorance, for it reflects an absence of interest in the nature of the discipline as a distinctive "voice" within the richly divergent conversation of human discourses. Deconstruction does not recognize that each genre presents an opportunity for knowing the world and for creating a human reality in unique and different ways.[16]

The Music Box

And now we come to the lesson of the music box, which can provide a helpful analogy to answer a host of poststructuralist protestations. One comes from Pierre Bourdieu who argues against an inherent category of aesthetic experience in favor of aesthetic response derived entirely from familial and formal schooling in the artistic "code": "A work of art has meaning and interest only for someone who possesses the cultural competence, that is, the code, into which it is encoded. (. . .) A beholder who lacks the specific code feels lost in a chaos of sounds and rhythms, colours and lines, without rhyme or reason."[17] Psychologists teach us that the operations of the mind are largely guided by the mental framework that permits a person to order data into coherent thoughts. Without the appropriate mental framework, provided through experience, education, or training, certain information will not be captured by the understanding. It will pass through the mind much like water flowing through a sieve. Whether the most fundamental appreciation of a work of art, such as a piece of music or a portrait, will appear as totally chaotic as Bourdieu suggests to somebody unschooled in the "codes" of that particular art is questionable.

Here it is important to distinguish between the essential and the secondary "codes" that operate in works of art. One is the essential "language" of the art form; the other is the secondary order of signs and symbols. Those aspects of works of art that depend most upon learning what Bourdieu calls the "code" generally belong to this second order, such as allegorical or emblematic references in the visual arts. If you have not learned that the broad-brimmed black hat, the reclining pose with the head resting on the hand, and the unbuttoned sleeves were all signs of "melancholy" well established in Western art, you certainly would miss that aspect of the "mean-ing" of Joseph Wright of Derby's portrait of *Sir Brooke Boothby* (1780–1) (Fig. 48).[18] Yet would this lack of knowledge keep you from responding to any of the human qualities that you might see in the face or to any of the so-called formal qualities derived from the disposition of shapes and colors? I suspect not.

To provide further perspective on this issue, let us turn to music. As one skeptic of this type of argument once objected to me, "but my students don't like Bee-thoven." The implication here is that there is no inherent value in works of art and that value is accorded to art through training and hence through a socially estab-lished and thus arbitrary scale of merit. Yet, it must be remembered that classical music presents an order of complexity whose appreciation for many people, to a

great extent, may require a preparatory development analogous to the way humans learn language.[19] Although none of us is born speaking a particular tongue, this does not mean that the human capacity for language is culturally determined rather than innate.[20] The question is, how does this innate capacity develop? With language, each child is focused on the subject from the earliest age and in a continual manner. With exposure to classical music, there obviously is no such customary continuity tied with the developing baby, child, and adolescent. In either case, to what extent is this a learned capacity and to what degree does it involve, to paraphrase Wilhelm von Humboldt, an awakening of the psyche?[21]

To explain the profound appreciation for Beethoven, or for that matter, of any other great artistic work, I invoke the efficacy of the music box that the protagonist played by Woody Allen in the film *Husbands and Wives* offers to his new girl friend. It was a gesture for opening one's heart. In the realm of art, it is often necessary to come to a point in one's life when one simply opens one's heart to deep aesthetic experience. For some people this comes in a flash, like the revelation visited upon St. Paul on the road to Damascus. You walk into a building, you hear a piece of music, you encounter a painting, and all of a sudden you are struck by its extraordinary beauty. From that moment onward you understand the power of deep aesthetic experience. For other people, this experience comes only after they have focused their minds on those aspects of what Bourdieu calls the "code" and which I have termed the essential language of the art form, properties such as the nature of composition typical of a period, the type of color palette or musical scale used, the range of customary subject matter, and so forth. Here the acquired capacity to appreciate the art form is analogous to that of learning to speak a language. It comes from within and has been nurtured through training. Whether through revelation or nurtured training, one is then ready to focus one's inner life on a work of art.

Once focused on the work of art rather than worrying about the stock market or planning the grocery list, one is then able to open one's soul like the music box to hear the lovely song of art. This is the type of experience that Otto analyzes in *The Idea of the Holy*, a study of "the existence of *a priori* factors universally and necessarily latent in the human spirit."[22] In his discussion of the earliest manifestations of the holy in the history of religions, Otto notes the opening of the human being to the numinous: "This experience of eerie shuddering and awe breaks out rather from depths of the soul which the circumstantial, external impression cannot sound, and the force with which it breaks out is so disproportionate to the mere external stimulation that the eruption may be termed, if not entirely, at least very nearly, spontaneous."[23] Otto is referring here to "the *primal numinous awe*,"[24] which he repeatedly asserts is analogous to deep aesthetic experience. The nature and meaning of both experiences merit our utmost consideration if we wish to understand the question of value in art.

Notes

Preface

1. Roger Kimball, *Tenured Radicals: How Politics Has Corrupted Our Higher Education* (New York: Harper and Row, 1991 ed.), 200.
2. For Bacon's essays, I have used the text edited by Michael Kiernan: Sir Francis Bacon, *The Essayes or Counsels, Civill and Morall* (Cambridge, Mass.: Harvard University Press, 1985), 153 (with original spelling and punctuation used in the epigram at the head of this Preface, but which I have modernized for this quotation).
3. "Longinus," *On Sublimity*, tr. D. A. Russell (Oxford: Oxford University Press, 1965), 3 (§2.3): "What Demosthenes said of life in general is true also of literature: good fortune is the greatest of blessings, but good counsel comes next, and the lack of it destroys the other also. In literature, nature occupies the place of good fortune, and art that of good counsel. Most important of all, the very fact that some things in literature depend on nature alone can itself be learned only from art." By extension, the very fact that some things in art depend on genius alone can itself be learned only by analyzing the creative process. Throughout this book, I follow Russell's convention of placing the name "Longinus" in quotation marks to indicate the uncertainty about the author's identity. On this subject, see ibid., x–xi.
4. The former include Raymond Tallis, *In Defence of Realism* (London: Edward Arnold / Hodder and Stoughton, 1988), and *Not Saussure: A Critique of Post-Saussurean Literary Theory* (London: Macmillan, 1988); John M. Ellis, *Against Deconstruction* (Princeton: Princeton University Press, 1989); Leonard Jackson, *The Poverty of Structuralism: Literature and Structuralist Theory* (London: Longman, 1991). The latter are best represented by Luc Ferry and Alain Renaut, *La Pensée 68: Essai sur l'anti-humanisme contemporain* (Paris: Gallimard, 1985), with an English edition published as *French Philosophy of the Sixties: An Essay on Antihumanism*, tr. Mary H. S. Cattani (Amherst: University of Massachusetts Press, 1990); Alain Finkielkraut, *La Défaite de la pensée, essai* (Paris: Gallimard, 1987), published in English as *The Undoing of Thought*, tr. Dennis O'Keeffe (London: Claridge, 1988). Of course, there have been numerous articles as well by scores of authors, many of whom are mentioned later in this book in the text or notes.
5. Kimball, *Tenured Radicals*; David Lehman, *Signs of the Times: Deconstruction and the Fall of Paul de Man* (New York: Poseidon / Simon and Schuster, 1991).

6. Dinesh D'Souza, *Illiberal Education: The Politics of Race and Sex on Campus* (New York: Vintage / Random House, 1991, 1992 rev. ed.).

7. Allan Bloom, *The Closing of the American Mind* (New York: Touchstone / Simon and Schuster, 1987, 1988), 236.

8. Ibid., 237.

9. Wincenty Lutoslawski, *The Origin and Growth of Plato's Logic* (London: Longmans, Green, and Co., 1897), 341. On the subject of Plato's dialectic, see also Francis M. Cornford, *Plato's Theory of Knowledge (The "Theaetetus" and the "Sophist" of Plato* (Indianapolis: Bobbs-Merrill, 1957), 182–3; W. G. Runciman, *Plato's Later Epistemology* (Cambridge: Cambridge University Press, 1962), 59–65; Brian Vickers, *Francis Bacon and Renaissance Prose* (Cambridge: Cambridge University Press, 1968), 30–4; G. B. Kerferd, *The Sophistic Movement* (Cambridge: Cambridge University Press, 1981), 64–5; Stanley Rosen, *Plato's "Sophist": The Drama of Original and Image* (New Haven: Yale University Press, 1983), 2; Thomas Cole, *The Origins of Rhetoric in Ancient Greece* (Baltimore: Johns Hopkins University Press, 1991), 5. I am indebted to Brian Vickers's text for an initial orientation on this subject, as well as for the bibliography of earlier secondary sources. My own discussion here closely parallels his, including the use of the same lines from the *Phaedrus* and the quotation from Hackforth. I have slightly reworked Vickers's presentation to suit my own ends.

10. Plato, *Phaedrus*, tr. and ed. R. Hackforth (Cambridge: Cambridge University Press, 1952; Indianapolis and New York: Bobbs-Merrill, n.d. reprint), p. 134 (266). Hackforth explains further: "It is in this section that Plato for the first time formally expounds that philosophical method – the method of dialectic – which from now onwards becomes so prominent in his thought, especially in the *Sophist*, *Statesman* and *Philebus*. . . ." See also Richard Robinson, *Plato's Earlier Dialectic* (Oxford: Oxford University Press, 1953 2nd ed.; 1966 reprint), 71: "Plato did not separate dialectic from philosophy as we tend to separate, say, logic or methodology from metaphysics. Dialectic was not a propaedeutic to philosophy. It was not a tool that you might or might not choose to use in philosophizing. It was philosophy itself, the very search for essences, only considered in its methodical aspect. The method occurred only in the search, and the search only by means of the method" (71).

11. Plato, *Sophist*, tr. and ed. Nicholas P. White (Indianapolis: Hackett, 1993), p. 46 (253d–e).

12. Rev. Lewis Campbell, *The Sophistes and Politicus of Plato with a Revised Text and English Notes* (Oxford: Oxford University Press, 1867; New York: Arno Press, 1973 reprint), xi. See also vi–xvi.

13. See Aristotle's *Poetics*, 1450b 34–1451a 15. Aristotle makes these remarks within the context of a discussion of the characteristics of the genre of tragedy.

14. Unless otherwise noted, all translations are my own.

15. Tony Tanner, "Additions to the World," *Times Literary Supplement* (August 14, 1992), 8.

Chapter 1

1. Susan Sontag, "On Style" (1965), in *Against Interpretation and Other Essays* (New York: Dell Publishing, 1961; 1970), 37.

2. William Hazlitt, *The Spirit of the Age: or, Contemporary Portraits* (1825); Richard Henry Horne, *A New Spirit of the Age* (1844). Perhaps our age has found its own Hazlitt or Horne in

the person of David Lehman, author of *Signs of the Times: Deconstruction and the Fall of Paul de Man* (1991). Lehman, as the title of his book partially suggests, is primarily concerned with deconstruction, which is one of several modes of poststructural thought that I consider in the text that follows.

3. Frank Kermode, in "Calls for Papers," *Common Knowledge* 1 (Spring 1992): 5–6. This journal is published by Oxford University Press.

4. Kimball, *Tenured Radicals*, 171, 194–5.

5. The issue as to whether a reader's different response over time to a work of art or as to whether different critical attitudes toward a work in various eras actually establishes true "contingencies of value," as opposed to contingencies of valuation, will be addressed in ch. 3. Kermode asks his readers to consider the issue of value in art within this context. He opens with a reference to Barbara Herrnstein Smith's *Contingencies of Value: Alternative Perspectives for Critical Theory* (Cambridge, Mass.: Harvard University Press, 1988) and uses the book's outlook throughout his call for papers. See n. 3.

6. According to Lehman (*Signs of the Times*, 47), the term "poststructuralism" was introduced by Jacques Derrida in 1966 at an "academic conference held at the Johns Hopkins University. At the conference, which was meant to herald the arrival of structuralism, Jacques Derrida subversively declared that structuralism was finished – and *post*structuralism was born. The following year Derrida published three of his most formidable theoretical studies of writing," which established the tenor of his particular branch of poststructuralism, called "deconstruction."

7. These quotations come from the final paragraph of the novel.

8. Thomas Paine, *Common Sense*, in *"Common Sense" and "The Crisis"* (New York: Dolphin Books / Doubleday, 1960), 27.

9. Speaking about deconstruction, Ellis writes, "for the dramatic denunciation of the person of common sense and received opinion is an important part of its intellectual orientation" (Ellis, *Against Deconstruction*, ix). I return to this issue in ch. 3 and the postscript below.

Elsewhere in his book (137–8), Ellis remarks that deconstruction "begins by focusing on the naive, common-sense viewpoint on each particular issue in order to undermine it. . . . By contrast, the beginning of other attempts to advance thought is normally taken to require a focus on the highest and most advanced level of thinking that has been achieved on a given question; we start with the latest state of the art and try to go on from there." "Common sense" is the term applied by the deconstructionists to what they would ridicule. I would not, as does Ellis, grant them its use, for in general the positions labeled as such by deconstruction are a caricature of the clear thought typical of common sense.

As for beginning an argument with the complexities of highly sophisticated intellectualizing, sometimes this procedure leaves behind the basics. Ellis himself rightly employs common sense when he makes the fundamental objection to "the equation of obscurity and profundity that has been readily available in European thought since Kant and Hegel" (147). Similarly, when Roger Scruton analyzes the way a poststructuralist text uses obfuscation, he is building with sophisticated clarity upon the understanding provided by common sense that purposefully obscure writing is inimical to profound thought. The text in question, observes Scruton, "not only says nothing, but is also *designed* to say nothing. From blocks of abstractions it erects an impassable barrier, behind which its

nothingness may be concealed" (Roger Scruton, "The Triumph of Nothingness" [July 17, 1984], in *Untimely Tracts* [London: Macmillan Press, 1987], 164).

10. Lehman, *Signs of the Times*, 19; Kimball, *Tenured Radicals*, 76 (for the last two quotations).

11. Max Horkheimer, *Eclipse of Reason* (Oxford University Press, 1947; New York: The Seabury Press, 1974), 28. For an introduction to the thought of Thomas Reid (1710–96) and his predecessor Claude Buffier (1661–1737), see Louise Marcil-Lacoste, *Claude Buffier and Thomas Reid: Two Common-Sense Philosophers*, McGill-Queen's Studies in the History of Ideas 3 (Kingston and Montreal: McGill-Queen's University Press, 1982). On the concepts of natural and divine law in ancient Greece, see Kerferd, *The Sophistic Movement*, ch. 10 ("The Nomos-Physis Controversy"). Of particular interest is the statement in Aristotle's *Rhetoric* (1373b). I use the translation from Lane Cooper, *The Rhetoric of Aristotle* (New York: Appleton-Century-Crofts / Meredith, 1932), 73–4, with the text in square brackets added by Cooper: "Justice and injustice admit of a twofold distinction with reference both to the laws [two kinds of law] and to the persons affected. I mean that law is either particular or universal; by 'particular' law I mean that which an individual community lays down for itself (a law partly unwritten, partly written); and by 'universal' law I mean the law of nature. For there is a natural and universal notion of right and wrong, one that all men instinctively apprehend, even when they have no mutual intercourse nor any compact. This is evidently the law to which Sophocles' Antigone alludes when she says that, despite [Creon's] interdict, it is right to bury [her brother] Polyneices; the implication being that it is right according to nature [*Antigone* 456–7]:

> Not of to-day nor yesterday is this, but law eternal;
> None can say when it first came into being.

Similarly the utterance of Empedocles against killing any animate creature; it is not right in one land and wrong in another:

> But the law for living creatures all, one law,
> Extends through sovran sky and endless sunlight.

Similarly, again, the saying of Alcidamas in his *Messeniacus* [a declamation justifying the Messenians in their revolt from Sparta:

> God has left all men free; Nature made no man a slave.

– The quotation is supplied by the scholiast. Notice that Aristotle illustrates 'universal law' with passages that would be useful to the orator in persuasion.]" In other words, these passages become useful as "commonplaces." On this subject, see the discussion that follows, as well as nn. 12–16.

12. Jean-Jacques Rousseau, *L'Etat de guerre*, as quoted in Jacques Derrida, *De la Grammatologie* (Paris: Les Editions de Minuit, 1967), 29: "Si la loi naturelle n'était écrite que dans la raison humaine, elle serait peu capable de diriger la plupart de nos actions. Mais elle est encore gravée dans le coeur de l'homme en caractères ineffaçables . . . C'est là qu'elle lui crie . . ." This line echoes Pascal: "Nous connaissons la vérité, non seulement par la raison, mais encore par le coeur; c'est de cette dernière sorte que nous connaissons les premiers principes, et c'est en vain que le raisonnement qui n'y a point de part, essaye de

les combattre. Les pyrrhoniens, qui n'ont que cela pour objet, y travaillent inutilement" (Blaise Pascal, from "Pensée No. 282," in *Pensées et opuscules*, ed. Léon Brunschvicg [Paris: Librairie Hachette, n.d.], 459).

The relationship of common sense to "the first movements of the soul" and to "the sentiment of Nature" is the theme of Claude Buffier's *Traité des premières vérités* (1724). See the eminently readable English translation by H. Fox, *First Truths and the Origin of Our Opinions Explained: With an Enquiry into the Sentiments of Modern Philosophers, Relative to Our Primary Idea of Things. Translated from the French of Pere [sic] Buffier* . . . (London: J. Johnson, 1780). Buffier's observations about the relationship between understanding and reason are particularly apt:

> In those matters, where knowledge acquired by reason and argument is necessary, and where particular reflections, that suppose experiments not made by every person, are required, a philosopher is more to be credited than another man; but in an affair of manifest experience, and of a sentiment immediately obvious to the first motions of the soul, and common to all mankind, all men in this respect become philosophers; or their evidence, with regard to the truth, is at least as well founded as if they were such in reality: so that, as to the first principles of Nature and common sense, when a philosopher is opposed to the rest of mankind, he is a philosopher opposed to a hundred thousand other philosophers, because they are as fully persuaded as he is of the first principles of knowledge (47–8, § 67).

In *Claude Buffier and Thomas Reid*, 13 n. 3, Marcil-Lacoste points out that the articles on "common sense" and "internal sentiment" in the *Encyclopédie* are basically taken from Buffier's *Traité*. In *G. B. Vico: The Making of an Anti-Modern* (Cambridge, Mass.: Harvard University Press, 1993), Mark Lilla repeatedly emphasizes Vico's belief in the "deep psychological roots" of common sense (158; see also 52, 157).

13. Sister Joan Marie Lechner, O.S.U., *Renaissance Concepts of the Commonplaces* (New York: Pageant Press, 1962), 201. This is the opening sentence of ch. 4 ("Virtue and Vice in the Commonplace Tradition"), 201–25, which traces this tradition through the Renaissance. On the use of commonplaces for the study of morals in the educational system of the English Renaissance, see also Alexander H. Sackton, *Rhetoric as a Dramatic Language in Ben Jonson* (New York: Columbia University Press, 1948; London: Frank Cass, 1967 reprint), 31.

14. Cornelius Valerius, *Rhetorica Cornelii Valerii* (1596), as quoted in English translation with explanation in Sister Lechner, *Renaissance Concepts of the Commonplaces*, 81–2. On Cicero's speech in defense of Milo, see also Giambattista Vico, *On the Study Methods of Our Time* (1709), tr. Elio Gianturco (Indianapolis: Bobbs-Merrill, 1965), 16 and n. 9 (for the historical information about Milo, Clodius, and the battle of January 20, 52 B.C. near Bovillae). For the speech itself, see Marcus Tullius Cicero, "The Speech on Behalf of Titus Annius Milo," in *The Speeches of Cicero with an English Translation*, tr. N. H. Watts, The Loeb Classical Library (London: William Heinemann; New York: G. P. Putnam's Sons, 1931), 1–136.

15. On this theme, see Lane Cooper's commentary on the passage quoted from Aristotle's *Rhetoric* in n. 11.

16. The "commonplace" also has played an important role in the history of Western music. On

this subject, see Wye Jamison Allanbrook, *Rhythmic Gesture in Mozart: "Le Nozze di Figaro"
and "Don Giovanni"* (Chicago: University of Chicago Press, 1983), 1–3. Allanbrook
observes, "Because of their connections with certain universal habits of human behavior,
these [musical] *topoi* [i.e., commonplaces] are also largely in the possession of the opera-
going audience today . . ." (2).

17. Henry Fielding, *Tom Jones* (1749), ed. Sheridan Baker (New York: W. W. Norton, 1973),
31. Consider also the comparable scenes in chs. 12–13 of George Eliot's *Silas Marner*
(1861), ed. Walter Allen (New York: Signet/Penguin, 1960; 1981), 115–16, 122–7.

18. Eugène-Emmanuel Viollet-le-Duc, *Entretiens sur l'architecture* (Paris, 1863), I, 55:
" . . . ce sentiment exquis qui soumet toutes les formes à la raison, non point à la raison
sèche et pédante du géomètre, mais à la raison dirigée par les sens et par l'observation des
lois naturelles"; Le Corbusier, *Le Voyage d'Orient* (Meaux: Les Editions Forces Vives,
1966), 162: " . . . cette masse formidable dressée avec l'inexorabilité d'un oracle. Le
gouffre de plus en plus, devant l'inexplicable acuité de cette ruine, se creuse entre l'âme
qui ressent et l'esprit qui mesure."

19. Peter Brunette and David Wills, "The Spatial Arts: An Interview with Jacques Derrida," in
Peter Brunette and David Wills, eds., *Deconstruction and the Visual Arts: Art, Media,
Architecture* (Cambridge: Cambridge University Press, 1994), 10.

20. Lehman, *Signs of the Times*, 57.

21. Walter Pater, *Three Major Texts (The Renaissance, Appreciations, and Imaginary Portraits)*, ed.
William E. Buckler (New York: New York University Press, 1986), 219–20.

22. Henri Bergson, "Life and Consciousness" (The Huxley Lecture, delivered at the Univer-
sity of Birmingham, May 1911), in *Mind-Energy: Lectures & Essays*, tr. H. Wildon Carr
(London: Macmillan, 1920), 1–2. This text was published in French in *L'Energie spirituelle:
essais et conférences* (Geneva: Albert Skira, 1946), 13–14: "Mais, au moment d'attaquer le
problème, je n'ose trop compter sur l'appui des systèmes philosophiques. Ce qui est
troublant, angoissant, passionnant pour la plupart des hommes n'est pas toujours ce qui
tient la première place dans les spéculations des métaphysiciens. D'où venons-nous? que
sommes-nous? où allons-nous? Voilà les questions vitales, devant lesquelles nous nous
placerions toute de suite si nous philosophions sans passer par les systèmes. Mais, entre ces
questions et nous, une philosophie trop systématique interpose d'autres problèmes.
'Avant de chercher la solution, dit-elle, ne faut-il pas savoir comment on la cherchera?
Etudiez le mécanisme de votre pensée, discutez votre connaissance et critiquez votre
critique: quand vous serez assurés de la valeur de l'instrument, vous verrez à vous en
servir.' Hélas! ce moment ne viendra jamais. Je ne vois qu'un moyen de savoir jusqu'où
l'on peut aller: c'est de se mettre en route et de marcher."

23. Pater, "Conclusion," in *The Renaissance*, 219.

24. Bergson, "Life and Consciousness," in *Mind-Energy*, tr. H. Wildon Carr, 3. The French text
reads: "Comme, d'autre part, rien n'est plus aisé que de raisonner géométriquement sur
des idées abstraites, il construit sans peine une doctrine où tout se tient, et qui paraît
s'imposer par sa rigueur. Mais cette rigueur vient de ce qu'on a opéré sur une idée
schématique et raide, au lieu de suivre les contours sinueux et mobiles de la réalité" ("La
Conscience et la vie," in *L'Energie spirituelle*, 15). Consider also T. S. Eliot's remarks on
humanism, philosophical systems, and common sense: "The function of humanism is not

to provide dogmas, or philosophical theories. Humanism, because it is general culture, is not concerned with philosophical foundations; it is concerned less with 'reason' than with common sense" (T. S. Eliot, "Second Thoughts," in *Selected Essays* [New York: Harcourt Brace Jovanovich, 1932; 1978], 436).

25. Kermode, in "Calls for Papers," *Common Knowledge* 1 (Spring 1992): 6.

26. Susanne K. Langer, *Feeling and Form: A Theory of Art Developed from "Philosophy in a New Key"* (New York: Charles Scribner's Sons, 1953), 22.

27. Sontag, "On Style," in *Against Interpretation*, 36.

28. Sigmund Freud, *Civilization and Its Discontents*, ed. and tr. James Strachey (New York: W. W. Norton, 1961; 1962), 27–9.

29. G. W. F. Hegel, *Aesthetics: Lectures on Fine Art*, tr. T. M. Knox (Oxford: Oxford University Press, 1975), I, 7.

30. John Ruskin, *The Seven Lamps of Architecture* (New York: Farrar, Straus and Giroux, 1986 ed.), 70.

31. I qualify this assessment with "generally," because at times ornamentation can rise to a higher position on the aesthetic scale. Certainly Christopher Dresser, in *The Art of Decorative Design* (London: Day and Son, 1862; American Life Foundation, 1977 reprint), had argued in this way: "Music, by its grateful strains, lulls the spirit to sweet and joyous forgetfulness, and retards its unruly outbreakings; so does ornament, for it too can soothe, and entrance, and hush to reverie, or kindle joys" (44). Yet Dresser himself anticipated objections: "But some will object to the assertion that ornament enjoys the power of working thus fully upon the spirits, but this is due to the rarity of worthy decorative examples" (ibid.).

One artist whose decorative work rose to that higher level was Louis H. Sullivan, an architect who was eloquent as well in explaining the high aesthetic potential of ornamentation. For Sullivan ornament should transform the inanimate geometric form into a "mobile geometry," a "mobile medium" that radiates the "energy" of a "primal life-impulse" issuing from the depths of the human spirit. (See the commentary accompanying plates 3–5, 7, of his *A System of Architectural Ornament According with a Philosophy of Man's Powers* [New York: American Institute of Architects, 1924].) For further observations on Sullivan's ideas about ornament infused with a life force, see n. 51.

Visitors to the exhibition "Painting and Illumination in Early Renaissance Florence" at the Metropolitan Museum of Art in New York (November 17, 1994–February 26, 1995) had the opportunity to view the work of the Pacino da Bonaguida (active c. 1300–40) whose decorative borders satisfied the criteria later articulated by Dresser and Sullivan.

Both Dresser's association of the aesthetic experience derived from decorative motifs with the sentience experienced through music and Sullivan's emphasis on ornamentation radiating the "energy" of a "primal life-impulse" anticipate the theme of sentience discussed in the section on "Aesthetic Experience." The same is true of Chinese calligraphy: "'The essence of beauty in [Chinese] writing is not found in the written word, but lies in response to unlimited change; line after line should have a way of giving life, character after character should seek for life movement.' (. . .) When Chinese writers talk about writing, their imagery . . . does not dwell only on proportions and purity of line, but on life forces, on the storage of energy" (Oleg Grabar, *The Mediation of Ornament*,

The A. W. Mellon Lectures in the Fine Arts, 1989, The National Gallery of Art, Washington, D.C., Bollingen Series XXXV-38 [Princeton: Princeton University Press, 1992], 58, 116, with quotation from Lucy Driscoll and Kenji Toda, *Chinese Calligraphy* [New York, 1962], 1).

Another theme to explore is the attempt by artists to fuse fine art and decorative art through the use of patterned surfaces in painting. For a discussion of this issue, see Susan Houghton Libby, "An Adjustable Means of Expression: A Selection of Edouard Vuillard's Decorative Works of the 1890s," *Decorative Arts* 1 (Spring 1994): 25–47. Finally, on ornament as a source of pleasure deserving of the neologism *terpnopoietic*, see Grabar, *The Mediation of Ornament*, 37 and passim.

32. As quoted in Julian Symons, "Against the Bitch Goddess," *Times Literary Supplement* (September 23, 1994), 25, a review article of Saul Bellow, *It All Adds Up. From the Dim Past to the Uncertain Future: A Nonfiction Collection* (London and New York: Viking / Penguin, 1994).

33. It would be mistaken to conclude that Hegel's and Ruskin's argument that insights into deep spiritual truths constitute the highest attainments of art is solely a nineteenth-century Romantic concept. For a penetrating study of this understanding of aesthetic experience in the work of Leonardo da Vinci and a discussion of related concerns reaching from the ancient Greeks to Martin Heidegger, see Alexander Nagel, "Leonardo and *Sfumato*," *Res* no. 24 (Autumn 1993): 7–20, especially 18–19.

34. Jakob Rosenberg, *Rembrandt, Life and Work* (London: Phaidon, 1964), 46–7. Such a response has not been limited to traditional humanists. Mikhail Bakhtin (1895–1975), for example, who has become an intellectual hero for so many poststructuralists, has written a suggestive and moving appreciation of the self-portrait in general and of a Rembrandt self-portrait in particular: "Besides, it seems to me that one can always distinguish the self-portrait from the portrait, thanks to the somewhat phantasmal aspect of the face in the former; the latter does not envelop in some manner the complete man, does not envelop him completely and to the very depths: the always smiling face of Rembrandt in his self-portrait gives me an almost sinister impression." Whereas there is a hint of a smile in several of Rembrandt's self-portraits, laughter emerges in the one in Cologne (Rosenberg, *Rembrandt*, 54 [Fig. 46]–5). For Bakhtin's text, which dates from around 1924, see Tzvetan Todorov, "Bakhtine et l'altérité," *Poétique* no. 40 (November 1979): 503, where Todorov provides the quotation in a French translation of the original Russian: "Il me semble d'ailleurs qu'on peut toujours distinguer l'autoportrait du portrait, grâce au caractère quelque peu fantomatique du visage, dans le premier cas; celui-ci n'englobe pas en quelque sorte l'homme complet, ne l'englobe pas entièrement et jusqu'au bout: le visage toujours rieur de Rembrandt dans son autoportrait produit sur moi une impression presque sinistre."

35. Lawrence W. Levine, *Highbrow / Lowbrow: The Emergence of Cultural Hierarchy in America* (Cambridge, Mass.: Harvard University Press, 1988), 31, 36.

36. Consider also Aldous Huxley's discussion of this subject: "The old distinction between the Fine Arts and the crafts is based to some extent upon snobbery and other non-aesthetic considerations. But not entirely. In the hierarchy of perfections a perfect vase or a perfect carpet occupies a lower rank than that, say, of Giotto's frescoes at Padua, or Rembrandt's

Polish Rider, or the *Grande Jatte* of Georges Seurat. In these and a hundred other master-pieces of painting the pictorial whole embraces and unifies a repertory of forms much more numerous, varied, strange and interesting than those which come together in the wholes organized by even the most gifted craftsmen. And, over and above this richer and subtler formal perfection, we are presented with a non-pictorial bonus of a story and, explicit or implicit, a criticism of life" (A. Huxley, "Variations on El Greco," in *Themes and Variations* [1943], now in *Writers on Artists*, ed. Daniel Halpern [San Francisco: North Point Press, 1988], 65–6).

There are, of course, other ways of assigning value to art outside of the aesthetic experience it affords. Perhaps foremost are ritual value and theological efficacy for art that serves religion. Then, too, one might value the ingenuity and care evidenced in a work of art. With respect to this latter issue, the narrator in Herman Melville's *Moby-Dick* remarks, "An ancient Hawaiian war-club or spear-paddle, in its full multiplicity and elaboration of carving, is as great a trophy of human perseverance as a Latin lexicon" (Herman Melville, *Moby-Dick*, eds. Harrison Hayford and Hershel Parker [New York: W. W. Norton, 1967], 232).

37. Richard A. Etlin, "Introduction," and June Hargrove, "Shaping the National Image: The Cult of Statues to Great Men in the Third Republic," in *Nationalism in the Visual Arts*, Studies in the History of Art 29, ed. Richard A. Etlin (Washington, D.C.: National Gallery of Art, 1991), 12, 48–63.

38. Etlin, *Modernism in Italian Architecture, 1890–1940* (Cambridge, Mass.: MIT Press, 1991), 377–90, 391–438; Giorgio Ciucci, *Gli architetti et il fascismo: architettura e città, 1922–1944* (Turin: Einaudi, 1989), 108–46; Dennis P. Doordan, *Building Modern Italy: Italian Architecture, 1914–1936* (New York: Princeton Architectural Press, 1988).

39. Robertson Davies, *What's Bred in the Bone* (New York: Penguin Books, 1985; 1986), 226–27. See also 406–7, 413–14.

40. This point has been developed by other observers in ways that are instructive for my argument. For example, in "Art after Philosophy, I and II" (1969), now in *Idea Art: A Critical Anthology*, ed. Gregory Battcock (New York: E. P. Dutton, 1973), 80–1, the conceptual artist Joseph Kosuth writes: "All art (after Duchamp) is conceptual (in nature) because art only exists conceptually. The 'value' of particular artists after Duchamp can be weighed according to how much they questioned the nature of art; which is another way of saying 'what they *added* to the conception of art' or what wasn't there before they started. Artists question the nature of art by presenting new propositions as to art's nature." In these passages Kosuth correctly identifies the mechanisms and values of conceptual art. He errs, though, in referring to them as a questioning of the "nature of art." Rather, they question only one aspect of art, i.e., its conventions. Conceptual artists' lack of interest in or rejection of the aesthetic scale and of the experience that issues from this concern limits the worth of their undertaking. Because of the partial and seriously reductive nature of this enterprise, in such cases it is not helpful to refer to these works as "art."

The lines quoted from Kosuth's article can also be found in the notes of Donald Kuspit, *The Cult of the Avant-Garde Artist* (Cambridge: Cambridge University Press, 1993), 125 n. 76. In this book, Kuspit suggests another way of understanding conceptual art. Arguing from a psychoanalytical perspective, Kuspit maintains that conceptual art can be under-

stood as the affirmation of the self against what is perceived as a decadent society: "The inner sense of decadence that avant-garde art overcame through a style that was partly projection and partly individualistic – even idiosyncratic – reversal of it, returns in neo-avant-garde or post-avant-garde art with ironic vengeance. Avant-garde art climaxes in the belief that every member of a society can be an innovator, that is, can transform himself, through the therapeutic practice of art, from a wounded decadent into a healthy Overman. This celebration of everyman's creativity, found in artists as different as Duchamp and Beuys – the alpha and omega of twentieth-century conceptual art – amounts to a kind of social revolution. (. . .) But this vision of art as individual reparation of social injury and of the curative power of creativity – creativity as universal panacea – degenerates, as Lévi-Strauss suggests, into the endorsement of 'innovation for its own sake.' We are no longer interested in 'what fertile innovation can still produce,' but in the production of novelties – fertility as such. This is the final, subtlest, most utopian decadence: innovation that leads nowhere, develops nothing, produces nothing of social or individual consequence . . ." (19). For a further development of Kuspit's argument, see n. 109.

41. This has been expressed most vigorously by Thomas McEvilley in "'On the Manner of Addressing Clouds,'" *Artforum* (Summer 1984): 67, when he referred to "the Abstract-Expressionist last gasp of Soul. . . . To a degree the purpose of Dada – and of Pop as neo-Dada – was to reveal the semiotic impersonality of the art process and to ridicule the idea of Soul and its timeless products." Consider also Donald Kuspit's observations about the "purging" of the spiritual from modern art in favor of an emphasis on the conventions of art. The occasion for these reflections was the arrival in the early 1980s of a "so-called 'new' Expressionism":

> Revival in the name of new interests is always botched because new interests mean discard-ing the foundations of the old interests. Abstract Expressionism discards the religiosity of Wassily Kandinsky's art from which it in part stems; Pop art is indifferent to the disgust that motivated much of Dadaism, and turns its bad humor into good humor (Andy Warhol's business success ethos shows how little disgust there is in Pop art); and Minimalism replaces the socio-political interests of Constructivism with modernist interests in the purity or autonomy of the medium, as Robert Morris' writing on sculpture demonstrates. Just by reason of the spiritual ineptitude of past revivals we can expect the current revival of Expressionism to abort the spirit of the old Expressionism. In every case, the American conversion or "revision" of European modern art has purged it of its spiritual dimension – or at least made that dimension much less prominent – and has replaced that spirit with a modernist aim.

Kuspit further defines the modernist aim as "the absolutization of the medium," which is basically synonymous with what I have termed the narrowly focused emphasis on the conventions of art. Kuspit returns to this point later in his article, where he emphasizes: "For neo-Expressionism cannot help but reflect decades of a *Zeitgeist* that insisted that the only aim of art is esthetic – the esthetic 're-form' of art in the name of the autonomy of the medium" (Donald Kuspit, "The New(?) Expressionism: Art as Damaged Goods," *Artforum* [November, 1981]: 47–8, 51).

There are instances of Minimalist art in which the question of the conventions of art might appear to be the artist's primary interest, whereas he or she was actually concerned with deep spiritual value. Such was the case, for example, of Mark Rothko's paintings.

Writing about Rothko's mature style developed toward 1949, Jack Flam explains the intentions behind Rothko's work:

> Rothko's paintings were meant to slow down the process of viewing and create a charged physical ambiance around themselves that could actually vibrate within the beholder, like music. When you looked at them, you were also virtually forced to look beyond them. You were urged to give yourself over to some sort of mystical experience, to be enveloped in a contemplative trance in which the paint surface seemed to throb with a kind of metaphysical energy.

Yet the minimalist nature of the work did not make this easy:

> There was indeed a sense that Rothko had so reduced painting to its most basic elements that it seemed to be on the verge of disappearing altogether, of becoming something else. His large, blurry rectangles of color demanded a substantial amount of patience and good will from the viewer. (. . .) Rothko's paintings contained no apparent evidence of drawing or design and were virtually devoid of the kinds of internal incidents that were supposed to make paintings interesting – or, in the jargon of the day, "plastic" (Jack Flam, "The Agonies of Success," *New York Review of Books* [December 2, 1993], 36).

42. Anthony Savile, review article of Arthur C. Danto, *Beyond the Brillo Box: The Visual Arts in Post-Historical Perspective* (New York: Farrar, Straus and Giroux, 1992), *New York Times Book Review* (September 6, 1992), 16.

43. Arthur C. Danto, *The Transfiguration of the Commonplace: A Philosophy of Art* (Cambridge, Mass.: Harvard University Press, 1981), vi–vii.

44. Fernand Léger, "Les Réalisations picturales actuelles" (1914), 26: "Tout cela, ce sont des moyens; il n'y a d'intéressant que la manière dont on s'en sert"; "Note sur la vie plastique actuelle" (1923), in *Fonctions de la peinture* (Paris: Editions Gonthier, 1965), 46: "l'état d'intensité plastique organisé."

45. Wassily Kandinsky, "Reminiscences" (1913), in Robert L. Herbert, ed., *Modern Artists on Art: Ten Unabridged Essays* (Englewood Cliffs, N.J.: Prentice-Hall, 1964), 32.

46. In "Minimal Art," *On Art and the Mind* (Cambridge, Mass.: Harvard University Press, 1974), 101–11, Richard Wollheim presents a variation on the theme of successive erasures. Wollheim grounds this discussion in the notion that "we have over the centuries come to regard [work, or manifest effort] as an essential ingredient in art" (106). Wollheim then postulates ascending and descending sequences of work such that a painting by Rembrandt, for example, is described as an additive process of putting "marks of paint" on a canvas whereas one by Ad Reinhardt reflects a subtractive process of "dismantling" and "destruction" (108–10). The logical end point of the subtractive sequence Wollheim sees in Duchamp's selection of the urinal as a work of art (111). Once again, the definition of art is narrowed to exclude aesthetic considerations. In this essay, Wollheim simply dismisses any fundamental objection to considering Duchamp's urinal as art: "In 1917 Marcel Duchamp submitted a urinal as a contribution to an exhibition of art. To many people such a gesture must have seemed totally at variance with their concept of art. But I am not concerned with them" (105).

47. The public has also reacted with hostility. In "Audience and the Avant-Garde," *Artforum* (December 1982): 36–9, Donald Kuspit focuses on the artist's defensiveness. He opens with a quotation from Mark Rothko, which serves as an epigram for the entire article: "[It

is] a risky business [to send a picture] out into the world. How often it must be impaired by the eyes of the unfeeling and the cruelty of the impotent who would extend their affliction universally!" As Adolf Gottlieb put it, "abstraction enrages [the average man] because it makes him feel inferior. And he *is* inferior." Commenting on Rothko's statement and by implication on Gottlieb's as well, Kuspit explains, "The history of advanced art is full of remarks similar to the above."

48. John Richardson, "Go Go Guggenheim," *New York Review of Books* (July 16, 1992), 22.

49. For a further discussion about the moral sense, see Buffier, *First Truths*, 50 (§ 72), which says, in part: "Is it not a natural sentiment that inspires parents with an affection for their children, and urges them to promote their welfare? I never yet knew any person that doubted this: nevertheless, this natural sentiment is altered or extinguished in some parents; but this does not prevent it from being a sentiment of Nature."

50. Sontag, "On Style," in *Against Interpretation*, 36, 38.

51. For a provocative and related discussion undertaken from a psychoanalytical perspective, which draws upon Nietzsche's account of the "aesthetic state" in his posthumous *The Will to Power* and which sees aesthetic experience as "therapeutic," see Kuspit, *The Cult of the Avant-Garde Artist*, 10–13. In the chapter "The Will to Power in Art" Nietzsche speaks of art as promoting "an enhancement of the feeling of life" (Friedrich Nietzsche, *The Will to Power: An Attempted Transvaluation of All Values*, in *The Complete Works of Friedrich Nietzsche. The First Complete and Authorised English Translation*, ed. Oscar Levy, tr. Anthony M. Ludovici [1910; New York: Russell and Russell, 1964], XV, 244). As might be expected, Nietzsche subsumes this experience within a celebration of the unbridled Id and Ego, with the Superego nowhere in sight: "The states in which we transfigure things and make them fuller, and rhapsodise about them, until they reflect our own fulness and love of life back upon us: sexuality, intoxication, post-prandial states, spring, triumph over our enemies, scorn, bravado, cruelty, the ecstasy of religious feeling. But three elements above all are active: *sexuality, intoxication, cruelty*; all these belong to the oldest *festal joys* of mankind, they also preponderate in budding artists" (243 [§801]). For a critique of Nietzsche's "will to power" as the basis for moral philosophy, see the section "Nietzsche's 'Will to Power'" in ch. 4.

For a transformation of Nietzsche's "will to power" into a humanistic "power to will" used by the artist as "the will to create in the likeness of his emotion and his intellect; the passion to create in the image of his own power; the urge to create companions of his inmost thought," see Louis H. Sullivan, *A System of Architectural Ornament According with a Philosophy of Man's Powers*, 9. As mentioned in n. 31, Sullivan looked to ornament to transform the inanimate geometric form into a "mobile geometry," a "mobile medium" that radiates the "energy" of a "primal life-impulse" issuing from the depths of the human spirit. In articulating his approach to art, Sullivan has used only those parts of Nietzsche's *Thus Spake Zarathustra* that suited his purpose (§ XXIV, XXXIII–XXXIV, XXXVII, LVI), while ignoring the sinister message as found especially in § XVIII–XXI, XXXIV, XLIII, XLIX, LV–LVII, LXI–LXIII, LXVII, LXXIII. If a reader today finds it strange that Nietzsche would conjoin a "will to power" understood as dominating others and celebrating war, hatred, and envy, while despising compassion and pity, with a celebration of "creativity," and the "creating will," then it should be kept in mind that morality and imagination were twin Romantic themes. This pairing is discussed at length by Shelley in

"A Defence of Poetry," whose argument can be summarized with his assertion, "The great instrument of moral good is the imagination; and poetry administers to the effect by acting upon the cause." In many respects Nietzsche's *Thus Spake Zarathustra* reads as the obverse of this component of the Romantic spirit. We can consider, for example, Blake's *Milton*, a poem written, as the subtitle explains, "To Justify the Ways of God to Men." In the preamble to the poem, Blake calls upon his contemporaries to be "just and true to our own Imaginations" while counseling them to "believe Christ & his Apostles that there is a Class of Men whose whole delight is in Destroying." Nietzsche has retained the Romantic faith in the special spiritual role accorded the creative imagination while siding with Satan rather than with Christ. As Zarathustra says, "I suspect ye would call my Superman – a devil!" (§ XLIII). The "moral" of his story: "The destroyer of morality, the good and just call me: my story is immoral" (§ XIX). (*Thus Spake Zarathustra,* in *The Complete Works,* XI.) For a further discussion of Nietzsche's philosophy, see ch. 4. For other reflections on the subject of Sullivan's use of Nietzsche's text, see Narciso G. Menocal, *Architecture as Nature: The Transcendentalist Idea of Louis Sullivan* (Madison: University of Wisconsin Press, 1981), 99–100, 195 n. 32. The quotations from Shelley and Blake can be found in Percy Bysshe Shelley, *The Selected Poetry and Prose*, ed. Carlos Baker (New York: Modern Library/ Random House, 1951), 502; *The Complete Poetry and Prose of William Blake*, ed. David V. Erdman, commentary by Harold Bloom (New York: Anchor/Doubleday, rev. ed. 1988), 95.

52. Raymond Bayer, as quoted in Sontag, "On Style," in *Against Interpretation*, 37; Langer, *Feeling and Form*, 31. The instrumental text for Rousseau on "le sentiment de l'existence" is *Les Rêveries d'un promeneur solitaire* (1776–8). As scholars of Rousseau have demonstrated, this concern pervades his work. See Georges Poulet, *Les Métamorphoses du cercle* (Paris: Plon, 1961), 102–32 ("Rousseau") [*The Metamorphoses of the Circle*, tr. Carley Dawson and Elliot Coleman (Baltimore: Johns Hopkins University Press, 1966), 70–90]; Marcel Raymond, *Jean-Jacques Rousseau: La Quête de soi et la rêverie* (Paris: José Corti, 1962), 132–55; Jean Starobinski, *J.-J. Rousseau: La transparence et l'obstacle* (Paris: Gallimard, 1971), 305–9 [*Jean-Jacques Rousseau, Transparency and Obstruction*, tr. Arthur Goldhammer (Chicago: University of Chicago Press, 1988), 258–60]; Pierre Burgelin, *La Philosophie de l'existence de J.-J. Rousseau* (Paris: J. Vrin, 1973 2nd ed), 123–48. For an intriguing discussion of the psyche as "androgynous," understood in a Jungian manner, with an *animus* as moral conscience and an *anima* as sentience, this model derived from an analysis of Rousseau's writings, see Raymond's text, 153–4.

53. Bayer, as quoted in Sontag, "On Style," in *Against Interpretation*, 37.

54. Langer, *Feeling and Form*, 31–2. Langer's insight into the relationship between sentience and music clarifies an understanding that for centuries has been expressed in analogous but slightly – and thus significantly – different terms. Her emphasis on sentience also has permitted her to generalize about aesthetic experience in the other arts. For earlier, analogous treatments of music, consider, for example, Plato ("education in music is most sovereign, because more than anything else rhythm and harmony find their way to the inmost soul and take strongest hold upon it"); Aristotle ("From these considerations therefore it is plain that music has the power of producing a certain effect on the moral character of the soul"); St. John Chrysostom ("For nothing so uplifts the mind, giving it wings and freedom from the earth, releasing it from the chains of the body, affecting it with

love of wisdom, and causing it to scorn all things pertaining to this life, as modulated melody and the divine chant composed of number"); Boethius (people of all ages are "naturally attuned to musical modes by a kind of spontaneous feeling . . . the whole structure of body and soul is united by musical harmony"). These quotations are from Oliver Strunk, ed., *Source Readings in Music History: From Classical Antiquity through the Romantic Era* (New York: W. W. Norton, 1950), 8, 19, 67, 80, 83. (For Cicero, see n. 98.) These observations were made more explicit in the Romantic era. Consider, for example, Franz Liszt: "Music embodies *feeling* without forcing it – as it is forced in its other manifestations, in most arts and especially in the art of words – to contend and combine with *thought*. If music has one advantage over the other means through which man can reproduce the impressions of his soul, it owes this to its supreme capacity to make each inner impulse audible without the assistance of reason. . ." (ibid., 849). This understanding of music's intimate relationship with sentience is what Arthur Schopenauer designates in *The World as Will and Representation* (1819) when he accords music a special status not enjoyed by the other arts. As Malcolm Budd explains, for Schopenauer, "whilst there is only an indirect relation between the other arts and the inner nature of the world, music's relation to the world's inner nature is immediate. (. . .) Music is a direct representation or copy of the innermost essence of the world, the will" (Malcolm Budd, *Music and the Emotions* [London: Routledge and Kegan Paul, 1985], 86). "The inexpressible depth of all music," explains Schopenhauer,

> by virtue of which it floats past us as a paradise quite familiar and yet eternally remote, and is so easy to understand and yet so inexplicable, is due to the fact that it reproduces all the emotions of our innermost being, but entirely without reality and remote from its pain. (. . .) In the whole of this discussion on music I have been trying to make it clear that music expresses in an exceedingly universal language, in a homogeneous material, that is, in mere tones, and with the greatest distinctness and truth, the inner being, the in-itself, of the world, which we think of under the concept of will, according to its most distinct manifestation (Arthur Schopenhauer, *The World as Will and Representation*, tr. E. F. J. Payne, 2 vols. [Indian Hills, Col.; The Falcon's Wing Press, 1958], I, 264).

As for Hegel, "music . . . has to do with the inner movement of the soul":

> On this account what alone is fitted for expression in music is the object-free inner life, abstract subjectivity as such. This is our entirely empty self, the self without any further content. Consequently the chief task of music consists in making resound, not the objective world itself, but, on the contrary, the manner in which the inmost self is moved to the depths of its personality and conscious soul (Hegel, *Aesthetics*, II, 855, 891).

I believe that in all of these examples the writer is attempting to explain or address the direct and profound link between music and sentience, while pointing out what he feels is music's privileged access to this inner experience of life itself. This is also expressed by T. S. Eliot in "Poetry and Drama" (1951):

> It is a function of all art to give us some perception of an order in life, by imposing an order upon it. (. . .) It seems to me that beyond the nameable, classifiable emotions and motives of our conscious life when directed towards action – the part of life which prose drama is wholly adequate to express – there is a fringe of indefinite extent, of feeling which we can only detect, so to speak, out of the corner of the eye and can never completely focus. . . . This peculiar range of sensibility can be expressed by dramatic poetry, at its moments of

greatest intensity. At such moments, we touch the border of those feelings which only music can express (T. S. Eliot, *On Poetry and Poets* [New York: Farrar, Straus and Cudahy, 1957], 93).

It has been Susanne K. Langer's achievement to identify the territory around that "border" as sentience and to point out that the path from music to sentience is shared in varying degrees and manners with the other arts as a fundamental component of aesthetic experience.

55. Paul Fussell, *Poetic Meter and Poetic Form* (New York: McGraw-Hill, 1979 rev. ed.), 5. Consider also Geoffrey Scott, *The Architecture of Humanism: A Study in the History of Taste* (1914; New York: W. W. Norton, 1974), 161–3:

> The processes of which we are least conscious are precisely the most deep-seated and universal and continuous, as, for example, the process of breathing. And this habit of projecting the image of our own functions upon the outside world, of reading the outside world in our own terms, is certainly ancient, common, and profound. It is, in fact, the *natural* way of perceiving and interpreting what we see. (. . .) It is the way of the poetic mind at all times and places, which humanises the external world. . . . [T]he naïve, the anthropomorphic way which humanises the world and interprets it by analogy with our own bodies and our own wills, is still the aesthetic way; it is the basis of poetry, and it is the foundation of architecture.

Perhaps Scott errs in talking too literally about aesthetic experience in architecture as deriving from "unconscious analogy with our own movements" (165–6) rather than focusing on sentience, the states of the flow of life. The same problem can be found in the otherwise admirable discussions about aesthetic experience in general in *The Beautiful: An Introduction to Psychological Aesthetics* by Vernon Lee [Violet Paget] (Cambridge: Cambridge University Press, 1913; Folcroft Library Editions, 1970 reprint), a work that Scott admires (159–60 n. 1).

56. As quoted in Fussell, *Poetic Meter*, 15.

57. Langer, *Feeling and Form*, 27.

58. We can further develop and nuance Langer's insights into aesthetic experience and its relationship to the elements of art as deriving from a pattern of sentience, as well as her observation that music is "a tonal analogue of emotive life" by turning to the categories that Georg Knepler articulates in his attempt to explain the "methods or 'modes' of music-making and the 'elements' in the music thus produced" (Georg Knepler, *Wolfgang Amadé Mozart*, tr. J. Bradford Robinson [1991; Cambridge: Cambridge University Press, 1994], 172). To this end Knepler has postulated a tripartite phenomenon characterized by an admixture of "logogenic," "biogenic," and "mimeogenic" elements (172–3). Logogenic elements "are analogous to language" and are found "most frequently in . . . those passages resembling the melody – or what linguistic theorists would call 'intonation' – of human utterances, chiefly poetically formed utterances with an underlying metre and rhythm." Knepler further qualifies this definition by pointing out the relationship of logogenic elements to the rhythms of bodily motion: "Here it should immediately be remarked that these metrical qualities of poetic language cannot be completely accounted for in logogenic terms; the order imposed upon them derives from the rhythms of bodily motion."

 Biogenic elements "can be traced back in evolutionary history to the origins of humanity and beyond to the behaviour of higher animals. They involve an entire world of

processes of the most varied kinds. Acoustically perceivable processes inside a living being – faster or louder heartbeat, heavier breathing, groans, cries – are symptomatic of mental states." Knepler points out that according to Hegel, it was "'the natural outburst of emotion, a cry of horror for example, or a sob of pain, the shouts and trills of high-spirited pleasure and merriment, and so forth' – all of them biogenic elements – that constituted the origins of music, though admittedly not in their natural form but 'cadenced', i.e. ordered into a system." "With our greater knowledge of musical cultures," continues Knepler, "we will treat biogenic elements not as *the* starting point of music but merely as *one* of its starting points."

As for mimeogenic elements, they "derive from the necessity in humans (and animals) to imitate much of what they are able to perceive acoustically." At this point Knepler confuses his argument by referring to "heartbeat rhythms as mimeogenic elements" (176).

On the basis of my discussion here, bolstered by the observations by I. A. Richards, Paul Fussell, and Ezra Pound, I would suggest that all three of Knepler's categories reflect human efforts to give artistic form to sentience through a particular medium such as music. The logogenic element is probably not ultimately grounded in language but, as Knepler himself recognizes, in rhythm, and more specially in rhythm related to the movements of the body. Both bodily rhythm in dance and verbal rhythm in poetry, I would argue, present deliberately stylized patternings of sentience for the purpose of promoting a manner of aesthetic response in relationship to the content (dance movements or words). Hence, "vitagenic" would be a more accurate designation for this phenomenon than "logogenic." As for biogenic elements, they refer to outbursts of passion or pleasure reflected in music or any other art form, as well as to biological rhythms such as heartbeats or breathing. These also are made into reflections of emotive states when they are presented through analogy in art forms. The designation of mimeogenic elements might be reserved for mimesis in its classical sense as understood throughout the history of the visual arts of the West and hence can be applied to the imitation of the external world. In music, this would refer to anything ranging from the evocation of thunder to rain, of wind to burbling brooks. In art mimeogenic elements readily serve as reflections of inner emotive states, much like their evocation in literature through what is known as the objective correlative of emotions. They are also important for their associative and symbolic content. One of the virtues of this tripartite division is to provide a unified descriptive as well as analytical model to relate what might otherwise seem to be disparate elements in the realm of aesthetics.

For the objective correlative, see T. S. Eliot, "Hamlet and His Problems" (1919), now conveniently reprinted in Hazard Adams, ed., *Critical Theory since Plato* (New York: Harcourt Brace Jovanovich, 1971), 789: "The only way of expressing emotion in the form of art is by finding an *objective correlative*; in other words, a set of objects, a situation, a chain of events which shall be the formula of that *particular* emotion; such that when the external facts, which must terminate in sensory experience, are given, the emotion is immediately evoked."

59. For a fuller development of the theme of "aesthetic experience," see the discussion on Proust in ch. 2.

60. Stanley Fish, *Self-Consuming Artifacts: The Experience of Seventeenth-Century Literature* (Berke-

ley: University of California Press, 1972), 408 (his emphasis). This passage comes from the appendix, "Literature in the Reader: Affective Stylistics," where, as Fish had pointed out in the preface (xi), he explains his approach to literature.

61. Freud, *Civilization and Its Discontents*, 11.

62. Ibid., 12.

63. The scientific support for this notion is intriguing. Consider, for example, the following observations about the structure of the brain and its relationship to music, as reported in Sandra Blakeslee, "The Mystery of Music: How It Works in the Brain," *New York Times* (May 16, 1995), p. C10: "At the University of California at Irvine, researchers built computer models of how cells in the auditory cortex might fire together during learning. When the computer program was connected to a device that translated its mathematical code into sounds, musical themes appeared. 'It got us to thinking,' said Dr. Gordon Shaw, a physicist at Irvine's Center for the Neurobiology of Learning and Memory. He said that the way cells are connected throughout the cortex might compose the basic neural language of the brain. 'When you hear music, you are exciting inherent brain patterns that derive from this structure and connectivity.'"

64. Roger Caillois, "Sciences diagonales," in *Méduse et Cie* (Paris: Gallimard, 1960), 13: " . . . car la spire constitue par excellence la synthèse de deux lois fondamentales de l'univers, la symétrie et la croissance;. . . . L'opposition de la droite et de la gauche se retrouve dans tous les règnes, depuis le quartz et l'acide tartrique jusqu'à la coquille de l'escargot, toujours dextrogyre à de rarissimes exceptions près, et jusqu'à la prééminence de la main droite chez l'homme." For the examples of spirals, except those of Louis Sullivan, see Alois Riegl, *Problems of Style: Foundations for a History of Ornament*, tr. Evelyn Kain (Princeton: Princeton University Press, 1992), 75–8, 128–31, 221, 230, 290–1, passim. Consider also the intriguing comparison between the decorative structures erected by male bowerbirds and the rich architectural displays of wealthy humans in David Thomson, *Renaissance Architecture: Critics, Patrons, Luxury* (Manchester: Manchester University Press, 1993), xiii–xv.

65. Caillois, "Sciences diagonales," in *Méduse et Cie*, 16–18: "Il est temps d'essayer la chance de *sciences diagonales*."

66. See Johann Wolfgang Goethe, *Die Wahlverwandtschaften. Ein Roman* (1809), translated as *Elective Affinities. A Novel*.

67. Caillois, "Sciences diagonales" and "Courte note sur l'anthropomorphisme," in *Méduse et Cie*, 13–14, 19–20: "Sur le clavier entier de la nature apparaissent ainsi de multiples analogies dont il serait téméraire d'affirmer qu'elles ne signifient rien. . . ." ". . . à douer les êtres et les choses des émotions, des sentiments, des réactions, des préoccupations, des ambitions, etc., propres aux hommes. (. . .) L'homme est un animal comme les autres, sa biologie est celle des autres êtres vivants, il est soumis à toutes les lois de l'univers, celles de la pesanteur, de la chimie, de la symétrie, que sais-je encore?"

68. I develop this thought further in the last section of ch. 3, " 'Intertextuality' and Base Metaphors," placed in that position to take advantage of other concepts and themes, introduced in the interim, that will serve this discussion to good advantage. For an introductory consideration of the biological foundations of moral behavior, see Jean-Pierre Changeux, ed., *Fondements naturels de l'éthique* (Paris: Editions Odile Jacob, 1993).

69. Caillois, "Les Ailes des papillons," in *Méduse et C^{ie}*, 52–3: ". . . les tableaux des peintres comme la variété humaine des ailes des papillons. (. . .) Mais il gagne d'être vraiment l'auteur de ses tableaux, qui en revanche, par un choix malencontreux ou par l'écriture défectueuse de ce seul être faillible, peuvent être de la mauvaise peinture, éloignés qu'ils sont des normes millénaires dont les ouvrages indéfiniment répétés ne peuvent pas éviter une froide et immuable perfection." In an essay on the patterns of color and form in rocks, Caillois addresses the subject of modern abstract art with the following observation: "Turning away from their traditional ambition to represent the human universe, painters, it seems, have engaged themselves on a path where unavoidably, sooner or later, they will encounter the most fearful competition: that of nature itself" ("Natura Pictrix. Notes sur la 'peinture' figurative et non figurative dans la nature et dans l'art,"ibid., 67): "S'écartant de leur ambition traditionnelle de représenter l'univers humain, les peintres, semble-t-il, se sont engagés dans une voie où il ne se peut pas qu'ils ne se trouvent pas tôt ou tard confrontés à la plus redoutable concurrence: celle de la nature elle-même."

70. Roger Caillois, "Esthétique généralisée," in *Cohérences aventureuses* (Paris: Gallimard, 1976), 42: "Ce qui paraît harmonieux à l'homme ne peut être que ce qui manifeste les lois qui gouvernent tout à la fois et le monde et lui-même, ce qu'il voit et ce qu'il est, ce qui donc, PAR NATURE – c'est le mot, – lui convient et le comble. Il est captif de la trame où il est tissé."

71. Noam Chomsky, *Problems of Knowledge and Freedom: The Russell Lectures* (New York: Pantheon / Random House, 1971), 43.

72. Ibid., 47.

73. In separate texts, Chomsky discusses two different types of underlying and fundamental mental operations related to language. In the Russell Lectures, he focuses on "linguistic universals, formal invariants of language" (40), which he terms the "underlying structure" and "underlying form" (35–6) of the "deep-seated and rather abstract principles" of mind that "determine the form and interpretation of sentences" (43). Earlier, in *Cartesian Linguistics: A Chapter in the History of Rationalist Thought* (New York: Harper and Row, 1966), 31–51, he had explained that sentences often are compressed structures that assume elided information only partially hinted at within their actual words or "surface structure." In this text "deep structure" referred to the full array of clauses before the elision and rearrangement of words. The phrase "transformational generative grammar" designated those silent and invisible grammatical transformations by which the mind moves from the surface structure to the deep structure and back to the surface again with the perceived meaning.

I believe that Chomsky's terminology would be clearer if he reversed his terms, using the phrase "deep structure" to designate the universal abstract principles that apply to the formation and interpretation of sentences, and using "underlying structure" to explain the hidden, "underlying system of elementary propositions" (ibid., 35) that undergo grammatical transformations to secure meaning for the surface pattern of words. Not only would this avoid the confusion caused by the use of the words "deep" and "underlying" in these two different cases, it would apply the terminology in what seems to me a more appropriate manner. Thus, I have used the phrase "deep structure" to pertain to Chomsky's discussion of the "deep-seated" universal principles of grammar as presented in the Russell Lectures.

Finally, I note that in *Language and Mind* (New York: Harcourt Brace Jovanovich, 1972 enlarged ed.), viii, Chomsky himself complained of the confusion caused by his use of the term "deep structure": "In fact, even the simplest and most basic points discussed in these essays have been widely misconstrued. For example, there has been a tendency in popular discussion to confuse 'deep structure' with 'generative grammar' or with 'universal grammar.'" The problem, I argue, derives both from Chomsky's applying the word "deep" to the principles of "formal grammar" (alternatively called "universal grammar") and from its being more suited to this principle than to serving as the partner to "surface structure."

74. Chomsky, *Problems of Knowledge*, 49.

75. Ibid., 50–1.

76. In the preface to the 1860 edition of *The Woman in White*, Wilkie Collins, writing evidently about a genre other than the epistolary novel, claimed, "An experiment is attempted in this novel, which has not (so far as I know) been hitherto tried in fiction. The story of the book is told throughout by the characters of the book. They are all placed in different positions along the chain of events; and they all take the chain up in turn, and carry it on to the end." (See Wilkie Collins, *Three Great Novels* [*The Woman in White*, *The Moonstone*, *The Law and the Lady*] [Oxford: Oxford University Press, 1994], 3.) For a brief introduction to the literary technique of sequential and related narratives told by different fictional personages in literature that dates back to the ancient Greeks, see Dorothy R. Thelander, *Laclos and the Epistolary Novel* (Geneva: Droz, 1963), 11–17. For a consideration of Laclos's accomplishment with the genre of the epistolary novel in comparison with his immediate predecessors, see Jean-Luc Seylaz, *Les Liaisons dangereuses et la création romanesque chez Laclos* (Geneva: Droz; Paris: Minard, 1965), 15–25.

77. John Hollander, *The Figure of Echo: A Mode of Allusion in Milton and After* (Berkeley: University of California Press, 1981), v (for the verses from Hollander's poem, "The Widener Burying-Ground"), 72–3.

78. T. S. Eliot, "Tradition and the Individual Talent," in *Selected Essays* (San Diego and New York: Harcourt Brace Jovanovich, 1978 new ed.), 3–11. The quotation is from pp. 4–5.

79. Pierre Choderlos de Laclos, *Les Liaisons dangereuses, ou Lettres recueillies dans une Société, et publiées pour l'instruction de quelques autres* (Paris: Garnier-Flammarion, 1964), 174 (letter LXXXI): "J'étudiai nos moeurs dans les romans; nos opinions dans les philosophes; je cherchai même dans les moralistes les plus sévères ce qu'ils exigeaient de nous, et je m'assurai ainsi de ce qu'on pouvait faire, de ce qu'on devait penser, et de ce qu'il fallait paraître."

80. Pierre Fontanier, *Traité général*, now the second part of *Les Figures du discours*, ed. Gérard Genette (Paris: Flammarion, 1968), 323:

> [L]'*Elocution* . . . c'est une *diction* ménagée avec art et avec goût, pour rendre telle idée ou tel sentiment de manière à produire sur l'esprit ou sur le coeur tout l'effet possible. Or, comment la *diction* peut-elle devenir telle que nous venons de le dire? Comment peut-elle acquérir cette sorte de force et de puissance magique? Par le choix, l'assortiment, et la combinaison de ses élémens, c'est-à-dire, des mots: et c'est là aussi ce qui donne lieu à diverses figures. (. . .) Veut-on rendre une idée principale plus vive, plus lumineuse, ou le coeur s'y arrête-t-il par la force du sentiment? Alors on croit ne l'avoir jamais assez exprimée, et, pour en épuiser en quelque sorte l'expression, on la *déduit* encore d'elle-même, et on la reproduit ou avec la même forme, ou avec des formes différentes: *Figures par déduction*.

For "gradation," see 333–6 (giving definition and examples), 484 (on its derivation from the Latin *gradus* and its being a synonym of *incrementum*). On this subject, see the next note as well. Brian Vickers has called Fontanier "one of the last great French rhetoricians in the classical tradition" (Vickers, *In Defence of Rhetoric* [Oxford: Oxford University Press, 1988], 302).

81. Since "gradation" entails a successive building up or a successive diminution, Fontanier distinguishes between "ascending gradation" and "descending gradation." Quintilian, in his extremely influential *De institutione oratoria*, terms this figure *incrementum*, describing it as follows: "Incrementum est potentissimum, cum magna videntur, etiam quae inferiora sunt. Id aut uno *gradu* fit, aut pluribus" (VIII.iv.3, my emphasis). On this basis, the French have tended to call this figure *la gradation* (see Quintilian, *De l'Institution de l'orateur*, traduit par M. l'abbé Gédoyn, des Académies Française et des Inscriptions, 6 vols. [Paris, Guillmard], IV, 278–9, as well as the treatise on rhetoric by Pierre Fontanier cited in the previous note).

Jane Austen, herself a master of "gradation," names this rhetorical technique while using it in a crucial moment of *Mansfield Park* (1816 2nd ed.; ed. Tony Tanner; Harmondsworth: Penguin, 1966, 319): "[Fanny's] heart was almost broke by such a picture of what she appeared to him; by such accusations, so heavy, so multiplied, so rising in dreadful gradation! Self-willed, obstinate, selfish, and ungrateful. He thought her all this." In the important English Renaissance treatise, *The Arte of English Poesie* (London, 1589; Amsterdam and New York: Da Capo, 1971 reprint), George (?) Puttenham uses the "Greek original," *auxesis*, to designate this figure: "It happens many times that to urge and enforce the matter we speake of, we go still mounting by degrees and encreasing our speech with words or with sentences of more waight one then another . . ." (182). Although "gradation" benefits from the accumulative effect of successive words or phrases, it relies primarily on the mounting or lessening gravity or intensity of each successive item.

The use of the term "gradation," as given here, should not be confounded with *gradatio*, which has been employed to designate a chainlike effect whereby, as Brian Vickers explains, in a sequence of clauses, "the last word(s) of one clause becomes the first of the next, through three or more clauses (an extended form of *anadiplosis*)." (See Brian Vickers, *Classical Rhetoric in English Poetry* [Carbondale and Edwardsville: Southern Illinois University Press, 1970; 1989 rev. ed.], 125–6, 139–40.) Confusion has resulted because historically *gradatio* has also been translated by the word "gradation," as in Quintilian, *De l'Institution de l'orateur*, traduit par M. l'abbé Gédoyn, V, 136–7. In *Shakespeare's Use of the Arts of Language* (New York: Hafner, 1947; 1966 printing), 82–3, 306, 361, Sister Miriam Joseph explains that English Renaissance treatises on rhetoric referred to *gradatio* as "climax." I suggest that "climax" be used for the extended form of *anadiplosis* and that "gradation" be reserved for *incrementum*.

Another figure related to gradation is *systrophe*. "The classical definition of *systrophe*," writes Salomon Hegnauer, " – and to my knowledge the only analysis of this particular rhetorical figure at all – is found in Peacham's *Garden of Eloquence* [1593], where it is exemplified by another classical instance from Cicero: '*Systrophe*, of some called *Conglobatio*, of others *convolutio*, and it is when the Orator bringeth in many definitions of one thing, yet not such definitions as do declare the substance of a thing by the general kind,

and the difference, which the art of reasoning doth prescribe, but others of another kind all heaped together: such as these definitions of *Cicero* be in the second booke of an Orator, where he amplifieth the dignitie of an hystory thus, An historie, saith he, is the testimony of times, the light of veritie, the maintenance of memorie, the schoolmistrisse of life, and messenger of antiquitie.'" Hegnauer opens his article with a striking example of *systrophe* from Shakespeare's *Richard III* (IV. iv. 26–8):

> Dead life, blind sight, poor mortal-living ghost,
> Woe's scene, world's shame, grave's due by life usurped,
> Brief abstract and record of tedious days.

See Salomon Hegnauer, "The Rhetorical Figure of *Systrophe*," in Brian Vickers, ed., *Rhetoric Revalued: Papers from the International Society for the History of Rhetoric*, Medieval and Renaissance Texts and Studies, vol. 19 (Binghamton, N.Y.: Center for Medieval and Early Renaissance Studies, 1982), 179–86. The properties of *systrophe* pertain to Fontanier's "figures by deduction" and to the similar category of "figures by liaison," for which Fontanier gives examples under the figures of *adjonction* and *conjonction* (Fontanier, *Les Figures du discours*, 336–40). See also Vickers, "Introduction," in *Rhetoric Revalued*, 29–30, where as editor he observes,

> As we see here, *systrophe*, consisting as it does of definitions heaped up in parallel, usually without connective links, achieves a composite evocation of a term of reference by accumulating a series of individual tropes. (. . .) It is also a figure that moves forward yet constantly refers back, and is capable of embracing the most ironic effects, such as . . . Macbeth's lament for the sleep that he has destroyed:
>> the innocent sleep,
> Sleep that knits up the ravelled sleeve of care,
> The death of each day's life, sore labour's bath,
> Balm of hurt minds, great Nature's second course,
> Chief nourisher in life's feast – .

Gradation and *systrophe* too figure among the chief nourishers of life's feast as they channel, mold, and color sentience.

82. Perhaps for this reason Quintilian placed irony alternately among the tropes and among the figures of thought (*figurae sententiarum*). See Quintilian, *De institutione oratoria*, IV. 1. In *Rhetoric in Greco-Roman Education* (New York: Columbia University Press, 1957), 89–91, Donald Lemen Clark explains that ancient rhetoric distinguished between tropes; figures of thought (*figurae sententiarum*), which "deal with the conception of ideas"; and figures of language (*figurae verborum*), which "deal with their expression." Since I discuss tropes and figures of language in this book, it might be helpful to keep in mind the nature of that third component of rhetoric, figures of thought, to round out the picture. Clark reviews the figures of thought, as found in Quintilian: the rhetorical question (*interrogatio*), anticipation (*prolepsis*), hesitation (*dubitatio*), consultation (*communicatio*), simulation of any passion, impersonation of characters (*prosopopoeia*), apostrophe, illustration (*evidentia*), irony, simulated reticence (*aposiopesis*), mimicry (*ethopoeia*), pretended repentance, and intimation (*emphasis*).

83. "*Metaphor*, the Greek term for our *translatio*." Quintilian, as quoted in Terence Hawkes, *Metaphor* (London: Methuen, 1972), 13. For a discussion of metaphor as "transference," see

2–13. Hawkes points out that metonymy and synecdoche, as well as other tropes – "Antonomasia, Hyperbaton, Metalepsis and the rest" – are effectively types of metaphor (4).

84. Fielding, *Tom Jones*, 114.

85. S. I. Hayakawa, explaining the argument of Weller Embler's *Metaphor and Meaning* (Deland, Fla.: Everett / Edwards, 1966), in his "Foreword," i.

86. For a similar distinction between tropes and figures of elocution, see Vickers, *Classical Rhetoric in English Poetry*, 86.

87. Victor Hugo, *Notre-Dame de Paris, 1482* (Paris: Garnier Frères, 1961), 136: "Peu à peu, le flot des maisons, toujours poussé du coeur de la ville au dehors, déborde, ronge, use et efface cette enceinte. Philippe-Auguste lui fait une nouvelle digue. Il emprisonne Paris dans une chaîne circulaire de grosses tours, hautes et solides. Pendant plus d'un siècle, les maisons se pressent, s'accumulent et haussent leur niveau dans ce bassin comme l'eau dans un réservoir."

88. Analysis of diction undertaken in this manner can become quite sophisticated and quite complex. See, for example, Leo Spitzer, "The Style of Diderot," *Linguistics and Literary History: Essays in Stylistics* (New York: Russell and Russell, 1962), 135–91. One does not have to concur with all of Spitzer's conclusions to recognize the fecund workings of a brilliant mind on a profoundly creative author. Spitzer's theme is essentially the relationship between sentience and diction: "*Argumentum*: I had often been struck, in reading Diderot, by a rhythmic pattern in which I seemed to hear the echo of Diderot's speaking voice: a self-accentuating rhythm, suggesting that the 'speaker' is swept away by a wave of passion which tends to flood all limits" (135). Spitzer then proceeds to correlate the relationship between rhythm and meaning.

89. "Longinus," *On Sublimity*, 12 (§ 9.9). Consider also another example given by "Longinus": "Thus Heracles says after the killing of the children: 'I'm full of troubles, there's no room for more'" (47 [§ 40.3]).

90. Pierre Fontanier, *Manuel classique pour l'étude des tropes ou Elémens de la science du sens des mots* (1830), now the first part of *Les Figures du discours*, 175–6: "N'est-ce pas l'extrême simplicité des mots? Comme, en effet, ces mots, si peu ambitieux, font bien concevoir et l'efficacité de la parole toute-puissante de Dieu, et la rapidité avec laquelle la lumière produite par cette parole, se répandit à l'instant même dans l'immensité de l'espace!"

91. The concept of "intertextuality" will be discussed in the last section of ch. 3, "'Intertextuality' and Base Metaphors."

92. For an analysis of this book, see the section "Edward W. Said: Imperialism Revisited" in ch. 4.

93. Victor Hugo, *Les Misérables*, ed. Yves Gohin (Paris: Gallimard, 1973), III, 529: "La misère morale de Thénardier, ce bourgeois manqué, était irrémédiable; il fut en Amérique ce qu'il était en Europe. Le contact d'un méchant homme suffit quelquefois pour pourrir une bonne action et pour en faire sortir une chose mauvaise. Avec l'argent de Marius, Thénardier se fit négrier." The French original, ending with "se fit négrier," is more compact and hence more powerful than my English translation.

94. Fyodor Dostoyevsky, *Crime and Punishment*, tr. David McDuff (London and New York: Viking / Penguin, 1991), 49–50 (ellipsis in the original).

95. Hugo, *Notre-Dame*, 569: "[O]n trouva parmi toutes ces carcasses hideuses deux squelettes dont l'un tenait l'autre singulièrement embrassé. L'un de ces deux squelettes, qui était celui d'une femme, avait encore quelques lambeaux de robe d'une étoffe qui avait été blanche, et on voyait autour de son cou un collier de grains d'adrézarach avec un petit sachet de soie, orné de verroterie verte, qui était ouvert et vide. Ces objets avaient si peu de valeur que le bourreau sans doute n'en avait pas voulu. L'autre, qui tenait celui-ci étroitement embrassé, était un squelette d'homme. On remarqua qu'il avait la colonne vertébrale déviée, la tête dans les omoplates, et une jambe plus courte que l'autre. Il n'avait d'ailleurs aucune rupture de vertèbre à la nuque, et il était évident qu'il n'avait pas été pendu. L'homme auquel il avait appartenu était donc venu là, et il y était mort. Quand on voulut le détacher du squelette qu'il embrassait, il tomba en poussière."

96. "Longinus," *On Sublimity*, 2 (§ 1.4), 41 (§ 34.4).

97. For a brief but illuminating history reaching from the fifth-century B.C. through the Renaissance of the importance of balance and serial development as the main *schemata verborum* or "schemes" of classical rhetoric, what Fontanier would call figures of elocution (from *figurae verborum* or figures of language), see Brian Vickers, *Francis Bacon and Renaissance Prose* (Cambridge: Cambridge University Press, 1968), ch. 4 ("Syntactical Symmetry"), 96–115 (see also 116–40 for Bacon's use of parallelism or syntactical symmetry). Vickers's discussion of "syntactical symmetry," a term that subsumes "gradation" [*incrementum*] without naming it or clearly articulating its features into a broader category of "parallelism," covers the many different components of what I have called balance. In this chapter Vickers also defines and illustrates the "most frequently used figures": *parison* ("corresponding structure in consecutive clauses"), *isocolon* (clauses of equal length), *antimetabole* ("corresponding structure with inversion"), *paromoion* (consecutive clauses with corresponding parts having internal rhyme), *anaphora* (identical word starting consecutive clauses), and *epistrophe* (identical word at the end of consecutive clauses). For the central importance of parallel and serial development to rhetoric, see also Cooper, *The Rhetoric of Aristotle*, 202 (1409a–9b); Cicero, *Partitiones oratoriae*, vi.21; xv.54; *De oratore*, III.liv.206–8. For a discussion of the importance and various modes of parallelism, including what was conceived as an antithetical balancing of clauses for what was designated as the "periodic style" of discourse, with particular reference to the writings of Gorgias of Leontini, Isocrates, Aristotle, and Quintilian, see Clark, *Rhetoric in Greco-Roman Education*, 92–3, 158–9. For an illuminating discussion of both balance and serial development in a modern author, see Jean Mouton, *Le Style de Marcel Proust* (1941; Paris: A. G. Nizet, 1968), ch. 4 ("Le Rythme"), ch. 5 ("L'Enumération"), 111–72.

98. Marcus Tullio Cicero, *De oratore*, III.li.195–8:

> [I]n all types of perception, but especially here [with oratory], some manner of strong and extraordinary natural instinct comes into play. In effect, through a sort of subconscious feeling all people, even those without any theory of art or reasoning, discern what is good or defective in matters of art and in matters of reasoning. Not only do they do this for pictures, statues, and other works of art that nature has less endowed them to understand; they also judge even more astutely when it comes to words, their rhythms and sounds, all these being impressions that rest upon sensations common to all. Nor has nature seen fit to deprive

anybody altogether of these faculties. (. . .) Since art started from nature, it would seem to have accomplished nothing if it did not stir and delight nature. Now nothing has such an intimate relationship with our souls as rhythm and sound, which animate us, calm us, soothe us, relax us, and often lead us to delight or sorrow. Their powerful influence is more suited to verse and song, nor was it neglected, in my opinion, either by Numa, so learned a king, or by our ancestors; . . . but it is especially in ancient Greece that it was known. . . . If the uninitiated see in a line of verse something that jars, they are no less sensitive to something that limps along in our oratory.

Consider also Diderot: "Qu'est-ce donc que le rythme? . . . C'est l'image même de l'âme rendue par les inflexions de la voix" (What then is rhythm? . . . It is the very image of the soul rendered through the inflexion of the voice). Quoted in Spitzer, "The Style of Diderot," *Linguistics and Literary History*, 178 n. 14. For an historical account of the mimetic function of figurative speech as argued from the time of the ancient Greeks through the eighteenth century, see Vickers, *In Defence of Rhetoric*, ch. 6 ("The Expressive Function of Rhetorical Figures").

99. For a discussion about the appropriate translation of the Greek title, *Peri Hupsous*, of "Longinus's" treatise, see W. Ross Winterowd, *Rhetoric: A Synthesis* (New York: Holt, Reinhart and Winston, 1968), 46–7, and "Longinus," *On Sublimity*, xvi–xvii. On the history of the sublime from "Longinus" onward, see Samuel H. Monk, *The Sublime: A Study of Critical Theories in XVIII-Century England* (Ann Arbor: University of Michigan Press, 1960); Edmund Burke, *A Philosophical Enquiry into the Origins of Our Ideas of the Sublime and Beautiful*, ed. J. T. Boulton (London, 1958; Notre Dame: University of Notre Dame Press, 1968). For the sublime in nature, see, in addition to Burke, Marjorie Hope Nicolson, *Mountain Gloom and Mountain Glory: The Development of the Aesthetics of the Infinite* (Ithaca: Cornell University Press, 1959; New York: Norton, 1963); Barbara Maria Stafford, *Voyage into Substance: Art, Science, Nature, and the Illustrated Travel Account, 1760–1840* (Cambridge, Mass.: MIT Press, 1984). On the sublime in late eighteenth-century architecture, see Richard A. Etlin, *The Architecture of Death: The Transformation of the Cemetery in Eighteenth-Century Paris* (Cambridge, Mass.: MIT Press, 1984), 101–59 (ch. 3, "The Sublime [1785]"); Anthony Vidler, *Claude-Nicolas Ledoux: Architecture and Social Reform at the End of the Ancien Régime* (Cambridge, Mass.: MIT Press, 1990), 147–9.

100. If I were to continue to define categories for value in literature, I would proceed in two directions, according to the distinctions made here between a heightened sense of sentience and insights into the nature of people and life. As with all such categories, which are enunciated to help clarify and direct thought, there are also important areas of overlap and mutual dependency, which merit further consideration.

For the first issue, I would study the musical quality of language in its relationship to the expression of thought and feeling. On this theme, see, for example, Dionysius of Halicarnassus, *On Literary Composition. Being the Greek Text of the "De compositione verborum,"* ed. and tr. W. Rhys Roberts (London: Macmillan, 1910), Ancient Greek Literature Series (New York: Garland, 1987), especially chs. 10–20; L. P. Wilkinson, *Golden Latin Artistry* (Cambridge University Press, 1963; Bristol: Bristol Classical Press, 1985), with a discussion of "verbal music" (ch. 2) and its relationship to "expressiveness" (ch. 3) and rhythm (part 2).

For the second issue, I would address the moving depiction of moral courage in the face of severe and even mortal danger. Here I would concentrate on instances in which the

author has placed a character in a situation where the refusal to act will result in the death or suffering of another as victim and where the decision to act carries the strong risk of serious injury, great physical suffering, total social ruination and imprisonment, or death to the rescuer. In Hugo's *Les Misérables*, Jean Valjean's assistance to the man crushed under the wagon and his self-exposure to free the innocent man wrongly accused through a case of mistaken identity, and in Dickens's *Bleak House*, Esther's and Charley's unhesitating decision to nurse the lad who is gravely ill with what is probably smallpox are examples of this phenomenon.

Still another category of value of this second type can be found in the successful depiction of the individual's infinitesimal place within the vastness of the world or cosmos. We find moving reminders about this fundamental aspect of our human condition, for example, deep in the mine in Zola's *Germinal*, on the heath in Hardy's *The Return of the Native*, and in the jungle of Conrad's *Heart of Darkness*.

101. See Etlin, *Modernism in Italian Architecture*, ch. 14 ("The Danteum"). For an engaging review of other literature on the architecture of literary form, ranging from studies of Virgil to Fielding and passing through the work of Chaucer, Milton, and Spenser, see K. K. Ruthven, *Critical Assumptions* (Cambridge: Cambridge University Press, 1979), 16–21.

102. Jonathan Bate, "Love Locked Out. The Downgrading of the Affections in New Shake-spearean Criticism," *Times Literary Supplement* (December 24, 1993), 4. Bate is referring to R. A. Foakes, *Hamlet Versus Lear: Cultural Politics and Shakespeare's Art* (Cambridge: Cambridge University Press, 1993).

103. For a further development of these themes, see Richard A. Etlin, *Frank Lloyd Wright and Le Corbusier: The Romantic Legacy* (Manchester: Manchester University Press, 1994), 30–60, 65–70, 129–43.

104. The integral nature of a heightened sense of body-space that occurs as one moves through a building is a principal theme in "Violence of Architecture," *Artforum* (September, 1981), 44–7, by the architect Bernard Tschumi. Unfortunately, Tschumi presents his case with a deconstructionist vocabulary in the manner of the followers of Michel Foucault, replete with references to imprisonment, violence, and torture. Independent of such phrases, the article offers important insights, such as Tschumi's observation about how the "spaces" of architecture become its "events" as one moves through them:

> This intrusion [of a human body] is inherent in the idea of architecture; any reduction of architecture to its spaces at the expense of its events is as simplistic as the reduction of architecture to its facades. (. . .) This also suggests that actions qualify spaces as much as spaces qualify actions; that space and action are inseparable and that no proper interpretation of architecture, drawing or notation can refuse to consider this fact (44).

For a further development of these themes, see the section below in this chapter, "Distinguishing between Greater and Lesser Art," and especially n. 112.

105. For a further development of this theme, see Richard A. Etlin, *Symbolic Space: French Enlightenment Architecture and Its Legacy* (Chicago: University of Chicago Press, 1994), 55–87.

106. We can find confirmation of these values in the best articles of dance criticism, which are those that also define the values that invest dance with its deepest meaning. See, for example, "The Long Goodbye," *New York Review of Books* (April 7, 1994), 24–30, in which

Joan Acocella explains George Balanchine's achievement, encapsulated by the terms "energy," "musicality," and "technique," illustrated in this order:

> Balanchine wanted to create in the body a kind of disciplined tension that would read, onstage, as energy. That, more than anything else, is what made his dancers look different from others. They seemed to be moving even when they were standing still. There are two kinds of stillness, Balanchine used to say. Think of a cat who is just standing; he is still. Now think of a cat who is about to pounce; he is still, too, but in a different way. That's the way Balanchine wanted, and he got it. (. . .) This organic musicality – the ability to *inhabit* the music – was what Balanchine tried to achieve. And apart from their hyper-energized look, it was the quality that made his dances exciting. (. . .) The fervid attack, the sudden, slicing gestures, the element of risk and exposure that made this dance seem at once so drastic and so natural. . . .

Behind this all was a sense of the intangible, of the spirit:

> Indeed, his ballets were clearly metaphors for the life of the spirit. Balanchine was a religious man. Art, he once told an interviewer, has something to do with "something that is not here". . . . Again and again in his work he would have the ballerina appear at the back of the stage and indicate by her action – at the same time that all other dancers onstage were indicating by their actions toward her – that she was a messenger from "that thing."

107. Clara Weyergraf-Serra and Martha Buskirk, eds., *The Destruction of "Tilted Arc": Documents* (Cambridge, Mass.: OCTOBER Books and MIT Press, 1991), 27, 65. See also Serra's paper presented to the *Tilted Arc* Site Review Advisory Panel, December 15, 1987 (180–7). In addition, see Grégoire Muller, *The Avant-Garde: Issues for the Art of the Seventies* (New York: Praeger, 1972), 19; Laura Rosenstock, "Introduction," and Douglas Crimp, "Serra's Public Sculpture: Redefining Site Specificity," in Rosiland Krauss, *Richard Serra / Sculpture*, ed. Laura Rosenstock (New York: Museum of Modern Art, 1986), 11, 53. I refer the reader to these additional texts by Serra and others to demonstrate that the quotation from Serra is typical of how he and his supporters see his work. Consider also Serra's description of *Arc* (1980), a curved piece made of Cor-Ten steel and measuring 200 feet long, 12 feet high, and 2.5 inches thick, located in Manhattan at the exit from the Holland Tunnel. In "St. John's Rotary Arc," *Artforum* (September 1980): 52–5, Serra describes *Arc* as "site-specific." This is how he explains the site: "Other than being indifferent to questionable ideologies and uses, the Rotary site has no romantic, historical, architectural, esthetic or picturesque pretensions; no commercial or symbolic references." Serra's account of the meaning and experience of *Arc* is dominated by references to "the *Arc*'s convexity and concavity," which is said to "foreshorten, then compress, overlap and elongate," and so forth. Serra never attributes to this work any of the enumerated "pretensions" or "references."

108. The response by Serra's defenders, as found in the selected testimony published by Clara Weyergraf-Serra and Martha Buskirk, was generally to avoid this issue of value and to concentrate instead on artistic freedom and the inviolability of a contract. With respect to visual matters, the editors' introduction to the transcripts from the public hearing is instructive on this account. "The primary reason, of course," adduced by those arguing in favor of the work, "was its site-specific nature, and many of the speakers emphasized the fact that any attempt to remove the work would destroy it" (57). On the other hand, "Most of the proponents of relocation focused on aesthetic dislike of *Tilted Arc*" (ibid.).

Among the twenty-three statements reproduced here in favor of *Tilted Arc*, the few people who raised its aesthetic value generally did not explain their assessment. They merely mentioned it in passing. Thus, Douglas Crimp simply says that *Tilted Arc* is "beautiful" (73) as does Coosje Van Bruggen (speaking as well for Claes Oldenburg), who puts the word in quotation marks (78). William Ruben pronounces *Tilted Arc* to be "a powerful work of great artistic merit" (101), once again without explanation about what makes it so great. There are two notable exceptions in this group. One is Rosiland Krauss, whose remarks are discussed later. The other is Roberta Smith, who speaks for the "aesthetic quality" of *Tilted Arc* by offering a detailed aesthetic assessment of the piece, which includes a brief reference to Donald Judd's appreciation as well (103–4).

109. To paraphrase Hilton Kramer writing on *Tilted Arc*, I am not making a judgment about Serra's artistic talent but rather about the uses to which he chose to put it in this work. See Hilton Kramer, "A Plaza Taken Hostage," review article of Weyergraf-Serra and Buskirk, eds., *The Destruction of "Tilted Arc": Documents*, in *Times Literary Supplement* (November 8, 1991), 25–6. The question of the contemporary artist's depth of engagement over the last half century has been raised as a comprehensive issue by Donald Kuspit, "The New(?) Expressionism: Art as Damaged Goods," *Artforum* (November, 1981): 47–55. See the quotation from this article in n. 41 as well as Kuspit's remarks on Richard Serra's work within the context of his theme (51–2). For a sampling of the testimony offered in favor of removing *Tilted Arc*, see Weyergraf-Serra and Buskirk, eds., *The Destruction of "Tilted Arc": Documents*, 111–29.

110. Weyergraf-Serra and Buskirk, eds., *The Destruction of "Tilted Arc": Documents*, 81–2.

111. Ibid., 66.

112. This type of experience applies even to examples of what the Italian architect and critic Vittorio Gregotti calls "radical minimalism" in today's architecture. Here is an excerpt from Ada Louise Huxtable's description of Alvaro Siza's Museum of Contemporary Art of Galicia in Santiago de Compostela, Spain, a leading example of this style:

> [T]here is an almost reverse high drama in the subtle precision with which the stair meets and stops the long portico that sweeps along the building's main facade. Inside, the reception area with its sleek, serpentine counter is an oasis of cool white marble. Where the structure's two sections merge, they form a triangular atrium sky-lit at the top, placed slightly to one side – rarely is anything straight ahead in this building. . . . Three shallow corner steps rotate the visitor diagonally down from the reception area into the first of a series of three irregularly shaped temporary exhibition spaces. A central spine of stairs, ramps, and corridors slashes straight across the angled plan. (. . .) [A]s you go up Siza's stairs you are offered views of low-walled balconies with partially glimpsed galleries behind them; these shifting planes and suggestive spaces – neither quite open nor closed – are constantly modified by variations in natural and artificial light. Vistas appear that Dr. Caligari might have envied, although there is nothing sinister here, only delight.

As Huxtable observes, "The paths people take through a building make movement an essential part of its design." Huxtable is reiterating the basic principle that Le Corbusier had stressed in his 1942 lectures to students of architecture: "An architecture must be *walked through and traversed*. (. . .) [A]rchitecture can be judged as dead or living by the degree to which the rule of *movement* has been disregarded or brilliantly exploited." The viewer experiences an "intense feeling that has come from that sequence of movements." (*Le Corbu-*

sier Talks with Students from Schools of Architecture, tr. Pierre Chase [New York: Orion Press, 1961], 44–5; *Entretien avec les étudiants des écoles d'architecture* [Paris, (1943)], § 4: "L'architecture *se marche, se parcourt*. . . . Il en ressent l'émoi, fruit de commotions successives. Si bien qu'à l'épreuve les architectures se classent en mortes et en vivantes selon que la règle du *cheminement* n'a pas été observée, ou qu'au contraire la voilà exploitée brillamment.")

For a discussion of the sequencing of spaces in architecture, with special reference to Auguste Choisy's treatment of this theme as a universal historical phenomenon, to Le Corbusier's use of the "architectural promenade," and to Frank Lloyd Wright's application of the *mise en scène*, see Etlin, *Frank Lloyd Wright and Le Corbusier: The Romantic Legacy*, 97–106, 112–43. The quotations from Ada Louise Huxtable come from her article, "The New Architecture," *New York Review of Books* (April 6, 1995), 18–21, which makes repeated reference to Le Corbusier's pilgrimage chapel at Ronchamp. For the quotation about the Egyptian pylon temple, see Auguste Choisy, *Histoire de l'architecture* (Paris: Edouard Rouveyre, [1899]), I, 60: "Dans la plupart des temples, à mesure qu'on approche du sanctuaire, le sol s'élève et les plafonds s'abaissent, l'obscurité croît et le symbole sacré n'apparaît qu'environné d'une lueur crépusculaire." The quotation about the suspended dome of Hagia Sophia is by Justinian's historian, Procopius, as found in David Watkin, *A History of Western Architecture* (New York and London: Thames and Hudson, 1986), 78. The description of moving through the Roman baths is from Thomas Leverton Donaldson, *Preliminary Discourse Pronounced before the University College of London, upon the Commencement of a Series of Lectures on Architecture, 17th October, 1842* (London: Taylor and Walton, 1842), 6 n. 2. The line by T. S. Eliot is from "Burnt Norton," in *Four Quartets* (see ch. 2, n. 64).

113. Weyergraf-Serra and Buskirk, eds., *The Destruction of "Tilted Arc": Documents*, 103.

114. There was, as is well known, controversy as to whether the abstract nature of the memorial was sufficient to its purpose, with the result being the addition of representational statuary to the site. On this issue, see Jan C. Scruggs and Joel L. Swerdlow, *To Heal a Nation: The Vietnam Veterans Memorial* (New York: Harper and Row, 1985), 68–134.

115. This discussion of the Vietnam Veterans Memorial has been adapted from my paper, "The Space of Absence," read at the First International Encounter on Contemporary Cemeteries, sponsored by the Department of Architecture and Housing, Ministry of Transportation and Public Works, Regional Government of Andalusia, Seville, June 4–7, 1991, and subsequently published in the symposium's acts, as well as in Etlin, *Symbolic Space*, 181. For a discussion of Blondel's advice on cemetery design and its subsequent place in academic architecture, see Etlin, *The Architecture of Death*, 47, passim.

116. Stephen Toulmin in "Calls for Papers," *Common Knowledge* 1 (Spring 1991): 4.

117. On the "unerring sentiment of Nature" and its relationship to the limits of ratiocination, see Buffier, *First Truths*, 43–9 (§ 63–71).

118. For a Marxist critique of the traditional Marxist suspicion about the spiritual autonomy of art, see Herbert Marcuse, *The Aesthetic Dimension: Toward a Critique of Marxist Aesthetics* (Boston: Beacon Press, 1978). Denis Donoghue discusses Marcuse's book and places it within the context of the history of "a 'defence of poesy'" in "The Use and Abuse of Theory" (1992) and "The Political Turn in Criticism" (1989), *The Old Moderns: Essays on Literature and Theory* (New York: Alfred A. Knopf, 1994), 87–8, 98–100.

119. Linda Nochlin, *Realism* (Baltimore: Penguin, 1971), 43–4, 49.

Chapter 2

1. This position, largely formulated from a caricature about the role of "creation, inspiration and expression" in art, constitutes the subject of the first part of a chapter devoted to "The Myth of Creation," as denounced by the theorists of the French *nouveau roman*, in Celia Britton, *The Nouveau Roman: Fiction, Theory and Politics* (New York: St. Martin's Press; London: Macmillan Press, 1992), 118–24.

2. Logan Pearsall Smith, *Four Words: Romantic, Originality, Creative, Genius*, S.P.E. Tract No. XVII (Oxford: Oxford University Press, 1924), 23–4. For testimonials by poets about the conviction that inspiration owes much to a "dependence upon some power outside oneself," see John Press, *The Fire and the Fountain: An Essay on Poetry* (Oxford: Oxford University Press, 1955), ch. 1 (this quotation is taken from p. 20). For a powerful account of this experience, consider Nietzsche's discussion of inspiration in his autobiography, *Ecce Homo*: "Has any one at the end of the nineteenth century any distinct notion of what poets of a stronger age understood by the word inspiration? If not, I will describe it. If one had the smallest vestige of superstition left in one, it would hardly be possible completely to set aside the idea that one is the mere incarnation, mouthpiece, or medium of an almighty power. The idea of revelation, in the sense that something which profoundly convulses and upsets one becomes suddenly visible and audible with indescribable certainty and accuracy – describes the simple fact. One hears – one does not seek; one takes – one does not ask who gives: a thought suddenly flashes up like lightning, it comes with necessity, without faltering – I have never had any choice in the matter. There is an ecstasy so great that the immense strain of it is sometimes relaxed by a flood of tears. . . . Everything happens quite involuntarily, as if in a tempestuous outburst of freedom, of absoluteness, of power and divinity." *The Complete Works of Nietzsche. The First Complete and Authorised English Translation*, ed. Oscar Levy, tr. Anthony M. Ludovici (London: George Allen and Unwin, 1911; 1924 reprint), XVII, 101–2.

3. William Duff in *An Essay on Original Genius; and Its Various Modes of Exertion in Philosophy and the Fine Arts, Particularly in Poetry* (London, 1767; New York: Garland, 1970 reprint), 6–7, 48, 86.

4. Ibid., 8–9, 11.

5. Duff, as well, argues for the "mutual influence" among them (ibid., 63–72).

6. Ibid., 66.

7. To continue this list I would next turn to the phenomenon of preparation that students of creative activity have studied in its two-part operation of seemingly unfruitful work, followed by an equally seemingly spontaneous inspiration, which issues from the subconscious of the prepared mind. As Press explains in *The Fire and the Fountain*, 25–6: "The poet may toil for long periods and his work will perhaps lack all trace of inspiration, yet his craftsmanship and the skill that grows with the practice of his trade are not wasted. When inspiration finally comes he is ready to take advantage of the unexpected gift." Press recommends John Livingstone Lowes's analysis of Coleridge's "Kubla Kahn" in *The Road to Xanadu: A Study in the Ways of the Imagination* (Boston and New York: Houghton Mifflin, 1927) for a study of this aspect of the creative process.

8. This point is stressed by K. K. Ruthven in *Critical Assumptions*, who also evokes the birth of

Athena, but then considers opinions expressed by writers and critics both for and against the revision of first drafts or first editions in his discussion of "The Prestige of Making," 71–5. To follow the artist through the process of the patient search, Ruthven (28) recommends Jon Stallworthy's analysis of Yeats's poems in *Between the Lines: Yeats's Poetry in the Making* (Oxford: Oxford University Press, 1963). Stallworthy's superb study can be supplemented profitably with Curtis B. Bradford, *Yeats at Work* (Carbondale and Edwardsville: Southern Illinois University Press, 1965), which considers Yeats's plays and prose writings as well.

9. Donald Hoffmann, *Frank Lloyd Wright's Fallingwater: The House and Its History* (New York: Dover, 1978), 13.

10. Ibid., 16–17.

11. On the subject of Le Corbusier's changing approach to the grid of structural columns, I am indebted to Barry Maitland, "The Grid," nos. 15 / 16 *Oppositions* (Winter–Spring 1979): 91–117.

12. For a further development of this theme, see Etlin, *Frank Lloyd Wright and Le Corbusier: The Romantic Legacy*, 17–21, 196–9.

13. All quotations from Proust are taken from the Bibliothèque de la Pléiade edition: *"Jean Santeuil" précédé de "Les Plaisirs et les jours"*, eds. Pierre Clarac and Yves Sandre (Paris: Gallimard, 1971), "Rêve" (127–30), "La Mer" (142–4), and *A la Recherche du temps perdu*, eds. Pierre Clarac and André Ferré (Paris: Gallimard, 1954), I, 3–5. Biographical information comes from the notes in these books.

14. Proust, "Rêve," in *Les Plaisirs et les jours* now in *"Jean Santeuil" précédé de "Les Plaisirs et les jours"*, eds. Clarac and Sandre, 128: "Je me couchai samedi d'assez bonne heure. Mais vers deux heures le vent devint si fort que je dus me relever pour fermer un volet mal attaché qui m'avait réveillé. Je jetai, sur le court sommeil que je venais de dormir, un regard rétrospectif et me réjouis qu'il eût été réparateur, sans malaise, sans rêves. A peine recouché, je me rendormis. Mais au bout d'un temps difficile à apprécier, je me réveillai peu à peu, ou plutôt je m'eveillai peu à peu au monde des rêves, confus d'abord comme l'est le monde réel à un réveil ordinaire, mais qui se précisa. Je me reposais sur la grève de Trouville qui était en même temps un hamac dans un jardin que je ne connaissais pas, et une femme me regardait avec une fixe douceur. C'était Mme Dorothy B***."

15. Ibid., 129: "Elle s'approcha, mit à la hauteur de ma joue sa tête renversée dont je pouvais contempler la grâce mystérieuse, la captivante vivacité, et dardant sa langue hors de sa bouche fraîche, souriante, cueillait toutes mes larmes au bord de mes yeux. Puis elle les avalait avec un léger bruit des lèvres, que je ressentais comme un baiser inconnu, plus intimement troublant que s'il m'avait directement touché. Je me réveillai brusquement, reconnus ma chambre et comme, dans un orage voisin, un coup de tonnerre suit immédiatement l'éclair, un vertigineux souvenir de bonheur s'identifia plutôt qu'il ne la précéda avec la foudroyante certitude de son mensonge et de son impossibilité. Mais, en dépit de tous les raisonnements, Dorothy B*** avait cessé d'être pour moi la femme qu'elle était encore la veille. Le petit sillon laissé dans mon souvenir par les quelques relations que j'avais eues avec elle était presque effacé, comme après une marée puissante qui avait laissé derrière elle, en se retirant, des vestiges inconnus. J'avais un immense

désir, désenchanté d'avance, de la revoir, le besoin instinctif et la sage défiance de lui écrire. Son nom prononcé dans une conversation me fit tressaillir. . . ."

16. Marcel Proust, "La Mer," ibid., 143–4: "Elle rafraîchit notre imagination parce qu'elle ne fait pas penser à la vie des hommes, mais elle réjouit notre âme, parce qu'elle est, comme elle, aspiration infinie et impuissante, élan sans cesse brisé de chutes, plainte eternelle et douce. Elle nous enchante ainsi comme la musique, qui ne porte pas comme le langage la trace des choses, qui ne nous dit rien des hommes, mais qui imite les mouvements de notre âme. Notre coeur en s'élançant avec leurs vagues, en retombant avec elles, oublie ainsi ses propres défaillances, et se console dans une harmonie intime entre sa trisesse et celle de la mer, qui confond sa destinée et celle des choses."

17. For a close textual analysis of how various writers (Bossuet, Fénélon, Pascal, Racine, Rousseau, Buffon, La Fontaine, Chateaubriand, Hugo, Balzac, Stendhal, Flaubert) re-worked individual passages, even up to five successive times, see Antoine Albalat, *Le Travail du style enseigné par les corrections manuscrites des grands écrivains* (Paris: Armand Colin, 1903; 1991 reprint).

18. See, for example, Ed. de Jongh, "The Spur of Whit: Rembrandt's Response to an Italian Challenge," *Delta* 12 (Summer 1969): 49–67, and G. W. Pigman III, "Versions of Imitation in the Renaissance," *Renaissance Quarterly* 33 (Spring 1980): 1–32.

19. Pigman, "Versions of Imitation," 20.

20. Nicolas Poussin, "Observations on Painting" (begun c. 1649–50), as quoted in Giovan Pietro Bellori, *Le vite de' pittori, scultori e architetti moderni,* ed. Evelina Borea (Rome, 1672; Turin: Giulio Einaudi, 1976), 481: "La novitá nella pittura non consiste principalmente nel soggetto non piú veduto, ma nella buona e nuova disposizione ed espressione, e cosí il soggetto dall'essere commune e vecchio diviene singolare e nuovo." I am grateful to Anthony Colantuono for his translation of this passage as well as for related historical information concerning its composition.

21. See Pigman, "Versions of Imitation," *Renaissance Quarterly* 33 (Spring 1980): 3–11, and Sister Lechner, *Renaissance Concepts of the Commonplaces,* 137–41, who explains, "The two images which recur most frequently in the rhetorical works for describing the invention and storing of material are the bee gathering nectar and the hunter pursuing game" (137).

22. John Claudius Loudon, "Architecture Considered as an Art of Imagination," *The Architectural Magazine* 1 (June 1834): 145.

23. John Claudius Loudon, "On the Difference between Common, or Imitative, Genius, and Inventive, or Original, Genius, in Architecture," *The Architectural Magazine* 1 (July 1834): 188.

24. On earlier uses of these terms, see Smith, *Four Words,* 17ff.

25. Loudon, "On the Difference between Common, or Imitative, Genius, and Inventive, or Original, Genius, in Architecture," *The Architectural Magazine* 1 (July 1834): 185.

26. See Hans Holbein the Younger, *The Dance of Death. A Complete Facsimile of the Original 1538 Edition of "Les simulachres & historiees faces de la mort",* intro. Werner L. Gundersheimer (New York: Dover, 1971).

27. This line, with one variation, is the refrain that ends each stanza in the opening poem, "The Hill."

28. Edgar Lee Masters, "The Genesis of Spoon River," as quoted in May Swenson's "Introduc-

tion" to the *Spoon River Anthology* (London: The Crowell-Collier Publishing Company, 1962; 1970 printing), 7.

29. May Swenson, "Introduction," 5.

30. John Hollander, review article of *Spoon River Anthology: An Annotated Edition by Edgar Lee Masters*, ed. John E. Hallwas (University of Illinois Press), in *New Republic* (July 27, 1992), 47–53.

31. Ibid., 52.

32. Although Jefferson could readily have worked according to the terms of mellificative imitation simply by artistic temperament, it should be noted that like other educated people of his class, he was familiar with the classical literature on rhetoric that discussed this concept. In *Thomas Jefferson among the Arts: An Essay in Early American Esthetics* (New York: Philosophical Library, 1947), Eleanor Davidson Berman reports that Jefferson's library had "three subdivisions under Fine Arts, Chapter 40. They are 'Logic, Rhetoric, Orations'; 'Rhetoric'; 'Orations.'" Berman then lists the extensive number of authors or works contained there (189–91).

33. For the latter building, see Colen Campbell, *Vitruvius Britannicus or The British Architect*, 3 vols. (London, 1715–25; New York: Benjamin Blom, 1967 reprint), III, 8, 37, and Paul Breman and Denise Addis, *Guide to "Vitruvius Britannicus": Annotated and Analytic Index to the Plates* (New York: Benjamin Blom, 1972), 18. I have used this edition of *Vitruvius Britannicus* for the dating of Mereworth Castle. The British-Italian Palladian lineage has been discussed recently with an up-to-date bibliography in Stanford Anderson, "Matthew Brettingham the Younger, Foots Cray Place, and the Secularization of Palladio's Villa Rotunda in England," *Journal of the Society of Architectural Historians* 53 (December 1994): 428–47. Anderson dates a preliminary design for Mereworth to c. 1721–2.

34. Thomas Jefferson, letter from 1787 to the Comtesse de Tessé, as quoted in Arnauld Bréjon de Lavergnée, "The Construction of the Hôtel de Salm," in William Howard Adams, ed., *The Eye of Thomas Jefferson* (Washington, D.C.: National Gallery of Art, 1976), 125. Adams himself is the author of the excellent *Monticello* (New York: Abbeville, 1983), which presents an earlier discussion of Jefferson's debt to Palladio, the Hôtel de Salm, and Chiswick House.

35. As quoted in Federick D. Nichols and James A. Bear, Jr., *Monticello* (Monticello: Thomas Jefferson Memorial Foundation, 1967), 18.

36. Loudon, "Architecture," *The Architectural Magazine* 1 (June 1834): 145.

37. Thomas Jefferson, letter of March 20, 1787, to the Comtesse de Tessé, in Howard C. Rice, Jr., *Thomas Jefferson's Paris* (Princeton: Princeton University Press, 1976), 98.

38. Ibid., 96, 98.

39. My transcription with slightly altered punctuation from the facsimile reproduced in Nichols and Bear, *Monticello*, 69.

40. Marvin Trachtenberg and Isabelle Hyman, *Architecture: From Prehistory to Post-Modernism: The Western Tradition* (Englewood Cliffs and New York: Prentice-Hall and Harry Abrams, 1986), 360.

41. John Dixon Hunt, *The Figure in the Landscape: Poetry, Painting, and Gardening during the Eighteenth Century* (Baltimore: Johns Hopkins University Press, 1976), 82. See also, Maynard Mack, *The Garden and the City: Retirement and Politics in the Late Poetry of Pope,*

1731–1743 (Toronto: University of Toronto Press, 1969), 28–31; Etlin, *The Architecture of Death*, 173–5.

42. See the discussion of "echo" in "Invariant Structures and Principles" in ch. 1.

43. Hollander, review article of *Spoon River Anthology*, in *New Republic* (July 27, 1992), 52.

44. *Kunstwollen* is sometimes translated as "will to art" and by extension as "will to form." I prefer "artistic will" because it suggests the directionality or coloring of the artistic impulse. Leo Spitzer, in "The Style of Diderot," *Linguistics and Literary History*, 151, uses the term *Grunderlebnis* in a similar manner.

45. Alois Riegl, *Spätrömische Kunstindustrie* (Vienna: Österreichische Staatsdruckerei, 1901).

46. This book has been translated as *The Poetics of Space* (1964; Boston: Beacon Press, 1969).

47. Frank Lloyd Wright, *The Natural House* (1954; New York and Ontario: Meridian, 1982), 32; *An Autobiography* (London and New York: Longmans, Green and Company, 1932), 139.

48. On the relationship of the Château de Marly to the University of Virginia, see Rice, *Thomas Jefferson's Paris*, 109, with credit given to Fiske Kimball's earlier work in this area; Ross Watson, "Château de Marly," in Adams, ed., *The Eye of Thomas Jefferson*, 131.

49. On Jefferson's admiration for the Pantheon, see Frederick D. Nichols, "Design for a Planetarium, University of Virginia," in ibid., 297.

50. Ross Watson, "Plan of the Ground Floor of the Désert de Retz Column House," in ibid., 295.

51. In "Section of the Rotunda, University of Virginia" and "Design for a Planetarium, University of Virginia," in ibid., 296–7, Frederick D. Nichols explains that "Jefferson originally wanted the dome to be painted blue and decorated with gilt stars" to transform the interior into a planetarium. Both Karl Lehmann and Richard Guy Wilson report that Jefferson envisaged making the planetarium, as Lehmann puts it, "by means of a complicated mechanism of movable and changeable stars" (Karl Lehmann, *Thomas Jefferson, American Humanist* [Chicago: University of Chicago Press, 1947; 1965], 187. See also Richard Guy Wilson, "Jefferson's Lawn: Perceptions, Interpretations, Meanings," in Richard Guy Wilson, ed., *Thomas Jefferson's Academical Village* [Charlottesville: Bayly Art Museum and University Press of Virginia, 1993], 71).

Because of the contribution to the very idea and design of the Rotunda by the architect Benjamin Latrobe, it might be helpful to review this history, as it has recently been recounted in this new book edited by Wilson in the article by Patricia C. Sherwood and Joseph Michael Lasala, "Education and Architecture: The Evolution of the University of Virginia's Academical Village." On his site plan of July 18, 1817, Jefferson indicated that there would be "'some principal building'" at the head of the campus in the central position that the Rotunda would eventually occupy (18). On August 2, 1817, Jefferson received an illustrated letter from Latrobe suggesting a large domed building at that central point (18, 20 [with Latrobe's illustration], 21). The authors note that Jefferson initially labeled a couple of drawings for the Rotunda with Latrobe's name, which was later crossed out or erased. They then speculate that Jefferson probably felt "that his reworking of the design sufficiently made it his own" (29) especially in the interior: "While the arrangement of the floor plans was worked out by Jefferson, . . . the overall exterior form of the building and its portico derives from" Latrobe (33). In *Benjamin Henry Latrobe*

(New York: Oxford University Press, 1955), 469–70, Talbot Hamlin had explained that Latrobe's proposal for a central domed building envisaged placing a public hall over administrative offices. Jefferson, "chang[ed] its use, however, from public auditorium to library."

52. See Richard A. Etlin, "Grandeur et décadence d'un modèle: L'Eglise Sainte-Geneviève et les changements de valeur esthétique au XVIIIe siècle," *Les Cahiers de la Recherche Architecturale*, supplement to nos. 6–7 (October 1980): 26–31, and *Symbolic Space*, 118–22 ("The New Aesthetic Experience").

53. In *Thomas Jefferson's Paris*, 62, Rice explains that both facades of the Hôtel de Salm "were among those 'celebrated fronts of modern buildings' that Jefferson cited as worthy models for his countrymen."

54. The only portico of the pavilions at the University of Virginia not modeled upon Palladio or an ancient Roman source, Pavilion IX, is based on Claude-Nicolas Ledoux's Hôtel Guimard (Paris, 1770), which presents an interlocking of volumetric forms suggested by the continuation of the partial cylinder and partial vault beyond the front columnar screen.

55. In addition to Proust's adherence to the Bergsonian intuition about the flow of lived time, also consider what Gaston Bachelard, developing the work of Gaston Roupnel, calls "the intuition of the instant." See G. Bachelard, *L'Intuition de l'instant* (1932; n.p.: Gonthier, 1971 reprint).

56. Debora L. Silverman, *Art Nouveau in Fin-de-Siècle France: Politics, Psychology, and Style* (Berkeley: University of California Press, 1989), 76–8.

57. Marcel Proust, *A l'Ombre des jeunes filles en fleurs*, in *A la Recherche du temps perdu*, eds. Pierre Clarac and André Ferré (Paris: Gallimard, 1954), I, 953–5: "A cause de la trop grande lumière, je gardais fermés le plus longtemps possible les grands rideaux violets qui m'avaient témoigné tant d'hostilité le premier soir. Mais comme, malgré les épingles avec lesquelles, pour que le jour ne passât pas, Françoise les attachait chaque soir et qu'elle seule savait défaire, malgré les couvertures, le dessus de table en cretonne rouge, les étoffes prises ici ou là qu'elle y ajustait, elle n'arrivait pas à les faire joindre exactement, l'obscurité n'était pas complète et ils laissaient se répandre sur le tapis comme un écarlate effeuillement d'anémones parmi lesquelles je ne pouvais m'empêcher de venir un instant poser mes pieds nus. Et sur le mur qui faisait face à la fenêtre, et qui se trouvait partiellement éclairé, un cylindre d'or que rien ne soutenait était verticalement posé et se déplaçait lentement comme la colonne lumineuse qui précédait les Hébreux dans le désert. Je me recouchais; A dix heures, en effet, [le concert] éclatait sous mes fenêtres. Entre les intervalles des instruments, si la mer était pleine, reprenait, coulé et continu, le glissement de l'eau d'une vague qui semblait envelopper les traits du violon dans ses volutes de cristal et faire jaillir son écume au-dessus des échos intermittents d'une musique sous-marine. (. . .) Et pendant des mois de suite, dans ce Balbec que j'avais tant désiré parce que je ne l'imaginais que battu par la tempête et perdu dans les brumes, le beau temps avait été si éclatant et si fixe que, quand [Françoise] venait ouvrir la fenêtre, j'avais pu toujours, sans être trompé, m'attendre à trouver le même pan de soleil plié à l'angle du mur extérieur, et d'une couleur immuable qui était moins émouvante comme un signe de l'été qu'elle n'était morne comme celle d'un émail inerte et factice. Et tandis

que Françoise ôtait les épingles des impostes, détachait les étoffes, tirait les rideaux, le jour d'été qu'elle découvrait semblait aussi mort, aussi immémorial qu'une somptueuse et millé-naire momie que notre vieille servante n'eût fait que précautionneusement désemmailloter de tous ses linges, avant de la faire apparaître, embaumée dans sa robe d'or."

58. Leon Battista Alberti, *On the Art of Building in Ten Books*, trs. Joseph Rykwert, Neil Leach, and Robert Tavernor (Cambridge, Mass.: MIT Press, 1988), 156. See also "Beauty" in the glossary on p. 420.

59. This same theme can be pursued in the realm of scientific creativity. In "Let Me Sleep On It: Creativity and the Dynamics of Dreaming," *Times Literary Supplement* (December 23, 1994), A. Alvarez recounts an experiment by the biochemist Otto Loewi and observes, "The experiment was simple, but with the kind of simplicity only genius can achieve" (13).

60. Robert L. Herbert, "*Un dimanche à la Grande Jatte, 1884–1886*," in R. L. Herbert, et al., *Georges Seurat, 1859–1891* (New York: Metropolitan Museum of Art, 1991), 170.

61. Seurat, as quoted in ibid., 174.

62. This latter point is discussed briefly by Herbert in ibid., 174.

63. Robert L. Herbert, "130. *La jupe rose*. 1884," ibid., 194.

64. T. S. Eliot, "Burnt Norton," in *Four Quartets*, (New York: Harcourt, Brace and World, 1943), 15–16 (I, ii, 62–74). *Erhebung* means elevation or exaltation.

65. John W. Alexander, *United States Naval Memorial: A Living Tradition* (n.p.: United States Naval Memorial Foundation, 1987), 35, 40.

66. Ibid., 33.

67. Ibid., 40.

68. For illustrations, see *Architecture Intérieure / Crée* no. 172 (July–August 1979): 48. Al-though the official English-language *Guide to the Musée d'Orsay* (Paris: Ministère de la Culture et de la Communication, Editions de la Réunion des musées nationaux, 1987), 10, says that the design was chosen through an "open competition," the interview conducted by Patrice Goulet for *Architecture Intérieure / Crée* with Jean Jenger, président de l'Etablissement Public du Musée du XIXe siècle (Musée d'Orsay), explains that this was not an open competition but rather an invited competition limited to six teams of architects (Patrice Goulet, "Le XIXe siècle: Terminus. 1. Comment choisir un archi-tecte?" *Architecture Intérieure / Crée* no. 172 [July–August 1979]: 48). This is confirmed by the current French-language press packet distributed by the Service de Presse et de Relations Publiques of the Musée d'Orsay. See item 7: "Le bâtiment et son histoire."

69. On this subject, see the article by June Hargrove cited in ch. 1, n. 37.

70. Both ACT Architecture and Gae Aulenti explain their aims in *Paris 1979–1989*, tr. Bert McClure (New York: Rizzoli, 1987), 59–69.

71. Michael Graves, "Le Corbusier's Drawn References," in Michael Graves, ed., *Le Corbusier: Selected Drawings* (New York: Rizzoli, 1981), 12–13, 24 n. 2. Graves credits Anthony Eardley for first making this observation.

72. Ibid., 12–13, for an analogous but slightly different interpretation.

73. Ibid., 12, for an abbreviated version of this theme, which is a subject that Graves had developed more extensively in his teaching in the graduate program in architecture at Princeton University in the early 1970s. I am much indebted to Michael Graves for these lessons.

74. Pierre Reverdy, "L'Image," *Nord-Sud* no. 13 (March 1918): 1–2, 4. Reverdy was the editor of this journal. For Reverdy on the contrast between "*réalité de la vie* et *réalité artistique*," see his essays "Sur le Cubisme," *Nord-Sud* no. 1 (March 15, 1917): 5–7; "Essai d'esthétique littéraire," *Nord-Sud* nos. 4–5 (June–July 1917): 4–6. Note that Le Corbusier appropriated the first line of this essay – "L'image est une création pure de l'esprit" – as the title of his essay in *L'Esprit Nouveau*, later used as a chapter in *Vers une Architecture* (1923), "Architecture, pure création de l'esprit." Although I have translated *l'esprit* as "mind," it also has the sense of enlisting the understanding of the "spirit" as well. In other words, the faculties of intuition and imagination are more important here than reason. Reverdy's essays in *Nord-Sud* have been conveniently reproduced in Pierre Reverdy, "*Nord-Sud*", "*Self Defence*" et autres écrits sur la poésie (1917–1926) (Paris: Flammarion, 1975). For a discussion about Reverdy's debts to other thinkers for the origins of his idea of the "image" as well as its influence on André Breton in his formulation of Surrealist doctrine, see Jean Schroeder, *Pierre Reverdy* (Boston: Twayne / G. K. Hall, 1981), 60–62. The French text quoted from "L'Image" reads:

> L'image est une création pure de l'esprit.
> Elle ne peut naître d'une comparaison mais du rapprochement de deux réalités plus ou moins éloignées.
> Plus les rapports des deux réalités rapprochées seront lointains et justes, plus l'image sera forte – plus elle aura de puissance émotive et de réalité poétique.
> . . .
> Une image n'est pas forte parce qu'elle est *brutale* ou *fantastique* – mais parce que l'association des idées est lointaine et juste.
> . . .
> L'Analogie est un moyen de création – C'est une *ressemblance de rapports*; . . .
> . . .
> On ne crée pas d'image en comparant (toujours faiblement) deux réalités disproportionnées.
> On crée, au contraire, une forte image, neuve pour l'esprit, en rapprochant sans comparaison deux réalités distantes dont *l'esprit seul* a saisi les rapports.

75. Benvenuto Cellini, as quoted in Howard Hibbard, *Michelangelo* (New York: Harper and Row, 1974), 56.

76. Ibid., 94.

77. Arthur Schopenhauer, *The World as Will and Representation*, tr. E. F. J. Payne (Indian Hills, Col.: Falcon's Wing Press, 1958), I, 214 (bk. 3, § 43); II, 416–18. Payne explains that the second edition of 1844 added a second volume while reprinting the first volume of 1819 virtually unchanged (I, xiii).

78. Of course, if Rembrandt's impasto and Cézanne's blank areas of canvas constitute polar opposites along one conceptual axis, this axis itself is diametrically opposed to the technique of *sfumato* by which forms gently appear to emerge from their background without the apparent artifice of linear outline or impasto. On *sfumato*, see Alexander Nagel, "Leonardo and *Sfumato*," *Res* no. 24 (Autumn 1993): 7–20. On the entire range of techniques from *sfumato* to impasto, see Philip Sohm, *Pittoresco: Mario Boschini, His Critics, and Their Critiques of Painterly Brushwork in Seventeenth- and Eighteenth-Century Italy*, Cam-

bridge Studies in the History of Art (Cambridge: Cambridge University Press, 1991), especially the introduction.

79. Herbert, "*Un dimanche à la Grande Jatte, 1884–1886*," in Herbert, et al., *Georges Seurat, 1859–1891*, 170.

80. Here Seurat is working within the tradition of *sfumato*. See n. 78.

81. This subject has been extensively explored by E. H. Gombrich in the 1956 A. W. Mellon Lectures in the Fine Arts at the National Gallery of Art in Washington. D.C., and published in the famous volume *Art and Illusion: A Study in the Psychology of Pictorial Representation*, Bollingen Series XXXV–5 (Princeton: Princeton University Press, 1960). I discuss this book in the section "Bryson and Fundamental Errors" in ch. 4.

82. H. W. Janson with Dora Jane Janson, *History of Art: A Survey of the Major Visual Arts from the Dawn of History to the Present Day* (Englewood Cliffs and New York: Prentice-Hall, and Harry N. Abrams, 1975 printing), 104.

83. Ibid.

84. The transformation from idealized to realistic portraiture began in the Hellenistic period in the early third century B.C. On this subject, see J. J. Pollitt, *Art in the Hellenistic Age* (Cambridge: Cambridge University Press, 1986), ch. 3, which begins: "The Hellenistic age was the first period in the history of western art in which a serious attempt was made to probe, capture, and express through the medium of portraiture the inner workings of the human mind" (59).

85. See the section "The Crisis of Contemporary Art" in ch. 1.

86. Wassily Kandinsky, "On the Question of Form" in Wassily Kandinsky and Franz Marc, eds., *The "Blaue Reiter" Almanac*, tr. Henning Falkenstein, et al. (New York: Viking, 1974), 149.

87. Duff, *An Essay on Original Genius*, 46.

Chapter 3

1. Not wishing to misrepresent Fish's position, I note that the primary meaning of this phrase in *Self-Consuming Artifacts: The Experience of Seventeenth-Century Literature* (Berkeley: University of California Press, 1972), refers to "works which do not allow a reader the security of his normal patterns of thought and belief" (409). In the preface to this book, Fish will not commit himself as to whether this concept can be applied to other literature outside of "either the seventeenth century or . . . the Platonic-Augustinian tradition" (xiii). He offers a purposefully ambiguous response that, as he explains, allows him to make "a very large claim in such a way as to escape responsibility for it" (ibid.). I am applying the notion of literature as a "self-consuming artifact" to Fish's general procedure advocated for reading any text, as outlined in the appendix to his book, "Literature in the Reader: Affective Stylistics." The place of this essay in Fish's subsequent work is discussed in n. 33.

2. These lines were written long before the Republican landslide in the November, 1994, elections. In "Inflicting Pain on Children" and "Contract on the Consumer," *New York Times* (February 25 and March 4, 1995), 23, Bob Herbert gauges the tenor of the new political majority:

> The Republican jihad against the poor, the young and the helpless rolls on. So far no legislative assault has been too cruel, no budget cut too loathsome for the party that took

control of Congress at the beginning of the year and has spent all its time since then stomping on the last dying embers of idealism and compassion in government. This week Republicans in the House began approving measures that would take food off the trays of hungry schoolchildren and out of the mouths of needy infants. With reckless disregard for the human toll that is sure to follow, they have also aimed their newly powerful budget-reducing weapons at programs that provide aid to handicapped youngsters, that support foster care and adoption, that fight drug abuse in schools and that provide summer jobs for needy youths. They have also targeted programs that provide fuel oil to the poor and assistance to homeless veterans.

A small group of ordinary Americans who were not protected against unsafe products or corporate negligence went to Washington this week to speak out against Republican-sponsored legislation that would make it much more difficult to obtain compensation for terrible injuries and deaths that result from corporate wrongdoing.

These two articles proceed to chronicle callous policies and practices, shameful and shameless in their disregard for basic and incontrovertible human need with respect to the issues raised in the first article and in their disregard for basic principles of corporate responsibility to the community in the second case. See also and especially Bob Herbert, "Health & Safety Wars," and Anthony Lewis, "Bare Ruined Choirs," *New York Times* (July 10, 1995). (All four articles are from the "Op-Ed" page.)

3. This need to establish balance is being addressed in various domains. Recently the National Association of Scholars felt compelled to issue a statement through public advertisement on "Sexual Harassment and Academic Freedom," which reads in part:

What we are witnessing, in short, is the transformation of a clear behavioral offense into a ubiquitous "thought crime" and the substitution of psychological manipulation for rational discussion. The resulting confusion of genuine harassment with less serious acts, and even with beliefs, brings anti-harassment policy into needless conflict with academic freedom. This confusion is bound to diminish the opprobrium that rightly attaches to sexual harassment. ("Sexual Harassment and Academic Freedom: A Statement of the National Association of Scholars," full-page advertisement in *New York Review of Books* [February 17, 1994], 5).

On the question first of medicine and then of athletics, Roy Porter observes:

The root of the trouble, particularly in America but elsewhere too, is structural. It is endemic to a medical system in which an expanding medical establishment, faced with a healthier population of its own creation, is driven to medicalizing normal life events (like menopause), to converting risks into diseases, and to treating trivial complaints with fancy procedures. (. . .) What an ignominious destiny for medicine if its future turned into one of bestowing meagre increments of unenjoyed life! It would mirror the fate of athletics, in which disproportionate energies and resources – not least medical ones, like illegal steroids – are now invested to shave records by milliseconds. (Roy Porter, "A Professional *Malaise*: How Medicine Became the Prisoner of Its Success," *Times Literary Supplement* [January 14, 1994], 4).

4. This point is emphasized by Brian Vickers in his critique of Paul de Man: "Paul de Man's discussion of Rousseau is typical of his whole critical method, being based on a very small amount of text, which is here interpreted in a way quite different to that meant, indeed insisted on by the author." Writing about deconstruction in general, Vickers observes, "But the oppositions, polarities, deconstructions, vertigo, are in the minds and method of the critics, not the material itself." See Vickers, *In Defence of Rhetoric*, 456, 459.

5. Lehman, *Signs of the Times*, 57.

6. Poststructuralism makes a shibboleth of complexity and ambiguity. It is instructive to see an honest observer, who wishes to celebrate the poststructuralist "rejection of unity," yet nonetheless notes its structural inadequacies as a technique of analytical writing. In a review of Stephen Pfohl's *Death at the Parasite Café: Social Science (Fictions) and the Postmodern* (St. Martin's Press), in *American Book Review* (December 1993–January 1994): 1, Carl L. Bankston III states the poststructuralist position and relates it to Pfohl's method, termed "collage":

> In place of the modern rational, unitary self [,] dominating a coherent world of discoverable, systematic certainties, the postmodern perspective posits a self emerging from a confluence of diverse experiences, arbitrary forms of social relations, and systems of communication. The collage may be the medium best suited to such a tentative, relativistic view of human beings and their world. (. . .) Pfohl allows his memories, readings, and imaginings to encounter one another as "open-ended or unfinished collage-texts aimed at exploding the artifactual reality of western cultural codes."

Yet in assessing the degree of success achieved by Pfohl's attempts at literary collage, Bankston concludes:

> Argument (like plot, its fictional equivalent), is, among other things, a device for carrying the attention from one point in time to another. Thus, I found that I was reading Pfohl as a series of glosses on his favorite authors, and not as a set of incongruous juxtapositions. Perhaps writing is an inescapably linear medium.

7. Here the poststructuralist debt to Nietzsche and Freud is apparent. In *Beyond Good and Evil*, that self-proclaimed "immoralist," Friedrich Nietzsche, perhaps anticipating that his notion "that the decisive value of an action lies precisely in that which is *not intentional*" would be dismissed as "something of the same rank as astrology and alchemy," proceeds to associate these domains of the occult with the opposite position, i.e., with the traditional understanding of morality that stresses the intention behind the action. Hence, for Nietzsche, humanist "intention-morality" is ranked with astrology and alchemy, while his own antecedent to poststructuralist concealed meanings, which Nietzsche himself terms the "conceal[ed]" meaning beneath the "surface" of intentionality, has nothing to do with the occult. This is a telling example of what Nietzsche himself terms "truth absolutely inverted." (Friedrich Nietzsche, *Beyond Good and Evil: Prelude to a Philosophy of the Future*, tr. Helen Zimmern, in *The Complete Works of Friedrich Nietzsche. The First Complete and Authorised English Translation*, ed. Oscar Levy (New York: Russell and Russell, 1964), XII, 47 (§ 32), 69 (§ 48). For a brief but intriguing comparison between the search for Hermetic meaning and poststructuralism, see Bernard Williams, "The Riddle of Umberto Eco," *New York Review of Books* (February 2, 1995), 33–5.

8. Charles S. Singleton, *Commedia. Elements of Structure. Dante Studies I* (Cambridge, Mass.: Harvard University Press, 1954), 25, 14.

9. As quoted in Robert Hollander, *Allegory in Dante's "Commedia"* (Princeton: Princeton University Press, 1969), 27–8. The original Latin reads: "Littera gesta docet, quid credas allegoria, / Moralis quid agas, quo tendas anagogia."

10. Ibid., 24. On Richard of St.-Victor, see Walter Cahn, "Architecture and Exegesis: Richard of St.-Victor's Ezekiel Commentary and Its Illustrations," *Art Bulletin* 76 (March 1994): 53–68. One can begin to appreciate the complexity of this approach simply from Dante's letter that explains his intentions in the *Divine Comedy*:

To elucidate, then, what we have to say, be it known that the sense of this work is not simple, but on the contrary it may be called polysemous, that is to say, "of more senses than one"; for it is one sense which we get through the letter, and another which we get through the thing the letter signifies; and the first is called literal, but the second allegorical or mystic. And this mode of treatment, for its better manifestation, may be considered in this verse: "When Israel came out of Egypt, and the house of Jacob from a people of strange speech, Judæa became his sanctification, Israel his power." For if we inspect the letter alone the departure of the children of Israel from Egypt in the time of Moses is presented to us; if the allegory, our redemption wrought by Christ; if the moral sense, the conversion of the soul from the grief and misery of sin to the state of grace is presented to us; if the anagogical, the departure of the holy soul from the slavery of this corruption to the liberty of eternal glory is presented to us. And although these mystic senses have each their special denominations, they may all in general be called allegorical, since they differ from the literal and historical. (Dante, "Letter to Can Grande della Scala," in A. G. Ferrers Howell and Philip P. Wicksteed, trs., *A Translation of the Latin Works of Dante Alighieri* [London: J. M. Dent, 1904], 347–8).

11. Gertrude Himmelfarb, *On Looking into the Abyss: Untimely Thoughts on Culture and Society* (New York: Alfred A. Knopf, 1994), 12. Himmelfarb offers this characterization after looking at J. Hillis Miller's analysis of Wordsworth's poem, "A Slumber Did My Spirit Seal," a deconstructionist reading that is "one of the best known and most highly regarded examples of this genre" (10).

12. On the Frankfurt School, see Ernest Gellner, "The Last Marxists: Pretensions, Illusions and Achievements of the Frankfurt School," *Times Literary Supplement* (September 23, 1994), 3–5. Gellner explains its basic position as follows: "[T]he Frankfurt School was in possession of something it called, with emphasis, the *Critical* Theory, which did not allow the apotheosis of the surface of society and of the status quo. The penetration of the depths which at the same time provided normative illumination . . . is made possible by the Marxist doctrine which insists on seeing society as a totality, and moreover, one tormented by inner contradictions. If you are not endowed with these insights, you can neither understand what is really going on, nor criticize and transcend it; your conceptual impoverishment leaves you superficial in your theory and passively conformist in your values and politics. (. . .) The Critical Theory which they commended seemed to be some kind of deep or secret philosophical algorithm by which one could pass from that which merely *was* to that which could be or ought to be. (. . .) Reading Frankfurt works is like going to an art exhibition in which most of the paintings are both abstract and tortuous, and not greatly appealing. . . . They tell us little about how the world actually works, and their formal and obscure utterances about social totality and conflict hardly help us to identify our political objectives."

13. Paul Ricoeur, in *Freud and Philosophy: An Essay on Interpretation*, tr. Denis Savage (New Haven: Yale University Press, 1970), 8, makes this important distinction: "By hermeneutics we shall always understand the theory of the rules that preside over an exegesis – that is, over the interpretation of a particular text, or of a group of signs that may be viewed as a text."

14. Lehman, *Signs of the Times*, 56–7.

15. In *Gender, Art and Death* (New York: Continuum Publishing, 1993), 7, the self-described "critic within literary history in a feminist mode" (6) Janet Todd warns, "The great trinity of gender, race and class that now so splendidly illuminates texts can also dazzle the reader

into seeing no shades and shadows and may become as dogmatically dominating as 'moral seriousness' and 'taste' in the academic church of the 1950s and 1960s." On this issue as well as the question of politically correct language, see also Robert Hughes, *Culture of Complaint: The Fraying of America* (New York: New York Public Library; Oxford: Oxford University Press, 1993), ch. 1 ("Culture and the Broken Polity").

Just as every abused slogan or principle has its appropriate use, so too does this contemporary "trinity." In "Foreward: In Her Own Write," which serves as a preface both to Pauline E. Hopkins's *Contending Forces: A Romance Illustrative of Negro Life North and South* (1900; New York and Oxford: Oxford University Press, 1988, 1991) and to the Schomburg Library of Nineteenth-Century Black Women Writers series in which this novel has been reprinted, Henry Louis Gates, Jr., makes a strong argument in favor of applying this trilogy to an entire body of literature by Black female authors:

> The collective publication of these works by black women now, for the first time, makes it possible for scholars and critics, male and female, black and white, to *demonstrate* that black women writers read, and revised, other black women writers. To demonstrate this set of formal literary relations is to demonstrate that sexuality, race, and gender are both the condition and the basis of *tradition* – but tradition as found in discrete acts of language use (xviii [his emphasis]).

It is unfortunate, however, that in this essay Gates appears to circumscribe the writings of Hopkins and others within the boundaries of this trinity without considering the universally human qualities that also sustain the tradition in which they worked and thus the echoes of other literature from which they drew sustenance and to which they allude. Certainly Pauline E. Hopkins herself teaches us this lesson by calling her work a "romance"; by making explicit reference to the work of Homer, Shakespeare, Cowper, Gray, Goldsmith, Emerson, Longfellow, and Tennyson; and by dedicating her book "to the friends of humanity everywhere."

16. Advocates of theory argue that without a clearly articulated theory, understood as a self-conscious working method, and without constant self-reflective testing of one's thoughts against that method, thinking cannot be lucid: "[T]hat before the search for meanings, one must first acquire a conceptual container, even if that container has later to be modified or superseded. Unless tested against theory, observations will remain piecemeal and fickle, incapable of being assimilated within our systems of intellectual understanding." Both parts of this proposition are hopelessly naive in their conception of the workings of the human mind. The last statement, moreover, is simply untrue. The human mind – perhaps I should say psyche to encompass that interplay between intelligence, instinct, and soul, all grounded in a living body – is such a marvelous entity that people almost never, perhaps even never, are able to articulate "theories" that equal the complexity of human understanding. Self-consciously articulated "conceptual containers," used both to guide thought and also to direct it along the way through the type of self-reflection that today's "theory" requires, end up constricting thought at best and misleading it at worst, all the while deluding the thinker with the notion that something profound is being achieved. Here one could apply L. P. Wilkinson's admonition about ancient Latin theoreticians writing on the subject of prose rhythm. In the following sentence drop the word "ancient" and substitute the words "intuit" and "intuition" for "feel" and "feeling" re-

spectively: "It is surely right also to be suspicious of ancient theory, which can be palpably wrong: for it is one thing to feel, and quite another to rationalize one's feeling, especially if one has to invent a technical vocabulary to do so, or if one takes the easier course of adopting an existing one that does not really fit" (Wilkinson, *Golden Latin Artistry*, 141).

For a helpful consideration of this subject, see also Denis Donoghue, "The Use and Abuse of Theory," in *The Old Moderns: Essays on Literature and Theory* (New York: Alfred A. Knopf, 1994), 77–90, which opens with an exchange between René Wellek and F. R. Leavis that pertains directly to this matter. I agree, of course, with Donoghue's observation – "Not to have a theory is to have someone else's" (89) – in the sense that all people engaged in history or criticism must attempt to become as conscious as possible of their assumptions and their working methods. (It has even been argued that artists are sometimes able to reach a higher level of creative maturity after they have successfully raised to a level of conscious awareness essential features of what they had been doing unconsciously.) Yet, as Donoghue rightly stresses (89), with assistance from Paul Valéry, theory that is fecund is largely autobiographical rather than the programmatic and impersonal methodologies that pass for "theory" in today's poststructuralist discourse.

The quotation at the head of this note is from Roger Cardinal's approving summary of the attitudes expressed by the contributors in Mieke Bal and Inge E. Boer, eds., *The Point of Theory: Practices of Cultural Analysis* (Amsterdam University Press), in the review article "Benefit of Theory," *Times Literary Supplement* (July 15, 1994), 20. On Leavis's response to Wellek, see my postscript, n. 16.

17. While my book was in production, I was pleased to learn of a kindred spirit in the newly published essay by Ray Carney, whose "A *Yellow Pages* of Theory and Criticism," *Partisan Review* 62 (Winter 1995): 138–43, a review of Michael Groden and Martin Kreiswirth, eds., *The Johns Hopkins Guide to Literary Theory and Criticism* (Baltimore: Johns Hopkins University Press, 1994), echoes many of the themes and sentiments expressed throughout my book. In particular, I direct the reader's attention to the passage that covers similar ground on the subject of what Carney terms the saints and priests of poststructuralism and which I quote in n. 83.

18. I intend no disrespect to either the lives or memories of Walter Benjamin and Antonio Gramsci. For a moving account of Gramsci's courageous opposition to Italian Fascism as well as his sad debilitation in prison, see Alastair Davidson, *Antonio Gramsci: Towards an Intellectual Biography* (London: Merlin Press, 1977), especially chs. 4–5. My interest is in the use of Benjamin and Gramsci by present-day poststructuralists. On this subject, consider the remarks by Richard Bellamy who, in commenting on the publication shortly after World War II of Gramsci's *Prison Notebooks*, observes:

> Regrettably, the almost immediate canonical status granted Gramsci's work has tended to distort its intended meaning. (. . .) Unfortunately most commentators have divorced the theory from the practice, in spite of Gramsci's deep commitment to their unity, and have applied his ideas to events and movements that he neither knew nor could have anticipated. The original context of the crisis of liberal democracies at the end of the First World War, the Russian Revolution and the rise of Fascism, were exchanged for the very different world that emerged after 1945.

In reviewing Renate Holub's *Antonio Gramsci: Beyond Marxism and Postmodernism*, Bellamy further explains, "the fact is that Gramsci is not 'a crucial figure in the politics of contemporary cultural theory', as her book's blurb claims." Richard Bellamy, "Gramsci for the Italians," *Times Literary Supplement* (August 14, 1992), 5.

19. Sylvia Lavin, "In the Names of History: Quatremère de Quincy and the Literature of Egyptian Architecture," *Journal of Architectural Education* 44 (May 1991): 136.

20. The use of strawmen by poststructuralists ranges from the erroneous attribution of overly simple to overly exacting positions to their opponents. On the former, see Ellis, *Against Deconstruction*, 137–42, where he explains what he terms the "naive" position postulated by deconstructionists as the object of their criticism. I address this particular issue in the postscript. On the latter, see Denis Donoghue, "The Status of Theory," *The Pure Good of Theory*, The Bucknell Lectures in Literary Theory (Blackwell: Oxford, 1992), 33–43, where Donoghue discusses unnecessary "techniques of trouble" in today's "rhetoric of theory": "I hope to show . . . how the work of theory – which sounds as if it were, or ought to be, speculative, notional, and experimental – is, more often than not, blatantly tendentious. (. . .) It seems to me that de Man, Jameson, and Barthes are making unnecessary trouble; they are setting up an exorbitant demand and taking grim pleasure in claiming that it can't be satisfied" (38, 43). On this subject see also Brian Vickers's earlier *In Defence of Rhetoric*, 465–6, with quotations also from Jeffrey Barnouw about Paul de Man and Stanley Fish who both "'create difficulties in and for a text. The difficulties in either case are not real, however, but simply needed for the therapeutic effects of reading.'" See also Martha C. Nussbaum, "Skepticism about Practical Reason in Literature and the Law," *Harvard Law Review* 107 (January 1994): 730, 739–40.

21. Lavin, "In the Names of History," and Mitchell Schwarzer, "Gathered This Unruly Folk: The Textural Colligation of Historical Knowledge on Architecture," *Journal of Architectural Education* 44 (May 1991): 135, 144; Réjean Legault, "Architecture and Historical Representation," *Journal of Architectural Education* 44 (August 1991): 200–2, with quotations from Hayden White, *Tropics of Discourse: Essays in Cultural Criticism* (Baltimore: Johns Hopkins University Press, 1973), 107, and Dominick LaCapra, "Rhetoric and History," in *History and Criticism* (Ithaca: Cornell University Press, 1985), 18.

22. According to K. K. Ruthven, the same is true of many poets: "Supposedly 'secondary elaboration' has a mysterious habit of throwing up primary materials, and the ornamentalist view of language proves quite inadequate to makers who are accustomed not to know what they are going to say until they have said it" (*Critical Assumptions*, 71).

23. For complementary discussions of these issues, see Marcia B. Hall, *Color and Meaning: Practice and Theory in Renaissance Painting* (Cambridge: Cambridge University Press, 1992), xi; Gertrude Himmelfarb, "Telling It as You Like: Postmodernist History and the Flight from Fact," *Times Literary Supplement* (October 16, 1992), 12–15; *On Looking into the Abyss: Untimely Thoughts on Culture and History* (New York: Alfred A. Knopf, 1994); and "Not What We Meant At All," *Times Literary Supplement* (June 10, 1994), 8–9, where Himmelfarb aptly points out the deficiencies in Joyce Appleby, Lynn Hunt, and Margaret Jacob, *Telling the Truth about History* (New York: W. W. Norton, 1994).

24. In the discussion that follows, I address the more moderate position of the "critical studies" tendencies. For a consideration of the false reasoning in deconstruction, found in proposi-

tions such as "what is a center, if the marginal can become central?" see Ellis, *Against Deconstruction*, 92–6, as well as my postscript.

25. Dell Upton, "Architectural History or Landscape History?" *Journal of Architectural Education* 44 (August 1991): 197.

26. Etlin, *The Architecture of Death*, 358–9, 366–7; David Schuyler, *The New Urban Landscape: The Redefinition of City Form in Nineteenth-Century America* (Baltimore: Johns Hopkins University Press, 1986), 38.

27. Barbara Herrnstein Smith, *Contingencies of Value: Alternative Perspectives for Critical Theory* (Cambridge, Mass.: Harvard University Press, 1988), 4–6 (ch. 1: "Fixed Marks and Variable Constancies: A Parable of Value").

28. Ibid., 11.

29. Perhaps of all instances of lyric poetry, Shakespeare's sonnets present the most difficulties through the combination of their sense of reticent privacy and through the "apprehension that in loving and writing of love, some things cannot be said, or require the unsaying." On these two themes, see the illuminating essay by Barbara Everett from which this last quotation was taken, "Shakespeare's Greening. The Privacy, Passion and Difficulty of the Sonnets," *Times Literary Supplement* (July 8, 1994), 11–13. This piece begins, "A friend whose mind I respect said not long ago that whenever he saw an essay on the *Sonnets* he knew he wasn't going to believe it."

In "The Music of Poetry" (1942), T. S. Eliot offers perceptive observations about the elusive and allusive qualities of poetry: "If, as we are aware, only a part of the meaning can be conveyed by paraphrase, that is because the poet is occupied with frontiers of consciousness beyond which words fail, though meanings still exist. A poem may appear to mean very different things to different readers. . . . ""[F]or it is only at certain moments that a word can be made to insinuate the whole history of a language and a civilization. This is an 'allusiveness' which is not the fashion or eccentricity of a peculiar type of poetry; but an allusiveness which is in the nature of words, and which is equally the concern of every kind of poet" (T. S. Eliot, *On Poetry and Poets* [New York: Farrar, Straus and Cudahy, 1957], 22–3, 25–6.) Similarly, A. Alvarez observes, "Poetry, in short, does not necessarily come from dreams, but the language and methods of dreaming [i.e., "condensation and elision"] come naturally to poetry" (A. Alvarez, "Let Me Sleep On It: Creativity and the Dynamics of Dreaming," [*Times Literary Supplement*, December 23, 1994], 14).

For an erudite, witty, and wide-ranging survey of the reasons adduced over the centuries for the obscurity of poetry, with an excellent bibliography to be culled from the endnotes, see Ruthven, *Critical Assumptions*, 32–45. This survey can be profitably supplemented with Sieghild Bogumil, "The Deliberate Order in the Discourse of the Unconscious"; Agnès Sola, "Hermétisme ou obscurité: XVIème et XXème siècles"; and James J. Wilhelm, "The 'Closed Troubadours' and Dante: Varieties of Medieval Hermeticism," in *Proceedings of the Xth Congress of the International Comparative Literature Association*, New York, 1982 (New York and London: Garland, 1985), II 505–11, 576–81, 587–91. For readers who appreciate the language of communications theory, see the summary of Jurij Lotman's analysis of poetic texts as fully "semantically loaded" and with "no redundancy" in Zsuzsanna Bjørn Andersen, "The Concept of 'Lyric Disorder,'" in ibid., 4. Finally, we should keep in mind that the subject of William Empson's famous *Seven Types of Ambiguity* (1930; 1947 2nd rev. ed.; 1953 3rd rev. ed.; 1963 reprint) is essentially poetry.

30. Mary Jo Salter, "Thick-skinned," *New Republic* (July 6, 1992), 42.

31. Smith, *Contingencies*, 183–4.

32. Blaise Pascal, *Pensées et opuscules*, ed. Léon Brunschvicg (Paris: Librarie Hachette, n.d.), 458: (no. 277) "Le coeur a ses raisons, que la raison ne connaît point; on le sait en mille choses."

33. Fish, "Literature in the Reader: Affective Stylistics," appendix to *Self-Consuming Artifacts*, 400. Fish reprinted this essay as the first chapter of *Is There a Text in This Class: The Authority of Interpretive Communities* (Cambridge, Mass.; Harvard University Press, 1980), 22–67. In introducing this text in 1980, Fish explained that it "summed up everything I then believed [in 1970], and I find its argument powerful and compelling even now, although it is long since that I began to see its flaws" (22). As Fish makes clear both in his "Introduction" (7–8) and in his prefatory remarks to "Literature in the Reader," his self-criticism does not involve a questioning of his basic stance about "objectivity" or "Truth": "Those flaws are discussed in detail in the introduction to this volume, but they all reduce to the substitution of one kind of reified entity for another. In place of the objective and self-contained text I put 'the basic data of the meaning experience' and 'what is objectively true about the *activity* of reading;' . . ." (22). Fish's underlying premise, dating from 1970, that meaning in literature derives from the reader is reaffirmed in the "Introduction" to his 1980 book (8–13, 15–17). Fish's "both and neither" argument about "interpretive communities" does not change this position (14–15).

 After stressing in 1980 the "powerful" and "compelling" quality of his argument in "Literature in the Reader" (1970), Fish, as we have seen in n. 1, once again declines responsibility for his text: " . . . I would not now subscribe to the tenets put forward in this article . . ." (22). Fish's apparently self-contradictory relationship with this text is not unique. Rather, it extends to "many" of the chapters in *Is There a Text in This Class*: "What interests me about many of the essays collected here is the fact that I could not write them today. I could not write them today because both the form of their arguments and the form of the problems those arguments address are a function of assumptions I no longer hold" (1).

 This type of intellectual activity has attracted the notice of social commentators such as Roger Kimball and David Lehman. "Yet," observes Kimball, "it is difficult to know quite what to make of [Fish's] retractions. There are so many of them" (*Tenured Radicals*, 148). "Stanley Fish," explains Lehman, "the Duke University professor who is widely believed to be the model for David Lodge's Professor Zapp [in *Small World*], made the ultimate statement of this position (which he would later retract). Fish asserted that critical theory 'relieves me of the obligation to be right . . . and demands only that I be interesting' . . ." (*Signs of the Times*, 75).

 Fish's ambiguous relationship to his "Literature in the Reader: Affective Stylistics" – reprinting it with praise for its main tenets while disavowing them – reminds me of the stance taken by Kierkegaard's "aesthetic" person in *Either / Or. A Fragment of Life*, published anonymously in 1843, and to a great degree of the postscript that Kierkegaard once imagined but did not add to the second edition of this book:

 I hereby retract this book. It was a necessary deception in order, if possible, to deceive men into the religious, which has continually been my task all along. Maieutically it certainly has had its influence. Yet I do not need to retract it, for I have never claimed to be its author

(Søren Kierkegaard, *Either / Or. A Fragment of Life*, trs. and eds. Howard V. Hong and Edna H. Hong, [Princeton: Princeton University Press, 1987], I, xvii).

Yet Kierkegaard, as he explained here, wished to direct "men into the religious." Thus, in the second part of this book, he had the "ethical" man explain to the "aesthetic" man that the contrived ambiguities of "either / or" were an ethical abnegation. In the end, one had an ethical obligation to choose, to take a stand. In light of Fish's postmodernist ambiguity with respect to his own intellectual position, part two of Kierkegaard's book is especially timely today.

34. Fish, "Literature in the Reader: Affective Stylistics," *Self-Consuming Artifacts*, 387–8 (his emphasis); *Is There a Text in This Class*, 26–7.

35. Fish, "Literature in the Reader: Affective Stylistics," *Self-Consuming Artifacts*, 386; *Is There a Text in This Class*, 25.

36. Ibid.

37. Fish, *Self-Consuming Artifacts*, 3–4.

38. Fish, "Literature in the Reader: Affective Stylistics," *Self-Consuming Artifacts*, 391–2; *Is There a Text in This Class*, 31.

39. Pater, *Three Major Texts*, 217–18.

40. Ibid., 219. Pater's use of the "clear" outline as a foil to the changing and fleeting conditions of life, invoked both to warn against rigid fixity and inattention, as well as to suggest that the clear form still provides the basis for capturing its condition in a moment when it was infused with special intensity or quality, was a recurrent theme in his work. Consider, for example, this passage from "Coleridge" (1865, 1880) the first part of which is also stressed by Richmond Crinkley in *Walter Pater: Humanist* ([Lexington, Ky.: University Press of Kentucky, 1970], 9):

> Modern thought is distinguished from ancient by its cultivation of the "relative" spirit in place of the "absolute." Ancient philosophy sought to arrest every object in an eternal outline, to fix thought in a necessary formula, and the varieties of life in a classification by "kinds," or *genera*. To the modern spirit nothing is, or can be rightly known, except relatively and under conditions. The philosophical conception of the relative has been developed in modern times through the influence of the sciences of observation. Those sciences reveal types of life evanescing into each other by inexpressible refinements of change. Things pass into their opposites by accumulation of undefinable quantities. (. . .) The faculty for truth is recognised as a power of distinguishing and fixing delicate and fugitive detail (Pater, "Coleridge," in *Three Major Texts*, 431).

41. Fish, "Literature in the Reader: Affective Stylistics," *Self-Consuming Artifacts*, 392; *Is There a Text in This Class*, 31.

42. Fish, "Literature in the Reader: Affective Stylistics," *Self-Consuming Artifacts*, 410; *Is There a Text in This Class*, 52.

43. On the culture of victimization and related themes, see Arthur M. Schlesinger, Jr., *The Disuniting of America* (1991, New York: W. W. Norton, 1992), especially 96–118. Schlesinger quotes from Diane Ravitch, "History and the Perils of Pride" (manuscript), on the hearings before the California State Board of Education about its history curriculum: " 'One group after another insisted that its forebears had suffered more than anyone else in history' " (96). See also Hughes, *Culture of Complaint*, and Albert Shanker, "Victim History" (advertisement) *New York Times* (April 10, 1994), E7.

44. Kimball, *Tenured Radicals*, 176.

45. Samuel B. Southwell, "Appendix: Note Against Deconstruction," *Kenneth Burke and Martin Heidegger: With a Note Against Deconstruction*, University of Florida Monographs, Humanities No. 60 (Gainesville: University of Florida Press, 1987), 88.

46. Ellis, *Against Deconstruction*, 6–8.

47. Southwell, "Appendix: Note," 87.

48. Ellis, *Against Deconstruction*, 18.

49. Jacques Derrida, *Of Grammatology*, tr. Gayatri Chakravorty Spivak (Baltimore: Johns Hopkins University Press, 1976), 3.

50. Ellis, *Against Deconstruction*, 26.

51. Derrida, *Of Grammatology*, 4–8.

52. Ellis, *Against Deconstruction*, 26.

53. The tenor of Derrida's language of oppression, emphasizing menace and dissimulation, is reminiscent of Nietzsche's vocabulary in his discussion of the undermining of an ideal moral world order ("aristocratic" and "Aryan") by the Jews and by what Nietzsche saw as their agent, Jesus. On this subject see the section "Nietzsche's 'Will to Power'" in ch. 4, especially nn. 132, 133 with long quotations from Nietzsche's *The Genealogy of Morals*.

54. Derrida, *Of Grammatology*, 6–7.

55. Ibid., 8.

56. Ibid.

57. Hawkes, *Metaphor*, 6. See also Vincent Leitch, *Deconstructive Criticism* (New York: Columbia University Press, 1983), 25: "As portrayed by Derrida, the logocentric system always assigns the origin of truth to the *logos* – to the spoken word, to the voice of reason, or to the Word of God." In *Against Deconstruction*, 31, Ellis quotes this passage among his sampling of highly regarded exponents of deconstruction who explain Derrida's use of the word "logocentric." For an explanation of the ancient Greek term "logos" as a "word with a range of applications all of which relate to a single starting point," see Kerferd, *The Sophistic Movement*, 83–4:

> In the case of the word logos there are three main areas of its application or use, all related by an underlying conceptual unity. These are first of all the area of language and linguistic formulation, hence speech, discourse, description, statement, arguments (as expressed in words) and so on; secondly the area of thought and mental processes, hence thinking, reasoning, accounting for, explanation (cf. *orthos logos*), etc.; thirdly, the area of the world, that *about* which we are able to speak and think, hence structural principles, formulae, natural laws and so on, provided that in each case they are regarded as actually present in and exhibited in the world-process. While in any one context the word logos may seem to point primarily or even exclusively to only one of these areas, the underlying meaning usually, perhaps always, involves some degree of reference to the other two areas as well, and this I believe is as true for the sophists as it is, say, for Heraclitus, for Plato and for Aristotle.

58. Derrida, *Of Grammatology*, 9.

59. Ibid.

60. Ibid., 7–8.

61. Ibid., 12. The words in square brackets are Derrida's.

62. Ibid., 10–11.

63. Ibid., 8.

64. Writing about the relationship of Derrida to Western philosophy, Martha C. Nussbaum observes, "Derrida's target is the entire tradition of Western philosophy. . . ." "In *Of Grammatology*, the author denounces the entirety of the Western philosophical tradition. . . ." See Nussbaum, "Skepticism about Practical Reason in Literature and the Law," *Harvard Law Review* 107 (January 1994): 725.

65. Robert Heiss, *Hegel, Kierkegaard, Marx: Three Great Philosophers Whose Ideas Changed the Course of Civilization*, tr. E. B. Garside (n.p.: Delacorte Press / Seymour Lawrence, 1975), 87, 88–91, 94, 101–4.

66. This was a recurrent theme in Hegel's principal works. Heiss explains, "And indeed the *Phenomenology [of Mind (1807)]* can be read as if it were a moral tract ending in the triumph of good. This dialectical sequence of conceptualizing history can be understood as if, in the last analysis, it does no more than proclaim the ineluctable progress of the spirit" (ibid., 61). Similarly, Heiss repeatedly stresses the importance of the following statement from the introduction to *The Science of Logic* (1812–16): "This realm is truth, as it is without integument, in and for itself. On this account it can be said that this content is the representation of God, as he is in his eternal essence, before the creation of nature and of any finite spirit" (ibid., 93; see also 97, 106). Writing about Hegel's *Philosophy of History* (1830–31; 1840), Heiss observes, "And since for Hegel the primacy of the Absolute Idea is taken for granted, it is easy for him to regard world history as the 'true theodicy, the vindication of God in history' " (142). For a more complete explanation of this last point by Hegel himself, see the "Introduction" to his *Philosophy of History*.

67. Heiss, *Hegel, Kierkegaard, Marx*, 240.

68. See the first paragraph of this section on Derrida.

69. Heiss, *Hegel, Kierkegaard, Marx*, 240. For Kierkegaard's explicit confirmation of this position, see Kierkegaard, *Either / Or*, eds. and trs. Hong and Hong, I, xiv, xvii.

70. Paul Cantor, "Friedrich Nietzsche: The Use and Abuse of Metaphor," in David S. Miall, ed., *Metaphor: Problems and Perspectives* (Sussex: Harvester Press, 1982), 74. On the importance of this theme in Nietzsche's other writings, see Ronald Hayman, *Nietzsche: A Critical Life* (Oxford University Press, 1980; New York: Penguin, 1982), 163–5, 196–7, 226.

71. Ibid. On Balzac's observations about the relativity of moral values with respect to different cultures, see ch. 4, n. 22. Discussions of the supposed instability of moral values often fail to consider the distinctions that should be made between pure ethics and applied ethics. In *The Categorical Imperative: A Study in Kant's Moral Philosophy* (London: Hutchinson, 1947; 1967 6th ed.), 23, Herbert J. Paton offers the following helpful observations: "We ought to distinguish (1) moral principles; (2) moral laws, like the ten commandments, which apply to men as men; (3) moral rules, such as the statement that it may be the duty of a soldier or an executioner to kill; and (4) singular moral judgements, such as the judgement that I ought not to kill John Smith." Paton's differentiated scale reads like a modern version of a more ancient system of discriminations as reported by Robert Burton in his discussion of the "Anatomy of the Soul," subsection "Of the Understanding," in *The Anatomy of Melancholy [Now for the First Time with the Latin Completely Given in Translation and Embodied in an All-English Text]*, eds. Floyd Dell and Paul Jordan-Smith (1651 6th ed.; New York: Farrar and Rinehart, 1927), 145–6: "*Synteresis*, or the purer part of the conscience, is an innate habit, and doth signify *a conversation of the knowledge of the law of God and Nature, to*

know good or evil. And (as our Divines hold) it is rather in the *understanding* than in the *will*. This makes the *major* proposition in a pratick *syllogism*. The *dictamen rationis* ["the Dictator of reason"] is that which doth admonish us to do good or evil, and is the *minor* in the *syllogism*. The *conscience* is that which approves good or evil, justifying or condemning our actions, and is the conclusion of the *syllogism*: as in the familiar example. . . ."

72. In *Against Deconstruction*, 64–5, Ellis quotes Gerhard Kurz's assessment of Paul de Man's appropriation of terms from the linguist Ferdinand de Saussure, which de Man, in *Allegories of Reading*, renders as "the liberating theory of the signifier," "the arbitrary power play of the signifier," and the "liberation of the signifier from the signified," to be *Unbegriffe*, that is, "nonsense-concepts." "The 'liberating theory of the signifier,'" Kurz further explains, "erroneously understands what for Saussure was an epistemological distinction as an ontological, substantial one." "This last sentence," comments Ellis, "puts the basic logical error of deconstruction's handling of Saussure's theory of the sign very neatly." This last sentence also explains the way deconstruction works, for it purposefully jumps from the epistemological to the ontological, using the former to justify the latter. This is not a confusion on the part of Derrida, de Man, and others; rather it is a willful mental leap of faith. In such cases when deconstructionists talk about "writing," they are speaking allegorically about Being.

73. Giambattista Vico, *On the Study Methods of Our Time*, tr. Elio Gianturco (Indianapolis: Bobbs-Merrill, 1965), 35.

74. Alan Bass in Jacques Derrida, *Writing and Difference*, tr. Alan Bass (Chicago: University of Chicago Press, 1978), 303 n. 18.

75. Vico, *On the Study Methods of Our Time*, 35.

76. On the association of common sense with divine providence that teaches us our natural rights, see Giambattista Vico, *Princìpi di scienza nuova d'intorno alla comune natura delle nazioni* (1744), in Giambattista Vico, *Opere*, ed. Andrea Battistini (Milan: Arnoldo Mondadori, 1990), I, 499 (§ 145). The phrase "senso comune" in Vico at times means primarily "common sense" and at other times superimposes the notion of "common human understanding," or, in the words of Isaiah Berlin, "something like the collective social outlook." This occurs especially in various instances in *On the Study Methods of Our Time* – "Consequently, since young people are to be educated in common sense [sensus communis], we should be careful to avoid that the growth of common sense be stifled in them by a habit of advanced speculative criticism" (13). This coordinated dual meaning of common sense accords with Claude Buffier's own definition of the term in his *Traité* (English trans. as *First Truths*, 32–3), where he explains that common sense is an understanding "so strongly imprinted in our minds" (§ 53) as well as "universally received amongst men, in all times and countries, and by all degrees of capacity" (§ 52).

For Vico common sense [sensus communis], besides being the criterion of practical judgment, is also "the guiding standard of eloquence" (*Study Methods*, 13). In discussing the relationship between common sense and eloquence, Vico associates the former with commonplaces (*ars topica*): "[Y]oung men . . . will become familiar with the art of argument, drawn from the *ars topica*. At the very outset, their common sense [sensu communi] should be strengthened so that they can grow in prudence and eloquence" (19). The common sense that Vico would nurture in young people he defines as grounded in verisimilitude and prudence (13, 19) and hence appears as an attribute which can be

related to Plato's fourth virtue, *sophrosyne*, explained by Sir Richard Livingstone as meaning something like a "soundness of spirit" achieved through intellectual "temperance" (R. W. Livingstone, "The Fourth Virtue" (1956), in *The Rainbow Bridge and Other Essays on Education* [London: Pall Mall Press, 1959], 135–42). On *sophrosyne*, see Plato's *Republic,* 430e.

With Vico, communal sense joins common sense because both are grounded in the divinely given capacity for ascertaining truth:

> . . . un diritto con essi costumi umani naturalmente dalla divina provvidenza ordinato in tutte le nazioni. Questa sarà uno de' perpetui lavori che si farà in questi libri: in dimostrare che 'l diritto natural delle genti nacque privatamente appo i popoli senza sapere nulla gli uni degli altri. . . . [E]ssendo elle ne' lor incominciamenti selvagge e chiuse, e perciò non sappiendo nulla l'una dell'altra, per la *Degnità* che "idee uniformi, nate tra popoli sconosciuti, debbon aver un motivo comune di vero," – ne dànno di più questo gran principio: che le prime favole dovettero contenere verità civili, e perciò essere state le storie de' premi popoli (§ 146, 198).

> (. . . a law which divine providence instituted naturally in all nations along with human customs themselves. As it will be one of our constant labors throughout this book to demonstrate, the natural law of the gentes had separate origins among the several peoples, each in ignorance of the others. . . . Moreover, since in their beginnings these nations were forest-bred and shut off from any knowledge of each other, and since uniform ideas, born among peoples unknown to each other, must have a common ground of truth. . . ." (*The New Science of Giambattista Vico. Revised Translation of the Third Edition (1744)* by Thomas Goddard Bergin and Max Harold Fisch [Ithaca: Cornell University Press, 1968 ed.], translation slightly modified. I use this English edition for the translated passages that follow).

Not all scholars accept this interpretation of the dual meaning of "common sense" in Vico's work. Isaiah Berlin, for example, in *Vico and Herder: Two Studies in the History of Ideas* (New York: Viking Press, 1976), 61, 85 (for the quotation by Berlin given in this note), 95–6, 102, 140, identifies Vico's "sensus communis" solely with the second meaning. To unravel this dilemma, we should consider the architecture of Vico's text.

In the *Scienza nuova*, Vico proceeds according to the method advocated by Descartes in his *Discours de la méthode* (1637), who counseled moving from the simple to the more complex by means of carefully measured and easily comprehended steps. Thus, we find Vico building his argument such that successive items in a given sequence subsume the meaning of those that immediately precede. If a reader extracts one element out of the sequence and views it in isolation, it is possible to misinterpret its meaning.

In the *Scienza nuova* Vico is concerned with establishing a "new science," one that parallels the natural sciences by explaining the principles that govern human affairs. Since the world was created by God, human affairs are regulated by scientific laws just as are the movements of the planets. Vico sets forth his basic principles for this "new science" in the early part of book one through the section devoted to the "elements," beginning with § 141. It is important to follow the nature of Vico's argument as he moves through sections § 141–6, for the text builds in a pyramidal manner, with each successive idea standing upon the foundations created by the previous one.

As his first principle, Vico postulates the fundamental role in human affairs of common sense: "Human choice, by its nature most uncertain, is made certain and determined by the common sense of men with respect to human needs or utilities, which are the two

sources of the natural law of the gentes" (§ 141). In this statement, common sense refers to an innate quality possessed by each individual. The innate quality of common sense is made explicit in the opening part of the next section (§ 142), where the common sense of each individual becomes the basis of a shared communal sense or understanding, an understanding not limited to any one group but rather belonging to all groups and to the entire human race: "Common sense is judgment without reflection, shared by an entire class, an entire people, an entire nation, or the entire human race" (§ 142). Thus, in this section, the phrase common sense refers both to the common sense of the individual and to that of all groups and of all people. In other words, it means both individual common sense and a shared communal understanding.

Section 144 further stresses the innate quality of common sense, understood in both its individual and collective capacities: "Uniform ideas originating among entire peoples unknown to each other must have a common ground of truth." Section 145 gives context to the innate and universal character of common sense by explaining it to be the creation of divine providence. At the same time this section explains that common sense is the basis for natural law: "This axiom is a great principle which establishes the common sense of the human race as the criterion taught to the nations by divine providence to define what is certain in the natural law of the gentes." Section 146 further explains that natural law is thus innate and was established by divine providence rather than having been, as others had argued, the product of specific civilizations, such as the Egyptians or the Greeks, which then had been spread to other nations. All of these sections belong to the set of "propositions" that Vico explains as giving "us the foundations of the true" (§ 163).

In *Vico*, Mark Lilla also argues in favor of a multifaceted understanding of Vico's use of the term "common sense": "Vico's conclusion is that, given its deep psychological roots, common sense naturally operates at several levels at once. In Axioms XI–XII of the *New Science* he links the common sense of individuals making judgments with those judgments 'shared by an entire class, an entire people, an entire nation, or the entire human race'" (158).

77. Vico, *De nostri temporis studiorum ratione* in Vico, *Opere*, I, 132: "nam in vita agenda stulti neque summa, neque infima vera attendunt; . . . imprudentes docti ex summis infima, sapientes vero ex infimis summa dirigunt." In the translation, I have modified the last phrase in this quotation to make it accord with the other references to "the sage" as found in the lines translated by Gianturco.

78. Derrida, *Of Grammatology*, 6–10.

79. Ibid., 8. In his "Appendix: Note Against Deconstruction," *Kenneth Burke and Martin Heidegger*, 88, Southwell writes: "In effect, it is *Of Grammatology* that brings Western civilization to an end. We are told, furthermore, that 'grammatology' is the product of historical necessity. Derrida appears in robes of prophecy gifted with a vision into the 'distance of a few centuries.'"

80. Derrida, "Force and Signification," *Writing and Difference*, 8 (for this last quotation).

81. Fielding, *Tom Jones*, 439.

82. Derrida, *Of Grammatology*, 4.

83. On the subject of intellectual household wares, we should also consider the stopped clock analogy: "Like a stopped clock, deconstruction may on occasion look right, but the fact that it indiscriminately announces that the same result is the right one everywhere, any time, can only lead in one direction: like the clock, it will be easy to ignore" (Ellis, *Against*

Deconstruction, 91). In "A *Yellow Pages* of Theory and Criticism," *Partisan Review* 62 (Winter 1995), Ray Carney makes a similar observation about poststructuralism in general:

> What is most disturbing about *The Johns Hopkins Guide [to Literary Theory and Criticism]* is not its superficial eccentricity or its unevenness, but, at a deeper level, its frightening uniformity. Approximately half of the volume is devoted to twentieth-century critics and critical theories, and in entry after entry (with only the fewest of exceptions) there is a near unanimity of critical values, assumptions, and methods. Notwithstanding the lip-service paid to "diversity," "otherness," and "heterogeneity," and the unending genuflections in the direction of resisting "hegemonic" and "dominant" forms of discourse, it is clear that almost everyone . . . worships at the same church. The God of this congregation is named Marx; its saints are Nietzsche, Freud, and Saussure; its high priests are Lévi-Strauss, Lacan, Derrida, and Foucault; its ceremonies are called Marxism, structuralism, hermeneutics, deconstruction, and cultural studies; and its sacred words are ideology, gender, class, and race (139–40).

The question of the underlying uniform outlook found in the world of poststructuralism raises a fascinating psychological issue about the nature of intellectual life.

It is ironic that adherents of a cultural phenomenon which finds so many admirers of Nietzsche – whose Zarathustra disparages the "herd" – so readily join a cultural herd whose members trod along the same well-beaten paths to arrive at the same, predictable end point. There certainly is no need to follow Zarathustra and his Superman in the direction of destroying the "tablets of values." Yet the intellectual would certainly profit from a greater degree of independence.

The ideal intellectual, to my mind, while learning from others, retains a marked degree of autonomy in his or her thinking and thereby exhibits a relatively strong degree of originality of thought. The problems that the true intellectual sets are generated from within that person's psyche and are not simply culled from popular, current trends. If we were to articulate a model for intellectual behavior, we might adopt several of the attributes for which Ferdinand Mount praises Ernest Gellner. Gellner's mind, explains Mount, exhibits an independence such that his "judgments are by no means predictable." This independence is both possible and viable because of "his width of reference and vivacity of judgment," the latter being "often carefully nuanced." Thus Gellner remains "nomadic . . . in a world of settled intellectual allegiances," with the added benefit that he judges thought on its merits and hence is "as ready to rescue the obscure as he is unimpressed by reputation." To this portrait, which begins to provide a profile for intellectual life, I would add the attributes that Joyce Cary admires: a "quick and ingenuous mind" that also displays a "quick sympathy, [an] instant response to shades of meaning and feeling." (I find it striking that Cary says "ingenuous" rather than "ingenious," for whereas he is suggesting the presence of the latter quality in the rapidity and subtlety that he mentions, he also requires that true innocence, the artless quality of ingenuousness.)

These are not characteristics fostered by the herd mentality. Not surprisingly, Carney, when looking at poststructuralism, finds these features lacking:

> In a word, the structuralists, the formalists, the Marxists, the gender analysts, and the cultural studies types treat experience and expression as if they were impersonal, generic, and representative, as if a culture produced them the way it produces other

commodities – cars or TV commercials – by means of a set of general rules and generalized practices disconnected from the eccentricity and specificity of individual feelings and visions (140).

See Ferdinand Mount, "Ruling Passions: Rival Explanations of the Rise of Nationalism," *Times Literary Supplement* (February 17, 1995), 11; Joyce Cary, *The African Witch* (1936; London: Michael Joseph, 1950, 1959), 20; Nietzsche, *Thus Spake Zarathustra*, in *Complete Works*, XI, 19—21 ("Prologue," § 9). I have modified the translation of "Tafeln" to read "tablets" rather than "tables" to emphasize the underlying reference to the Biblical tablets as found in the original. See Friedrich Nietzsche, *Also sprach Zarathustra: Ein Buch für Alle und Keinen*, ed. Alfred Baeumler (Stuttgart: Alfred Kröner, 1969), 21: "Den, der zerbricht ihre Tafeln der Werte, den Brecher, den Verbrecher. . . ."

84. Derrida, *De la Grammatologie*, 200; *Of Grammatology*, 138: ". . . the dream of the nineteenth-century Utopian Socialisms, most specifically with the dream of Fourierism."

85. Jonathan Beecher and Richard Bienvenu, *The Utopian Vision of Charles Fourier: Selected Texts on Work, Love, and Passionate Attraction*, eds. and trs. J. Beecher and R. Bienvenu (Boston: Beacon Press, 1971), 36.

86. Charles Fourier, *Théorie des quatre mouvements et des destinées générales* (Paris, 1846 3rd ed.), in Beecher and Bienvenu, eds., *The Utopian Vision*, 94. (The editors point out that the citation from Montesquieu, *Lettres persanes*, letter CXII, was "one of Fourier's favorite *devises*.")

87. Ibid., 95.

88. Charles Fourier, *Le Nouveau monde industriel*, as quoted in ibid., 36.

89. Beecher and Bienvenu, eds., "Introduction," *The Utopian Vision*, 41.

90. Ibid., 37—8.

91. Fourier's terms, as quoted in ibid., 38.

92. Derrida, *Of Grammatology*, 9.

93. Beecher and Bienvenu, eds., "Introduction," *The Utopian Vision*, 38.

94. Lehman, *Signs of the Times*, 55.

95. It is time for humanists to reclaim the concept of *aporia* from the deconstructionist lexicon. In *The Sophistic Movement*, Kerferd discusses Plato's attitude toward the state of *aporia* created by antilogic and concludes, "For Plato . . . antilogic is the first step on the path that leads to dialectic" (67). In other words, *aporia* is not an end itself. Scholars of Aristotle have explained that for this philosopher, *aporia* was a method of providing a stimulus for further thought. In *Practices of Reason: Aristotle's Nicomachean Ethics* (Oxford: Oxford University Press, 1992), 38, C. D. C. Reeve explains, "Aristotle often uses the term *aporia* to refer to problems whose solution seems simply to lie in further observations, in acquiring knowledge of more facts. (. . .) But some of the *aporiai* Aristotle wrestles with in his own philosophical works . . . seem not to be empirical. It is not more facts we need to solve them, it seems, but more conceptual sophistication or greater subtlety." In *Substance and Essence in Aristotle: An Interpretation of "Metaphysics" VII–IX* (Ithaca: Cornell University Press, 1989), Charlotte Witt explains that Aristotle's method consists in creating a "mental puzzle," which he termed an *aporia*. According to Witt, this mental puzzle had a stylized character, which consists in articulating "considerations on both sides of a given issue." The word *aporia* is used because it

has the connotation of "a blocked path or passage." The intellect is bound by the consider-
ations for and against a given position. However, Aristotle thinks that this stage is unavoid-
able; indeed, it is a necessary preliminary for an adequate resolution of the intellectual
dilemma. (. . .) [I]t is only through a statement of the difficulties that one can envision
what an adequate solution would have to look like (10–11).

Thus, *aporia* has been and can be a fruitful intellectual tool for considering fully all aspects
of a problem. In this way it serves a constructive role in contradistinction to its destructive
use in deconstruction where it is employed to generate terminal uncertainty and where it
is applied to undermine meaning and erode moral conviction.

Historically, we also find that *aporia* was used to create doubt for its own value within
the delimited context of a rhetorical figure. See, for example, Puttenham, *The Arte of
English Poesie*, 189: "*aporia*, or the doubtfull."

96. Southwell, "Appendix," 93.

97. Ibid.

98. Derrida, *Of Grammatology*, 23.

99. Charles Fourier, *Théorie de l'unité universelle* (Paris, 1841–3 2nd ed.), in Beecher and
Bienvenu, eds., *The Utopian Vision*, 219.

100. For an example of words placed "under erasure," see Derrida, *De la Grammatologie*, 31; *Of
Grammatology*, 19. In *Signs of the Times*, Lehman discusses this concept and practice and
observes, "In a larger sense, however, putting things 'under erasure' suggests an intellec-
tual program that would apply a fresh wet sponge to the blackboard of received ideas. And
the logic of self-cancellation – the idea of printing words with slash marks through them –
is not merely a clever bit of typographical horseplay but a metaphor for a larger enterprise:
the workings of a theory that revels in extreme doubt, boasts of its own contrarian stance,
asserts ideas without necessarily subscribing to them, and regards moments of self-
contradiction as supernally important" (53).

101. Derrida, *Of Grammatology*, 24. At this point, we can return to Ellis for explanations about
several of Derrida's other terms – play, "differance," supplement, and trace – all of which
are used to suggest, as Ellis explains, that "meaning has become limitless, infinite, and
indefinite." In explaining the unjustified assumptions and conclusions that Derrida makes
when appropriating Ferdinand de Saussure's concepts and terminology relative to these
four words, Ellis repeatedly remarks that Derrida has "misunderstood what Saussure is
saying" (Ellis, *Against Deconstruction*, 54–8). Yet, Derrida is a man of high intelligence. It is
doubtful that he has misunderstood each of Saussure's basic concepts. Rather, it would
seem that Derrida simply has transformed Saussure's meanings to make them serve his
own ends. In *The Cult of the Avant-Garde Artist*, 123–4 n. 61, Kuspit offers a critique of what
he terms the "pretentious, pseudo-avant-garde wordplay" of Jacques Lacan and Jacques
Derrida.

102. Kerferd, *The Sophistic Movement*, 61, 84–5.

103. As quoted in ibid., 85.

104. Ibid.

105. Kerferd also identifies the abuse of sophistic relativism with the broad attack on value
found in today's poststructuralism: "In its extreme modern form this leads to the doctrine
that there are no facts and no truth, only ideologies and conceptual models and the choice

between these is an individual matter, perhaps dependent on personal needs and prefer-
ences, or perhaps to be influenced by the thinking of social groups treated as units, but not
to be established in any other ways than these" (ibid., 78). For a critique of Derrida, Fish,
and Barbara Herrnstein Smith as modern-day practitioners of a type of skepticism devel-
oped by the fourth century B.C. Greek philosopher Pyrrho of Elis, see Nussbaum,
"Skepticism about Practical Reason in Literature and the Law," *Harvard Law Review* 107
(January 1994): 714–44.

106. See Lehman, *Signs of the Times*, 35–40.

107. Thomas Patin, "From Deep Structure to an Architecture in Suspense: Peter Eisenman,
Structuralism, and Deconstruction," *Journal of Architectural Education* 47 (November
1993): 96–7.

108. Finkielkraut, *La Défaite de la pensée*, 65–73 ("Un monde désoccidentalisé"); *The Undoing of
Thought*, 53–9 ("A Dewesternized World").

109. Derrida, *Of Grammatology*, 132.

110. Lévi-Strauss as quoted in ibid., 130.

111. Susan Sontag, "Thinking Against Oneself: Reflections on Cioran" (1967), in *Styles of
Radical Will* (New York: Farrar, Straus and Giroux, 1969), 75.

112. Ibid.

113. Ibid., 74.

114. Susan Sontag, "The Aesthetics of Silence" (1967), in ibid., 34.

115. Wilhelm von Humboldt, *The Limits of State Action*, ed. J. W. Burrow (Cambridge: Cam-
bridge University Press, 1969), vii. The line from Mill is quoted in the "Editor's
Introduction." For Humboldt's text in this current translation, see p. 11.

116. Ibid., 3.

117. Marc Angenot, "L'*intertextualité*: enquête sur l'émergence et la diffusion d'un champ
notionnel," *Revue des Sciences Humaines* 60 (January–March 1983): 121–2.

118. Pauline Marie Rosenau, *Post-Modernism and the Social Sciences: Insights, Inroads, and Intrusions*
(Princeton: Princeton University Press, 1992), xii, with a further quotation from Zyg-
munt Bauman, "Philosophical Affinities of Postmodern Sociology," *The Sociological Review*
38 (1990): 427.

119. Angenot, "L'*intertextualité*," *Revue des Sciences Humaines* 60 (January–March 1983): 130–
1: "L'idée d'*intertexte* . . . refusait tout clôture au texte. . . ."

120. Jonathan Culler, "Presupposition and Intertextuality," *Modern Language Notes* [henceforth,
MLN] 91 (December 1976): 1382.

121. Laurent Jenny, "La stratégie de la forme," *Poétique* no. 27 (1976), 257: "Hors de l'intertex-
tualité, l'oeuvre littéraire serait tout simplement imperceptible. . . ." Consider also
Michael Riffaterre, "La syllepse intertextuelle," *Poétique* no. 40 (November 1979): 496:
"L'intertextualité est un mode de perception du texte, c'est le mécanisme propre de la
lecture littéraire."

122. Jenny, "La stratégie de la forme," 261: "Si en effet, pour J. Kristeva 'tout texte se construit
comme une mosaïque de citations et tout texte est absorption et transformation d'un
autre texte,' la notion de texte est sérieusement élargie chez elle. Elle devient synonyme
de 'système de signes,' qu'il s'agisse d'oeuvres littéraires, de langages oraux, de systèmes
symboliques sociaux ou inconscients."

123. Culler, "Presupposition and Intertextuality," *MLN* 91 (December 1976): 1383. Consider also, Leon S. Roudiez, "Introduction," in Julia Kristeva, *Desire in Language: A Semiotic Approach to Literature* (New York: Columbia University Press, 1980), ed. Leon S. Roudiez, trs. Thomas Gora, Alice Jardine, and Leon S. Roudiez, 15: "[Intertextuality] has nothing to do with matters of influence by one writer upon another, or with the sources of a literary work;"

124. Jenny, "La stratégie de la forme," *Poétique* no. 27 (1976): 257: "loin d'être . . . un effet d'écho."

125. Julia Kristeva, "Problèmes de la structuration du texte," in *Théorie d'ensemble*, Collection "Tel Quel" (Paris: Seuil, 1968), 299: "Le texte . . . est une permutation de textes, une inter-textualité: dans l'espace d'un texte plusieurs énoncés pris à d'autres textes se croisent et se neutralisent." This article occurs in the collaborative volume published by *Tel Quel* in which the concept of intertextuality and related notions were articulated as a collective effort to mark the existence of "une percée théorique générale" (anon., "Division de l'ensemble," 7).

126. Jenny, "La stratégie de la forme," *Poétique* no. 27 (1976): 267.

127. Although Celia Britton in *The Nouveau Roman: Fiction, Theory and Politics* (New York: St. Martin's Press, 1992), 145, observes that "subsequent practitioners of intertextuality [after Kristeva] have sometimes used it simply as a more fashionable name for the traditional study of literary influences," Britton appears to do the same when she discusses the relationship between the *nouveau roman* and traditional literature:

> The use of the biblical story of Cain in Butor's *L'Emploi du temps*, for instance, explores the connections between moral guilt and creative renewal. Robbe-Grillet's *La Jalousie* refers to an "African novel" which has been identified as Graham Greene's *The Heart of the Matter*, and which acts as a focus for questioning the logic of the conventional plot. The Orpheus myth in Simon's *Les Géorgiques* comes in the first place from Virgil's *Georgics*, but the novel draws our attention to the permutations that it has already undergone, in the form for instance of Gluck's opera *Orpheus and Eurydice* . . . (150).

All of these examples are easily subsumed under the traditional, humanistic notion of "echo" discussed in ch. 1.

The concept of "echo" also applies to Jenny's analysis of Lautréamont's *Chants de Maldoror*, both in its specifics and in its concluding summary: "From one text to the other, the tone, the ideology, the movement even of the scene has changed, not accidentally, but rather through a chain of contradictions and symmetries item by item." Likewise, Jenny's concept of "amplification" – "transformation of an original text by developing its semantic possibilities" – offered as one of the rhetorical "figures of intertextuality," is none other than the classical concept of filial imitation. (Jenny, "La stratégie de la forme," *Poétique* no. 27 [1976]: 262–3, 276: "D'un texte à l'autre, le ton, l'idéologie, le mouvement même de la scène ont changé, non pas au hasard, mais par une suite de contradictions et de symétries terme à terme." "*Amplification*: transformation d'un texte originel par développement de ses virtualités sémantiques.")

Similarly, Michael Riffaterre's notion of intertextuality as presented in "Sémiotique intertextuelle: l'interprétant," in *Rhétoriques sémiotiques* (*Revue d'Esthétique*, nos. 1–2 (1979): 128–50, is actually an example of the phenomenon of echo. Analyzing what he sees as the intertextuality of a passage from Lautréamont's *Chants de Maldoror*, which

presents marked parallels with a painting by Pierre-Paul Prud'hon, Riffaterre remarks that "I certainly do not have to demonstrate that the painter inspired the writer." With intertextuality there is no need, explains Riffaterre, to establish "a filial relationship between one work and another. (. . .) This is even one of the advantages of the notion of intertext, its most notable superiority over those of source or influence, fundamental concepts of historicist criticism." And yet, what Riffaterre has identified is simply an aspect of the old-fashioned concept of echo, in this case signalling the resonance between painting and literary text in the mind of the reader. ("Ceci dit, les similitudes constatées ne sauraient être ramenées à un rapport de filiation d'une oeuvre à l'autre, et je n'ai certes pas à démontrer que le peintre a inspiré l'écrivain. C'est même là un des avantages de la notion d'intertexte, sa supériorité la plus marquante sur celles de source ou d'influence, con-cepts fondamentaux de la critique historiciste" [131].)

When Riffaterre next explains that the intertext here is not any specific work but rather is a theme (139–40), or is constituted with reference to a theme (133–4), that has been repeatedly treated in the arts – what he calls "une identité structurale" (132) – in this case, the theme of remorse that pursues the guilty person without respite – he has returned to the classical concept of imitation. As I read Riffaterre's explanation about what he terms those features that differentiate the new work from others that had previously treated this theme – "la dissemblance, la différence spécifique qui, au sein de l'intertexte, constitue la textualité propre à *Maldoror* 2, 15" (133) – I could not help thinking about how over three hundred years ago Poussin had made the same observation (quoted in ch. 2) about the nature of novelty within the context of the classical notion of imitation.

Even Kristeva offers a demonstration of intertextuality in one of her early articles that is simply a version of the concept found in classical rhetoric of mellificative imitation, which I discussed in ch. 2 as an aspect of what John Claudius Loudon in the early nineteenth century called "imitative genius." Applying a so-called intertextual analysis to "Jehan de Saintré" (1456) by Antoine de La Sale, Kristeva concludes, "Thus the structure of the French novel of the fifteenth century can be considered the result of the transformation of several other codes: scholastic, chivalric poetry, oral literature (advertising) of the city, carnival" ("Problèmes," in *Théorie d'ensemble*, 311: "Ainsi la structure du roman français au XVe siècle peut être considérée comme le résultat d'une transformation de plusieurs autres codes: la scholastique, la poésie courtoise, la littérature orale [publicitaire] de la ville, le carnaval").

128. Culler, "Presupposition and Intertextuality," *MLN* 91 (December 1976): 1384–5.
129. Ibid., 1384.
130. I find efforts to apply the concept of intertextuality in ways other than "echo" and "imitation" unconvincing. Recognizing that interpretations that provide no more than a text's "relation to specific precursors" inadequately serve the concept of intertextuality (1388), Culler, in "Presupposition and Intertextuality," *MLN* 91 (December 1976), attempts to rescue intertextuality with a theory of "presupposition." To illustrate this concept, Culler quotes the opening two lines from a poem by Baudelaire and then observes, "There is implicit reference to prior poetic discourse, to a poetic tradition, even though no poet may ever have described the sky as the lid of a pot" (1390). Culler himself acknowledges that he has tamed the *enfant terrible* of poststructuralism into a "modest intertextuality" (1389). Yet to say that when we read a poem or a novel we situate it within

a broader literary and social context is to utter a truism that hardly merits a new term to designate it. If this is to become the meaning of intertextuality, then it places the word within the heart of humanistic understanding. With his notion of "presupposition," Culler has emptied the concept of intertextuality of any possible significant meaning for post-structuralist discourse.

Michael Riffaterre has attempted an explanation of intertextuality that draws upon its connections with Freud and the theory of repression. (For the Freudian link to intertextuality, see Angenot, "L'*intertextualité*," *Revue des Sciences Humaines* no. 189 [January–March 1983]: 124–5, 129–30; Jenny, "La stratégie de la forme," *Poétique* no. 27 [1976]: 280 n. 23; Julia Kristeva, *The Kristeva Reader*, ed. Toril Moi [London: Basil Blackwell, 1986], 83–5, 98.) In "La syllepse intertextuelle," *Poétique* no. 40 (November 1979): 496–501, Riffaterre offers a theory of the "intertextual syllepsis." Syllepsis, as Riffaterre reminds us, is a term from rhetoric that refers to "using the same word in two different senses, the first being generally its literal meaning, the second its figurative meaning." "Intertextual syllepsis," according to Riffaterre, consists of a two-part reading that constitutes the nature of the response to poetry. Riffaterre believes that "the first reading [of a poem] only gives the meaning that is acceptable in the context [of the poem]" and that through a "retroactive reading" one discovers an "aberrant derivation" of the meaning that creates the intertextual syllepsis. ("La syllepse, on le sait, consiste à prendre un même mot dans deux sens différents à la fois, le premier étant en général son sens littéral, le second son emploi figuré" [496]. "Mais l'indécidable n'est reconnu qu'après coup, dans la lecture rétroactive, puisque la première lecture ne donne que le sens acceptable en contexte, et qu'il faut revenir en arrière, à partir de la dérivation aberrante, pour comprendre que le mot matriciel est une syllepse" [501].)

Furthermore, according to Riffaterre, this two-part reading operates according to the Freudian mechanism of repression and compensation. In following Riffaterre as he takes his reader through various poems, I do not see the operation of repressed meaning that generates a compensatory meaning. My own experience with these and other poems teaches me that the literal and figurative meanings of words often appear simultaneously and that the so-called repressed theme in the poem begins to suggest itself from the very first words and at the initial reading. Certainly this is true of the poem "Marrons sculptés par Miro" by Michel Leiris, which Riffaterre analyzes at length and whose quatrain begins, "Ma mie, mon pain, mon sel."

Once one removes the psychoanalytic superstructure that envelops Riffaterre's theory – because it does not correspond to the reality of how a poem is read – all that is left is an appropriate humanistic appreciation of the allusive quality of lyrical poetry. So-called "intertextual syllepsis" is transformed into the rich ambiguities of classically humanistic syllepsis, analyzed with such subtlety by Fontanier in his *Manuel classique pour l'étude des tropes*, now in *Les Figures du discours*, 105–8. In particular, what Riffaterre terms "intertextual syllepsis" corresponds to the traditional type of syllepsis that Fontanier illustrates with an example such as the line from Racine, "Du coup qui vous attend vouz mourrez moins que moi," where death refers to a physical death for Iphigenia and a moral death for Agamemnon. Even an enthusiast such as Angenot has recognized the "conservative" turn and the "limited field of application" that Riffaterre has given the word intertextuality: "Il

n'empêche que 'l'intertextualité' sert ici une stylistique littéraire dont la subtilité et l'érudition ne peuvent dissimuler le caractère conservateur et l'étroitesse relative du champ d'application" (Angenot, "L'*intertextualité*," 129).

131. In addition to the works discussed below, consider also the major role played by Claude Simon's *La Bataille de Pharsale* in Jenny, "La stratégie de la forme," *Poétique* no. 27 (1976): 272–81. In *The Nouveau Roman*, 166–7, Britton describes Simon's novel as follows: "[A]lthough the bulk of the text is still in the characteristic Simonian style, interpolated fragments of other discourse become far more apparent. Moreover, there are eminently social intertexts: advertisements, tram routes, signs over shops and bars, etc. Topographical signs . . . a list of the street names . . . newspaper headlines . . . the writing on the banners of the demonstration. . . . Sometimes these quotations are themselves fragmented. . . . These kinds of transformation are quite violent; Simon's own discourse attacks the intertextual sequences."

132. Michel Butor, as quoted in Leyla Perrone-Moisés, "L'intertextualité critique," *Poétique* no. 27 (1976): 382. I had to distend Butor's text in the translation to render its meaning in English: "Il n'y a pas d'oeuvre individuelle. L'oeuvre d'un individu est une sorte de noeud qui se produit à l'intérieur d'un tissu culturel au sein duquel l'individu se trouve non pas plongé mais *apparu*."

133. Ibid., 380: "Dans *Histoire extraordinaire*, livre de 270 pages, au moins la moitié appartient à Baudelaire. Butor y ré-écrit Baudelaire à travers un travail de collage et de remontage de textes; le matériau est baudelairien, le nouvel ordre et les joints sont butoriens."

134. Jean Duvignaud, as quoted in ibid., 380: "Par l'usage que vous faites des collages, où de moins en moins les textes cités se distinguent du vôtre, vous dissolvez vos auteurs."

135. Barthes, as quoted in ibid., 383: "L'intertextualité n'a d'autre loi que l'infinitude de ses reprises. L'auteur lui-même – déité quelque peu vétuste de l'ancienne critique – peut, ou pourra un jour constituer un texte comme les autres: il suffira de renoncer à faire de sa personne le sujet, la butée, l'origine, l'autorité, le Père, d'où dériverait son oeuvre." One wonders what drives a person to snub "authority, the Father" in such a manner and to consider the goal of art as consisting in such a seemingly defiant act.

136. Ibid., 382: "La nouvelle de Balzac a été décomposée en fragments . . . empaquetés en blocs . . . , ces blocs à leur tour étant enveloppés par le texte barthésien (qui les ponctue, leur donne une articulation et une modulation). Le texte intégral de la nouvelle balzacienne, publié à la fin du volume, fonctionne lui-même comme une pièce du montage: non plus un objet fini et tutélaire, mais une sorte de miniature appendue au grand tableau de *S / Z*, une *citation*, un miroir sphérique dans un intérieur flamand." For an explanation of the reference to the spherical mirror in a Flemish interior, see n. 161.

137. Thomas McEvilley, "'On the Manner of Addressing Clouds,'" *Artforum* (Summer 1984): 70.

138. Perrone-Moisés, "L'intertextualité critique," *Poétique* no. 27 (1976): 383: "des objets forclos et sacrés"

139. Angenot, "L'*intertextualité*," *Revue des Sciences Humaines* 60 (January–March 1983): 124–5: "Il faut remarquer maintenant autre chose, c'est que le mot d'intertextualité, chez Kristeva . . . et chez d'autres telqueliens, n'apparaît que dans des contextes à caractères théorique général et en relation avec 'écriture textuelle,' 'productivité,' 'écri-

ture monumentale.' Cela constitue un term-clé d'une réflexion principielle, qui ne semble susceptible ni 'd'application,' ni de spécification. L'intertextualité se présente au contraire dans une grande indétermination anhistorique, dans des passages quasi-allégoriques où Texte, Société, et Histoire entretiennent des rapports courtois mais imprécis."

140. Jean-Louis Baudry, "Ecriture, fiction, idéologie," in *Théorie d'ensemble*, 136: "Un tel espace n'a évidemment ni axe, ni centre."

141. Eugène Minkowski, *Vers une Cosmologie: fragments philosophiques* (1936; Paris: Aubier-Montaigne, 1967 2nd ed.), 79−87 (ch. 6, "La Métaphore"): "Parmi les métaphores, les métaphores de base ne sont point, à tout prendre, des métaphores à proprement parler. Nous ne transportons pas la signification propre d'un mot à une signification autre, mais désignons d'un seul mot, dans l'exemple choisi, une façon particulière d'affecter l'âme humaine, Certains mots sont 'métaphoriques' par essence, et c'est là que réside la 'véracité' du langage. Le langage ne cherche point à faire du mot un signe algébrique, mais au contraire, à désigner à l'aide du mot des affinités, des identités même, entre les phénomènes, que notre pensée qui dissèque et juxtapose, méconnaît et anéantit vraiment trop facilement." In *Freud and Philosophy: An Essay on Interpretation*, tr. Denis Savage (New Haven: Yale University Press, 1970; 1972 2nd printing), Paul Ricoeur has more recently developed a concept analogous to Minkowski's "base metaphor" through his discussion of the symbol. See bk. 1, chs. 1−2, "Language, Symbol, and Interpretation" and "The Conflict of Interpretations," where Ricoeur discusses the "double meaning" of the symbol (15), the "bond of meaning to meaning in a symbol as analogy" (16−17), the "analogy of the physical and the existential" effectuated by the symbol (17), the "symbolic naïveté" that "characterize[s] this manner of living in and through analogy without the latter being recognized as a distinct semantic structure" (19), and the distinction between signs and symbols (30−31), the latter involving "full language" and "bound language" (31). The examples that Ricoeur gives to illustrate these properties of the symbol, ranging from the "symbolism of the heavens, as a figure of the most high and the immense" (14) to the "symbolism of evil" with its "analogy between spot and stain" (17), present instances of what Minkowski had termed base metaphors. On this subject, see also n. 142.

142. Minkowski, *Vers une Cosmologie*, 65−6 (depth, breadth, and height as considered in ch. 4, "La Triade psychologique"), 69−78 (ch. 5, "L'Espace primitif"). For a further consideration about our inner psychic and spiritual space, see Etlin, *Symbolic Space*, xviii−xxii, 37−43, 116−23, 172−98, and *Frank Lloyd Wright and Le Corbusier: The Romantic Legacy*, 30−47, 70−5, 120.

143. T. S. Eliot, "The Hollow Men" (1925), *Collected Poems, 1909−1962* (New York: Harcourt, Brace and World, 1963), 77−82.

144. Nietzsche, *Thus Spake Zarathustra*, in *The Complete Works*, XI, 59 (§ XII). See also 67 (§ XV), 226 (§ LIII).

145. Blake, "Milton, a Poem in 2 Books" I, pl. xv, 21−4, in *The Complete Poetry and Prose of William Blake*, ed. David V. Erdman, commentary by Harold Bloom (New York: Anchor/Doubleday, 1988 rev. ed.), 109.

146. The notion of an inner core or center as a base metaphor used to explain the nature of being

and, at times, of one's relationship to divinity, has been studied as a widespread historical phenomenon by Georges Poulet, *Les Métamorphoses du cercle* (Paris: Plon, 1961); *The Metamorphoses of the Circle*, trs. Carley Dawson and Elliot Coleman (Baltimore: Johns Hopkins University Press, 1966). For a related issue, see also Gaston Bachelard, *La Poétique de l'espace* (Paris: Presses Universitaires de France, 1957; 1970), ch. 10 ("La phénoménologie du rond"); *The Poetics of Space*, tr. Maria Jolas (1964; Boston: Beacon Press, 1969), ch. 10 ("The Phenomenology of Roundness"). For a perceptive study of the recurrence of the center, as point or axis, in the visual arts, see Rudolf Arnheim, *The Power of the Center: A Study of Composition in the Visual Arts* (Berkeley: University of California Press, 1982). Always perceptive to the psychological dynamics of line and form in the visual arts, Arnheim unfortunately consciously refrained from considering the role of the center and axis, to use Minkowski's terminology, as base metaphors: "My work is based on the assumption that the most powerful conveyor of meaning is the immediate impact of perceptual form. And it is this impact that distinguishes art from other kinds of communication. Because of this preeminent concern with the immediacy of visual expression, I have resisted the temptation to explore the profound connotations of 'center' as a philosophical, mystical, and social concept. These deeper meanings are undoubtedly relevant to the full interpretation of the works of art I am discussing" (xi).

147. Nietzsche, *Beyond Good and Evil*, in *The Complete Works*, XII, 8 (§ 3). This thought is developed further on pp. 9–10 (§ 5). Nietzsche may well have been reiterating in his own manner what Ernst Cassirer reports to have been "a well known utterance of Fichte's": " 'The kind of philosophy a man chooses depends upon the kind of man he is. For a philosophic system is no piece of dead furniture one can acquire and discard at will. It is animated with the spirit of the man who possesses it' " (Fichte, *First Introduction to the Science of Knowledge*, as quoted in Ernst Cassirer, *Rousseau, Kant and Goethe*, trs. James Gutmann et al. [Princeton: Princeton University Press, 1945; New York: Harper and Row, 1963], 2). In this discussion, Fichte attributes the choice of a philosophical orientation to "inclination and interest." (Johann Gottlieb Fichte, *Science of Knowledge* ("*Wissenschaftslehre*") *with the First and Second Introductions*, eds. and trs. Peter Heath and John Lachs [New York: Appleton-Century-Crofts / Meredith, 1970], 15. The quotation given by Cassirer can be found in a slightly different translation on p. 16.)

Such observations periodically recur over the course of the history of philosophy. See, for example, Ernest Gellner's *Legitimation of Belief* (Cambridge: Cambridge University Press, 1974), which offers valuable insights into this question. Whereas Fichte saw philosophy as being divided into two irreconcilable orientations, which he termed "dogmatism" and "idealism," Gellner places thinkers into two camps, monism and pluralism. In formulating his argument, Gellner stresses approvingly that William James had "considered the dispute between pluralists and monists to be *the* most fundamental intellectual issue . . ." (1). As Gellner's text makes clear, each camp attracts its adherents through inner conviction. Speaking about his own philosophical orientation, Gellner the monist writes, "In passages such as the ones quoted, I find my inner life, its sources and anxieties, laid bare" (4). Thus, "What is at issue here, though no formal definition of monism and pluralism has yet been attempted, is the difference between two styles of conducting *intellectual* life: between the pursuit, and the very high valuation of a single (or

failing that, non-numerous) and explicitly formulated unifying principle or idea, treated with respect and reverence, and on the other hand a derogation of such ideas or principles, and consequently a high valuation of inexplicit and multiform adjustments or devices" (4–5).

148. Nietzsche, *Beyond Good and Evil*, in *The Complete Works*, XII, 8 (§ 3).

149. Percy Bysshe Shelley, *Essay on Christianity* (c. 1816) as quoted in Olwen Ward Campbell, *Shelley and the Unromantics* (1924; New York: Russell and Russell, 1966 reprint), 282; Francis Ponge, "Notes premières de 'l'homme'" (1943–4), from *Proêmes* (1948), in *Le parti pris des choses . . . suivi de Proêmes* (Paris: Gallimard, 1967), 216: "Une certaine vibration de la nature s'appelle l'homme."

150. Minkowski, *Vers une Cosmologie*, 7, 261: "qui faisaient vibrer tout mon être"; "l'axe de l'élan personnel."

151. Herman Melville, "Hawthorne and His Mosses," in *The Piazza Tales and Other Prose Pieces, 1839–1860*, eds. Harrison Hayford, Alma A. MacDougall, G. Thomas Tanselle, et al. (Evanston and Chicago: Northwestern University Press and Newberry Library, 1987), 244.

152. Sullivan, *A System of Architectural Ornament*, 11, and commentary accompanying plates 5, 7.

153. In *Contingency, Irony, and Solidarity* (Cambridge: Cambridge University Press, 1989), 189, Richard Rorty denies "that there is anything like a 'core self.'" A complete response to this position would entail postulating a model of the human psyche, a task that extends far beyond the confines of this book. For the moment, let us briefly test one of Rorty's prime examples used to support his argument:

> Consider, as a final example, the attitude of contemporary American liberals to the unending hopelessness and misery of the lives of the young blacks in American cities. Do we say that these people must be helped because they are our fellow human beings? We may, but it is much more persuasive, morally as well as politically, to describe them as our fellow *Americans* — to insist that it is outrageous that an *American* should live without hope. The point of these examples is that our sense of solidarity is strongest when those with whom solidarity is expressed are thought of as "one of us," where "us" means something smaller and more local than the human race. That is why "because she is a human being" is a weak, unconvincing explanation of a generous action (191).

I believe that Rorty is right with respect to the political expediency of his approach in this particular instance but wrong about the conclusions that he draws about the moral sense and hence about an inner moral core.

The appeal to our common humanity to which Rorty alludes involves our moral sense; the appeal to our solidarity with our fellow Americans invokes our tribal sense. Now, the tribal sense, I believe, does not primarily involve moral sentiments. The tribal sense relies primarily on two factors, our sense of self-preservation and our need for social bonding, the latter having both positive and negative components, especially when manifested in a sense of us and them, with "them" being seen as alien to "us." The tribal sense, underpinned by these two factors that come into play either singly or in combination at different times, can override the moral sense.

As the basis for practical action, an appeal to the tribal sense in a case such as the one portrayed by Rorty is usually, as Rorty argues, more effective than an appeal to the moral sense. But this issue of practicality does not deny the existence of an essential inner moral

core. Furthermore, it is a mistake to say that an appeal to our tribal sense is "more pursuasive, morally," because the tribal sense is not grounded in moral sentiment.

The conflict between the moral sense and the tribal sense largely explains the dichotomy in responses to saving the Jews during World War II as discussed by Rorty at the beginning of his chapter on "solidarity" (189–91). Without making this crucial distinction between the moral sense and the tribal sense and without explaining how each is grounded in the psyche, Rorty incorrectly feels justified to deny the validity of "ideas like 'essence,' 'nature,' and 'foundation'" (189).

Whereas Rorty appeals to the tribal sense while disparaging both the importance and the efficacy of the moral sense (as "a weak, unconvincing explanation of a generous action"), we find a counter argument, for example, in E. M. Forster's *A Passage to India*, where the conflict between the moral sense and the tribal sense is one of the main subjects, with the author favoring the claims of the former over the latter through the characterization of Fielding and Mrs. Moore in contrast with the other British figures in the book. To watch the operations of the moral sense largely independent of the pull of the tribal sense, consider the incidents referred to in ch. 1, n. 100, in *Les Misérables* and *Bleak House*.

Although both Rorty and I use *Bleak House* for our arguments about moral behavior, we characteristically invoke different, albeit related passages, for our ostensibly different purposes. I say "ostensibly," because in the end, Rorty contradicts his position about the absence of an inner moral core in favor of the tribal sense when he writes, "But it seems quite compatible with saying that the ability to shudder with shame and indignation at the unnecessary death of a child – a child with whom we have no connection of family, tribe, or class – is the highest form of emotion that humanity has attained while evolving modern social and political institutions" (147). I could not imagine a more eloquent testimonial to the essential moral sense against which Rorty ironically has been arguing.

Yet when one looks to the point of origin of this moral sentiment, this "highest form of emotion that humanity has attained," Rorty and I disagree. The key to our difference on this matter resides in the word "attained." For Rorty, "attained" means that this moral sentiment is merely "the voice of a contingent human artifact, a community which has grown up subject to the vicissitudes of time and chance, one more of Nature's 'experiments'" rather than "the voice of a divinized portion of our soul" (60). I find Rorty's attribution of this moral sentiment to the former rather than the latter source arbitrary and unconvincing.

It is arbitrary and unconvincing because Rorty's view of moral issues dismisses the importance of intuition and grounds moral meaning in language. On intuition, Rorty writes:

> On the view I am suggesting, the claim that an "adequate" philosophical doctrine must make room for our intuitions is a reactionary slogan, one which begs the question at hand. For it is essential to my view that we have no prelinguistic consciousness to which language needs to be adequate, no deep sense of how things are which it is the duty of philosophers to spell out in language. What is described as such a consciousness is simply a disposition to use the language of our ancestors, to worship the corpses of their metaphors. Unless we suffer from what Derrida calls "Heideggerian nostalgia," we shall not think of our "intuitions" as more than platitudes, more than the habitual use of a certain repertoire of terms, more than old tools which as yet have no replacements (21–2).

On the relationship of understanding and of moral sentiments to language Rorty asserts: "truth is a property of linguistic entities, of sentences" (7), "truth is a property of sentences" (21), "the demands of a morality are the demands of a language," with language being "historical contingencies" (60). Such an explanation trivializes the moral sense beyond recognition. Finally, although I differ with the author on certain issues, *The Moral Sense* by James Q. Wilson (New York: Free Press / Simon and Schuster, 1993) provides an important response to the position taken by Rorty and others against the reality of our inner moral core that stands "beyond history and institutions," beyond "contingent historical circumstance" (Rorty, *Contingency*, 189).

154. For anybody who doubts the reality of the subject, the primacy of the text (as opposed to the so-called intertext), and of the special quality of genius, then consider Nietzsche's apt account of inspiration in *Ecce Homo*, quoted in ch. 2, n. 2.

155. Blake, "Milton, a Poem in 2 Books," I, pl. ix, 35 in *Blake. Complete Writings with Variant Readings*, ed. Geoffrey Keynes (Oxford: Oxford University Press, 1972), 490.

156. Culler, "Presupposition and Intertextuality," *MLN* 91 (December 1976): 1382 (my translation: *je* n'est pas un sujet innocent, antérieur au texte . . . Ce "moi" qui s'approche du texte est déjà lui-même une pluralité d'autres textes, de codes infinis, ou plus exactement: perdus [dont l'origine se perd]). Culler makes his own attempt to dissolve meaning into "an infinite intertextuality" just because "It is difficult to explain what it is that enables us to make sense of a new instance of discourse" (ibid.). Certainly the former does not follow necessarily from the latter. This is another instance of the false syllogism whereby faced with the impossibility of full certainty, the poststructuralist pronounces the certainty of total uncertainty.

157. Mikhail Bakhtin, "Slovo v romane," *Voprosy literatury* (1965), as quoted in French translation in Julia Kristeva, "Bakhtine, le mot, le dialogue et le roman," *Critique* no. 239 (1967): 459–60 n. 12: "Le langage du roman ne peut pas être situé sur une surface ou sur une ligne. Il est un système de surfaces qui se croisent. L'auteur comme créateur du tout romanesque n'est trouvable sur aucune des surfaces linguistiques: il se situe dans ce centre régulateur que représente le croisement des surfaces. Et toutes les surfaces se trouvent à une distance différente de ce centre de l'auteur." In *The Nouveau Roman*, 145, Britton points out that Kristeva quoted this passage (Britton gives only the first two of these sentences) and observes, "The following year Kristeva develops this idea to arrive at a basic definition of intertextuality."

158. Kristeva, "Bakhtine, le mot, le dialogue et le roman," *Critique* no. 239 (1967): 463: ". . . Bakhtine saisit la structure au niveau le plus profond. . . . celles d'un texte fait de relations, dans lequel les mots fonctionnent comme quanta. Alors la problématique d'un modèle du langage poétique n'est plus la problématique de la ligne ou de la surface, mais de l'*espace* et de l'*infini*, formalisables par la théorie des ensembles et les nouvelles mathématiques."

159. Lucien Dällenbach, "Intertexte et autotexte," *Poétique* no. 27 (1976): 287 ("la mise en abyme prospective 'double'"), 290.

160. Lucien Dällenbach, *Le Récit spéculaire: essai sur la mise en abyme* (Paris: Seuil, 1977); *The Mirror in the Text*, tr. Jeremy Whiteley with Emma Hughes (Chicago: University of Chicago

Press, 1989), 22. The second quotation, used by Dällenbach, comes from C. E. Magny, *Histoire du roman français depuis 1918* (Paris: Seuil, 1950), 273.

161. Craig Owens, "Photography *en abyme*," *October* no. 5 (Summer 1978): 76. The poststructuralist notion of the "abyss" presents still another instance of the transformation of humanistic concepts for poststructuralist ends. I briefly discussed above how the notions *antilogikē* or "antilogic" and *aporia* were changed to this effect. Dällenbach's book permits us to chart the fortunes of "abyss" in a similar way.

 According to Dällenbach, the story begins with a remark by André Gide in 1893 about how he enjoyed seeing the entirety of a work of art reproduced within that work as a miniature (*Le Récit*, 15; *The Mirror*, 7). Gide then cited the examples of the convex mirror in paintings by Memling and Quentin Metsys, the mirror in Velásquez's *Las Meniñas*, the play within the play in *Hamlet*, the puppet shows in *Wilhelm Meister*, and so forth. Gide likened this phenomenon to " 'the device from heraldry that involves putting a second representation of the original shield "en abyme" within it' " (*The Mirror*, 7). As Dällenbach explains, "The word *abyme* here is a technical term. I shall not therefore speculate on its many connotations or hasten to give it a metaphysical meaning: instead of invoking Pascal's 'gouffre', the abyss of the Mystics, Heidegger's 'Abgrund', Ponge's 'objeu' or Derrida's 'différance', I shall refer to a treatise on heraldry: ' "Abyss" ("Abîme") – the heart of the shield. A figure is said to be "en abîme" when it is combined with other figures in the centre of the shield, but does not touch any of these figures' " (*The Mirror*, 8).

 The artistic phenomenon that Gide has described at some point made its way into the French pedagogical system, for the ability to see the entire work mirrored within a particular passage was precisely the analytical procedure that I was taught over thirty years ago by my high school French teacher in New York state as the *explication de texte*. Yet, through a subtle transformation the humanistic relationship of the whole mirrored in the part was transformed by poststructuralists such that the mirroring became fractured and endless and the word "abyss," now rendered as part of the expression *mise en abyme*, was used with its non-heraldic and metaphysical meaning. Dällenbach attributes the initial change in meaning to the interpretation of Gide's phrase by Magny, who coined the term *mise en abyme*, and to P. Lafille, *André Gide romancier* (Paris: Hachette, 1954) (*The Mirror*, 20–6).

162. Derrida, *Of Grammatology*, 163 (his emphasis). This passage was also quoted as important to the discussion in Owens, "Photography *en abyme*," *October* no. 5 (Summer 1978): 77. The clause in square brackets is from the sentence that precedes this quotation. Derrida's next sentence reads, "Thus Rousseau inscribes textuality in the text." Derrida's discussion of Rousseau has provided him with the opportunity to explain the nature of "textuality" through a discussion of the "abyss."

163. Hans Sedlmayr, *Verlust der Mitte – Die bildende Kunst des 19. und 20. Jahrhunderts als Symptom und Symbol der Zeit* (Salzburg: Otto Müller); *Art in Crisis: The Lost Center*, tr. Brian Battershaw (Chicago: Henry Regnery, 1958). The book ends with a metaphysical call to order:

> The fourth critical way depends upon these three, but transcends them through the introduction of an absolute standard of values. It takes works of art as symptoms of a disturbance in the condition of man, whether individually or collectively. Disturbance, as here used, has

only one meaning, and presupposes a norm (which is *not* the cross-section), an *eternal "being"* of mankind. This book diagnoses from the facts of art that the disrupted relationship with God is at the heart of the disturbance. (. . .) For in the last analysis the fourth way of criticism is concerned with "not the wheel of history, but with the axle about which it revolves. It treats of the *centre*." (Helmut Thielicke.) (*Art in Crisis*, 260, 262, his emphasis).

I am not subscribing to Sedlmayr's method or conclusion. Rather, I am noting his use of the related concepts of axis and center as base metaphors.

Chapter 4

1. For my discussion of these issues I am greatly indebted to Finkielkraut, *La Défaite de la pensée*.

2. Hippolyte Taine, *Histoire de la littérature anglaise* (Paris: L. Hachette, 1863), I, xi—xii: ". . . au siècle dernier; on se représentait les hommes de toute race et de tout siècle comme à peu près semblables, le Grec, le barbare, l' Hindou, l'homme de la Renaissance et l'homme du dix-huitième siècle comme coulés dans le même moule, et cela d'après une certaine conception abstraite, qui servait pour tout le genre humain. On connaissait l'homme, on ne connaissait pas les hommes;"

3. Finkielkraut, *La Défaite de la pensée*, 14—15: "Il renvoie le Bien, le Vrai et le Beau à leur origine locale, déloge les catégories éternelles du ciel où elles se prélassaient pour les ramener sur le petit morceau de terre où elles ont pris naissance. Il n'y a pas d'absolu, proclame Herder, il n'y a que des valeurs régionales et des principes advenus."

4. Joseph de Maistre, *Considérations sur la France* (1796; Lyon and Paris: Emmanuel Vitte, 1924), 74: "Or, il n'y a point d'*homme* dans le monde. J'ai vu, dans ma vie, des Français, des Italiens, des Russes, etc., je sais même, grâce à Montesquieu, *qu'on peut être Persan*: mais quant à l'*homme*, je déclare ne l'avoir rencontré de ma vie; s'il existe, c'est bien à mon insu" (emphasis in the original). These lines are quoted by Finkielkraut in *La Défaite de la pensée*, 25, as well as Luc Ferry and Alain Renaut in *Heidegger and Modernity*, tr. Franklin Philip (Chicago: University of Chicago Press, 1990), in a discussion of "The Romantic Critique of Enlightenment Humanism," 91—4.

5. Andrew Hacker, "'Diversity' and Its Dangers," *New York Review of Books* (October 7, 1993), 22.

6. Arthur M. Schlesinger, Jr., *The Disuniting of America* (New York: W. W. Norton, 1992), 16.

7. De Maistre, *Considérations sur la France*, 74: "La constitution de 1795, tout comme ses aînées, est faite pour l'*homme*. Or, il n'y a point d'*homme* dans le monde."

8. For a profound and fascinating discussion about the "danger in making racial identities too central to our conceptions of ourselves," see K. Anthony Appiah, "Race, Culture, Identity: Misunderstood Connections," to appear in *The Tanner Lectures of Human Values*. I am grateful to the author for sending me a copy of this talk in anticipation of its publication.

9. David Denby, "Does Homer Have Legs?," *New Yorker* (September 6, 1993), 52, 54.

10. Terry Eagleton, "Proust, Punk or Both. How Ought We to Value Popular Culture?" *Times Literary Supplement* (December 18, 1992), 6.

11. In *The Disuniting of America*, 90—2, Arthur M. Schlesinger, Jr., offers moving testimonials from Frederick Douglass, W. E. B. Du Bois, and Ralph Ellison about the intellectual and

moral sustenance that they derived from authors that today are derisively dismissed as "dead White males."

12. Michael Wood, "Lost Paradises" [review article of Edward W. Said, *Culture and Imperialism*], *New York Review of Books* (March 3, 1994), 44. Consider also John Bayley's observations about Terry Eagleton's "Discourse and Discos: Theory in the Space between Culture and Capitalism," *Times Literary Supplement* (July 15, 1994), 3–4: "But has it become an article of faith with Professor Eagleton that Theory should have a Humanist face? By unobtrusively bringing back such terms as 'particularity,' 'human nature,' and 'the human spirit' he seems to be hedging his bets, or perhaps trying like Tony Blair to wear the enemy's wardrobe as well as his own" (letter to the editor, *Times Literary Supplement* [July 29, 1994], 15). On Eagleton's article, see the section "Justifying 'Theory.'"

13. Said, *Culture and Imperialism* (1993; New York: Vintage / Random House, 1994), 57.

14. Ibid., 12.

15. Ibid., 69–70.

16. Said's explanation is as follows: "[Frantz] Fanon understands that conventional narrative is, as we noted in Conrad's work, central to imperialism's appropriative and dominative attributes. Narrative itself is the representation of power, and its teleology is associated with the global role of the West" (ibid., 273).

17. Ibid., 9.

18. On John Brown, the American abolitionist hanged in 1859 for having forcefully taken over the United States arsenal at Harpers Ferry as part of a plan to liberate Southern slaves, Hugo wrote: "For us, who prefer the martyr to the successful, John Brown is greater than Washington, Pisacane is greater than Garibaldi" (*Les Misérables*, III, 296: "John Brown est plus grand que Washington, et Pisacane est plus grand que Garibaldi."). For Hugo, John Brown was one of those "glorious combatants for the future, the confessors of utopia," utopia understood not as an idle dream but rather as a vision of a just world that humankind had to work hard to achieve (ibid.: "les glorieux combattants de l'avenir, les confesseurs de l'utopie"). Hugo had been among those eminent people who had protested unsuccessfully against Brown's death sentence (ibid., 590 n. 1).

19. Leo Tolstoy, "A Letter to a Hindu" (1908), in *I Cannot Be Silent: Writings on Politics, Art and Religion* (Bristol: The Bristol Press, 1989), 213. This letter continues the line of reasoning that Tolstoy had developed in "What Then Must We Do?" (1886): "What is the cause of the fact that some people who have land and capital are able to enslave those who have no land or capital?" (88).

20. Said, *Culture and Imperialism*, 9.

21. Honoré de Balzac, *Eugénie Grandet*, ed. P. -G. Castex (Paris: Garnier Frères, 1965), 231: "Pendant que ces choses se passaient à Saumur, Charles faisait fortune aux Indes. (. . .) Le baptême de la Ligne lui fit perdre beaucoup de préjugés; il s'aperçut que le meilleur moyen d'arriver à la fortune était, dans les régions intertropicales, aussi bien qu'en Europe, d'acheter et de vendre des hommes. Il vint donc sur les côtes d'Afrique et fit la traite des nègres. . . ." (I have used the English translation by May Tomlinson [Philadelphia: George Barrie and Sons, 1897], 257–8, to assist me in my own translation of this text, as well as of the subsequent passage from Balzac.)

22. Ibid., 232: "Au contact perpétuel des intérêts, son coeur se refroidit, se contracta, se

dessécha. Le sang des Grandet ne faillit point à sa destinée. Charles devint dur, âpre à la
curée. Il vendit des Chinois, des Nègres. . . ." It is instructive for today's detractors of
fixed or absolute values to reflect on how Charles justified his actions: "In the process of
crossing various countries and encountering their peoples, of observing conflicting
customs, his ideas changed and he became a sceptic. He no longer had fixed ideas about
what is just and unjust, seeing what is called a crime in one country called a virtue in
another" (ibid.) In *Crime and Punishment* (tr. Sidney Monas; New York: Signet / Penguin,
1980), 51, Dostoyevsky, who is not mentioned in Said's book, uses the situation of the
Black slave, about which he is critical, as a point of comparison for Raskolnikov's reflec-
tions about his sister's plans to marry an older man, virtually a stranger, to provide the
destitute family with financial security: "Nevertheless, I know that my sister would sooner
work like a Negro slave on a plantation or like a Lett peasant for a Baltic German
landowner than debase her soul and her moral sense by marrying a man she does not
respect and with whom she has nothing in common, and for life, just for her personal gain!
And even if Mr. Luzhin were all of purest gold or solid diamond, even then she would not
agree to become the legal concubine of Mr. Luzhin!" In this comparison the Black slave
retains a degree of dignity that Dunia the sister would lose because the servitude of the
former was not voluntary.

23. The success or failure of Said's indictment of European culture depends primarily on the
accuracy of his case studies offered in evidence to support his thesis. One important
section in *Culture and Imperialism* not discussed below is Said's analysis of Verdi's opera *Aida*
(111–32). For a detailed consideration of this item, see John M. MacKenzie, "Edward Said
and the Historians," *Nineteenth-Century Contexts*, special issue "Colonialisms," vol. 18 no. 1
(1994), 16–18. MacKenzie opens and closes his assessment as follows: "Such a single-
minded contrapuntalism leads Said into wilful misunderstandings. (. . .) Said's analysis
[of *Aida*] is plucked from the air. (. . .) *Aida* is just about as anti-imperialist an opera as
you can get, and Said's interpretation of it, so little grounded in real substance, is little
short of grotesque." (See also MacKenzie's sequel in this journal, vol. 19 no. 1 [1995], 96.)

Ironically, whereas in *Culture and Imperialism*, 150, Said had expressed respect for Mac-
Kenzie's scholarship where he praised his "valuable book *Propaganda and Empire*," Mac-
Kenzie has written his article to explain "why it is that historians, including this particular
historian of cultural imperialism, some of whose political sympathies are close to those of
Said, are unlikely to secure much mental sustenance from *Culture and Imperialism*" (10).
The "procedures of Edward Said and of his followers," concludes MacKenzie, "and the
colonial discourse analysts (some of whose work he does not necessarily find sympathetic)
are at odds with fundamental tenets of historical procedures" (20). MacKenzie devotes
most of his article to explaining such shortcomings.

Said's analysis of Kipling's *Kim* also figures prominently in his book. Although not
directly addressed to Said's text, the chapter entitled "Rudyard Kipling: The Myth-Maker
of Empire?" in *Images of the Raj: South Asia in the Literature of Empire* (London: Macmillan,
1988), 78–111, by D. C. R. A. Goonetilleke, Professor of English, University of Kel-
aniya, Sri Lanka, offers an effective alternative view. I mention Goonetilleke's affiliation
because he feels that his experience as an Asian offers him a particular perspective: "My
own basis in Asian conditions helps me to respond to literature set in such condi-

tions . . . differently from a Western critic" (3, see also 42 where this sentiment is reiterated).

In *Kim*, Said sees primarily an "imperialist vision" (*Culture and Imperialism*, 159) written "from the dominating viewpoint of a white man in a colonial possession" (134), an "acceptance by everyone (even the lama) of the doctrine of racial separation" (155) along with the expression of "the inferiority of non-white races" (151) and the assurance that "a Sahib is a Sahib, and no amount of friendship or camaraderie can change the rudiments of racial difference" (135). For Said, Kim "is an irrefragable part of British India" (145), his role being that of "an essential player in the British Secret Service Great Game" (141) whose purpose is to sustain British imperialistic rule over India.

In contrast, Goonetilleke argues that in "articulating his central theme, Kipling shows himself capable of transcending his political and racial phobias and he is genuinely humane and warm-hearted, appreciating a person not for his status, caste, race or religion but for his intrinsic human worth . . ." (*Images of the Raj*, 47). Goonetilleke also discusses the Great Game and concludes, "Thus, Kipling, through the Lama, implies a criticism of the British Secret Service. But the Lama is not the only touchstone and other means contribute to the critical dimension" (48). On the question of race, "Even Indians like Mahbub Ali for example, endorse conventional white opinion, 'Once a Sahib always a Sahib,' but it is simply not true of Kim" (48). Rather, "in the relation between Kim and the Lama, it is only human considerations that count, no differences being felt except for that of age . . ." (45). As for Kim's relationship to the Great Game, "while most critics surmise that Kim returns to the British Secret Service, I think Kipling's suggestion is that Kim follows the Lama . . ." (55).

Finally, where Said argues that Kipling only saw an "absolute unchanging essence" (*Culture and Imperialism*, 151) in the Indians, sustained by "stereotypical views – some would call them racialist – on the Oriental character" (135), Goonetilleke emphasizes that "Kipling shows an amazing understanding of the variety of Indian life, both the landscape and the communities . . ." (*Images of the Raj*, 51). "Kipling," explains Goonetilleke, "takes into account the poverty and squalor in India too, but the predominant impression I receive from his rendering of India is of the vitality, warmth and generosity of the Indian people. . . . Kipling's basic respect for, and appreciation of, Indians and things Indian are extraordinary" (52).

24. See Edward W. Said, "Jane Austen and Empire," in Terry Eagleton, ed., *Raymond Williams: Critical Perspectives* (Boston: Northeastern University Press, 1989), 150–64.

25. Said, *Culture and Imperialism*, 59.

26. Ibid., 84.

27. On this issue, see Margaret Kirkham, *Jane Austen, Feminism and Fiction* (Brighton, Sussex: Harvester Press; Totowa, N.J.: Barnes and Noble, 1983), 132; Mary Deforest, "Mrs. Elton and the Slave Trade," *Persuasions* [Victoria, B. C.: Jane Austen Society of North America] no. 9 (December 18, 1987), 11–13; Claudia L. Johnson, *Jane Austen: Women, Politics and the Novel* (Chicago: University of Chicago Press, 1988), 107–8.

28. Can Said be so sure that the references to empire in *Mansfield Park* have the meaning that he suggests? In a recent article on this subject, Brian Southam, Chairman of the Jane Austen Society, questions Said's interpretation. Citing a little known connection with an Anti-

guan plantation in Austen's own family history, as well as offering a new timetable for the events of the novel, both of which support a reading of the book within its historical context, Southam concludes:

> Where does Jane Austen stand in this? With Sir Thomas, as Said believes? Or with her heroine? Readers of the novel will decide for themselves. But the logic of history, biography and the text itself places Austen beside Fanny Price. *Mansfield Park*'s "power to offend" is not, as Said would have us believe, to render Fanny Price (and her creator) friends of the plantocracy. At this notable moment [during the discussion of the slave trade], in the lion's den, Fanny is unmistakably a "friend of the abolition," and Austen's readers in 1814 would have applauded the heroine and her author for exactly that. (Brian Southam, "The Silence of the Bertrams: Slavery and the Chronology of *Mansfield Park*," *Times Literary Supplement* [February 17, 1995], 13–14. All further references to Southam in this note pertain to this article.)

More can be said to assist readers in deciding, for an entire body of scholarship related to Austen's novels and to the slave trade can be marshalled in favor of Southam's conclusion.

Austen introduces Sir Thomas Bertram's plantation in Antigua not to support "the rationale for imperialist expansion" (Said, *Culture and Imperialism*, 84) but rather to characterize the social status and values of the family into which the heroine Fanny is introduced, just the way Austen marks the status and character of the family that she leaves. This characterization of Sir Thomas's financial situation is also a critique. As Avrom Fleishman astutely observed nearly three decades ago, "*Mansfield Park* has been generally assumed to be a defense, even a celebration, of the gentry's way of life, but after examining Fanny's opposition to that way of life we can no longer believe that Mansfield represents the good society." (Avrom Fleishman, *A Reading of "Mansfield Park": An Essay in Critical Synthesis*, Minnesota Monographs in the Humanities, vol. 2 [Minneapolis: University of Minnesota Press, 1967], 34.)

Thus, Said's assertion that Austen's repeated references to Antigua are "uninflected, unreflective" (93) is untenable. As Fleishman perceptively points out, references to Antigua are rather pointed. On the one hand, the dependence on the colonial landholdings suggests a criticism of Sir Thomas and his "entire socioeconomic class" for a lack of self-sufficiency (36). As for the immorality of slavery, see my discussion later in this note and consider as well Fleishman's observations on p. 38 about the possible significance of the remarks by Tom Bertram, who is Sir Thomas's eldest son, upon his return from Antigua, made to the clergyman, Dr. Grant: "A strange business this in America, Dr. Grant! – What is your opinion? – I always come to you to know what I am to think of public matters." Given Tom's limited moral perspicacity, this is the most that one would expect from him. Even the passage cited by Said about asking William to bring back two shawls if he travels in the other geographic direction to the East Indies is not neutral, for it further reflects the shallow, narcissistic egotism of Lady Bertram, thereby demonstrating her inability to see in colonialism anything other than an opportunity to provide her with consumer goods.

Fleishman has not been alone in noting the faulty moral world that Mansfield Park represents. In *A Reading of Jane Austen* (New York: New York University Press, 1979), 154–6, Barbara Hardy argued that "Mansfield Park . . . resembles its owner. (. . .) As

a home, Mansfield is imperfect. (. . .) For Mansfield Park lacks a heart and a centre."
More explicitly, Claudia L. Johnson, in *Jane Austen: Women, Politics and the Novel*, 96, ex-
plained that in *Mansfield Park*, Austen "exposes not only the hollowness but also the
unwholesomeness of [the] moral pretensions" of "the parameters of conservative myth-
ology about the august gentry family." Among the instances that Johnson cites as belong-
ing to Austen's "tendency . . . to sully [Sir Thomas's] probity with deadpan insouciance"
is the fact that "the family fortunes [Sir Thomas] rescues depend on slave labor in the West
Indies." Similarly, in *Domestic Realities and Imperial Fictions: Jane Austen's Novels in Eighteenth-
Century Contexts* (Athens, Ga.: University of Georgia Press, 1993), 113, Maaja A. Stewart
noted that Austen's contemporaries associated colonial absenteeism with "economic and
moral failures," while remarking specifically that Sir Thomas's absentee ownership of his
West Indian plantation "evoke[s] troublesome questions about [his] power and morality."
See also the critique discussed later offered by Mary Evans in *Jane Austen and the State*
(London and New York: Tavistock, 1987), 26–8, as well as by Southam.

Fleishman observes that Sir Thomas shows moral growth upon his return from his visit
to his Antigua plantation, for which Fleishman offers the following plausible explanation:

> He goes to Antigua as a planter, presumably opposed to [the] abolition [of the slave trade]; he
> occupies himself, for economic reasons, with improving the slaves' condition; he acquires
> some of the humanitarian or religious message of the Evangelical and other missionaries
> laboring in the same vineyard; and he returns critical of his own moral realm, with a warmer
> feeling for his young dependent [Fanny], a sterner rejection of aristocratic entertainment
> (especially that with a marked revolutionary content), and a strong defense of his son's [i.e.,
> Edmund's] dedication to resident [as opposed to absentee] pastoral duty (Fleishman, *A
> Reading of "Mansfield Park,"* 39.)

Fleishman's speculation about Sir Thomas's actions during his visit to Antigua and about
his moral growth are accepted by Warren Roberts in *Jane Austen and the French Revolution*
(New York: St. Martin's Press, 1979), 140–1. As Johnson explains in her chapter on
Mansfield Park in *Jane Austen: Women, Politics and the Novel*, 94–120, the moral improvement
that Sir Thomas has undergone is neither complete nor totally permanent. (This chapter
provides a subtle, eloquent, and persuasive account of Austen's undertaking in this novel
"to turn conservative myth sour.")

This, then, is the context for the "dead silence" in the family conversation after Fanny
asks Sir Thomas about the slave trade. For Said, this silence "suggest[s] that one world
could not be connected with the other since there simply is no common language for both.
(. . .) In time [i.e., long after Austen's day] there would no longer be a dead silence when
slavery was spoken of, and the subject became central to a new understanding of what
Europe was" (Said, *Culture and Imperialism*, 96).

Reading Said's account, it would seem that the "dead silence" had come from Sir
Thomas. Yet, as the dialogue in the novel makes clear, Sir Thomas had answered the
question, thereby leaving his son Edmund hoping that Fanny would continue with still
another question: "It would have pleased your uncle to be inquired of farther." The silence,
then, came not from Sir Thomas, but rather from the female cousins, for Fanny answers
Edmund as follows: "And I longed to do it – but there was such a dead silence! And while
my cousins were sitting by without speaking a word, or seeming at all interested in the

subject, I did not like – I thought it would appear as if I wanted to set myself off at their expense, by shewing a curiosity and pleasure in his information which he must wish his own daughters to feel" (Jane Austen, *Mansfield Park*, ed. Tony Tanner [1816 2nd ed.; Harmondsworth: Penguin, 1966], 213). As is apparent from this exchange, one of the main points of this scene concerns Fanny's shyness and insecurity. Why then did Austen even introduce the subject of slavery? As Said himself admits, "everything we know about Austen and her values is at odds with the cruelty of slavery" (Said, *Culture and Imperialism*, 96).

Said offers his own interpretation of this scene without explaining either the general or specific social climate in which this conversation is situated. When *Mansfield Park* appeared, even the most casual reader would have known that this discussion took place within the climate of efforts to abolish the slave trade. Careful readers, who followed the chronology established within the novel, would have noted that this conversation actually occurs in the aftermath of the passage of the Abolition Act that "utterly abolished, prohibited and declared to be unlawful" all trading in African slaves. (As quoted in Sir Alan Burns, *History of the British West Indies* [London: George Allen and Unwin, 1954, 1965 2nd rev. ed.], 589.)

In *A Reading of "Mansfield Park,"* 91–2, Fleishman establishes a chronology based upon the composition of the novel as having occurred in 1811. According to this chronology, Sir Thomas and his elder son Tom had sailed for Antigua in 1805, with the latter returning in September, 1806, and the former before November, 1807. On March 25, 1807, about a half year before Sir Thomas's return, the King signed the newly passed Abolition Act. More recently, Southam has proposed an alternative chronology on the basis of Austen having placed in the novel George Crabbe's *Tales in Verse*, published in September, 1812. Thus, according to Southam, Sir Thomas and his son would have left for Antigua toward October, 1810, to return toward late October, 1812, and September, 1811, respectively. Whereas Fleishman stresses the passage in 1807 of the Abolition Act during Sir Thomas's voyage, Southam stresses the passage in 1811 of the subsequent Slave Trade Felony Act to render the earlier law more effective. Southam's alternative dating does not vitiate the force of Fleishman's argument. Either date is pregnant with meaning for the novel in general and for the discussion about slavery in particular.

Commenting on the importance of both the economic crisis in Antigua to the fortunes of absentee landholders such as Sir Thomas and of the passage of the Abolition Act, Fleishman correctly observes: "The novel makes little explicit reference to the economic situation of Antigua – although it was written in the wake of the Abolition Act – yet these important colonial associations would have been in the mind of any reasonably well-informed reader of the times" (7). As for the subtle ways in which Austen raises important social issues, Fleishman observes, "It seems to have been Jane Austen's assumption that the novel, to reverse Ortega [y Gasset's] formula, may be sociological, but must contain no sociology: it may trace the impact of historical reality on fictional subjects, or make special appeals to the contemporary imagination, but it must not import data into the text itself. As a result of this rigorous artistic control of her materials, Jane Austen has become the novelist we lean on most heavily to tell us what it was like to be alive in England at the beginning of the nineteenth century, yet in whose works we can discover no documenta-

tion of the period" (ibid.). In an endnote to *Culture and Imperialism* (342 n. 39), Said refers his readers to the pages in Roberts, *Jane Austen and the French Revolution* (1979), 97–8, where Roberts accepts Fleishman's chronology and where he discusses Sir Thomas and the question of abolition, and to the pages in Fleishman's book in which Fleishman discusses slavery and the Abolition Act.

To Austen's contemporaries, a reference to the slave trade at a moment either when it had just been abolished or when the abolition had been further reinforced by stronger legislation would mean that this law or the subject it addressed was at the heart of the discussion between Sir Thomas and Fanny. As Southam has stressed, at the time of this conversation, "the 'slave trade' was still a burning issue, a persistent and horrifying scandal, debated in Parliament and extensively reported and discussed in the newspapers and periodicals." If Fanny, who is the true innocent in the ways of the world, as well as the voice of reason and morality, poses the question, it would appear that her goodness is being highlighted. If her more worldly cousins react with "dead silence," then it would seem that Austen is indicating either their embarrassment or their indifference about an inquiry that touched the matter of the family's slaves. In either case, this would amount to a criticism of the practice of slavery, while highlighting a victory on the part of the abolitionists in their campaign not only to end the slave trade but also to emancipate the slaves themselves, a goal achieved later in 1833–4. Yet Said does not consider either alternative, just as he neglects to mention Austen's explicit condemnation of the slave trade in *Emma*.

In support of my interpretation, I refer the reader once again to Fleishman's astute remarks, "But the Bertrams [i.e., the female cousins about whom Fanny refers in her conversation with Edmund] are dead to moral experience; it is Fanny alone who is concerned about Sir Thomas's experience of slavery . . ." (39). Similarly, Roberts, in *Jane Austen and the French Revolution*, comments on the significance of Fanny's question about the slave trade by observing, "Not only had Fanny changed physically during the period of Sir Thomas's absence, but also matured, unlike his own daughters, into a person of sound judgment and moral substance" (141). Likewise, Southam concludes, "The gap of 'silence' between [Sir Thomas's] slave-owning 'values' and those of Fanny, the sole questioner of those 'values,' could not be more effectively shown."

Said is certainly correct in maintaining that Sir Thomas's slave plantation in Antigua is an integral pendant to his English estate named Mansfield Park and that life in the latter cannot be understood without reference to that in the former. Yet, his misappropriation of Austen's statement that the subject of this novel was "ordination" to mean that it was "property 'ordained'" within the context of colonial slave holdings turns Austen upon her head to make her represent the opposite of what she believed in her personal life and of the position she sustained in her novels (Said, *Culture and Imperialism*, 84). In her letter of January 29, 1813, to Cassandra Austen, Jane Austen wrote, "Now I will try to write of something else, and it shall be a complete change of subject – ordination" (Jane Austen, *Selected Letters 1796–1817*, ed. R. W. Chapman, intro. by Marilyn Butler [Oxford: Oxford University Press, 1985], 132.) The reference to ordination has generally been understood by Austen scholars to refer to the affirmation of the need to pursue a moral life and has been tied to evangelicalism. In his study of the novel, Fleishman remarks, "If there is an Evangelical strain in *Mansfield Park*, we should expect to find it in some indication of Jane

Austen's awareness of the Evangelicals' campaign against slavery. We know from her letters that she had read a work by Thomas Clarkson, the author of *The [History of the] Abolition of the African Slave Trade* [1808], and one of the few writers on public affairs she mentions" (38). We know that after a visit to Antigua in 1806 Austen's brother Frank had written home "in an evangelical tone" to condemn slavery. (See Austen, *Selected Letters 1796–1817*, ed. Chapman, intro. Butler, xviii). In *Jane Austen and the French Revolution*, Roberts remarks, "Austen's views on slavery seem exactly to have coincided with those of that brother" (98, see also 97). Austen herself was, in her own words, "in love" with the writings of Thomas Clarkson, one of the leading opponents of slavery (Austen, *Selected Letters 1796–1817*, ed. Chapman, 127.) We have seen how explicitly Austen condemned the slave trade in *Emma* and how this followed upon a subtler condemnation in *Mansfield Park*. Yet, the scattered references to Antigua and the slave trade in *Mansfield Park* are not isolated instances. Rather, they belong to a larger moral structure that the very name of Sir Thomas's estate evokes.

As scholars of Austen's work have noted, Sir Thomas's English property carried the name of England's Chief Justice (1756–88), Lord Mansfield, who in 1772 rendered a famous judgment that set free a Negro slave bought in Virginia and taken to England by his master. One does not have to agree with all of the interpretations about the meaning of names in *Mansfield Park* as suggested by Stewart in *Domestic Realities and Imperial Fictions* to recognize that, as Stewart repeatedly emphasizes, Mansfield Park is a house "that bears the authority-saturated name of England's chief justice William, Lord Mansfield" (17, see also 116). As Stewart reminds her readers, Lord Mansfield had pronounced "an important antislavery opinion" in 1772 (116, also 120). In *Jane Austen, Feminism and Fiction*, Kirkham had previously asserted that the "title of *Mansfield Park* is allusive and ironic," the allusion referring "to a legal judgment, generally regarded as having ensured that slavery could not be held in accordance with the manners and customs of the English" (116–17). In a book written from a doctoral dissertation for which Said was one of the two advisors, *Reaches of Empire: The English Novel from Edgeworth to Dickens* (New York: Columbia University Press, 1991), 42, Suvendrini Perera also associates Lord Mansfield's decree with the title of *Mansfield Park*. Finally, on the subject of Austen's use of allusive names, in "Mrs. Elton and the Slave Trade," *Persuasions* No. 9 (December 18, 1987): 11, Mary Deforest points out that in *Emma*, "the family name of Hawkins evokes the slave trade because Sir John Hawkins introduced the slave trade to Britain."

After two years in England, the slave, James Somerset, left his master, refused to return to service, and was abducted and imprisoned on a ship that was to take him away from England when he was rescued through a Writ of Habeas Corpus. (In the following account of the Somerset trial, including the quotations from Cowper and Clarkson, I am dependent principally on F. O. Shyllon, *Black Slaves in Britain* [published for the Institute of Race Relations, London, by Oxford University Press, 1974], especially 22–8, 82–3, 106–10, 121–6, 165–74. Shyllon gives the text of Lord Mansfield's judgment of June 22, 1772, on pp. 108–10.) The conservative Lord Mansfield could easily have decided the case by relying on the prevailing opinion established in 1729 by Yorke and Talbot that the slave remained his master's property. Instead, he side-stepped this ruling and freed the man.

Lord Mansfield's decision to liberate Somerset gave rise to a popular misconception

that he had emancipated all slaves in England. The word was spread through newspapers, speeches, tracts, and even poetry, with William Cowper, "famous for abolitionist sympathies," lending his pen to the cause with the well-known lines from *The Task* (1785):

Slaves cannot breathe in England; if their lungs
Receive our air, that moment they are free:
They touch our country, and their shackles fall.

(The characterization about Cowper is by Claudia L. Johnson, who in *Jane Austen: Women, Politics and the Novel* observes that Austen "appears to favor writers famous for abolitionist sympathies, such as [Samuel] Johnson and Cowper" [107]. For other antislavery poems by Cowper as well as references to Samuel Johnson's denunciations of slavery see 180 n. 19 and Eva Beatrice Dykes, *The Negro in English Romantic Thought, or A Study of Sympathy for the Oppressed* [Washington, D.C.: The Associated Publishers, 1942], 15–18, 37–8, and passim. On Austen and Samuel Johnson, see also Kirkham, *Jane Austen, Feminism and Fiction*, 118. In *Mansfield Park*, Austen has Fanny quote from two of Cowper's poems, including *The Task* [87, 420].)

Clarkson himself, in the book so beloved by Austen, helped to spread this misunderstanding: "The great and glorious result of the trial was, That as soon as ever any slave set foot upon English territory, he became free." Thus, the memory of "Lord Mansfield's celebrated judgment," as this legal decision was later called, was readily associated with the name of Mansfield Park, hovering over the estate as a reminder of the moral transgressions upon which its material prosperity was grounded. (In *Jane Austen, Feminism and Fiction*, Kirkham, writing about Austen's concern about the slave trade, points out that "at the house of her brother Edward Knight, [Jane Austen] met Lord Mansfield's niece on a number of occasions [118].)

Even more, in rendering the court's judgment, Lord Mansfield could have limited himself to freeing Somerset merely on technical grounds by declaring the laws of Virginia inapplicable in England. Yet, he went further to point out the morally "odious" nature of slavery and to reiterate in his opinion the argument by one of Somerset's attorneys that slavery was an affront to natural law. Through this opposition between the morality of natural law, represented by the name (and hence unrealized promise) of Sir Thomas's estate, and its transgression through the legal and economic system represented by the plantation in Antigua, Austen created an unresolved moral paradigm that governed all of the action in the novel. As Mary Evans has astutely observed about what she terms "Austen's most fully ideological novel, in that she sets out in it with almost evangelical clarity her views on the proper organization of society," in *Mansfield Park* Austen is saying "that no community, however rich or prosperous, can prosper or survive without a secure moral basis and that morality is not derived from property, or from the relationships of property" (Mary Evans, *Jane Austen and the State*, 26–7).

With the pairing of two distant names, Antigua and Mansfield, the former in the spatial background and touching the novel only at discrete points, the latter in the temporal background and invoked through the title of the book and the name of Sir Thomas's property, Austen established the paradigm for understanding the interpersonal relationships at Mansfield Park that constitute the bulk of the novel's action. Empire truly is the

silent presence that watches over this story; but it is not the tacit acceptance of empire, as argued by Said. Rather it is the moral critique that the paired names of Antigua and Mansfield establish which holds the key to understanding Austen's intentions.

29. Said, *Culture and Imperialism*, 81–2. Said also invokes Wordsworth's name on pp. 60, 305.

30. Perhaps he had in mind those brief lines that Patrick Brantlinger quotes from these two men in which they speak approvingly of British citizens settling abroad in new colonies. (Patrick Brantlinger, *Rule of Darkness: British Literature and Imperialism, 1830–1914* [Ithaca: Cornell University Press, 1988], 24–5, 118–19.) Imperialism is closely associated with the oppression and exploitation of peoples encountered in foreign lands. Immigration or even colonialism does not in and of itself constitute what Said terms "horrendously unattractive imperialistic practices."

To discuss the propriety of immigration to another region of the world one must ponder two related matters that yield no easy solutions. First, since the earth has been entrusted to humankind to sustain its people in a manner consistent with the welfare of the planet itself – a gift accorded by either divinity or chance – then at what point in time and in what manner does any one parcel of land, whether the size of Mansfield Park or the United States of America belong exclusively to any one person or to particular groups? One does not have to be a Marxist to pose this question. In *Moby-Dick* (1851), Herman Melville touches the heart of the matter when, using the terminology of maritime law, he asks rhetoriaclly, "What are the Duke of Dunder's hereditary towns and hamlets but Fast-Fish?" (Herman Melville, *Moby-Dick*, eds. Harrison Hayford and Hershel Parker [New York: W. W. Norton, 1967], 333). In *L'Interdiction* (1836), Balzac addresses a more limited but nonetheless important aspect of this problem with a text that begins: "If those people who are in possession of confiscated property . . . were obliged to return it after one hundred fifty years, there would be few legitimate property owners in France." ("Si les gens qui possèdent des biens confisqués de quelque manière que ce soit . . . étaient, après cent cinquante ans, obligés à des restitutions, il se trouverait en France peu de propriétés légitimes.") (Honoré de Balzac, *L'Interdiction*, in *Le Colonel Chabert suivi de . . . L'Interdiction* [Paris: Garnier Frères, 1964], 303.)

Second, what are we to make of the fact that since the earliest times, peoples have migrated and settled, either peacefully or through conquest, in territories where others were already living? (For an introduction to competing histories concerning the creation of a nation even in England and France, with arguments about which ethnic groups furnished the core to these countries and about the manner in which they mixed with earlier populations, see Martin Thom, "Tribes Within Nations: The Ancient Germans and the History of Modern France," in Homi K. Bhabha, ed., *Nation and Narration* [London: Routledge, 1990], 23–43.) These are not rhetorical questions but rather thorny, practical issues of great moral import as well, which must be considered when discussing the allocation of the earth's resources.

Neither Said in *Culture and Imperialism* nor Brantlinger in *Rule of Darkness* addresses these concerns. Yet Coleridge did. Rather than simply quote a few lines from Coleridge about emigration and colonization, leaving them to stand naked as a badge of shame, Brantlinger might have attempted to place Coleridge's words in the context of his other thoughts on the matter as would Carl Woodring, who shows that Coleridge, while believing in the propriety and necessity of the colonial enterprise, was also concerned with treating native

peoples morally and with dignity. (*The Collected Works of Samuel Taylor Coleridge [vol. 14]. Table Talk, I, Recorded by Henry Nelson Coleridge (And John Taylor Coleridge)*, Bollingen Series LXXV [London: Routledge; Princeton: Princeton University Press, 1990], ed. Carl Woodring, 370 n. 2.) To raise these issues is not to justify either colonialism or imperialism. Whatever one thinks today about the morality of establishing colonies, certainly the full range of thought found in these earlier cultural leaders should be presented. Yet the spirit of the times militates against such evenhandedness. Ours is a sceptical and even cynical age, whose historians, when imbued with the postmodern or poststructuralist ethos, are "averse to heroes and hero-worship." I borrow this characterization from Roy Porter who in "A Seven-bob Surgeon: 'Pope' Huxley and the New Priesthood of Science," *Times Literary Supplement* (November 18, 1994), 3, writes of "the *enfants terribles* among today's historians of science. For they are biographers not of the Smilesian but of the Stracheyan stamp, averse to heroes and hero-worship – indeed, sceptical of anything smacking of the glorification of science." This is the broad cultural context in which Gertrude Himmelfarb's "Of Heroes, Villains, and Valets" (ch. 2 of *On Looking into the Abyss*) should be read. For more on the themes discussed in this note, see n. 38 and n. 39, as well as the Postscript, n. 3.

31. Brantlinger, *Rule of Darkness*, 175: "From the 1790s to the 1840s, the most influential kind of writing about Africa was the abolitionist propaganda. (. . .) To Blake's poem ['Little Black Boy'] can be added Coleridge's 'Greek Prize Ode on the Slave Trade,' Wordsworth's 'Sonnet to Thomas Clarkson,' and stanzas and poems by Byron and Shelley."

32. William Wordsworth, "To Thomas Clarkson, on the Final Passing of the Bill for the Abolition of the Slave Trade. March, 1807," in *Poems, Volume I*, ed. John O. Hayden (London: Penguin, 1977), 736.

33. See also, Dykes, *The Negro in English Romantic Thought, or A Study of Sympathy for the Oppressed*, 69–74. Dykes further reports, "Wordsworth and his sister Dorothy were on intimate terms with the Clarksons. . . . The correspondence of Wordsworth and his sister Dorothy reveals that from 1791 to 1849 they kept in close touch with the progress of the slavery question" (71). As a measure of the balanced scholarship that characterizes this book, it should be noted that Dykes was not deterred from reporting on the "increasing conservatism [that] appeared in [Wordsworth's] attitude toward slavery" as he "neared the end of his life" (73–4). The same is true of her treatment of Coleridge (75–80): "Later Coleridge became more and more conservative in his attitude. On June 8, 1833, we find him saying . . ." (79).

34. Wylie Sypher, *Guinea's Captive Kings: British Anti-Slavery Literature of the XVIIIth Century* (New York: Octagon, 1969), 217. I take the translation from Dykes, *The Negro in English Romantic Thought*, 217. For details about the Brown Gold Medal, see Richard Holmes, *Coleridge: Early Visions* (New York: Penguin / Viking, 1990), 43.

35. The quotation about Coleridge's bravery at Bristol is from Holmes, *Coleridge: Early Visions*, 97. This was not simply a question of risking social ostracism. In *Guinea's Captive Kings*, Sypher reports that William Roscoe, "a tireless campaigner [against the slave trade], . . . as M.P. for Liverpool in 1807 spoke so hotly against the trade that the seamen of that city attacked him with bludgeons during a procession in his honor" (181).

Writing to Clarkson on March 3, 1808, Coleridge reviewed the history of his antislavery activity: "[M]y first public Effort was a Greek Ode against the Slave Trade, for which I

had a Gold Medal, & which I spoke publickly in the Senate House [of Cambridge University], and tho' at Bristol I gave an especial Lecture against the falling off of zeal in the friends of the Abolition, combating the various arguments, exposing the true causes, and re-awakening the fervor & the horror, and published a long Essay in the Watchman on the Trade in general, in confutation of all the arguments, *all* of which I there stated, besides a Poem, & several Parts of Poems. (. . .) I may add, that I preached a Sermon of an hour's length & a few minutes against the Trade at Taunton." *Collected Letters of Samuel Taylor Coleridge*, ed. Earl Leslie Griggs, (Oxford: Oxford University Press, 1959), III, no. 684, and reproduced in excerpt in *The Collected Works of Samuel Taylor Coleridge [vol. 1]. Lectures 1795 on Politics and Religion*, Bollingen Series LXXV, eds. Lewis Patton and Peter Mann (London: Routledge and Kegan Paul; Princeton: Princeton University Press, 1971), 232, as part of the background to Coleridge's "Lecture on the Slave-Trade," delivered June 16, 1795, at the Assembly Coffee-house on the Quay in Bristol. For the text of Coleridge's speech of 1795, see 235–51. For Coleridge's essay in *The Watchman* (March 25, 1796), see "On the Slave Trade," in *The Collected Works of Samuel Taylor Coleridge [vol. 2]. The Watchman*, Bollingen Series LXXV, ed. Lewis Patton (London: Routledge and Kegan Paul; Princeton: Princeton University Press, 1970), 130–40.

In his letter of March 3, 1808, just quoted in part, Coleridge speaks modestly of his antislavery efforts in comparison with those of Robert Southey's: "yet I consider my own claim, which is feeble in itself as an *Author*, as evanescent when compared with Robert Southey's, whose twelve Sonnets on the Slave Trade were not only among his best, but likewise among his most popular productions." See also the draft of Coleridge's letter of [June, 1833(?)] to Thomas Pringle, Secretary of the Anti-Slavery Society which he writes as "an ardent & almost life-long Denouncer of Slavery" and in which he asserts that the Negro slaves in the West Indies are "the Image of God, in which God *created* men" (in *Collected Letters*, ed. Griggs, VI, no. 1770). For a further sampling of Coleridge's outrage about slavery as expressed in poems and letters, see Dykes, *The Negro in English Romantic Thought*, 75–9.

36. Lowell J. Ragatz, *The Fall of the Planter Class in the British Caribbean, 1763–1833* (1928; New York: Octagon, 1963), 251. Said, though, used Ragatz's book only to serve his particular thesis (see *Culture and Imperialism*, 94–5).

37. J. R. Oldfield, *Popular Politics and British Anti-slavery: The Mobilisation of Public Opinion Against the Slave Trade, 1787–1807* (Manchester: Manchester University Press, 1995), 114: "Any estimate of this kind is necessarily tentative, but 400,000 petitioners would represent about thirteen per cent of the adult male population of England, Scotland, and Wales in 1791 (assuming, of course, that most petitioners were males over the age of fifteen). (. . .) It is not inconceivable, therefore, that in some parts of the country between a quarter and a third of the adult male population petitioned Parliament."

38. See Sypher, *Guinea's Captive Kings* and then Dykes, *The Negro in English Romantic Thought*. In "Literary Sources and the Revolution in British Attitudes to Slavery," in Christine Bolt and Seymour Drescher, eds., *Anti-Slavery, Religion, and Reform: Essays in Memory of Roger Anstey* (Folkestone, Kent: Wm. Dawson and Sons; Hamden, Conn.: Archon, 1980), 320–1, C. Duncan Rice unfairly judges these two books as flawed for a variety of reasons including their alleged failure to "[isolate] propaganda from references representing assumptions held com-

monly by the writer and his public." Sypher, in particular, distinguished between sincere feeling and stock phrases, commenting from the outset that the "novels and more especially the poems extolling the Negro are a singular illustration of that extreme pseudo-classicism whereby what is observed is cast into a highly artificial 'literary' form" (5). Moreover, both books contain what appear as heartfelt expressions of outrage at the injustice and moral depravity of slavery.

39. I say "little" rather than "none" because although no mention of this material is made in the section on Austen, Coleridge, and Wordsworth (80–97), Said does briefly allude to opposition to slavery by intellectuals of that period 143 pages later with two sentences:

> As the major studies of Gordon K. Lewis (*Slavery, Imperialism, and Freedom*) and Robert Blackburn (*The Overthrow of Colonial Slavery, 1776–1848*) show, an extraordinary amalgam of metropolitan individuals and movements – millenarians, revivalists, do-gooders, political radicals, cynical planters, and canny politicians – contributed to the decline and end of the slave trade by the 1840s. (. . .) Most French Enlightenment thinkers, among them Diderot and Montesquieu, subscribed to the Abbé Raynal's opposition to slavery and colonialism; similar views were expressed by Johnson, Cowper, and Burke, as well as by Voltaire, Rousseau, and Bernardin de St. Pierre (240).

Said attempts to undercut this opposition to slavery by making what he calls a "distinction between anti-colonialism and anti-imperialism" (240) and by arguing, "Liberal anti-colonialists, in other words, take the humane position that colonies and slaves ought not too severely to be ruled or held, but – in the case of Enlightenment philosophers – do not dispute the fundamental superiority of Western man or, in some cases, of the white race" (241). Here Said suggests a unanimity of feeling that did not exist. As Wylie Sypher has shown, Enlightenment thinkers debated this question from a variety of points of view, many of which were framed by contemporary theories about the influence of climate on human abilities. "Professor Johann Friedrich Blumenbach," explains Sypher, "author of the monumental *De generis humani varietate nativa* (1775), writes in 1799 some 'Observations on the Bodily Conformation and Mental Capacity of the Negroes,' in which he asserts that the African is *not* inferior to the rest of the human race" (52, Sypher's emphasis). See also Oldfield, *Popular Politics*, 52, who reports on American sources dating from the 1780s which attempted to convince contemporaries that Blacks had innate intellectual and artistic abilities of high capacity.

In Said's earlier discussion of Austen, Coleridge, and Wordsworth, his brief mention of antislavery sentiment was offered in the most qualified manner so as to stress selfish political motives and hence underplay humanitarian impulses: "Earlier in the century, the upright abolitionist posture of Wilberforce and his allies developed partly out of a desire to make life harder for French hegemony in the Antilles" (84). Said develops this theme further on p. 256. Yet Said does not mention that Wilberforce's "moral equivocation" had been noted and criticized during his lifetime by William Hazlitt in *The Spirit of the Age* (1825). For Hazlitt's opposition to slavery, as well as his characterization of Wilberforce, see Dykes, *The Negro in English Romantic Thought*, 93–6.

40. Said, *Culture and Imperialism*, 91.

41. This included the publication of poems that chastised the public for its unthinking or unfeeling use of sugar and rum derived from slave labor. For sources, see the next note.

42. Sypher, *Guinea's Captive Kings*, 19–20. Also see p. 215: "Wedgwood . . . also distributed two thousand copies of Fox's pamphlet on abstaining from West-Indian sugar and rum." In *Popular Politics*, 57, Oldfield reports, "Fox's pamphlet [with approximately 70,000 copies distributed], and a host of pirated versions, inspired a nationwide boycott of West Indian sugar which at its peak involved some 300,000 families." (See also Dykes, *The Negro in English Romantic Thought*, 8, 16, 67, 72, 81, 93, 99, 122.) Coleridge included his appeal to boycott West Indian sugar and rum in his condemnation of the "false and bastard sensibility" that weeps over the sorrows of literary figures while ignoring the real suffering of real human beings: "The merchant finds no argument against it [i.e., the slave trade] in his ledger: the citizen at the crouded feast is not nauseated by the stench and filth of the slave-vessel – the fine lady's nerves are not shattered by the shrieks! She sips a beverage sweetened with human blood, even while she is weeping over the refined sorrows of [Goethe's] Werter or of [Richardson's] Clementina." ("On the Slave Trade," *The Watchman* [March 25, 1796], now in *Collected Works [vol. 2]. The Watchman*, 139.

43. [Samuel Taylor Coleridge], review article of Thomas Clarkson, *The History of the Abolition of the Slave Trade* (London: 1808), *Edinburgh Review* 12 (July 1808): 355–79. Coleridge's authorship is established through a number of letters discussed in Dykes, *The Negro in English Romantic Thought*, 78, and is accepted in Sypher, *Guinea's Captive Kings*, 215, as well as in the "Chronological Table" in *The Collected Works of Samuel Taylor Coleridge [vol. 3]. Essays on His Time in "The Morning Post" and "The Courier", 1*, Bollingen Series LXXV, ed. David V. Erdman (London: Routledge and Kegan Paul; Princeton: Princeton University Press, 1978), l. Clarkson's book was the latest in a series of his publications on the subject, which had begun with *An Essay on the Slavery and Commerce of the Human Species* (1786), itself "a revision of his Latin prize essay at Cambridge" (editors' note in *The Collected Works of Samuel Taylor Coleridge [vol. 1]. Lectures 1795 on Politics and Religion*, 232).

 Clarkson read his prize essay in the Senate House of Cambridge University. The subject of a 1785 Latin prize competition for senior bachelors – "Anne liceat invitos in servitutem dare" (Is it lawful to make slaves of others against their will?) – had been framed by Peter Peckard, Vice-Chancellor. "Dr. Peckard," explains Ellen Gibson Wilson, "was known as an advocate of civil and religious liberty. In a university sermon at St. Mary's Church he denounced the activities of the British 'Man-Merchants'. . . ." (See Ellen Gibson Wilson, *Thomas Clarkson: A Biography* [New York: St. Martin's Press, 1990, 9 (her translation of the Latin), 11]; Earl Leslie Griggs, *Thomas Clarkson: The Friend of Slaves* [Ann Arbor: University of Michigan Press, 1938], 24–5). For other references to the role played by Cambridge University or its members in opposing the slave trade, see Sypher, *Guinea's Captive Kings*, 16, 18, 63.

44. [Coleridge], review article of Thomas Clarkson, *The History of the Abolition of the Slave Trade*, in *Edinburgh Review* 12 (July 1808): 355, 357.

45. Said, *Culture and Imperialism*, xvii–xxii, 31–43, 59, 80–1, 66–7, 125–7, and passim for this and related issues.

46. Ibid., 201, 203–5.

47. E. M. Forster, *A Passage to India* (New York: Harcourt, Brace and World, 1924; 1952 reprint), 46, 50, 145–6, 319.

48. Ibid., 26. See also 173 ("Fear is everywhere; the British Raj rests on it; . . ."), 260 ("British officialdom remained, as all-pervading and as unpleasant as the sun; . . .").

49. Ibid., 33.

50. Ibid., 112 ("'Chuck'em out'"), 160 ("'You will never kick us out, you know, until you cease employing M. L.'s and such'").

51. Ibid., 62. This outlook is repeatedly seconded throughout the novel. Mrs. Moore, for example, explains to her son the City Magistrate that the British must treat Indians decently, "'Because India is part of the earth. And God has put us on the earth in order to be pleasant to each other. God . . . is . . . love.' She hesitated, seeing how much he disliked the argument, but something made her go on. 'God has put us on earth to love our neighbors and to show it, and He is omnipresent, even in India, to see how we are succeeding'" (51, Forster's ellipsis). See also 116–17, 146.

52. Ibid., 54.

53. Ibid., 322. We must not forget that there were and still are alternative forms of political association. In "Nationalism and the Two Forms of Cohesion in Complex Societies," *Culture, Identity, and Politics* (Cambridge, Cambridge University Press, 1987), 6, Ernest Gellner reminds us about Ernest Renan's distinction between "*national* states – France, Germany, England, Italy, Spain" and that "conspicuously un-national political unit of his time, Ottoman Turkey." Renan had argued and Gellner agrees that national states have one "crucial trait": the "anonymity of membership." Hence, a "nation is a large collection of men such that its members identify with the collectivity without being acquainted with its other members, and without identifying in any important way with sub-groups of that collectivity." In contrast, in the Ottoman empire of Renan's time "the Turk, the Slav, the Greek, the Armenian, the Arab, the Syrian, the Kurd, are as distinct today as they had been on the first day of the conquest." Whatever assimilation of earlier Anatolian populations had occurred "in the early days of conquest," adds Gellner, this stopped "when the Ottoman empire was well established, a centrally regulated system of national and religious communities exclud[ing] any possibility of a trend towards an ethnic melting-pot. It was not so much that the ethnic or religious groups of the Ottoman empire had failed to forget. They were positively instructed to remember." Gellner than quotes a long passage from Bernard Lewis, *The Emergence of Modern Turkey* (1968 2nd ed.) on this subject.

As the quotation from *A Passage to India* that conveys Fielding's outlook about the world suggests, the character of Fielding incarnates to a great degree the cosmopolitan whom Ernest Gellner sketches in "*Zeno of Cracow* or *Revolution at Nem* or *The Polish Revenge*, A Drama in Three Acts," *Culture, Identity, and Politics*, 50:

> A man might also simply repudiate the worship of history, of states, of nations. (. . .) [He] could turn to internationalism, cosmopolitanism, seek to identify with humanity and not some segment of it, and endeavour to detach government and the maintenance of order from any links with special national interests and culture. It is obvious that, at the political level, [Bronislaw] Malinowski was attracted by this option.

Gellner argues that beginning in the 1920s Malinowski articulated another option (51), which, in the words of Andrzej Flis, "'contrasts . . . the culture of a national community with the aggression and destruction rooted in the state organization'" (58). Gellner

explains that Malinowski became "a cultural nationalist and a political internationalist. His holism vindicated the importance of culture, whilst his positivism firmly countermanded the nationalist political imperative, allegedly issued by History" (72). It is possible that Fielding too shared in this dual Malinowskian outlook. The important point here, though, is that world views with alternatives to an enthusiasm either for the nation state or for imperialism were available in the period in which Forster wrote *A Passage to India*. Fielding's questioning of political nationalism cannot simply be equated with an imperialist stance.

54. In many respects, Said's reading of this final exchange between Dr. Aziz and Fielding repeats an earlier misunderstanding that had occurred in the novel when Dr. Aziz asks whether Miss Quested is a "Post Impressionist," with Fielding responding, "Post Impressionism, indeed!" The narrator then explains, "Aziz was offended. The remark suggested that he, an obscure Indian, had no right to have heard of Post Impressionism – a privilege reserved for the Ruling Race, that." Yet Dr. Aziz had misunderstood Fielding: "Fielding, for instance, had not meant that Indians are obscure, but that Post Impressionism is; a gulf divided his remark from Mrs. Turton's [supercilious and condescending observation,] 'Why, they speak English,' but to Aziz the two sounded alike" (66–7). In a similar vein, Fielding was not saying that India was not ready for nationhood and that it should be ruled by the British. Rather he was mocking the contemporary faith placed in the nation state as a solution to social problems and as an object of secular worship.

55. The gradually emerging of sense of common purpose and communal identity as Indians rather than primarily as members of different religious and ethnic groups is progressively developed throughout the novel. In addition to the passage about the weaving of a new social fabric quoted earlier, see also 214, 266–9, 293 ("I am an Indian at last"), and climaxing in the last two pages of the book, 321–2, where Dr. Aziz responds to remarks by Fielding by ordering the British out: "Clear out, all you Turtons and Burtons. (. . .) Clear out, clear out, I say. (. . .) India shall be a nation! No foreigners of any sort! Hindu and Moslem and Sikh and all shall be one! Hurrah! Hurrah for India!"

56. Ibid., 322.

57. For a complementary reading of *A Passage to India*, which, I believe, sustains my argument, see the chapter "E. M. Forster: Difficulties of Relationship in India," in Goonetilleke's *Images of the Raj*, 78–111. Whereas for Said, Forster in *A Passage to India* "cannot put his objections to the iniquities of British rule in political or philosophical terms," Goonetilleke believes the opposite: "Thus, in *Howard's End*, we have the embryo of the radical vision of imperial realities that is fully developed in *A Passage to India*" (80). Goonetilleke situates his interpretation of *A Passage to India* within a biographical context that shows Forster's ongoing critique of imperialism even before *Howard's End*.

One other important omission from Said's book is an account of the work of Leonard Woolf, who in his autobiography explained how he became "an anti-imperialist," learning "from the inside how evil the system was beneath the surface for ordinary men and women" (58). I quote this passage from Goonetilleke's chapter "Leonard Woolf: The Tragedy of the 'Native' in Ceylon," now Sri Lanka, in *Images of the Raj*. It is striking that Said, as author of *Culture and Imperialism* (1993), makes no mention of Leonard Woolf, author of the political tract *Imperialism and Civilization* (1928) and of the novel *The Village in*

the Jungle (1913). As a Sri Lankan, Goonetilleke praises this novel as follows: "I agree with majority Sri Lankan opinion that Woolf's novel is the finest creative work in English to date about our island. Though an alien, Woolf's insight into, and concern for, indigenous life are such that he can write a novel wholly about it with only indigenous people as his major characters. He is closer to the Ceylonese than Forster is to the Indians" (60).

For an introduction to Woolf's political writings, see Selma S. Meyerowitz, *Leonard Woolf* (Boston: Twayne / G. K. Hall, 1982), especially 73–85. Meyerowitz explains that Woolf's *Empire and Commerce in Africa* (1918) "established Woolf's anti-imperialist views" (73). In this book, Woolf argues, " 'Neither France nor the British Empire had the slightest right to the possession either of Egypt or the Sudan or the Nile. The claims of each state, when they are stripped of the fig-leaves of diplomacy and patriotic journalism, are based upon economic imperialism and nothing else' " (75). "Furthermore," continues Meyerowitz as she summarizes Woolf's argument, "the effects of economic imperialism have been overwhelmingly destructive for the Africans, who were dispossessed of their land and forced to work for white settlers in order to pay their taxes; as a result, white settlers came to dominate African countries, controlling land and commerce by virtue of having the armed forces of a European state at their command" (76). In *Imperialism and Civilization* (published jointly by Leonard and Virginia Woolf), Woolf "returned to the problems of Empire, reemphasizing his negative views of imperialism" (Meyerowitz, *Leonard Woolf*, 83).

58. Said, *Culture and Imperialism*, 258.

59. For further remarks on this issue, see "History or Theory" in ch. 3, especially n. 23 for other sources.

60. Friedrich Wilhelm Joseph von Schelling, *System of Transcendental Idealism (1800)*, tr. Peter Heath (Charlottesville: University Press of Virginia, 1978), 202–3, 211.

61. Johann Gottlieb Fichte, *Die Grundzüge des gegenwärtigen Zeitalters. Dargestellt von Johann Gottlieb Fichte in Vorlesungen gehalten zu Berlin, im Jahre 1804–1805* (Berlin, 1806), in *Fichte's sämmtliche Werke* (Berlin: Verlag von Veit und Comp., 1846) VII: 6, 11 ("Es giebt . . . fünf Grundepochen des Erdenlebens"), 65, 62: "So, sagte ich, windet die ewig sich selbst ganz erfassende, in sich selber lebende, und aus sich selber lebende Eine Idee sich fort durch den Einen Strom der Zeit. Und, setze ich hinzu, in jedem Momente dieses Zeitstroms erfasst sie sich ganz, und durchdringt sich ganz, wie sie ist in dem ganzen unendlichen Strome; ewig und immer sich selber allgegenwärtig. Was in ihr in jedem Momente vorkommt, *ist* nur, inwiefern *war*, was vergangen ist, und weil da *seyn soll*, was in alle Ewigkeit werden wird. Nichts geht in diesem System verloren. Welten gebären Welten, und Zeiten gebären neue Zeiten, welche letzteren betrachtend über den ersteren stehen, und den verborgenen Zusammenhang der Ursachen und Wirkungen in ihnen erhellen."

62. Georg Wilhelm Friedrich Hegel, "The Philosophical History of the World" (Second Draft, 1830) in Hegel, *Lectures on the Philosophy of World History*, tr. H. B. Nisbet (Cambridge: Cambridge University Press, 1975), 52.

63. Taine, *Histoire de la littérature anglaise*, I: "un problème de mécanique: l'effet total est un composé déterminé tout entier par la grandeur et la direction des forces qui le produisent" (xxxi); "la race, le milieu et le moment" (xxii–xxiii).

64. Stephen Greenblatt in "Symposium on Disinterestedness," *The Threepenny Review* (Spring 1993), 14.

65. Luc Ferry and Alain Renaut, "Preface to the English Translation," *French Philosophy of the Sixties: An Essay on Antihumanism*, xi–xii.

66. The antihumanism of contemporary philosophy rooted in this Idea, as developed by Theodor W. Adorno, Max Horkheimer, Louis Althusser, Michel Foucault, Jean-François Lyotard, Jacques Lacan, and Jacques Derrida, is the subject of Luc Ferry's and Alain Renaut's book cited in the previous note.

67. Hannah Arendt, "Introduction: Walter Benjamin: 1892–1940," in Walter Benjamin, *Illuminations: Essays and Reflections*, tr. Harry Zinn (New York: Schocken Books, 1968), 11.

68. The quotations in the following paragraphs come from the text of "The Work of Art in the Age of Mechanical Reproduction" as found in ibid., 217–42.

69. For a reiteration of this position, justified by Benjamin's purported "insights," see, for example, Richard Wolin, *Walter Benjamin: An Aesthetic of Redemption* (New York: Columbia University Press, 1982), 190–1: "Regardless of its shortcomings (which we shall take up shortly) Benjamin's 'The Work of Art' essay remains a path-breaking study in the field of modern aesthetics. (. . .) By taking the social or material preconditions for artistic production as his point of departure, Benjamin is able to show the transient, historically determinate nature of all art forms and genres, a fact which undermines the neoclassical attempt to define art in terms of eternally valid aesthetic categories such as 'beauty,' 'genius,' 'creativity,' etc. – categories which are patently inapplicable to the entirety of 'modernism.'"

70. Whereas I am arguing that the aura of the original work of art is enhanced by comparison with mechanical reproductions from the point of view of the aesthetics of art, Laurel Bradley suggests a similar conclusion from the vantage point of the sociology of art:

> While received wisdom declares that an art object's aura is diminished once the image is multiplied by mass-media means, 19th-century practice suggests a rather different dynamic. In the first age of mechanical reproduction, the measure of a picture's power could often be calculated by the number and variety of reproductions, as well as reproduction formats – from engravings in magazines to holy cards and devotional prints, tea-tin decorations, advertising posters, and fancy dress possibilities. (Laurel Bradley, "The Portable Aura: Fine Art and Its Reproductions in the 19th Century," in "Call for Participation, College Art Association 84th Annual Conference, Boston, Massachusetts, February 21–4, 1996," p. 3).

Thus, the aura of the work of art was reflected in its popularity as a mass-produced image and possibly was reinforced through the iconic value that it achieved through mass reproduction. One might also imagine that the viewer's openness to respond to the original was prepared by this familiarity or by the respect accorded to its iconic stature. On the subject of being "open" to responding deeply to a work of art, see the section "The Music Box" in the Postscript.

71. Franz Werfel, "Ein Sommernachtstraum, Ein Film von Shakespeare und Reinhardt," *Neues Wiener Journal*, cited in *Lu* (November 1935), as quoted in Benjamin, *Illuminations*, 228.

72. Hayden White, "Introduction: Tropology, Discourse, and the Modes of Human Consciousness," *Tropics of Discourse: Essays in Cultural Criticism* (Baltimore: Johns Hopkins University Press, 1978), 5, 10–11.

73. John Keats, letter to George and Tom Keats of December 21, 1817, as quoted in Colin Falck, *Myth, Truth and Literature: Towards a True Post-Modernism* (Cambridge: Cambridge University Press, 1989), 2.

74. "Synecdoche," *The American College Dictionary* (New York: Random House, 1962), 1229.

75. For a discussion of both Hayden White's and Kenneth Burke's debt to Vico's theory of the so-called four basic tropes as necessary modes of expression in the earliest development of language and hence found in "all the first poetic nations," see Vickers, *In Defence of Rhetoric*, 439–42.

76. Legault, "Architecture and Historical Representation," *Journal of Architectural Education* 44 (August 1991): 204.

77. Frank E. Manuel, *The New World of Henri Saint-Simon* (Cambridge, Mass.: Harvard University Press, 1956; Notre-Dame: University of Notre Dame Press, 1963), 220.

78. For a summary of the German-language literature as well as its application, see Hendrik Petrus Berlage, *L'Art et la société* (1913–14; Brussels: Editions Tekhné, 1921), 4–5, 18–20, 22–3.

79. See, for example, Etlin, *Modernism in Italian Architecture*, 6, 13, 20, and *Frank Lloyd Wright and Le Corbusier: The Romantic Legacy*, 167 ("The Call for a New Style").

80. Gilbert Adair, *The Post-Modernist Always Rings Twice: Reflections on Culture in the 90s*, as quoted in Roger Scruton, "In Inverted Commas: The Faint Sarcastic Smile on the Face of the Postmodernist," *Times Literary Supplement* (December 18, 1992), 4.

81. This characterization is from Erich Kahler, *The Disintegration of Form in the Arts* (New York: George Braziller, 1968), 3.

82. Scruton, "In Inverted Commas," *Times Literary Supplement* (December 18, 1992), 3.

83. Johann Gottlieb Fichte, *Die Grundzüge des gegenwärtigen Zeitalters*, in *Fichte's sämmtliche Werke*, VII, 139–40: "Der Philosoph, der als Philosoph sich mit der Geschichte befasst, geht jenem *a priori* fortlaufenden Faden des Weltplanes nach, der ihm klar ist ohne alle Geschichte; und sein Gebrauch der Geschichte ist keinesweges, um durch sie etwas zu erweisen, da seine Sätze schon früher und unabhängig von aller Geschichte erwiesen sind:"

84. Paul de Man, *The Rhetoric of Romanticism* (New York: Columbia University Press, 1984), 67. De Man purportedly addresses the issue as to why "the theory of autobiography" is "stymied" by two of these supposedly "false" and "confining" approaches, one that considers autobiography as "a literary genre" (67) and another that sees autobiography as raising "the distinction between autobiography and fiction" (68). Yet, in pursuing his argument, de Man does not adequately confront the fundamental distinction between the fictional account of nonexistent characters and the recounting of a self-examined life of a real person. The presence either of fiction and fantasy in autobiography or of autobiographical material in fictional writing does not justify de Man in concluding "that the distinction between fiction and autobiography is not an either / or polarity but that it is undecidable" (70). Likewise, it is not true that we "assume that life *produces* the autobiography as an act produces its consequences" (69 [his emphasis]).

85. Norman Bryson *Vision and Painting: The Logic of the Gaze* (New Haven: Yale University Press, 1983), xi. Compare Bryson's text with this earlier indictment of "scholars" by Nietzsche:

> Too long did my soul sit hungry at their table: not like them have I got the knack of investigating, as the knack of nut-cracking. (. . .)
>
> But they sit in the cool shade: they want in everything to be merely spectators, and they avoid sitting where the sun burneth on the steps.
>
> Like those who stand in the street and gape at the passers-by: thus do they also wait, and gape at the thoughts which others have thought.
>
> Should one lay hold of them, then do they raise a dust like flour-sacks, and involuntarily. . . .
>
> Good clockworks are they: only be careful to wind them up properly! Then do they indicate the hour without mistake, and make a modest noise thereby.
>
> Like millstones do they work, and like pestles: throw only seed-corn unto them! – they know well how to grind corn small, and make white dust out of it. (*Thus Spake Zarathustra*, in *Complete Works* XI, 149–50 [§ XXXVIII].)

86. Terry Eagleton, "Discourse and Discos: Theory in the Space between Culture and Capitalism," *Times Literary Supplement* (July 15, 1994), 3–4.

87. Theodor Adorno, *Aesthetic Theory*, eds. Gretel Adorno and Rolf Tiedemann, tr. C. Lenhardt (1970, 1972; London: Routledge and Kegan Paul, 1984).

88. Eagleton, "Discourse and Discos," 4. Eagleton missed a perfect opportunity to explore the social engagement of modern art in *Marxism and Literary Criticism* (Berkeley: University of California Press, 1976), where he wrote a chapter entitled "The Writer and Commitment" (37–58). Although primarily concerned here with literature, Eagleton nonetheless permitted himself generalizations about "art" and "revolutionary art" in general.

89. For the engagement with contemporary social life of the individual artists mentioned in this paragraph, see the various studies that their respective careers have prompted. As for Russian Constructivism, the list is enormous. For an introduction see El Lissitzky, *Russia: An Architecture for World Revolution*, tr. Eric Dluhosch (1930; Cambridge, Mass.: MIT Press, 1970; 1984); Christina Lodder, *Russian Constructivism* (New Haven: Yale University Press, 1983); John Milner, *Vladimir Tatlin and the Russian Avant-Garde* (New Haven: Yale University Press, 1983); Anatole Kopp, *Constructivist Architecture in the USSR* (London: Academy Editions; New York: St. Martin's Press, 1985). On American artists responding to Fascism, see Cécile Whiting, *Antifascism in American Art* (New Haven: Yale University Press, 1989). For a general introduction to the social commitment of modern architecture, see Kenneth Frampton, *Modern Architecture: A Critical History* (1980; London: Thames and Hudson, 1985 rev. ed.). On more specific themes, in addition to the books on Russia listed here, see Richard Pommer and Christian F. Otto, *Weissenhof 1927 and the Modern Movement in Architecture* (Chicago: University of Chicago Press, 1991), with an excellent bibliography arranged by topic. Another fundamental text is Giorgio Grassi, ed., *Das neue Frankfurt, 1926–1931* (Bari: Dedalo, 1975). For a brief summary and bibliography on the issue of "art in everything and for everybody," see Etlin, *Modernism in Italian Architecture*, 28–9, and passim for "rationalism" in the French and Italian contexts.

90. Whereas I have stressed the inadequacies of Eagleton's text from the point of view of culture, others have objected to his claims in the domain of political theory. See John Butt's response to Eagleton's work in which Butt says, "Ask him to give us some specifics about this 'politics' that he constantly invokes but never actually *talks* about. Invite him to make clear to us his policies, eg, on ownership, inheritance, taxation; let's have some economics

and figures, so that I can stop thinking that he's as innocent as the birds about such things. And let's have plenty of politics too. When and how [etc.]" (letter to the editor, *Times Literary Supplement* [July 29, 1994], 15).

91. From the introductory blurb to Sohm, *Pittoresco*.

92. Bryson, *Vision and Painting*, xii.

93. Erwin Panofsky, "Introductory," in *Studies in Iconology: Humanistic Themes in the Art of the Renaissance* (1939; New York: Harper and Row, 1967 printing), 16, and later in revised form as "Iconography and Iconology: An Introduction to the Study of Renaissance Art," in *Meaning in the Visual Arts* (Garden City: Doubleday, 1955), 39.

94. Bryson, *Vision and Painting*, 37.

95. Although Bryson characterizes what he sees as Gombrich's position in the preface to *Vision and Painting*, the first time the reader encounters that full title of Gombrich's book is in endnote 7 to ch. 2.

96. E. H. Gombrich, *Art and Illusion: A Study in the Psychology of Pictorial Representation*, Bollingen Series XXXV–5 (Princeton: Princeton University Press, 1960; 1961 rev. ed; 1969 printing), 1–9.

97. Bryson, *Vision and Painting*, xii.

98. Ibid., 15, see also 5–6.

99. Pierre Francastel, *La Figure et le lieu: L'ordre visuel du Quattrocento* (Paris: Gallimard, 1967), 237: "once it has been admitted, equally, that the general aim of artists is not to discover a means for transforming as rigorously as possible the optical image of the exterior world on a two-dimensional screen" ("une fois admis, également, que le but général des artistes n'est pas de découvrir un procédé pour transférer aussi rigoureusement que possible l'image optique du monde extérieur sur un écran à deux dimensions").

100. Tom Wolfe, *Mauve Gloves, Madmen, Clutter & Vine, and Other Stories, Sketches, and Essays* (New York: Farrar, Straus and Giroux, 1976), 105.

101. Bryson, *Vision and Painting*, 6. Bryson's treatment of Francastel here follows upon his earlier *Word and Image: French Painting of the Ancien Régime* (Cambridge: Cambridge University Press, 1981; 1987 reprint), where Bryson's argument in his first chapter, "Discourse, Figure" (1–28), which establishes the premises for the entire book, relies heavily on his critique of Francastel's work. In this earlier text, which has been reprinted numerous times, Bryson used virtually the same quotation from Francastel without marking the elided text, as well as the same terminology of "'Universal Visual Experience'" and "Essential Copy."

To ascertain the distance between what Francastel actually says and what Bryson makes him say, we should begin with the quotation that Bryson offers in translation from Francastel's original French text:

> Placed at the edge of the space and of the fresco, his calves tense, his bearing insolent, this magnificent *sabreur* bears no relation to the figures of gothic cathedrals: he is drawn from universal visual experience. He does not owe his imposing presence to the weight and volume of robes: his tunic moulds itself on his body. Henceforth man will be defined not by the rules of narrative, but by an immediate physical apprehension. The goal of representation will be appearance, and no longer meaning.

Bryson then explains, "What Francastel voices here is not only the view of the illustrious ancestors, but of received opinion: the generally held, vague, common-sense conception

of the image as the resurrection of Life. (. . .) In its perfect state, painting approaches a point where it sheds everything that interferes with its reduplicative mission; what painting depicts is what everyone with two eyes in his head already knows: 'universal visual experience' " (Bryson, *Vision and Painting*, 3. All further references to Bryson's work refer to this book.).

Francastel's purpose in the passage quoted by Bryson is not to establish Masaccio (1401−c.28) as the king of illusionism. Actually, Francastel has just explained that Masolino (1383−c.1447) was more skillful in depicting illusion through the use of perspective. Masaccio's contribution to painting at this time was for Francastel a construction of the figure through color. Francastel contrasts the "sculptural" quality of the human figure in painting by Giotto (c.1276−1337) with the "properly pictorial values" that Masaccio achieves through a modeling of color. This modeling, moreover, uses the body as its foundation. In place of the sculptural molding of a figure through the weight and volume of drapery in Giotto's figures, Masaccio makes the clothing adhere to the contours of the body.

The full context of this passage and its surrounding text is, of course, the entire book and most especially the preface. In the preface, Francastel introduces Masaccio's paintings in the Brancacci Chapel (Santa Maria del Carmine, Florence) with an even more complex analysis. There he explains that the figures partake of two systems of spatial conventions. On the one hand, they stand out by themselves in space and in that sense belong to the medieval world of art. At the same time, they also belong to a space organized according to perspective illusionism and thus belong to the new vision of art. Francastel summarizes these two features while also adducing the new use of color to model pictorial as opposed to sculptural form.

Later, in ch. 4, Francastel further develops these insights through the passage that Bryson quoted and that I reproduce here in its entirety along with selected passages from the two preceding paragraphs that help to establish the context. For the reader's convenience, I have placed in italics the passages quoted by Bryson. The final italics is also found in Francastel's original text:

> Aussi bien la maîtrise de Masaccio dans le domaine de la création formelle a-t-elle été soulignée par Vasari autant que son habileté dans le domaine de la géométrisation du support. Si bien qu'en voyant dans la présence de l'homme rendue manifeste par le maniement de la couleur le vrai ressort du génie de Masaccio, on ne fait que renouer avec des jugements de valeur traditionnels jusqu'à l'académisme du siècle dernier.
>
> Les personnages drapés qu'on trouve dans la peinture de Giotto possèdent la même évidence humaine. Mais ils sont plus sculpturaux que ceux de Masaccio. Si bien qu'on peut se demander si, en dernière analyse, le vrai passage qui assure à travers Masaccio, au début du Quattrocento, le renouveau de l'art n'est pas la substitution aux valeurs dominantes du volume des valeurs proprement picturales, et cela surtout parce que, pour Masaccio, c'est la couleur qui est l'instrument privilégié et complet de l'art, et parce que la peinture se détache de la statuaire et se pose, désormais, comme un système complet, autonome de valeurs sensibles. (. . .)
>
> Un bel exemple de ce conflit des valeurs et des moyens propres aux différents arts est fourni par la figure du soldat recevant le tribut dans la composition célèbre de la chapelle Brancacci. *Planté, le dos tourné aux spectateurs, à la limite de l'espace et de la fresque, ce magnifique sabreur aux mollets tendus, arc-bouté dans son insolence, ne renvoie plus aux figures des cathédrales*

gothiques, mais à l'expérience visuelle de chaque homme. Il ne doit plus sa présence au poids et au volume de sa draperie, sa tunique moule son corps. Il existe par lui-même, détaché du fond, suspendu dans l'espace, suivant des principes qui n'ont rien à voir non plus avec les pratiques de la perspective mesurée; oscillant sous nos yeux par les prestiges propres de la peinture. Quant à Adam et Eve, ils sont, eux, nus et présents ainsi par leur seule corporéité. Ils sont, eux aussi, posés à la limite du cadre, soustraits au mur, oscillants dans l'espace du spectateur. Un siècle avant Masaccio, Giotto avait traité l'homme-objet d'une manière novatrice, mais il l'avait maintenu dans le système figuratif du passé et tous ceux qui, après lui, avaient donné vie à des figures humaines les avaient laissées intégrées dans les cadres figuratifs anciens; il n'y avait pas eu ainsi, jusque-là, rupture de la notion d'image. Masaccio apporte ce changement. Désormais, l'homme sera défini non par les actions et les récits qui le situent dans une histoire, mais par une saisie physique immédiate, sensorielle, qui crée la présence. Le but de la figuration, ce sera les apparences et non plus le sens. (Pierre Francastel, *La Figure et le lieu: L'ordre visuel du Quattrocento* [Paris: Gallimard, 1967], 234–5.)

By restoring the elided passage and by considering the lines quoted by Bryson within the context of the preceding paragraphs as well as of the preface, we find a text significantly at variance with the one produced by Bryson as a quotation.

The difference comes not simply from the inclusion of missing sentences but issues from the different translations that Bryson and I offer. I now wish to demonstrate that Bryson has offered a tendentiously ideological translation of what he takes to be the key passages in Francastel's work. Where Bryson has Francastel say – "this magnificent *sabreur* bears no relation to the figures of gothic cathedrals: he is drawn from universal visual experience" – Francastel actually says, "this magnificent *sabreur* no longer refers back to the figures of gothic cathedrals, but rather to the visual experience of each person." Here Francastel is explaining Masaccio's new technique of modeling the body, largely through the use of color, a modeling by which the figure's tunic appears molded to his actual body rather than assuming quasi-independent form as had the sculpted drapery of Gothic statuary. Thus, we should read the phrase "visual experience of each person" to mean what we see when we look at a clothed real person. Note that Francastel is not postulating a universal principle about art or about vision; rather, he is simply referring to an experience of which all people who can see (that is, who are not physically blind) are capable.

Yet Bryson translates the phrase as "universal visual experience," thereby making Francastel's words mean, as Bryson puts it, that "each human being universally experiences the same visual field" (6). Furthermore, according to Bryson, Francastel's alleged notion of "universal visual experience" is linked to the idea that painting is a naive and literal depiction of the subject through a process that Bryson calls making the "Essential Copy." In vain for Bryson's argument does Francastel not say this, to no avail does Francastel actually repudiate this position, and to no effective purpose has Francastel said from "the visual experience of each person," because three pages later Bryson has elevated his tendentious translation of this passage into a universal principle, crowned with capital letters – "Universal Visual Experience."

In the passage quoted by Bryson, Francastel has not been discussing the nature of representation in general but rather the depiction of the human body. Yet Bryson has translated the last sentence to read: "The goal of representation will be appearance, and no longer meaning." Francastel, on the other hand, had said that henceforth, from Masaccio

onwards in Western art, "The goal of *la figuration* [i.e., the depiction of the human body] will be appearances and no longer that of sense."

To understand what Francastel means by the word "sense," this sentence must be read in conjunction with the previous one: "Henceforth, man will be defined not by his actions and the stories that situate him in history [as had been the emphasis in medieval painting] but through the immediate, sensorial, physical aspect that creates his presence." Once again, the reader of Bryson's text would not have access to this meaning, because Bryson has translated "not by his actions and the stories that situate him in history" as "not by the rules of narrative." Yet Francastel is not talking as a poststructuralist about the "rules of narrative." He is noting the importance of history for the depiction of the human body in medieval art. This is the meaning of "sense" in the next sentence, i.e., the "sense" or "meaning" of the depicted person as found in his or her actions or story. Having made Francastel say that the "goal of representation will be appearance, and no longer meaning," Bryson then proceeds to criticize this still further mistaken notion about the nature and history of painting, which he also associates with the naively mistaken "natural attitude." Through tendentious translation Bryson has created a series of strawmen whom he effortlessly fells with his poststructuralist sword.

102. White, *Tropics of Discourse*, 12–16 (his italics).

103. See also "Derrida's Mythical Twilight Zone" in ch. 3.

104. Terry Eagleton, "The Emptying of a Former Self," *Times Literary Supplement* (May 26–June 1, 1989), 573.

105. Jacques Derrida, "Force and Signification," *Writing and Difference*, tr. Alan Bass (Chicago: University of Chicago Press, 1978), 8. Although Derrida's essay "Force and Signification" is largely a reading of Rousset's book, the convolutions of Derrida's text read as a parody of Rousset's balanced combination of figurative and descriptive prose, exaggerating the former and nearly eliminating the latter. If readers wish to find the quotation by Focillon in Rousset's text, they can locate it on page ii rather than on page 11, a minor misreading of the French original that renders ii with the Roman numerals II.

106. For the German text, see n. 61.

107. Shelley Walia, "Fruitful Interactions," *Times Literary Supplement* (November 12, 1983), 27.

108. The accompanying note reads: "Rhétorique de la drogue," in *Points de suspension: Entretiens* (Paris: Galilée, 1992), 241–67.

109. Brunette and Wills, "The Spatial Arts: An Interview with Jacques Derrida," in Brunette and Wills, eds., *Deconstruction and the Visual Arts*, 12. Compare this text to Nietzsche's explanation about his intentions as a philosopher in the chapter "Why I Am a Fatality," in his pretentiously entitled autobiography *Ecce Homo*: "If you should require a formula for a destiny of this kind that has taken human form, you will find it in my *Zarathustra*. 'And he who would be a creator in good and evil — verily, he must first be a destroyer, and break value into pieces. Thus the greatest evil belongeth unto the greatest good: but this is the creative good.' I am by far the most terrible man that has ever existed; but this does not alter the fact that I shall become the most beneficent. I know the joy of *annihilation* to a degree which is commensurate with my power to annihilate. In both cases I obey my Dionysian nature, which knows not how to separate the negative deed from the saying of yea. I am the first immoralist, and in this sense I am essentially the annihilator" (*The Complete Works of Nietzsche*, XVII, 132–3). Nietzsche's italics.

110. Stanley Corngold, letter to the *Times Literary Supplement* (August 26–September 1, 1988), 931. As Corngold indicates, this text by de Man comes from his essay on Rousseau's *Confessions* in *Allegories in Reading: Figural Language in Rousseau, Nietzsche, Rilke, and Proust* (New Haven: Yale University Press, 1979), 296.

111. Ibid. The quotations from de Man and Corngold in the remainder of this section all come from this same letter to the editor.

112. John Mullan, "Ha, Reginald," *Times Literary Supplement* (December 12, 1993), 7, review article of several books, including Robert Miles, *Gothic Writing, 1750–1820: A Genealogy* (London: Routledge, 1993).

113. Derrida, as quoted in Brunette and Wills, "The Spatial Arts: An Interview with Jacques Derrida," in Brunette and Wills, eds., *Deconstruction and the Visual Arts*, 13.

114. Mullan, "Ha, Reginald," *Times Literary Supplement* (December 12, 1993), 7.

115. Mark Wigley, "The Domestication of the House: Deconstruction After Architecture," in Brunette and Wills, eds., *Deconstruction and the Visual Arts*, 226–7. In a similar vein, see "Violence of Architecture," *Artforum* (September 1981): 44–7, by the architect Bernard Tschumi, who has been closely associated with deconstruction in architecture.

116. Derrida, as quoted in Brunette and Wills, "The Spatial Arts: An Interview with Jacques Derrida," in Brunette and Wills, eds., *Deconstruction and the Visual Arts*, 10.

117. This intellectual chain was briefly discussed in the section "Derrida's Mythical Twilight Zone," ch. 3.

118. Heidegger as quoted in Wigley, "The Domestication of the House," in Brunette and Wills, eds., *Deconstruction and the Visual Arts*, 206.

119. Ibid., 206–7.

120. Michel Foucault, *Discipline and Punish: The Birth of the Prison*, tr. Alan Sheridan (New York: Vintage / Random House, 1979), 7.

121. Ibid., 17, 25–7.

122. As is evident from the text, Nietzsche considered his earlier work such as *Beyond Good and Evil* and *Thus Spake Zarathustra* as being subsumed and extended by this later book. See also the editor's note, which precedes the text in Friedrich Nietzsche, *The Genealogy of Morals. A Polemic*, in *The Complete Works of Friedrich Nietzsche. The First Complete and Authorised English Translation*, ed. Oscar Levy, tr. Horace B. Samuel (New York: Russell and Russell, 1964), XIII. For a more complete discussion about Nietzsche's philosophy, see nn. 127, 132, 133.

123. Luigi Rognoni, *The Second Vienna School: Expressionism and Dodecaphony*, tr. Robert W. Mann (1966; London: John Calder, 1977), xx.

124. As quoted in ibid., xxiv.

125. Béla Bartók, letter of August 15, 1905, to Irmy Jurkovics, as quoted in John C. Crawford and Dorothy L. Crawford, *Expressionism in Twentieth-Century Music* (Bloomington and Indianapolis: Indiana University Press, 1993), 7. For the inspirational value of Nietzsche to German Expressionist architects, see Wolfgang Pehnt, *Expressionist Architecture*, trs. J. A. Underwood and Edith Küstner (London: Thames and Hudson, 1973), 41–3: ". . . the long shadow of Friedrich Nietzsche lies across Expressionist architecture as it lies across Expressionist poetry. The sketches of [the architects] Bruno Taut and Josef Emanuel Margold are annotated with quotations from his works. *Thus Spake Zarathustra*

(1883–5) was a canonical text for the Expressionists" (41). On Nietzsche's importance for the American architect Louis Sullivan, see ch. 1, n. 51.

126. Nietzsche's outlook, as reflected by these thoughts, was a late stage in what might be called Miltonian Satanism. Toward the end of the eighteenth-century, painters in Great Britain such as James Barry and Henry Fuseli were inspired by John Milton's *Paradise Lost* (1667) to depict Satan and his cohorts, not in the traditional manner of ugly and deformed creatures but rather as Supermen, rendered with all the nobility of idealized proportion and heightened musculature pioneered earlier by Michelangelo. This they deemed the fitting portrait of Satan, "th'Arch-Enemy" (I, 81):

> . . . "I know thee, stranger, who thou art,
> That mighty leading Angel, who of late
> Made head against Heav'n's King, though overthrown.
> I saw and heard, for such a numerous host
> Fled not in silence through the frighted deep
> With ruin upon ruin, rout on rout,
> Confusion worse confounded; and Heav'n Gates
> Pour'd out by millions her victorious Bands
> Pursuing." [II, 990–8]
> . . .
> He ceas'd; and Satan stay'd not to reply,
> But glad that now his Sea should find a shore,
> With fresh alacrity and force renew'd
> Springs upward like a Pyramid of fire
> Into the wide expanse, and through the shock
> Of fighting Elements, on all sides round
> Environ'd wins his way; . . . [II, 1010–16]
> . . .
> [the Son] Drove them before him Thunder-struck, pursu'd
> With terrors and with furies to the bounds
> And Crystal wall of Heav'n, which op'ning wide,
> Rolled inward, and a spacious Gap disclos'd
> Into the wasteful Deep; the monstrous sight
> Struck them with horror backward, but far worse
> Urg'd them behind; headlong themselves they threw
> Down from the verge of Heav'n, Eternal wrath
> Burnt after them to the bottomless pit.
> Hell heard th'unsufferable noise, Hell saw
> Heav'n ruining from Heav'n and would have fled
> Affrighted; but strict Fate had cast too deep
> Her dark foundations, and too fast had bound.
> Nine days they fell; confounded Chaos roar'd,
> And felt tenfold confusion in their fall
> Through his wild Anarchy, so huge a rout
> Encumber'd him with ruin: Hell at last
> Yawning receiv'd them whole, and on them clos'd,
> [VI, 858–75]

As Antoine Adam has observed in his notes on *Les Litanies de Satan*, one of the last poems of Baudelaire's *Les Fleurs du Mal* (The Flowers of Evil) (Paris: Garnier Frères, 1961), 423, the myth "of Satan was at the center of Romanticism, and the greatest names of the new

literature had spoken of the tragic figure drawn by Milton." After quoting Schiller on Milton, that " 'panegyrist of Hell,' " Adam continues,

> In effect, it is not as the instigator of evil that [Satan] appears in Baudelaire's poem. It is as the symbol of a heroic energy that even defeat does not succeed in breaking. And perhaps to explicate *Les Litanies de Satan* no text elucidates this poem better than these lines by Shelley in *A Defence of Poetry*: "Nothing can exceed the energy and magnificence of the character of Satan as expressed in *Paradise Lost*. It is a mistake to suppose that he could ever have been intended for the popular personification of evil. (. . .) Milton's Devil as a moral being is as far superior to his God, as one who perseveres in some purpose which he has conceived to be excellent in spite of adversity and torture, is to one who in the cold security of undoubted triumph inflicts the most horrible revenge upon his enemy, not from any mistaken notion of inducing him to repent of a perseverance in enmity, but with the alleged design of exasperating him to deserve new torments."

Moving forward from Baudelaire we find a further development of the heroic embrace of the defiant and battling Satan in a manner that anticipates Nietzsche in Stéphane Mallarmé's poem *Les Fenêtres* (The Windows), which P. N. Furbank associates with Mallarmé's letter of May 14, 1867, to Henri Cazalis, "describing how, after a terrible spiritual wrestling match, he floored that 'ancient and wicked plumage, God' and 'fell victoriously, bewilderedly and infinitely . . . ' ":

> Est-il moyen, mon Dieu qui voyez l'amertume,
> D'enfoncer le crystal par ce monstre insulté
> Et de m'en fuir, avec mes deux ailes sans plume,
> – Au risque de tomber pendant l'Eternité?

> (Is there any way, O God who sees my bitter tears,
> For me to break the glass insulted by the Monster
> And to fly off on my two featherless wings
> – Even at the risk of falling until the end of Time?)

As Furbank remarks, this early poem by Mallarmé is "very Baudelairean." In this respect, consider the last stanzas of the final poem (*Le Voyage*) in the last cycle *La Mort* (Death) of the second edition (1861) of *Les Fleurs du Mal* (The Flowers of Evil):

> O Mort, vieux capitaine, il est temps! levons l'ancre!
> Ce pays nous ennuie, ô Mort! Appareillons!
> Si le ciel et la mer sont noirs comme de l'encre,
> Nos coeurs que tu connais sont remplis de rayons!

> Verse-nous ton poison pour qu'il nous réconforte!
> Nous voulons, tant ce feu nous brûle le cerveau,
> Plonger au fond du gouffre, Enfer ou Ciel, qu'importe?
> Au fond de l'Inconnu pour trouver du *nouveau!*

> (O Death, old captain, it is time! weigh anchor!
> This country wearies us, O Death! Let us get under way!
> If the sky and the sea are black like ink,
> Our hearts which you know are filled with radiance!

> Pour us your poison to fortify us!
> We wish, so long as this fire burns the mind,
> To plunge to the depths of the abyss, Hell or Heaven, what does it matter?
> To the depths of the Unknown to find the *new!*)

See Adam's explanation (424–5) of the profound change to the ending of *Les Fleurs du Mal* effected through the addition in the second edition of the last three pieces, of which *Le Voyage* is the concluding statement, thereby reinforcing the cult of Milton's Satan.

The attention to Milton's Satan in the domain of opera and oratorio in the second half of the nineteenth century can be summed up with the lines from John Ellerton's oratorio *Paradise Lost* (1862), quoted directly from the original poem:

> All is not lost; th'unconquerable will,
> And study of revenge, immortal hate,
> And courage never to submit or yield!

How close we are here Nietzsche's subsequent "will to power."

In studying the relationship of Milton's Satan to Romanticism, both Antoine Adam and Mario Praz have stressed the importance of Friedrich von Schiller's *Die Räuber* (The Robbers) (1781), which incarnated the values of Miltonian Satanism and influenced subsequent works of literature in this manner. We know that by the age of fourteen, Nietzsche already was admiring this work for these features and with a vocabulary that would prove prophetic: "The characters seem to me almost superhuman (*übermenschlich*)." "It is like watching the Titans battling against religion and virtue" (Nietzsche, diary entry of August 24, 1859, as quoted in Hayman, *Nietzsche*, 43).

On Mallarmé, see P. N. Furbank, "Mysteries of Mallarmé," *New York Review of Books* (September 22, 1994), 42–3. The translation of *Les Fenêtres* is by Gordon Millan from his *A Throw of the Dice: The Life of Stéphane Mallarmé* (Farrar, Straus and Giroux) and is quoted in Furbank's review-article. On Milton and British art, see Marcia R. Pointon, *Milton & English Art* (Toronto: University of Toronto Press; Manchester: Manchester University Press, 1970), and Ernest W. Sullivan II, "Illustration as Interpretation: *Paradise Lost* from 1688 to 1807," in Albert C. Labriola and Edward Sichi, Jr., eds., *Milton's Legacy in the Arts* (University Park, Pa.: Pennsylvania State University Press, 1988), 59–92. The lines from Shelley, given by Adam in French translation, I have quoted from the original as found in Percy Bysshe Shelley, *The Selected Poetry and Prose*, ed. Carlos Baker (New York: The Modern Library / Random House, 1951), 512. For Ellerton's oratorio and its cultural context, see Stella P. Revard, "From the State of Innocence to the Fall of Man: The Fortunes of *Paradise Lost* as Opera and Oratorio," in Labriola and Sichi, eds., *Milton's Legacy*, 92–134. For the influence of Milton's Satan on early Romantic literature, see Mario Praz, *The Romantic Agony*, tr. Angus Davidson (Oxford: Oxford University Press, 1933; 1951 2nd ed.; 1970), 59–63. The original French for the quotations from Antoine Adam reads: "Comme le mythe de Caïn, celui de Satan était au centre du romantisme, et les plus grands noms de la nouvelle littérature avaient parlé de la tragique figure dessinée par Milton. (. . .) Ce n'est pas en effet comme inspirateur du mal qu'il apparaît dans le poème de Baudelaire. C'est comme le symbole d'une énergie héroïque que la défaite même n'a pas réussi de briser. Et peut-être pour commenter *Les Litanies de Satan* n'existe-t-il pas de texte qui les éclaire mieux que ces lignes de Shelley dans *Défense de la poésie*:"

127. In a sense, though, it is incorrect to speak of the two "sides" of Nietzsche's work. Nietzsche himself saw his inspirational aphorisms of *Thus Spake Zarathustra* as fully consistent with the vicious immorality of *The Genealogy of Morals*. In his autobiography, *Ecce Homo*, in *The*

Complete Works, tr. Anthony M. Ludovici (1911), XVII, 57–8, Nietzsche repudiated the idealistic reading, or rather misreading of Zarathustra's and the Superman's character:

> He who thought he had understood something in my work, had as a rule adjusted something in it to his own image – not infrequently the very opposite of myself, an "idealist," for instance. (. . .) The word "Superman," which designates a type of man that would be one of nature's rarest and luckiest strokes, as opposed to "modern" men, to "good" men, to Christians . . . a word which in the mouth of Zarathustra, the annihilator of morality, acquires a very profound meaning, – is understood almost everywhere, and with perfect innocence, in the light of those values to which a flat contradiction was made manifest in the figure of Zarathustra – that is to say, as an "ideal" type, a higher kind of man, half "saint" and half "genius." (. . .) Once, when I whispered to a man that he would do better to seek for the Superman in a Caesar Borgia than in Parsifal, he could not believe his ears.

The artists cited earlier certainly saw themselves more as Parsifal than as the cruel and treacherous Caesar Borgia. More than any of the Romantics who preceded Nietzsche in their admiration for Milton's Satan, Nietzsche knew how to draw the full implications of the type. As Nietzsche later says in *Ecce Homo* about Zarathustra's Superman, "the just would regard his superman as the *devil*" (137). See also n. 133 and in ch. 1 n. 51.

The Nietzsche about whom I am referring is the "mature" rather than the "youthful" writer. If we look to an early work such as "Richard Wagner in Bayreuth" (1876), the fourth of Nietzsche's published *Untimely Meditations* (tr. R. J. Hollingdale [Cambridge and New York: Cambridge University Press, 1983]), we find Nietzsche championing Judaeo-Christian morality. Here Nietzsche argues that through the will to power people have a choice between good and evil. He admonishes his fellow humans to select the former and to "fight" for "love and justice" (211–12). Writing about Richard Wagner, Nietzsche outlines the parameters of each person's potential moral dilemma:

> As soon as his [i.e., Wagner's] spiritual and moral maturity arrives, the drama of his life begins. (. . .) His nature appears in a fearful way simplified, torn apart into two drives or spheres. Below there rages the precipitate current of a vehement will which as it were strives to reach up to the light through every runway, cave and crevice, and desires power. Only a force wholly pure and free could direct this will on to the pathway to the good and benevolent; had it been united with a narrow spirit, such an unbridled tyrannical will could have become a fatality; A mighty striving conscious of repeated failure makes one bad; Even among those whose objective is only their own moral purification, among hermits and monks, there are to be found such savage and morbid men, hollowed out and consumed by failure. It was a spirit full of love, with voice overflowing with goodness and sweetness, with a hatred of violence and self-destruction, which desires to see no one in chains – it was such a spirit that spoke to Wagner (201–2).

Later in this essay Nietzsche celebrates the Judaeo-Christian credo, which he sees rooted in the nature of the human psyche: "We cannot be happy so long as everything around us suffers and creates suffering; we cannot be moral so long as the course of human affairs is determined by force, deception, and injustice; . . ." (212). In this same vein, Nietzsche accepts the traditional understanding of "conscience." "Bad conscience" results from a "feeling of guilt" occasioned by moral transgressions, such as "violence and cunning and revengefulness" (220). Nietzsche offers these remarks as part of a discussion of social Darwinism, which at this point in his life he rejects. Yet, in the last section of this essay,

which focuses on the capabilities of a future generation, we find the seeds of Nietzsche's future orientation, of his disparagement of humanist values:

> Perhaps this generation as a whole will even seem more evil than the present generation – for, in wicked as in good things, it will be more *candid*; it is possible, indeed, that if its soul should speak out in free full tones it would shake and terrify our soul as would the voice of some hitherto concealed evil spirit of nature. Or how do these propositions strike us: that passion is better than stoicism and hypocrisy; that to be honest, even in evil, is better than to lose oneself in the morality of tradition; However shrill and uncanny all this may sound, what speaks here is the voice of that world of the future . . . (251–2).

Nietzsche was to make this voice of the future his own.

128. Nietzsche, *The Genealogy of Morals*, 73.
129. Ibid., 104 (for this equation).
130. Ibid., 45.
131. Ibid., 100–1. For Nietzsche's earlier understanding of "bad conscience" see n. 127.
132. Ibid., 26, 29–33. In a classic example of projection, Nietzsche attributed his hatred of the Jews to them, so that they became "a nation of the most jealously nursed priestly revengefulness" (30), "the trunk of that tree of revenge and hate, Jewish hate, – that most profound and sublime hate" (31). Likewise, "Rome found in the Jew the incarnation of the unnatural, as though it were its diametrically opposed monstrosity, and in Rome the Jew was held to be *convicted of hatred* of the whole human race: and rightly so, in so far as it is right to link the well-being and the future of the human race to the unconditional mastery of the aristocratic values, of the Roman values" (54). Here is how Nietzsche explains what that so-called Jewish hatred was:

> It was the Jews who, in opposition to the aristocratic equation (good = aristocratic = beautiful = happy = loved by the gods), dared with a terrifying logic to suggest the contrary equation, and indeed to maintain with the teeth of the most profound hatred (the hatred of weakness [i.e., the hatred felt by those who are weak]) this contrary equation, namely, "the wretched are alone the good; the poor, the weak, the lowly, are alone the good; the suffering, the needy, the sick, the loathsome, are the only ones who are pious, the only ones who are blessed, for them alone is salvation – but you, on the other hand, you aristocrats, you men of power, you are to all eternity the evil, the horrible, the covetous, the insatiate, the godless; eternally also shall you be the unblessed, the cursed, the damned! (30)

With this obscene caricature of Jewish and Christian values, Nietzsche attacked his two preferred objects of hatred. According to Nietzsche, Christ was the Jews' "*cleverest revenge*" (30):

> We know who it was who reaped the heritage of this Jewish transvaluation. (. . .) This Jesus of Nazareth, the incarnate gospel of love, this "Redeemer" bringing salvation and victory to the poor, the sick, the sinful – was he not really temptation in its most sinister and irresistible form, temptation to take the tortuous path to those very *Jewish* values and those very Jewish ideals? Has not Israel really obtained the final goal of its sublime revenge, by the tortuous paths of this "Redeemer," for all that he might pose as Israel's adversary and Israel's destroyer? Is it not due to the black magic of a really *great* policy of revenge, of a far-seeing, burrowing revenge, both acting and calculating with slowness, that Israel himself must repudiate before all the world the actual instrument of his own revenge and nail it to the cross, so that all the world – that is, all the enemies of Israel – could nibble without suspicion

at this very bait? Could, moreover, any human mind with all its elaborate ingenuity invent a bait that was more truly *dangerous*? [etc.] (30–2)

I am fully aware that the account of Nietzsche's ideas that I am presenting in this chapter is strongly at variance with many of the popular and seemingly authoritative studies of his thought. How to respond? Unlike so many of Nietzsche's texts, filled with aphorisms which Nietzsche himself relishes for the partial obscurity that he gives them (see "On the Question of Being Understandable," *The Gay Science*, bk. 5), *The Genealogy of Morals* presents a sustained and coherent argument. Therefore, any serious discussion of Nietzsche's moral philosophy must come to terms with this coherent and, with respect to date of publication, mature work.

In *Nietzsche: Philosopher, Psychologist, Antichrist* (Princeton: Princeton University Press, 1950), 259, Walter A. Kaufmann, ever attentive to protecting his subject from charges of having inspired Nazism, cites in part passages from "We Who Are Homeless" in bk. 5 of *The Gay Science* which Kaufmann offers as a demonstration that Nietzsche condemned racism. Even within the confines of this aphorism, Nietzsche's attitude toward racism is much more problematic than Kaufmann would allow. For Nietzsche's narrator to dismiss racism because he is "too malicious" (not mentioned by Kaufmann) certainly makes a straightforward acceptance of Nietzsche's words here on racism difficult. As we ponder his possible meaning, we must also consider the passage, also not mentioned by Kaufmann, which precedes these remarks: "Humanity! Has there ever been a more hideous old woman among all old women – (unless it were 'truth': a question for philosophers)? No, we do not love humanity; . . ." (Friedrich Nietzsche, *The Gay Science*, tr. Walter Kaufmann [New York: Random House, 1974], 339).

For another important discussion about both the Jews and anti-Semitism, see *Beyond Good and Evil*, in *The Complete Works of Friedrich Nietzsche. The First Complete and Authorised English Translation*, ed. Oscar Levy, tr. Helen Zimmern (New York: Russell and Russell, 1964), XII, 206–10 (§ 250–1). In these sections, Nietzsche presents a qualified criticism of anti-Semitism, including a repudiation of his past offenses on this ground: "May it be forgiven me that I, too, when on a short daring sojourn on very infected ground, did not remain wholly exempt from the disease. . . ." Although toward the end of *The Genealogy of Morals* (205), Nietzsche speaks out against the current German anti-Semitism, as other passages in this text reveal, Nietzsche was still wrestling with this "disease" in a battle that he did not win. From *Thus Spake Zarathustra* to *Beyond Good and Evil* and then to *The Genealogy of Morals*, there is a progressive moral darkening of Nietzsche's vision.

Even Michael F. Duffy and Willard Mittelman, in "Nietzsche and the Jews," *Journal of the History of Ideas* 49 (April–June 1988), note the "invidious treatment," the "derisory" language, the "harshness and bitterness with which Nietzsche in *The Genealogy of Morals* describes the Jews of the prophetic era and their revaluation of values" (312–13). In spite of this recognition, Duffy and Mittelman attempt to minimize the significance of Nietzsche's anti-Semitism. I do not find their article convincing. The intellectual strategy that Duffy and Mittelman employ is to fragment into separate components Nietzsche's attitude toward Jews and the Jewish religion. As a result, these authors diminish the cumulative impact of Nietzsche's writings when considered together. Thus, Duffy and Mittelman would isolate Nietzsche's "early anti-Semitism," defined as found in Nietzsche's

"pre-*Zarathustra* writings" (307, 309, 316) or as "vestiges" and "traces" of this early attitude when it appears in his mature works (307, 317). In this way, they would quarantine the anti-Semitism expressed in the *Genealogy*, to argue that this book is virtually unique in Nietzsche's *oeuvre* (317). Second, they would assign the virulent anti-Semitism of the *Genealogy* a "biographical" (302, 314, 317) explanation, thereby deflecting Nietzsche's philosophical purpose into a disguised "venting [of] anger at [the Jewish] Paul Rée" (317). Third, they postulate "a threefold distinction" in Nietzsche's attitude toward the Jews grounded in what they see as his separate and different responses to "(i) the Judaism of the older, pre-prophetic parts of the Old Testament, (ii) the prophetic Judaism out of which Christianity arose, and (iii) modern Judaism" (302). This tripartite distinction, recognized by "no commentators" (302) previous to the study by Duffy and Mittelman, does not work when applied to *The Genealogy of Morals*. As Nietzsche repeatedly makes clear, the Judaism that he is discussing and that Duffy and Mittelman would circumscribe as the Judaism "of the prophetic era" (313) presents a timeless Jewish spirit that has reappeared to the detriment of humankind repeatedly throughout history and even through events not concerned primarily with the Jews themselves, such as the Reformation and the French Revolution (*Genealogy*, 55–6 [ch. 1, § 16]; see also 32–3 [ch. 1, § 8]).

All of these related strategies employed by Duffy and Mittelman reflect their attitude toward the tenor and the specifics of Nietzsche's philosophy. In justifying their biographical explanation for the anti-Semitism of *The Genealogy of Morals*, they maintain, "Nor is there anything in Nietzsche's philosophy as a whole that compels him to view the Judaism of the prophets as he did" (314). Because these authors fail to see the antihumanism of Nietzsche's mature work, they misread *The Antichrist* in which they find a "much more positive" treatment of "prophetic Judaism" than in the *Genealogy* (316). Yet how can Duffy and Mittelman come to this conclusion in light of the following passage from *The Antichrist*?:

> The Jews are the strangest people in world history because, confronted with the question whether to be or not to be, they chose, with a perfectly uncanny deliberateness, to be *at any price*: this price was the radical *falsification* of all nature, all naturalness, all reality, of the whole inner world as well as the outer. (. . .) [O]ut of themselves they created a counter-concept to *natural* conditions: they turned religion, cult, morality, history, psychology, one after the other, into an incurable *contradiction to their natural values*. We encounter this same phenomenon once again and in immeasurably enlarged proportion, yet merely as a copy: the Christian church cannot make the slightest claim to originality when compared with the "holy people." That precisely is why the Jews are the *most catastrophic* people of world history: by their aftereffect they have made mankind so thoroughly false that even today the Christian can feel anti-Jewish without realizing that he himself is *the ultimate Jewish consequence* (§ 24, in Kaufmann, *The Portable Nietzsche*, 592–3 [Nietzsche's italics]).

Duffy and Mittelman do not quote these and other such lines that echo comparable ones in the *Genealogy* about the Jews' "sublime revenge" upon "all the world" effected through Jesus. Rather than isolating the *Genealogy* as an anomaly (315–16), *The Antichrist* demonstrates the degree to which the overall outline of Nietzsche's philosophy in his mature works was thoroughly consistent.

133. Nietzsche, *The Genealogy of Morals*, 26. Many of the themes that I address have recently been the subject of "Nietzsche under Fire" by Nicholas Martin (*Times Literary Supplement*,

[August 5, 1994], 11–12), who argues a diametrically opposed position. Commenting on the image of Nietzsche presented in the British press in 1914, Martin writes, "This Nietzsche of 1914 bore no resemblance to the ironic and incisive, elliptical and elusive Nietzsche who emerges from his texts." According to Martin, Nietzsche "rigidly separated" the "unique *Übermensch* and the blond beast." Yet Martin must excuse readers from associating the two together, since in *The Genealogy of Morals* Nietzsche repeatedly used terms that sound as if he is talking about the collectivity of *Übermenschen* – "the conquering and *master* race – the Aryan race" (26), "the godlike race" (26), "a higher dominant race" (20), which he opposes to "a meaner race, an 'under race'" (20). In the same chapter, Nietzsche repeatedly refers to this master race as harboring "the magnificent *blonde brute*" (40), "the blonde Teuton beast" (41), "the blonde beast" (42). Later, in a discussion that approves "a Will to Power" "master[ing] a less powerful force" (90), Nietzsche reintroduces the theme of the Superman as he explains, "humanity as a mass sacrificed to the prosperity of the one *stronger* species of Man – that *would be* a progress" (91).

Next, Martin refers to Nietzsche's "alleged German nationalism" while concluding his article by insisting that to be "pronounced German" would have been "intolerable" to Nietzsche. Although Nietzsche's disdain for contemporary Germans is clear enough in the *Genealogy*, this reflects the decline of contemporary Germany from what he saw as its glorious past. He makes it clear that his master race, his Aryan race, is the race that speaks German and that the Teutons are the Germans' ancestors. For evidence I refer the reader to the first chapter of the *Genealogy*, citing for brevity's sake, only the following sentence: "The profound, icy mistrust which the German provokes, as soon as he arrives at power, – even at the present time, – is always still an aftermath of that inextinguishable horror with which for whole centuries Europe has regarded the wrath of the blonde Teuton beast (although between the old Germans and ourselves there exists scarcely a psychological, let alone a physical, relationship)" (41). Or, more simply, "We Germans" (67). All of the lines quoted by Martin from "What the Germans Lack" and *Ecce Homo* should be considered in the context of this sentence. (See also the discussion of "we Germans" in *Beyond Good and Evil* (250), as well as Nietzsche's identification with "the German soul" in "On the Old Problem: 'What is German?'" in *The Gay Science*, bk 5. For further references to Nietzsche's identification with Germans, see Hayman, *Nietzsche*, 108, 124–5, 127–8, 134, 150–2.)

This leads to another of Martin's claims, that the "incitements to cruelty" invoked by the British press in 1914 as important features of Nietzsche's thought are not present in his writings. Martin comments on the British press accounts: "much of the criticism was groundless or else based on crude twistings of Nietzsche's words and their context. . . ." There is no twisting and no alteration of context when I offer the repeated instances of what can only be described as Nietzsche's bloodlust – "the ecstasies of victory and cruelty" (41), "the intoxication of sweet revenge" (50), "Because the *infliction* of suffering produces the highest degree of happiness" (73), "the *infliction* of suffering – a real *feast*" (73), "the *infliction* of suffering . . . a veritable bait of seduction to life" (76).

Why then was Nietzsche disappointed in contemporary Germans? As he explains in the *Genealogy*, "modern men" were like "tame domestic animals" and thus pale shadows of early mankind. Consequently, modern men were incapable of realizing

with all their energy the extent to which *cruelty* constituted the great joy and delight of ancient man, was an ingredient which seasoned nearly all his pleasures, and conversely the extent of the naïveté and innocence with which he manifested his need for cruelty, when he actually made as a matter of principle "disinterested malice" (or, to use Spinoza's expression, the *sympathia malevolens*) into a *normal* characteristic of man – as consequently something to which the conscience says a hearty *yes*. The more profound observer has perhaps already had sufficient opportunity for noticing this most ancient and radical joy and delight of mankind. . . . The sight of suffering does one good, the infliction of suffering does one more good – this is a hard maxim, but none the less a fundamental maxim, old, powerful, and "human, all-to-human"; one, moreover, to which perhaps even the apes as well would subscribe: for it is said that in inventing bizarre cruelties they are giving abundant proof of their future humanity, to which, as it were, they are playing the prelude. Without cruelty, no feast: so teaches the oldest and longest history of man – and in punishment too there is so much of the *festive* (73–5).

How does Nietzsche propose to counter the alleged deleterious effects of Jewish and Christian morality? He answers, "For such a consummation we need spirits of *different* calibre than seems really feasible in this age; spirits rendered potent through wars and victories, to whom conquest, adventure, danger, even pain, have become a need; Is this even feasible to-day?" (116–17). Yes, responds Nietzsche, "through the coming of Nietzsche's "redeemer," "this Antichrist," "this conqueror of God" (117). For Nietzsche at this point in his life, this was the meaning of Zarathustra, the only one to whom the path to the future was open, "open alone to *Zarathustra, Zarathustra the godless*" (118). In Nietzsche's later *The Antichrist* (1888), he explicitly reaffirmed the arguments of *The Genealogy of Morals* (see *The Antichrist* in Walter Kaufmann, ed., *The Portable Nietzsche* [New York: Viking, 1954], 593).

According to Walter Kaufmann, Nietzsche "tried to deepen the Enlightenment" ("Introduction," *The Portable Nietzsche*, 16). Yet according to Nietzsche, he wrote the *Genealogy* for quite a different purpose: "we need a *critique* of morals, *the value of these values* is for the first time to be called into question" (*Genealogy*, 9). The reason for calling into question the value of morals is because, as Nietzsche explains approvingly, "their commencement, like the commencement of all great things in the world, is thoroughly and continuously saturated with blood" (ibid., 72).

For a more accurate assessment of Nietzsche's thought, see the introduction by Keith Ansell-Pearson to *On the Genealogy of Morality*, tr. Carol Diethe, Cambridge Texts in the History of Political Thought (Cambridge: Cambridge University Press, 1994). Ansell-Pearson begins his conclusion as follows:

Nietzsche is an immensely challenging thinker, but disturbing too. His challenge is to argue that if one wants to esteem life, then it is necessary to affirm the "grand economy of the whole," including, he states in the opening section of *The Joyful Science*, "the lust to rob and dominate," "the mischievous delight taken in the misfortune of others," and "whatever else is called evil." (. . .) What is disturbing about Nietzsche is his application of this way of thinking "beyond good and evil" to the social sphere, which results in his contention that culture and the advancement of man are not possible without slavery and cruelty (xxi–xxii).

134. Paul de Man, "Les Juifs dans la littérature actuelle" ["Jews in Current Literature"], *Le Soir* (March 4, 1941), photographically reproduced in Werner Hamacher, et al., eds., *Wartime Journalism, 1939–1943: Paul de Man* (Lincoln: University of Nebraska Press, 1988), 45. For other wartime articles by de Man that accept Nazi racial theories, that argue for the

moral legitimacy of Nazi military conquests, and that welcome what de Man envisions as the new totalitarian world order to be ushered in by Nazi victories, see in *Le Soir*, "Dans la constitution d'une élite, le rôle de la jeunesse sera considérable" (June 7–8, 1941), "'Le testament politique de Richelieu' par Frédéric Grimm" (August 19, 1941), "Dans nos murs" (August 26, 1941), "Après les journées culturelles germano-flamandes: Le destin de la Flandre" (September 1, 1941), "'Notes pour comprendre le siècle,' par Drieu la Rochelle" (December 9, 1941), "La littérature française devant les événements" (January 20, 1942), and in the Flemish-language *Het Vlaamsche Land*, the English-language translation provided by this volume for "Art as Mirror of the Essence of Nations: Considerations on 'Geist der Nationen' by A. E. Brinckmann" (March 29–30, 1942), 99, 135–40, 170–1, 187–8, 302–3. The original French text of the passage quoted here reads: "De même, les Juifs ne sauraient prétendre en avoir été les créateurs, ni même avoir exercé une influence prépondérante sur son évolution. A examen quelque peu proche, cette influence apparaît même comme extraordinairement peu importante. . . . La constatation est d'ailleurs réconfortante pour les intellectuels occidentaux. Qu'ils ont été capables de se sauvegarder de l'influence juive dans un domaine aussi représentatif de la culture que la littérature, prouve pour leur vitalité. Il ne faudrait pas formuler beaucoup d'espoirs pour l'avenir de notre civilisation si elle s'était laissé [sic] envahir sans résistance par une force étrangère." The text of the entire article is presented in English translation in Lehman, *Signs of the Times*, 269–71.

135. For a passing reference to Nietzsche as a sadist and on his affinities to the Marquis de Sade, see Praz, *The Romantic Agony*, 269, 290 n. 50. See also the account of de Sade's philosophy sketched with quotations from *Justine* (104–6). These affinities have also been discussed in Max Horkheimer and Theodor W. Adorno, *Dialectic of Enlightenment*, tr. John Cumming (1944; New York: Herder and Herder, 1972), 97–104; and Hayman, *Nietzsche*, 294.

136. Nietzsche, *The Genealogy of Morals*, 72. See also Nietzsche's further attack on "Kant as a *moralist*" in *The Antichrist*, in Kaufmann, ed., *The Portable Nietzsche*, 576–9.

137. According to Paul Guyer, this line, taken from the conclusion of Kant's *Critique of Practical Reason* (1788), "may be his single most famous passage." See Paul Guyer, "Introduction: The Starry Heavens and the Moral Law," in Paul Guyer, ed., *The Cambridge Companion to Kant* (Cambridge: Cambridge University Press, 1992), 1.

138. Nietzsche, *The Genealogy of Morals*, 72–3.

139. Immanuel Kant, *Dreams of a Spirit-Seer* (1766), as quoted in Guyer, "Introduction," *The Cambridge Companion to Kant*, 9.

140. Nietzsche's dripping blood (see n. 133) has given way to polite consternation at Kant's supposed errors. The approach is generally more genteel and can be found even in those who have rejected major aspects of poststructuralist thought. For example, consider a recent statement from Denis Donoghue, who elsewhere has pointed out the problems with deconstruction (see ch. 3, nn. 16, 20, as well as Donoghue, *Ferocious Alphabets* [1981]):

> There is no truth in anyone's claim to be beyond ideology. Kant's appeal, in *The Critique of Judgment*, to the faculty of taste as "a sense common to all mankind" was unwise, and regrettably it has been used by those who want to sustain the notion that each of us is spiritually the same, at a level of being far deeper than that of our differences. It would be

more reasonable to claim that equality, universality and disinterestedness are sentiments to be imagined, not states of being or gifts of God to be enjoyed. Literature could then be presented as one of the means by which we are enabled to imagine being other than we are. (Denis Donoghue, "Doing Things with Words. Criticism and the Attack on the Subject," *Times Literary Supplement* [July 15, 1994], 4−5).

I believe that Donoghue errs in listing ideology, a common spiritual core, universality, equality, and disinterestedness as if they were all on one level and of the same nature. He does not distinguish between a scale of concerns of the type elaborated by Herbert J. Paton in his discussion of the difference between pure ethics and applied ethics in *The Categorical Imperative: A Study in Kant's Moral Philosophy* (London: Hutchinson, 1947; 1967 6th ed.), 23, and given in ch. 3, n. 71. Donoghue himself previously seems to have made such distinctions when in "The Political Turn in Criticism," *The Old Moderns*, he agreed with Northrop Frye's assessment that an ideology " 'expresses secondary and derivative human concerns,' " whereas mythology " 'expresses the primary desires of existence.' " "Mythology, in Frye's sense," continues Donoghue, "calls . . . for a description that recognizes the primordial character of the experiences it expresses" (94−5). In that sense, Kant's appeal was in no way unwise.

141. Nicholson Baker, "Survival of the Fittest," *New York Review of Books* (November 4, 1993), 18.

142. Leo Tolstoy, *Anna Karenina*, tr. David Magarshack (New York: The Penguin Group, 1961, 1980), 779 (translation modified).

Postscript

1. Michael Oakeshott, *The Voice of Poetry in the Conversation of Mankind. An Essay* (London: Bowes and Bowes, 1959), 9.

2. Derrida, as quoted in Brunette and Wills, "The Spatial Arts: An Interview with Jacques Derrida," in Brunette and Wills, eds., *Deconstruction and the Visual Arts*, 11.

3. Ibid., 10. Another way of expressing this can be found in Paul Ricoeur's notion of a hermeneutics of suspicion. In "A *Yellow Pages* of Theory and Criticism," *Partisan Review* 62 (Winter 1995): 142, a review of Michael Groden and Martin Kreiswirth, eds., *The Johns Hopkins Guide to Literary Theory and Criticism* (1994), Ray Carney evokes this paradigm and further explains, "As different as they may be in other respects, the Marxists and the Derrideans, the feminists and the formalists, the new historians and the structuralists are all engaged in a fundamentally debunking project. They want to unmask, to demystify, to demythologize." (On this theme, see also ch. 4, n. 30.)

Carney proceeds to explore the implications of an alternative approach to understanding that Ricoeur calls the hermeneutics of faith. "In this tradition," explains Carney, "rather than holding himself outside of the text and resisting its language by imposing his language upon it, the critic allows the text its own unique and alien way of speaking, and as hard as it may be, attempts to bring himself, through demanding intellectual and emotional discipline, into relationship with it" (142−3). For a further development of such an approach to history and to the art and literature of the past, see Georges Poulet, *La Conscience critique* (Paris: José Corti, 1971), which traces this tradition from Montaigne and Mme de Staël through the "*nouvelle critique* of Gaston Bachelard, Marcel Raymond,

Maurice Blanchot, Jean Rousset, Jean-Pierre Richard [and] Jean Starobinski" (9), with a postscript on Poulet's own mental growth. Several of the finest books clustered under the rubric of the *nouvelle critique* are listed in ch. 1, n. 52. I also highly recommend as a model of this type of scholarship Mona Ozouf, *La Fête révolutionnaire, 1789–1799* (Paris: Gallimard, 1976); *Festivals and the French Revolution*, tr. Alan Sheridan (Cambridge, Mass.: Harvard University Press, 1988).

In pursuing this second approach to understanding, we might seek a different term for the hermeneutics of faith, because the word "faith" suggests a blind acceptance, a "vow of obedience" (Ricoeur, *Freud and Philosophy*, 27). This alternative tradition, which Poulet has studied and to which he has contributed, is more a pluralistic hermeneutics of conviction, since it is grounded in the conviction that one's own consciousness of self has much to learn from a sympathetic encounter with the individuality of other people's unique consciousness – what Poulet terms the encounter between "conscience de soi et conscience d'autrui" (the title of his last chapter). Poulet himself, through an appeal to Aristotle, Descartes, Leibnitz, and Kant, calls this approach "un acte *catégoriel* ou *catégorique*" (310). See in that final chapter Poulet's fascinating discussion of the entire gamut of responses ranging from the "*Cogito* maximum" of Descartes to the "*Cogito* minimum" of Rousseau. For Ricoeur's discussion of the hermeneutics of suspicion, grounded in the thought of Marx, Nietzsche, and Freud, those "three masters of skepticism," see Ricoeur, *Freud and Philosophy*, especially ch. 2, and "The Critique of Religion," in *The Philosophy of Paul Ricoeur: An Anthology of His Work*, eds. Charles E. Reagan and David Stewart (Boston: Beacon, 1978), 213–22.

4. For these slogans as well as for a discussion of "textuality," see Ellis, *Against Deconstruction*, 97–136. On "intertextuality" see my concluding section of ch. 3.

5. Oakeshott, *The Voice of Poetry*, 9. See also his *Experience and Its Modes* (Cambridge: Cambridge University Press, 1933; 1991), which distinguished between historical experience, scientific experience, and practical experience.

6. Michael Oakeshott, "A Place of Learning," in *The Voice of Liberal Learning*, ed. Timothy Fuller (New Haven: Yale University Press, 1989; 1990 reprint), 38. In "A *Yellow Pages* of Theory and Criticism," *Partisan Review* 62 (Winter 1995): 141, Ray Carney offers interesting observations about the relationship of understanding gained through literature to the poststructuralist enterprise:

> What is lost sight of [in poststructuralist literary theory] is that literature is essentially a different way of knowing from the forms of knowing that philosophy, history, sociology, and cultural studies offer. Indeed, it might be argued that literature figures what will *not* be known in those ways. (. . .) It is humanized and bent by voice tones and emotional overtones. It exists only in specific, local, unrepeatable forms: in the obliquities of particular words and the convolutions of specific syntactic shapes. In fact, it might be argued that literary knowledge is not knowledge at all in the sociological, historical, or philosophical sense of the word – but something more like experience (since reading a novel is more like having an unusually complex and stimulating life experience than like encountering an argument in a sociology or philosophy text).

Here Carney is independently echoing the observation made nearly a half century ago by Joyce Cary that the fiction "writer's responsibility is . . . to do justice and to give truth, in

a medium which is at once the only vehicle of truth as an experience, and at the same time highly subjective and irrational: that is to say, the truth of art which is true because it conveys the feeling without which 'facts' are insignificant and delusive, but at the same time personal to each reader" (Joyce Cary, "A Prefatory Essay," *The African Witch* [1936; London: Michael Joseph, 1950, 1959], 11). These are the types of observations that would well serve a study of the different "voices" of "human utterance."

7. Oakeshott, "A Place of Learning," *The Voice of Liberal Learning*, 38.

8. Wilhelm von Humboldt offers helpful reflections on the relationship between what he terms "objective truth" and "subjective individuality" that apply to this argument. In reading the passage below, substitute Oakeshott's phrase "languages of understanding" for Humboldt's "languages" as well as "humanistic study" for "linguistic study" to discern how apt the German thinker's observations about languages are for the broader subject of different disciplines or genres:

> The mutual interdependence of thought and word illuminates clearly the truth that languages are not really means for representing already known truths but are rather instruments for discovering previously unrecognized ones. The differences between languages are not those of sounds and signs but those of differing world views. Herein is contained the reason for and the final aim of all linguistic study. The sum of the knowable, that soil which the human spirit must till, lies between all the languages and independent of them, at their center. But man cannot approach this purely objective realm other than through his own modes of cognition and feeling, in other words: subjectively. Just where study and research touch the highest and deepest point, just there does the mechanical, logical use of reason – whatever in us can most easily be separated from our uniqueness as individual human beings – find itself at the end of its rope. From here on we need a process of inner perception and creation. And all that we can plainly know about this is its result, namely, that objective truth always rises from the entire energy of subjective individuality.

(Wilhelm von Humboldt, *Humanist without Portfolio. An Anthology of Writings*, tr. Marianne Cowan [Detroit: Wayne State University Press, 1963], 246.)

9. Rudolf Otto, *The Idea of the Holy: An Inquiry into the Non-Rational Factor in the Idea of the Divine and Its Relation to the Rational*, tr. John W. Harvey (Oxford: Oxford University Press, 1923; 1973), 149, 144 (for the definition of divination).

10. Jacques Derrida, "The Law of Genre," in *Acts of Literature*, ed. Derek Attridge (London: Routledge, 1992), 223–4. See the lines that follow in Derrida's text, which further develop this idea of "interdictions."

11. Derek Attridge, introductory remarks to ibid., 221.

12. Pete Conrad, *A Song of Love and Death: The Meaning of Opera* (New York: Poseidon / Simon and Schuster, 1987), 11, 13.

13. The first expression is from Hegel, *Aesthetics: Lectures on Fine Art*, II, 710, where it furnishes a main theme in this volume. The second phrase is from Kierkegaard, *Either / Or*, I, 71 and passim in the section entitled "The Immediate Erotic Stages or the Musical-Erotic."

14. On this subject, see "'Intertextuality' and Base Metaphors" in ch. 3.

15. Ellis, *Against Deconstruction*, 137–42. See also Tallis, *In Defence of Realism*, 73. I discuss this matter in greater detail in ch. 1, n. 9.

16. In the exchange, famous in literary circles, between René Wellek and F. R. Leavis, decades before the advent of deconstruction, Leavis responded to Wellek's criticism about his not

having articulated his underlying "assumptions" by reminding Wellek that literary criticism and philosophy are essentially two different voices or discourses: "I hope [Wellek] will forgive me if I say that his demonstration has, for me, mainly the effect of demonstrating how difficult it is to be a philosopher and a literary critic at the same time." Leavis makes it clear that he believes that the philosopher's refusal or inability to recognize the distinctive voice of poetry blinds him to the nature and meaning of this type of discourse. Wellek's use of a philosopher's way of thought in discussing Blake, Wordsworth, and Shelley, observes Leavis, "can only suggest the irrelevance of the philosophic approach." Finally: "The confidence of [Wellek's] paraphrase made me open my eyes. It is a philosopher's confidence – the confidence of one who in the double strength of a philosophical training and a knowledge of Blake's system ignores the working of poetry." F. R. Leavis, "Literary Criticism and Philosophy" (a reply to Wellek's criticism in *Scrutiny* [March 1937] of Leavis's *Revaluation*), in *The Common Pursuit* (New York: New York University Press, 1952), 210–22 (quotations taken from 216–17).

17. Pierre Bourdieu, *Distinction: A Social Critique of the Judgement of Taste*, tr. Richard Nice (Cambridge, Mass.: Harvard University Press, 1984), 2.

18. See Frederick Cummings, "Boothby, Rousseau, and the Romantic Malady," *Burlington Magazine* 110 (December 1968): 659–66. In addition to these emblems, Cummings also points out other emblems of melancholy in this painting: the pose of being stretched out on the earth, the partially unbuttoned waistcoat, and the presence of the stream. The key to the emblematic meaning of this painting, explains Cummings, is to be found in the book that Boothby holds in his hand and on whose spine is legible the name "Rousseau." Among the several and related meanings that Cummings adduces, the central one appears to be "the transience of human institutions and the fragility of human creations," which can be countered in part, as Boothby himself explains in his own moral writings, through an attention to the work of Rousseau, which " 'would lead us back to virtue and happiness as to our native rights and possessions' " (665).

19. It is instructive that this requirement of a preparatory development has been observed and explained by behavioral scientists as corresponding to a human tendency to need more time to learn certain complex processes and to prefer such complexities to situations that lack them. Thus F. G. Hare reports:

> Washburn, Child, and Abel (1927) observed that repetition of musical excerpts produces different effects, depending upon the type of music used. For example, "with very popular selections the tendency is to attain maximum pleasantness at an early performance, whereas in the case of . . . classical music the tendency is to reach maximum enjoyment at a late performance" (205).

Hare further explains that this tendency to require more time to appreciate a complex phenomenon such as classical music while simultaneously preferring it to a less complex one occurs with other stimuli – such as patterns of light – and is shared with animals – such as rats in a maze:

> If one were to assume that the differences between "popular" and "classical" include, at least to a certain extent, differences in complexity, a link may be established between this music-preference research and two other types of investigation. In one, Dember, Earl & Paradise (1957) predicted that "any change in preference (of rats) will be from the less to

the more complex path" (p. 514). In the other, Jones, Wilkinson & Braden (1961) found that [subjects] who were allowed to choose among various sequential patterns of lights over a 12-hour period tended, the longer they were in the experiment, to choose the more complicated patterns. Thus, there seems to be at least some conceptual consistency among three different types of preference studies. (F. G. Hare, "Artistic Training and Responses to Visual and Auditory Patterns Varying in Uncertainty," in D. E. Berlyne, ed., *Studies in the New Experimental Aesthetics: Steps Toward an Objective Psychology of Aesthetic Perception* [Washington, D.C.: Hemisphere Publishing Corporation, 1974], 159–60.)

In "The Mystery of Music: How It Works in the Brain," *New York Times* (May 16, 1995), p. C10, Sandra Blakeslee briefly explores the relationship between language acquisition and musical ability and comments on the relative degrees of complexity of rock and roll and classical music as a function of "the violation of . . . brain-based expectations," while observing that "the note-to-note violations in classical music are very subtle."

20. Humboldt, *Humanist without Portfolio*, 239–40:

> Language, I am fully convinced, must be looked upon as being an immediate given in mankind. Taken as a work of man's reason, undertaken in clarity of consciousness, it is wholly inexplicable. Nor does it help to supply man with millennia upon millennia for the "invention" of language. Language could not be invented or come upon if its archetypes were not already present in the human mind. For man to understand but a single word truly, not as a mere sensuous stimulus (such as an animal understands a command or the sound of the whip) but as an articulated sound designating a concept, all language, in all its connections, must already lie prepared within him. (. . .)
>
> Naturally this does not mean that one is to think of language as a given that is complete and finished, for then one could not comprehend how a man could understand or use any single given language. It necessarily grows out of an individual, gradually growing up with him, but in such a way that its organization does not lie, like an inert mass, in the dark of a man's soul till it is brought forth, but instead that its laws condition the functions of thought. (. . .) If one seeks an analogy for this – and there is really nothing comparable to it in the whole realm of the mind – one might remember the natural instincts of animals and call language an intellectual instinct of the mind.

In *Cartesian Linguistics*, 29, Chomsky writes approvingly of the tradition of thinking about language that stretches from Descartes to Wilhelm von Humboldt and concludes:

> In summary, one fundamental contribution of what we have been calling "Cartesian linguistics" is the observation that human language, in its normal use, is free from the control of independently identifiable external stimuli or internal states and is not restricted to any practical communicative function, in contrast, for example, to the pseudo language of animals. It is thus free to serve as an instrument of free thought and self-expression. The limitless possibilities of thought and imagination are reflected in the creative aspect of language use. The language provides finite means but infinite possibilities of expression constrained only by rules of concept formation and sentence formation, these being in part particular and idiosyncratic but in part universal, a common human endowment. The finitely specifiable form of each language – in modern times, its generative grammar – provides an "organic unity" interrelating its basic elements and underlying each of its individual manifestations, which are potentially infinite in number.

The implications of this understanding were developed further in *Problems of Knowledge*, 10, 13–14, where Chomsky summarizes aspects of Jacques Monod's thought while adding his own reflections:

It is quite reasonable to suppose that specific principles of language structure are a biological given, at the present stage of human evolution. (. . .) I think Monod is correct in commenting that "these modern discoveries thus give support, in a new sense, to Descartes and Kant, contrary to the radical empiricism that has dominated science for two centuries, throwing suspicion on any hypothesis that postulates the 'innateness' of forms of knowledge." So far as we know, animals learn according to a genetically determined program. There is no reason to doubt that this is also true of "the fundamental categories of human knowledge, and perhaps also other aspects of human behavior, less fundamental, but of greater significance for the individual and society" [*Le Hasard et la nécessité*, 167–8]. In particular, this may be true of man's apparently unique linguistic faculties, and of his abilities of imaginative thought, as manifested in language, in visual imagery, in plans of action, or in true artistic or scientific creation.

To argue in this manner for the innate character of language capacity as well as for aesthetic experience does not decide the issue as to "whether these systems are constructed on the basis of distinct innate schemata or whether there are overriding characteristics of mind that integrate and underlie these systems" (ibid., 49). For a critique of the argument "that a language is a 'habit structure' or a network of associative connections, or that knowledge of language is merely a matter of 'knowing how,' a skill expressible as a system of dispositions to respond," see Noam Chomsky, *Language and Mind* (New York: Harcourt Brace Jovanovich, 1972 enlarged ed.), 25–6. This discredited approach constitutes the underlying basis for Bourdieu's notions of learning an artistic "code."

21. Humboldt, *Humanist without Portfolio*, 275. In a similar vein, consider John Press's observation about the writing of poetry in *The Fire and the Fountain*, 23: "Before we can write poetry we must have a firm grasp of both the formal and the emotional meaning of words. This grasp cannot be achieved *until education and experience have developed whatever faculties may be latent within us*. Words are the instruments of poetry and words have no power to move us unless they are charged with the intellectual and the emotional associations that arise out of experience" (my emphasis).

22. Otto, *The Idea of the Holy*, 140.

23. Ibid., 125–6.

24. Ibid., 126.

Index

1. Rembrandt van Rijn, *Self-Portrait at the Easel*, c. 1660 (111 × 85 cm.). Oil on canvas. (Louvre, Paris. © Photo R.M.N.)

2. *Griot New York*, Garth Fagan Dance (dancers: Norwood Pennewell and Valentina Alexander). (Photo: © Steve Labuzetta, courtesy Garth Fagan Dance)

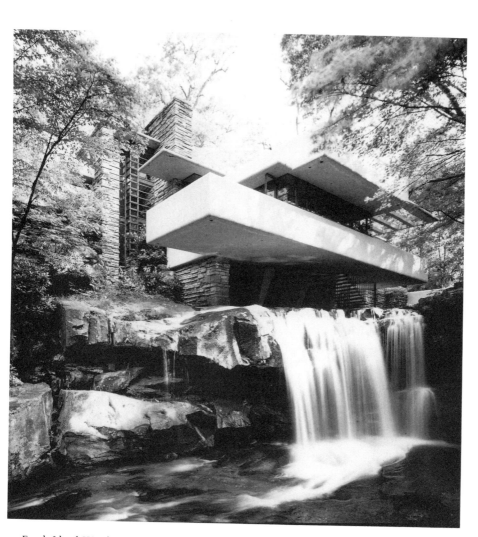

3. Frank Lloyd Wright, Fallingwater, Bear Run, Pa., 1935 (Photo: Western Pennsylvania Conservancy / Art Resource, N.Y.)

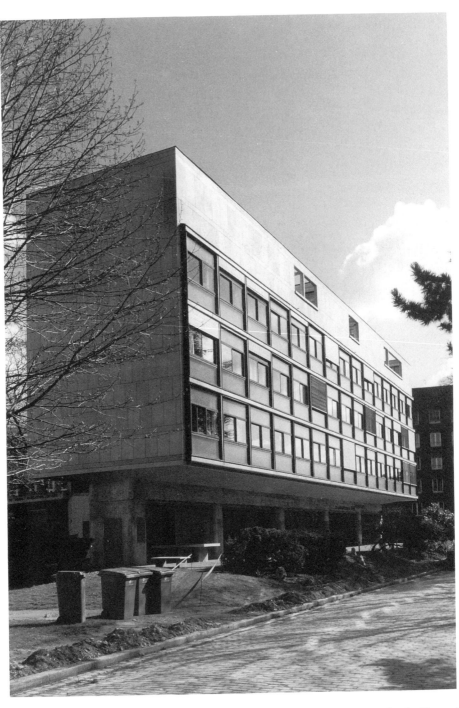

4. Le Corbusier and Pierre Jeanneret, Swiss Dormitory, Paris, 1930–2, south facade. View of the dormitory block elevated off the ground. (Photo: author)

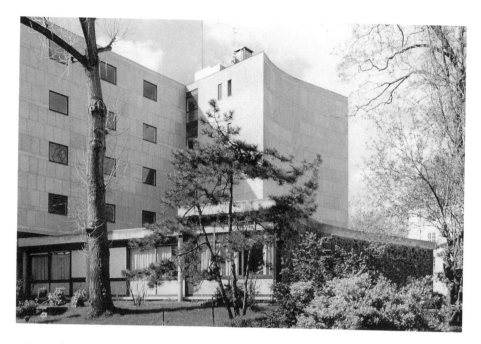

5. Le Corbusier and Pierre Jeanneret, Swiss Dormitory, north facade. View of the low, rubble stone wall behind the communal social hall. The tall stair tower rises behind; the square windows light the corridors to the dormitory rooms. (Photo: author)

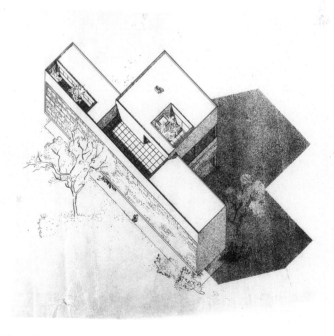

6. Le Corbusier and Pierre Jeanneret, Swiss Dormitory, early project. (Photo: Fondation Le Corbusier. © 1995 Artists Rights Society [ARS], New York / SPADEM, Paris)

7. Le Corbusier and Pierre Jeanneret, Swiss Dormitory, early project. View of the entrance under the elevated dormitory block. (Photo: Fondation Le Corbusier. © 1995 Artists Rights Society [ARS], New York / SPADEM, Paris)

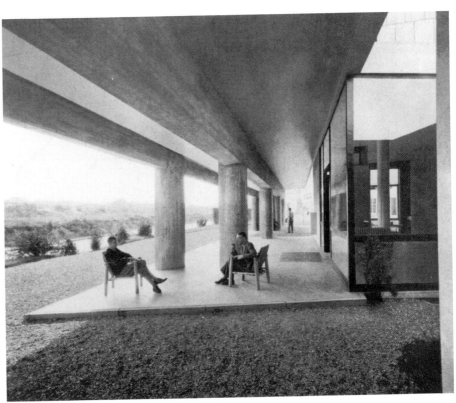

8. Le Corbusier and Pierre Jeanneret, Swiss Dormitory, view under the dormitory block. (© 1995 Artists Rights Society [ARS], New York / SPADEM, Paris)

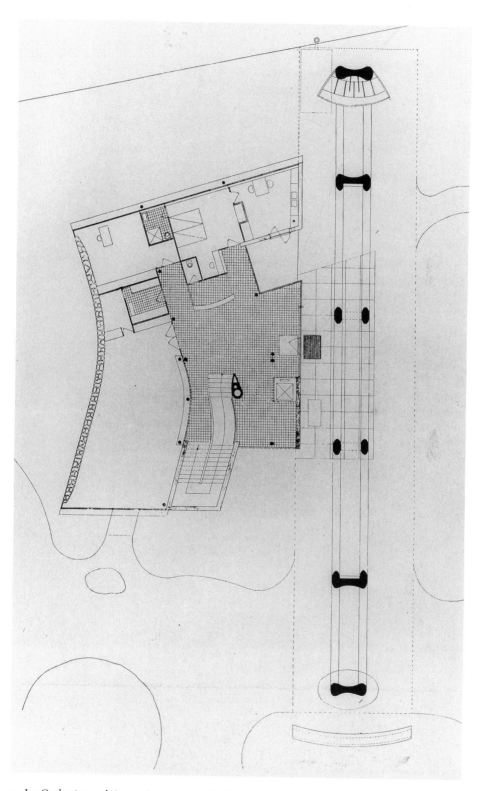

9. Le Corbusier and Pierre Jeanneret, Swiss Dormitory, plan. (© 1995 Artists Rights Society [ARS], New York/SPADEM, Paris)

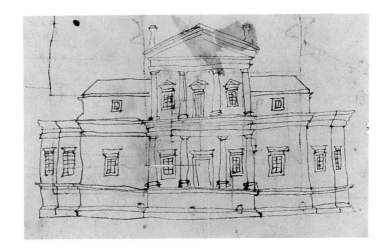

10. Thomas Jefferson, Monticello, Charlottesville, Va. First project, c. 1771. (Photo: Monticello / Thomas Jefferson Memorial Foundation, Inc.)

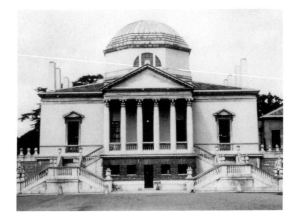

11. Lord Burlington, Chiswick House, London, c. 1725. (Photo: courtesy David P. Fogle)

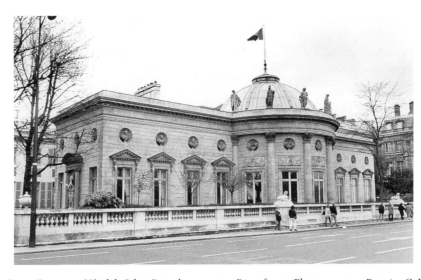

12. Pierre Rousseau, Hôtel de Salm, Paris, begun 1782. River front. (Photo: courtesy Beatrice C. Rehl)

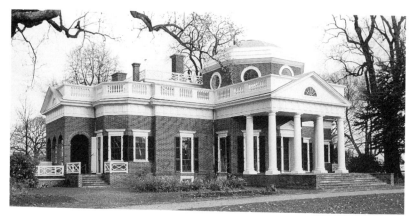

13. Thomas Jefferson, Monticello, garden facade. (Photo: author)

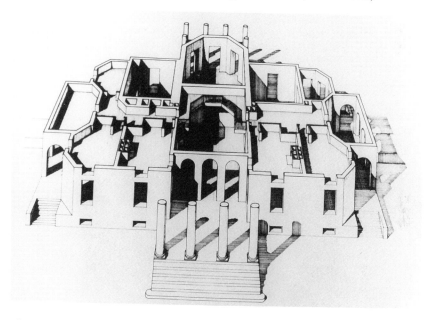

14. Thomas Jefferson, Monticello. Cut-away analytical diagram showing the arrangement of the rooms, as well as indicating which spaces rise to a height above the level of the common ground-floor ceiling. From Frederick D. Nichols and James A. Bear, Jr., *Monticello* (Monticello: Thomas Jefferson Memorial Foundation, Inc., 1967). (Photo: Monticello / Thomas Jefferson Memorial Foundation, Inc.)

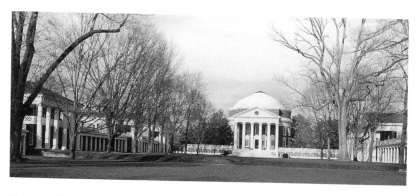

15. Thomas Jefferson, University of Virginia, Charlottesville, Va., 1816–26. Partial view focusing on the central Rotunda. (Photo: author)

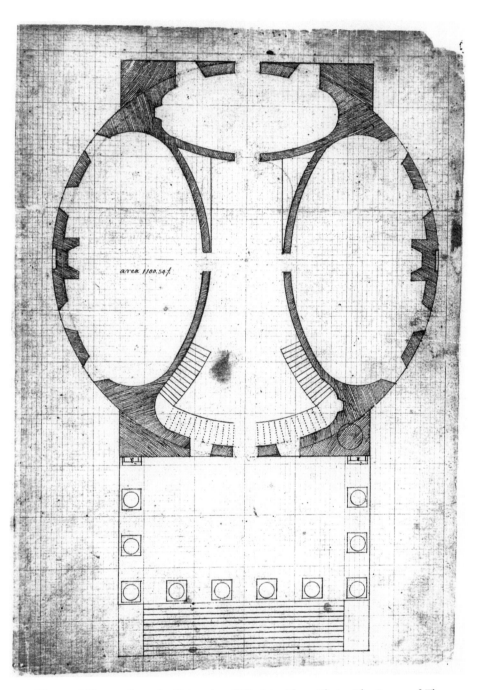

area 1100.sqf

16. Thomas Jefferson, Rotunda, University of Virginia. Plan. (Photo: The Papers of Thomas Jefferson, Manuscripts Division, Special Collections Department, University of Virginia Library)

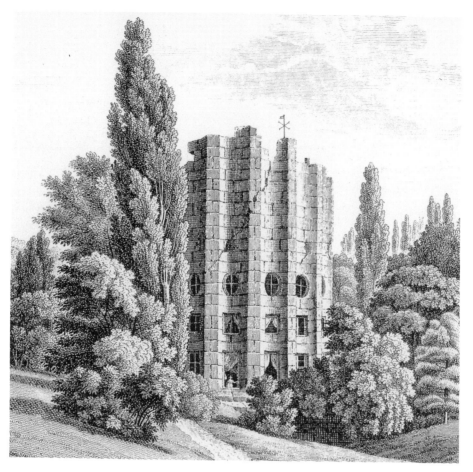

17. Broken column house, Désert de Retz, near Chambourcy, France, c. 1780–1. From G.-L. Le Rouge, *Détail des nouveaux jardins anglo-chinois à la mode* (Paris, 1776–88)

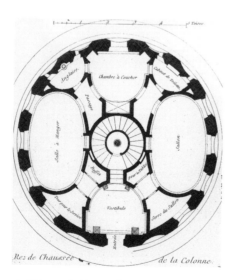

18. Broken column house, Désert de Retz, plan. From Le Rouge, *Détail des nouveaux jardins anglo-chinois à la mode* (Paris, 1776–88). (Photo: Dumbarton Oaks: Studies in Landscape Architecture, Photo Archive)

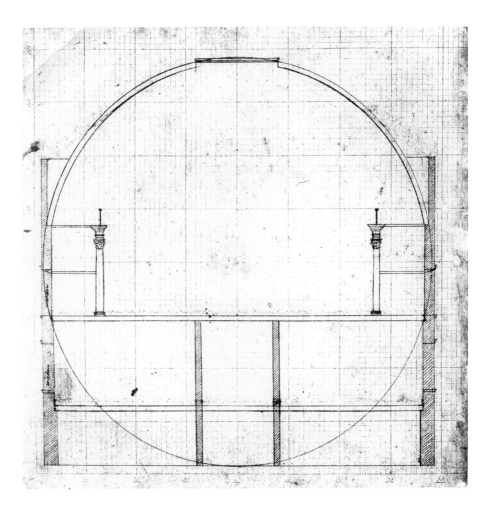

19. Thomas Jefferson, University of Virginia, Rotunda. Section. (Photo: The Papers of Thomas Jefferson, Manuscripts Division, Special Collections Department, University of Virginia Library)

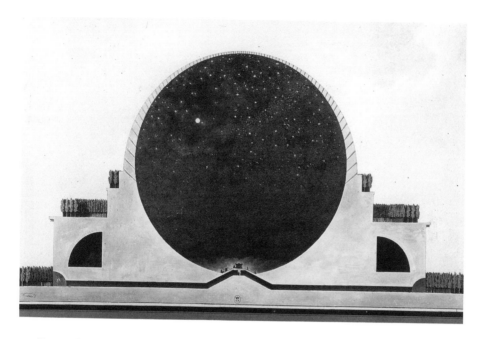

20. Etienne-Louis Boullée, Cenotaph to Sir Isaac Newton (project), 1784. Section. (Photo: Bibliothèque Nationale, Paris)

21. Pierre Rousseau, Hôtel de Salm, Paris, begun 1782. Courtyard. (Photo: courtesy Beatrice C. Rehl)

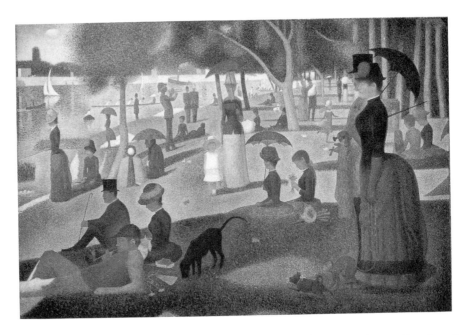

22. Georges Seurat, *Un Dimanche à la Grande Jatte*, 1884–6. Oil on canvas (207.6 × 308 cm.). Helen Birch Bartlett Memorial Collection, 1926.224 (Photo: © 1994, The Art Institute of Chicago. All rights reserved)

23. Georges Seurat, *La Jupe Rose*, 1884. Oil on wood (15.2 × 24.1 cm.). (Photo: courtesy private collection)

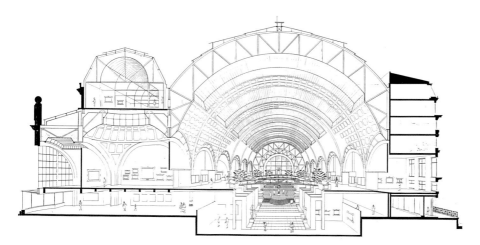

24. ACT Architecture (Renaud Bardon, Pierre Colboc, and Jean-Paul Philippon), Musée d'Orsay, Paris, 1978–80. Section. (Photo: courtesy ACT Architecture)

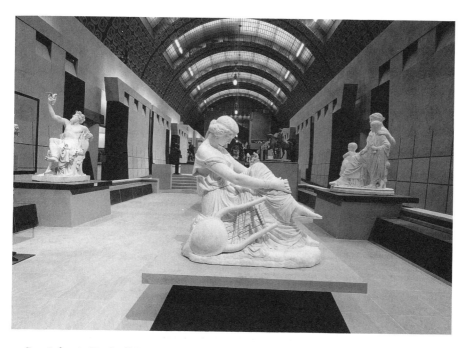

25. Gae Aulenti, Musée d'Orsay, Paris, 1980–5. Interior decor. (Photo: Jim Purcell, Clichés Musées nationaux; courtesy Musée d'Orsay)

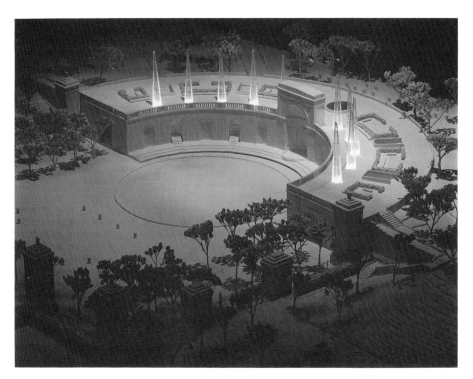

26. Weiss/Manfredi Architects, Women in Military Service for America Memorial, Washington, D.C., 1989. (Photo: © Jock Pottle/Esto)

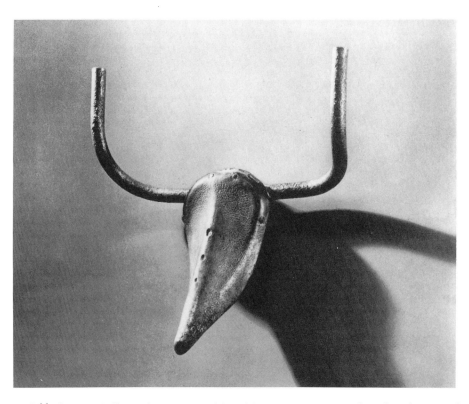

27. Pablo Picasso, *Bull's Head*, 1943 (42.9 × 41 × 14.9 cm.). Bronze, from bicycle seat and handle bars (© 1995 Artists Rights Society [ARS], New York/SPADEM, Paris)

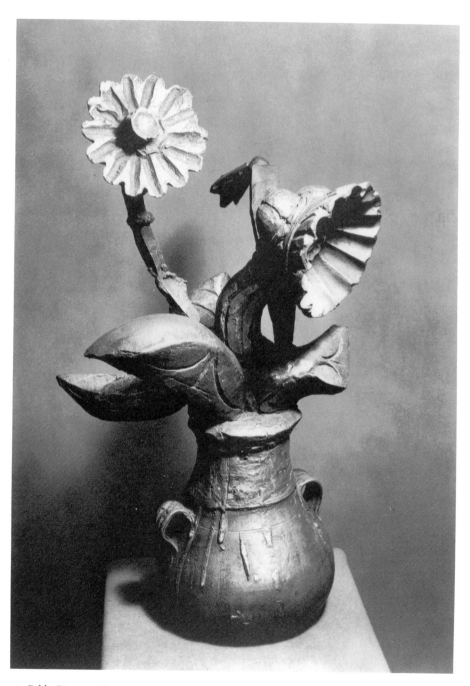

28. Pablo Picasso, *Flowers in a Vase*, 1953 (73 cm. high). (© 1995 Artists Rights Society [ARS], New York / SPADEM, Paris)

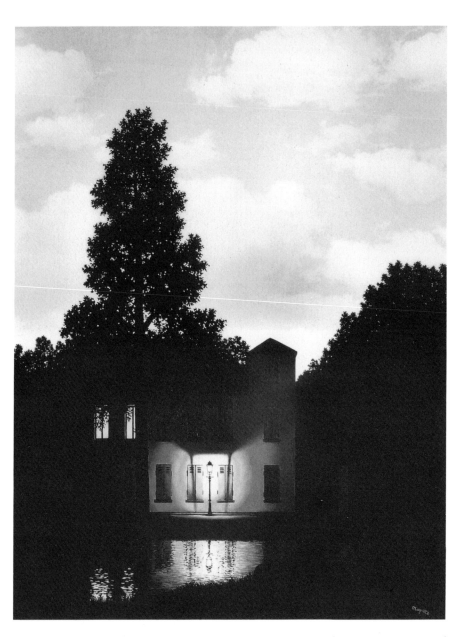

29. René Magritte, *L'Empire des Lumières*, 1954. (Musées Royaux des Beaux-Arts, Brussels, Belgium. Photo: C. Herscovici, Brussels/Art Resource, N.Y.; © 1995 Artists Rights Society [ARS], New York)

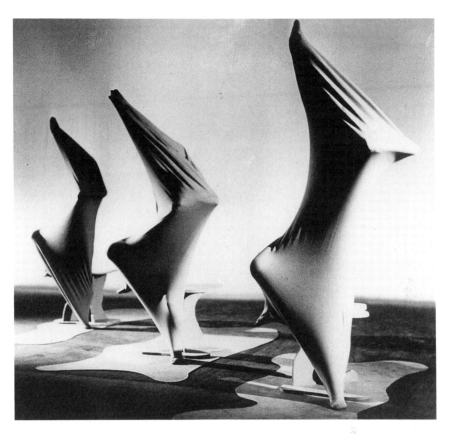

30. Alwin Nikolais, *Noumenon*, 1953. (Photo: courtesy Nikolais & Murray Louis Dance)

31. Le Corbusier and Pierre Jeanneret, Villa Stein, Garches, 1927. (© 1995 Artists Rights Society [ARS], New York / SPADEM, Paris)

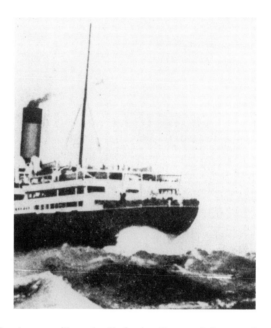

32. Rear deck of the *Aquitania*. From Le Corbusier, *Vers une Architecture* (1923). (© 1995 Artists Rights Society [ARS], New York / SPADEM, Paris)

33. Le Corbusier and Pierre Jeanneret, Villa Savoye, Poissy (1928−31). (© 1995 Artists Rights Society [ARS], New York / SPADEM, Paris)

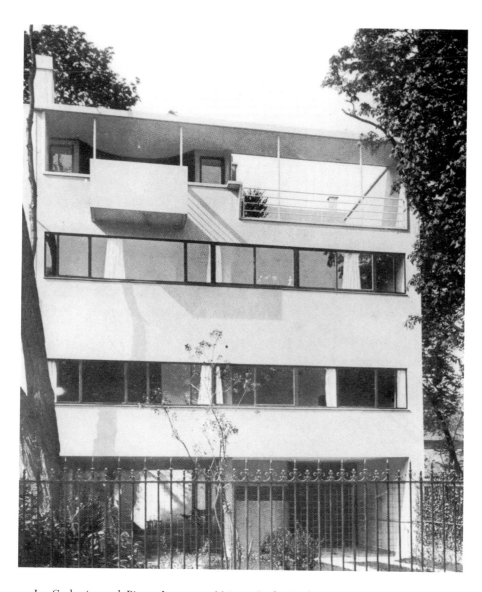

34. Le Corbusier and Pierre Jeanneret, Maison Cook, Boulogne-sur-Seine, 1926. (© 1995 Artists Rights Society [ARS], New York/SPADEM, Paris)

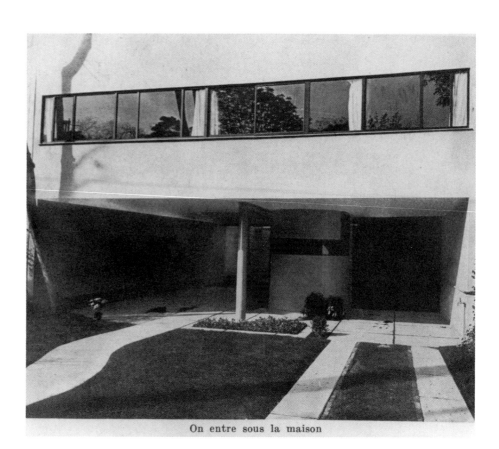

On entre sous la maison

35. Le Corbusier and Pierre Jeanneret, Maison Cook. Detail of the entrance. (© 1995 Artists Rights Society [ARS], New York / SPADEM, Paris)

DES YEUX QUI NE VOIENT PAS...

« AIR EXPRESS », le Goliath Farman.

36. "'Air Express,' le Goliath Farman." From Le Corbusier, "Des Yeux qui ne voient pas" ("Eyes That Do Not See"), *Vers une Architecture* (1923). (© 1995 Artists Rights Society [ARS], New York/SPADEM, Paris)

Le Goliath FARMAN. Paris-Prague en six heures, Paris-Varsovie en neuf heures.

37. "Le Goliath Farman. Paris–Prague in six hours. Paris–Warsaw in nine hours." From Le Corbusier, "Des Yeux qui ne voient pas" ("Eyes That Do Not See"), *Vers une Architecture* (1923). (© 1995 Artists Rights Society [ARS], New York/SPADEM, Paris)

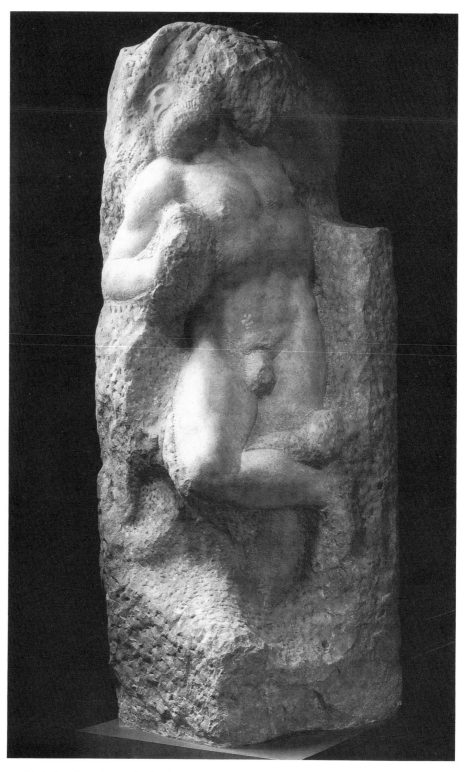

38. Michelangelo, *Slave* (unfinished sculpture). (Accademia, Florence, Italy. Photo: Alinari / Art Resource, N.Y.)

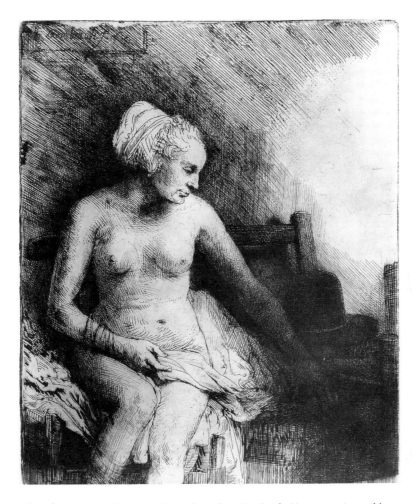

39. Rembrandt van Rijn, *Woman at the Bath, with a Hat Beside Her*, 1658 (15.6 × 12.9 cm.).
Etching (Bartsch 199). (Photo: Marburg/Art Resource, N.Y.)

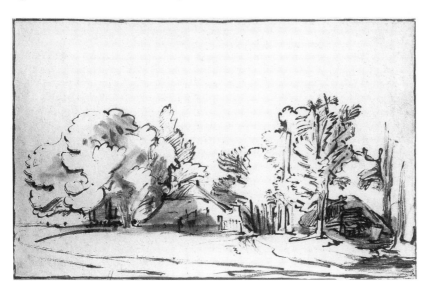

40. Rembrandt van Rijn, *Cottages among the Trees* (19.5 × 31 cm.) Drawing. (Kupferstichkabinett, Staatliche Museen, Berlin, Germany. Photo: Marburg/Art Resource, N.Y.)

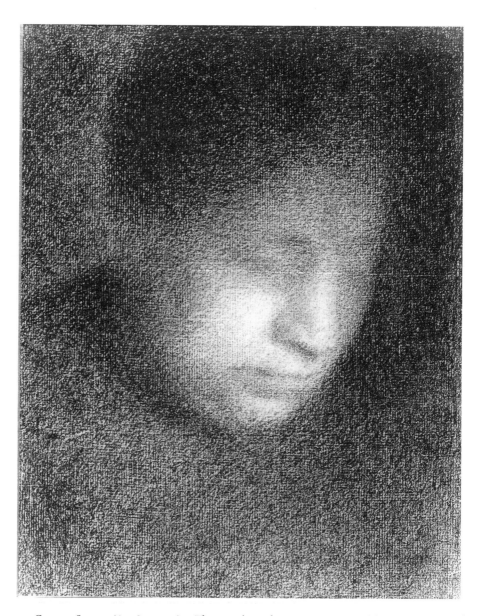

41. Georges Seurat, *Mme Seurat, mère* (The artist's mother), 1882–3 (30.5 × 23.3 cm.). Conté crayon. (Private collection. Photo: courtesy Mrs. Elisabeth Lewyt)

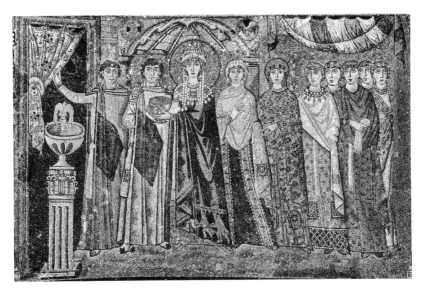

42. *Empress Theodora and Her Attendants Making Religious Offerings*, San Vitale, Ravenna, Italy, c. 547 A.D. Portion of a mosaic. (Photo: Art Resource, N.Y.)

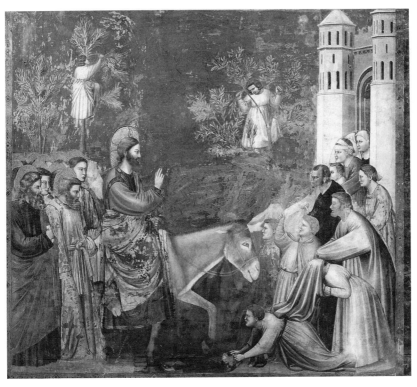

43. Giotto, *Christ Entering Jerusalem*, Scrovegni Chapel, Padua, Italy, 1305–6. Fresco. (Photo: Alinari/Art Resource, N.Y.)

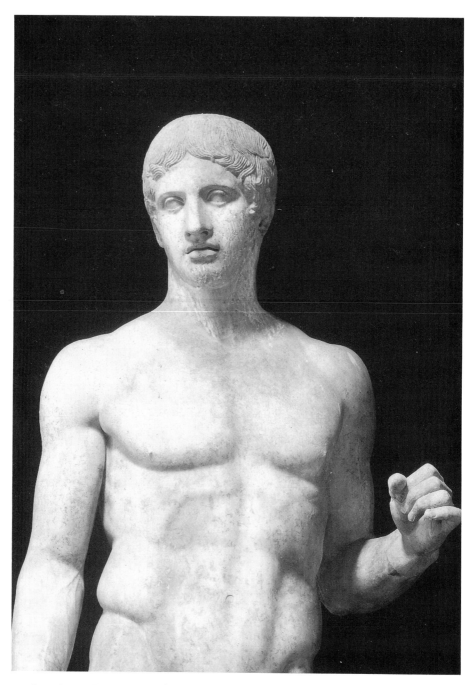

44. *Spear Bearer*, Roman copy after an original by Polyclitus, c. 450–440 B.C. Partial view. (Museo Archeologico Nazionale, Naples, Italy. Photo: Alinari / Art Resource, N.Y.)

45. *Man of the Republic*, Roman, late first century B.C. (H: 35.7 cm.; L. of face 18 cm.). Terracotta. (Gift by Contribution. Courtesy, Museum of Fine Arts, Boston)

46. Burghard Müller-Dannhausen, *Mai 1988 XII* (140 × 90 cm.). Acrylic on canvas. (Museum für Neue Kunst, Freiburg, Germany. Photo: courtesy of the artist)

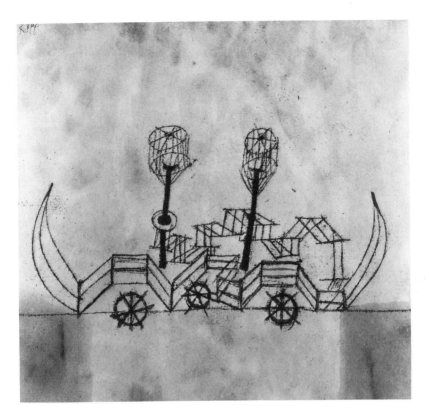

47. Paul Klee, *Alter Dampfer* (Old Steamer), 1922 (15.8 × 16.8 cm.). Oil transfer drawing and watercolor. (Rosenwald Collection, © 1994 Board of Trustees, National Gallery of Art, Washington, D.C.)

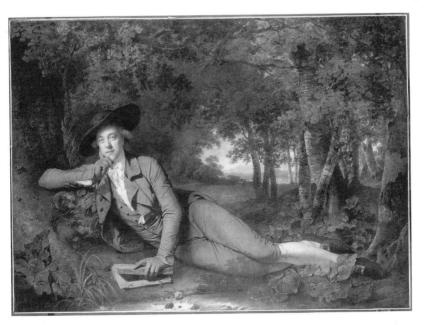

48. Joseph Wright of Derby, *Sir Brooke Boothby*, 1780–1. Oil on canvas. (Courtesy Tate Gallery)